THE ROYAL HORSE AND RIDER

PAINTING, SCULPTURE, AND HORSEMANSHIP 1500-1800

WALTER LIEDTKE

ABARIS BOOKS

A Woodner Foundation Company

in assocation with

THE METROPOLITAN MUSEUM OF ART

WINNER
OF THE
1989 C.I.N.O.A. PRIZE

CONFÉDÉRATION INTERNATIONALE DES NÉGOCIANTS EN OEUVRES D'ART
IS PLEASED TO SUPPORT THE PUBLICATION OF

THE ROYAL HORSE AND RIDER
PAINTING, SCULPTURE, AND HORSEMANSHIP 1500–1800
BY WALTER LIEDTKE

Copyright © 1989 Walter Liedtke

International Standard Book Number 0-89835-267-3

Printed by Meriden-Stinehour Press

Design by Kristen Reilly; assisted by Philip Abrams

Frontispiece: Anthony van Dyck,
Equestrian Portrait of Charles I,
about 1638. (Plate 132)

This book
is inspired by and dedicated to
Nancy Nitcher-Liedtke
and is published on October 7, 1989,
the twentieth anniversary of the day we met.

The author's special thanks to

Anthony Kaufmann, Publisher
Elizabeth Pratt, Managing Editor
Kristen Reilly, Designer
John Spike, Editor
Daniel J. Strauss
Ian Woodner

CONTENTS

FOREWORD

The Metropolitan Museum of Art is proud to co-publish this book by Walter Liedtke, who is the Museum's curator responsible for Dutch and Flemish paintings. Our partner in this project, Abaris Books, is a not-for-profit publisher of scholarly books and a company of the Ian Woodner Family Collection. Mr. Woodner is closely associated with the Museum as a renowned collector of drawings, a donor of European paintings, and an important lender and patron. It is especially gratifying that the shared interests of the Museum and of the Woodner Family Collection now extend to significant publications in the history of art.

It seems particularly appropriate for the Museum to participate with Abaris in the publication of this book. Walter Liedtke wrote the original manuscript when he first came to the Museum as an Andrew Mellon Fellow in 1979. He made extensive use of the Museum's libraries and of the collections, documentation, and expertise available in several departments of the Museum. The many Museum objects reproduced and cited in the book are merely the most obvious resources made accessible by the departments of European Paintings, European Sculpture and Decorative Arts, Prints and Photographs, Drawings, Arms and Armor, Greek and Roman Art, Medieval Art, The Costume Institute, and their specialized libraries of books and photographs. This study is also indebted to the editorial department, and especially to the Museum's Executive Editor, Barbara Burn, who like Dr. and Mrs. Liedtke is equally at home in the world of horses and of art.

The Museum is committed not only to the collection, exhibition, and study of objects in its care, but also to education, research, and publishing in many different areas of art history, archaeology, and connoisseurship. *The Royal Horse and Rider*, while in some ways a standard art-historical survey (the author taught for seven years in universities), reflects at the same time the direct experience of actual objects that is distinctive of a curatorial staff. In many passages of the present text, and indeed in its very premise, the reader is asked to consider a familiar picture or monument not as an example of a given category, but as a unique encounter between the artist, his patron, the medium, and historical circumstance. An essential aspect of the latter is the importance of horsemanship in general, and of *haute école* riding in particular, during the relevant periods. Furthermore, the epochs covered here, which in the plates and their discursive captions range from antiquity to about 1900, are represented not only by the major works of art that would illustrate any textbook or monograph (Leonardo, Velázquez, and Rubens are among the artists treated at length), but also by a great variety of less well-known objects: prints, drawings, small bronzes, wooden sculptures, and public monuments that were erected outside the centers of European art. These delightfully diverse examples of equestrian art illustrate the complexity of European styles and recall the comprehensive nature of an institution such as the Museum.

Finally, it is felicitous in the fullest sense of the word that the manuscript of this book has been awarded the 1989 prize of the Confédération Internationale des

Négociants en Oeuvres d'Art. As an organization of associations representing art dealers throughout Europe and America, CINOA shares with the Museum an emphasis on the object as a unique instance of human creativity.

There are many other approaches to the work of art, as the present study also demonstrates. Nonetheless, the artist and the *haute école* rider know those critical moments when years of practice and centuries of tradition must be realized in an individual act. If today we can still speak of nobility it is at those times when a person or a horse exhibits the finest character of his kind.

Philippe de Montebello, Director
The Metropolitan Museum of Art

PREFACE

The subject of this book now seems to me to be central to the study of European culture, yet it came to me, as if *aus blauem Himmel*, as I was standing in the ring of the Spanish Riding School. On that day in Vienna in the summer of 1978, the idea was to forget about art for once and let my wife, Nancy, see the famous Lipizzaners (see Pl. 220). Neither plan proved possible. Since the horses were enjoying their summer recess, a film, not a live performance, was presented in the ring, and it may be that the projection of those equestrian images onto a two-dimensional surface made me more aware that the movements, which I only later learned "from life," were already familiar from paintings by such eminent artists as Rubens and Velázquez.

It soon became apparent, from a brief review of the literature, that what for me was a revelation was once fairly common knowledge among art historians. In their books dating from the early 1930s, for example, Otto Grossmann and Hjalmar Friis (see Bibliography) made meaningful comparisons between Baroque and later equestrian portraits and monuments, and the "airs," as they are called, of *haute école* horsemanship. Earlier authors, even when they were concerned with Rubens, Velázquez, or some other artist, rather than with equestrian portraiture *per se*, proved themselves conversant with basic questions of equine behavior and anatomy: they knew a walk from a trot, a hock from a fetlock, and were probably less prepared to pull a sparkplug than a shoe.

Perhaps, then, this new book, to some extent a remedial text, will be "useful for younger scholars," the words that an older colleague, at my College Art Association lecture on this subject in 1980, employed to pay me a somewhat deprecating compliment. The same man, however, along with many authors of his generation and as many of mine (not more — the problem is now pervasive), has made misinformed remarks about equine inclinations like the *levade* (see Pl. 220), and art historians in general are now innocent of equitation, so that the very horses that "walk," "trot," and "gallop" through their pages trot, walk, and rear, respectively, to the horseman who happens to peruse their plates. One even reads of a "Cavalier executing a passade" in a painting (Pl. 143), whereas it is disappointingly plain, from the reproduction, that the *pesade* (or rather, *levade*) is performed by the horse. Another writer claims that Marcus Aurelius (Pl. 8) "rides without the aid of reins, defying the logic of riding itself by virtue of his special gifts." Whatever that logic might be it has nothing to do with the emperor's *Meditations* or his ability to sit a slow trot: riding with leg signals alone is a talent one might find today at any local competition, and in battle it was once a routine matter of life and death.

Riding experts, in my experience, have in common with art historians the tendency to think that they are absolutely right on any point concerning their particular subject, even though both disciplines are far from being "hard sciences," require aesthetic discrimination, and involve what might be called trial and error (and sometimes punishment and reward) methodologies. Thus dressage instructors, trainers, breeders, and even authors of books on the horse in art (or the horse in history, as seen in art) will, like patrons and peasants of past times, pronounce this or that painting of a horse to be "wrong," or at least indicative of poor breeding in the horse, the rider, or the artist. Here enthusiasts

of equitation might benefit from consultation with an art historian, even one unable to discuss riding forms, since he or she can explain that art, too, depends upon stylistic conventions as well as nature: what might seem to the horseman an absurdity in a picture or statue could well be the continuation of a venerable tradition or a deliberate departure on the part of the artist (who himself may have been a good horseman) from everyday experience.

It follows from these remarks that no riding master, and no art historian, will have the last word on the subject and that this book will draw a lot of criticism. My "Apology," as prefatory remarks once were called, is that the text is not intended as a definitive survey, but rather as a "study," the record of a student's reading and looking at the relevant material. I have concentrated upon a few questions that seemed inadequately treated in the literature, such as the relationship between Rubens and Velázquez in respect to this genre and the levels of meaning that were once discerned in royal equestrian portraiture. More broadly, the text attempts to sketch out the main lines of development, from the Renaissance onward, of the formal types to which equestrian portraits and monuments conformed. The extended captions to the plates provide something like a chronological review, but still not the kind of concise history one finds in the Pelican volumes. There seemed no need to duplicate information readily available in standard monographs and in surveys of particular periods. Furthermore, in this restricted area of artistic enterprise peculiar problems, precedents, and points of iconography often counted for more than the usual circumstances of an artist's time and place did. For him, the commission of an equestrian portrait was an exceptional event, while that for a monument was extraordinary, a commitment to undertake an unusual and difficult project over a course of years.

My disclaimers notwithstanding, the present book can be said to have very few precedents, the principal one, by Friis, being about monuments only, being sixty years out of date, and being in Danish. Prints, drawings, statuettes, and related paintings, as well as all the major portraits and monuments and quite a few lesser examples, are discussed in the following pages, or at least in the captions to the plates. Footnotes and the Bibliography refer to the very varied books and articles bearing on the subject, if sometimes only tangentially. The index will lead scholars to the artists, works or patrons that especially interest them. However, I warn this kind of hit-and-run reader that the present volume is meant to be digested whole, as an introduction to the questions involved. It is not a register recording the behavior of horses in a few hundred works of art.

The long and frequently interrupted progress of this project began in 1979-80 with the writing of the text and was made possible by an Andrew Mellon Fellowship at the Metropolitan Museum of Art. My College Art Association lecture in 1980 and my article (incorporating contributions from Prof. John Moffitt) in the September 1981 issue of *The Burlington Magazine* drew upon passages of this material, which was not published whole because photos and information, much of which had been encountered casually, continued to fall into the "Equus file." Thus the plates proliferated to about three times the number necessary to illustrate the text and were provided with critical comments.

For some readers the plate section will be the more engaging part of the book, but the text, though denser in its discussion of art historical questions, has been made more accessible by the publisher's agreement to illuminate it with seventy-five illustrations. The majority of these are reproduced again as plates, but the captions to the latter repeat information found in the text only when it seemed to deserve extra emphasis.

Finally, some words of thankfulness. I had the good fortune to meet, over a copy of Pluvinel's treatise, Mme. Lily Froissard, and later her husband Jean Froissard, both of whom are authors and practitioners of the art of equitation. I have learned much from their publications, and through Lily I also came to know a distinguished authority in the field, Alexander Mackay-Smith, Curator and Chairman of the Board at the National Sporting Library in Middleburg, Virginia. Mr. Mackay-Smith kindly wrote, at my request, the essay included here as an Appendix, which any readers less "horsey" than "artsy" might do well to read first.

The book's existence in this ample form is due above all to the vision and enthusiam of my late friend Walter Strauss, with whom Abaris was identical until his death in early 1988. The Strauss family and the family foundation of Walter's distinguished friend, the collector Ian Woodner, have committed themselves to the continuation of Abaris as a living memorial to Dr. Strauss and to his seemingly impossible dream of assembling, in scholarly publications, any number of reproductions deemed necessary to a comprehensive survey of a subject in the history of art. Walter Strauss's legacy is embodied in projects as varied as *The Illustrated Bartsch* and the present, surprisingly single volume, the first non-Bartsch book to be published by Abaris while Walter, unimaginably, is away from his desk.

More recent support has been given generously by Barbara Burn and John Spike, editors at the Metropolitan Museum and at Abaris, respectively, and by Professors David Freedberg and John Rupert Martin, authoritative reviewers of the text. Gerald Stiebel of Rosenberg and Stiebel, New York, submitted the manuscript to the Confédération Internationale des Négociants en Oeuvres d'Art; the writer is honored, the reader rewarded by the substantial contribution that the 1989 CINOA prize has made to the physical appearance of this book.

Grateful acknowledgement must also be made to scholars whose names will reappear in the notes: Robert Berger, Jonathan Brown, Marcus Burke, Laura Camins, John Moffitt, Kristi Nelson, Sir John Pope-Hennessy, and the Hon. Jane Roberts; and the many museum and other colleagues who helped me obtain photographs. Numerous requests were gracefully handled by Polly Sartori. My old friends Haig Oundjian and Edward B. Heston contributed their professional services as photographers. My wife's riding instructors patiently lent me an ear while their eyes were on her. It was Nancy herself who inspired and, in so many ways, encouraged this book, along with the larger members of our four-footed family, Jaeger, Flander, Winston, and Willie.

Bedford, New York
Summer 1989

INTRODUCTION

This book has a double purpose. Firstly, it is a study of Baroque equestrian portraits and monuments from a particular point of view, one which comes closer to that of the patrons and public of the period than has most literature on the subject of the past fifty years. The five chapters that follow do not constitute an historical survey, but a thesis: that equestrian portraits and monuments of the late sixteenth and seventeenth centuries are intimately related in form and meaning to the contemporary art of riding. The two art forms—for so riding was as well to those who practiced *haute école* equitation—share the social setting of the leading courts of Europe.

This study's second purpose is to place the discussion of Baroque art, riding, and rulership in the broader context of equestrian portraits and monuments from about 1500 to 1800, and of their most important representatives, sources, and points of significance for later work. This goal is addressed by Chapters Three and Four, on the equestrian monument from Leonardo to the late seventeenth century; and by the plates and their captions, which proceed to some extent by school and chronologically.

Portraits of individuals flourished in Roman times and from the Renaissance onward. The portrait is now a minor and comparatively miserable art form. Equestrian portraits were among the most important works of art in antiquity, the Renaissance, and through the eighteenth century. Today the equestrian portrait, far more than any other kind of portrait, is a thing of the past, and not likely to be revived. A black limousine is more presidential; if a head of state rides a horse today it is widely appreciated as a quaint personal pursuit. Lesser public figures on horseback risk being numbered among the idle rich, their horses status symbols rather than symbols of state. With her equestrian interests in mind, one unkind journalist described Princess Anne as "an Olympic trial."

To many others, however, riding and the horse itself remain in some ways noble, if no longer associated with the nobility. Post-Romantic princes still appear as riders, but their mounts seem at best sympathetic and often indifferent or with a will of their own. In Western culture the horse has always been admired for its free spirit. The Baroque period was no exception: the whip, the spurs, the bridle (familiar as an attribute of Temperance), and the discipline displayed in Baroque equestrian portraits and discussed in contemporary emblem books pay tribute to the equine temperament in a manner characteristic of absolute monarchies. The horse was often understood as a symbol of the people. In modern times the identification is likely to be with the individual, something very different, and a concept not similarly understood during the great age of equestrian portraiture.

The subject of the horse in art is regarded somewhat skeptically by scholars: recent books by enthusiasts of equitation have put the horse before the art.[1] These essays do, however, contain informed and, for most of us, occasionally surprising comments on the actions of horses and riders in familiar paintings like the *Equestrian Portrait of Philip IV* by Velázquez.[2] It is even more disconcerting to discover that about fifty years ago a few able art historians, most notably Otto Grossmann and Hjalmar Friis, brought a knowledge of horsemanship and its history to bear on equestrian images,[3] whereas,

Pl. 112; Fig. 1

today, most authors make basic mistakes in describing what is going on in equestrian portraits and monuments of the Renaissance and Baroque periods. The problem seems to be our dependence on the automobile and on Heinrich Wölfflin.[4]

Pl. 60

The automobile has inevitably clouded our view of how important the horse once was in everyday life. The story of the peasant who advised Giambologna on a detail of equine anatomy would seem less quaint, and Rubens's farewell to the Duke of Mantua ("Mounting my horse") would sound less romantic, if the experience of people working with and traveling on horses were as familiar today as it was in the seventeenth century.[5] The realism of Caravaggio's *Conversion of Saint Paul* must have been intensified by its resemblance to an accident in the city streets. Most of us are well aware of what perspective meant to artists such as Alberti and Leonardo, but may find a useful reminder in Pope-Hennessy's remark that "the human figure apart, the horse was the canonical subject of Renaissance artists."[6]

Pl. 97; Fig. 2

As for Wölfflin's widely-read *Principles of Art History*, it is not a question of a wrong approach, but of how far it can be taken and still be right. The rearing horse, especially in Rubens's early *Saint George*, would indeed seem to be a motif perfectly suited to Baroque style as Wölfflin has defined it.[7] But the curious idea that the rearing horse is so prominent in Baroque art because it satisfied the seventeenth-century

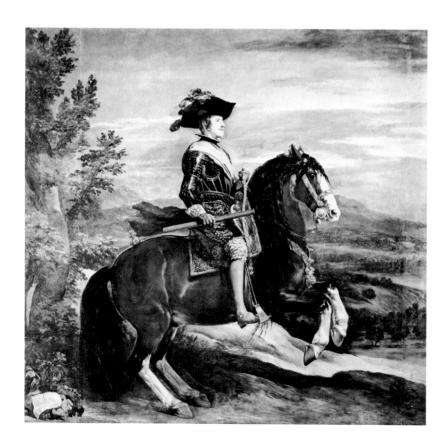

Figure 1
Velázquez,
Equestrian Portrait
of Philip IV,
1634–35. Madrid,
Museo del Prado.
(Plate 112)

artist's will to dynamic form — a widely employed academic shortcut through social history since about 1935[8] — fails to recognize conventions of meaning and especially of form that were clear to contemporary viewers and remained so for many writers down to the early decades of this century.[9]

A fresh comparison of the two paintings mentioned above makes it obvious that stylistic considerations alone do not account very well for the similarity in action, let alone for the considerable differences. Rubens's horse can certainly be said to rear above the dragon in an excited but very deliberate manner, which skillfully positions his experienced master for a second and final blow. The horse painted by Velázquez, on the other hand, appears unexcited and even more controlled, as if sharing in the famous formality of Philip IV.[10] This bearing has struck a number of scholars, possibly with examples by Rubens in mind, as awkward or unconvincing. A recent writer describes the horse here and in Velázquez's equestrian portraits of Prince Baltasar Carlos and the Count-Duke Olivares as "in the unstable rearing pose"; the same author's suggestion that "the impression of incipient change that is implicit in this pose has a Baroque dynamism" raises the question of how much Velázquez succeeded in achieving (or attempted to achieve) this frequently observed effect of *seicento* style.[11]

This question was openly expressed (and the desire for "dynamism" equally assum-

Pls. 97, 112; Figs. 1, 2

Pls. 119, 122

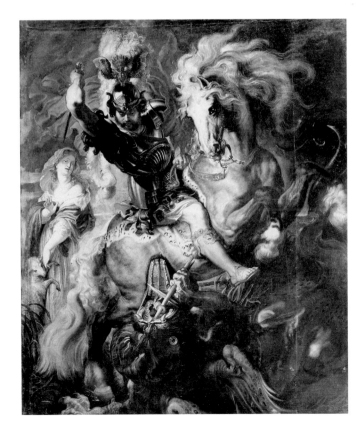

*Figure 2
Rubens, Saint George
and the Dragon,
about 1606. Madrid,
Museo del Prado.
(Plate 97)*

ed) by the eminent art historian Rudolf Wittkower in respect to the closely related design

Pl. 74; Fig. 3 of Pietro Tacca's *Equestrian Monument of Philip IV*.[12] Wittkower's comments are typical of and evidently influential for recent literature on equestrian art. Stressing the rôle of court patronage in defining this kind of portrait, he writes:

> The idea of representing the horse in a transitory position on its hindlegs —
> from then on *de rigueur* for monuments of sovereigns — was forced upon Tac-
> ca by Duke Olivares, who had a Spanish painting sent to Florence to serve
> as model. But Tacca's equestrian statue remains reserved and immobile and
> is composed for the silhouette. It lacks the Baroque momentum of Francesco
Pls. 151, 153 > Mochi's *Alessandro Farnese* and Bernini's *Constantine*.[13]

This description, whether or not it responds to Wölfflin, is modern and misdirected in its regret of the work's immobility and reserve, terms that Olivares would have considered appropriate praise. Since Wittkower's writing, a considerable number of stylistic and iconographic studies have made us more aware of how conventional in form and content Baroque art can be, and often this is supported by a closer look at contemporary literature. We might compare Wittkower's analysis to that of the prolific seventeenth-century biographer of artists, Filippo Baldinucci, who includes a long discussion of this monument in his life of Pietro Tacca.[14] The account of Olivares's specific and emphatic instructions to Tacca on the question of the horse's pose goes back to Baldinucci and has often been recalled.[15] But his detailed discussion of the difficulty of supporting an equestrian monument on the hindlegs alone and of the pose that Tacca nevertheless managed to achieve has not attracted the attention it deserves.[16]

Baldinucci's remarks on the pose of Tacca's horse are prefaced by a reference to the "professors of the art of horsemanship," and he states that "it is first necessary to know the two modes in which the horse is schooled, that is, in the air and on the ground." It is clear from what Baldinucci says and the way he says it that he is relying directly upon contemporary treatises on equitation. He observes that the pose of Tacca's horse does not represent a gallop, *pesade*, *courbette*, or *levade*, giving specific reasons why not in each case, but "something in between the *courbette*, *pesade* and *levade*, but more like a simple *levade* than anything else." Tacca chose this position advisedly, Baldinucci concludes, because the "professors of the art of sculpture" maintain that any other movement has less grace.[17]

The terms that Baldinucci readily (and correctly) employs are those of formal dressage, and of *haute école* riding in particular. They were evidently better known to art critics of the seventeenth century than to those of today and were certainly familiar to the courtly patrons who commissioned equestrian portraits and monuments. The most important names in this book are not only those of artists such as Leonardo, Giambologna, Rubens, Velázquez, and Bernini, but those of Olivares, Buckingham, Philip IV, Louis XIII, Louis XIV, and other famous horsemen.

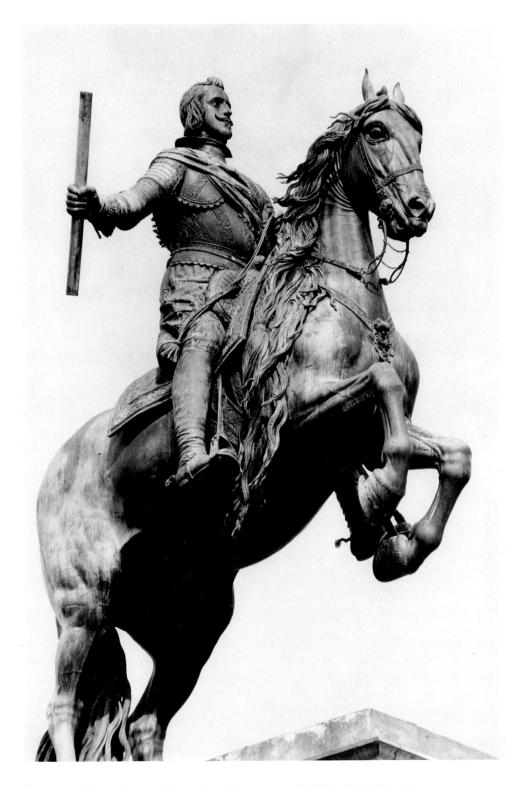

*Figure 3 Pietro Tacca, Equestrian Monument of Philip IV, 1636–40.
Madrid, Plaza de Oriente. (Plates 74–75)*

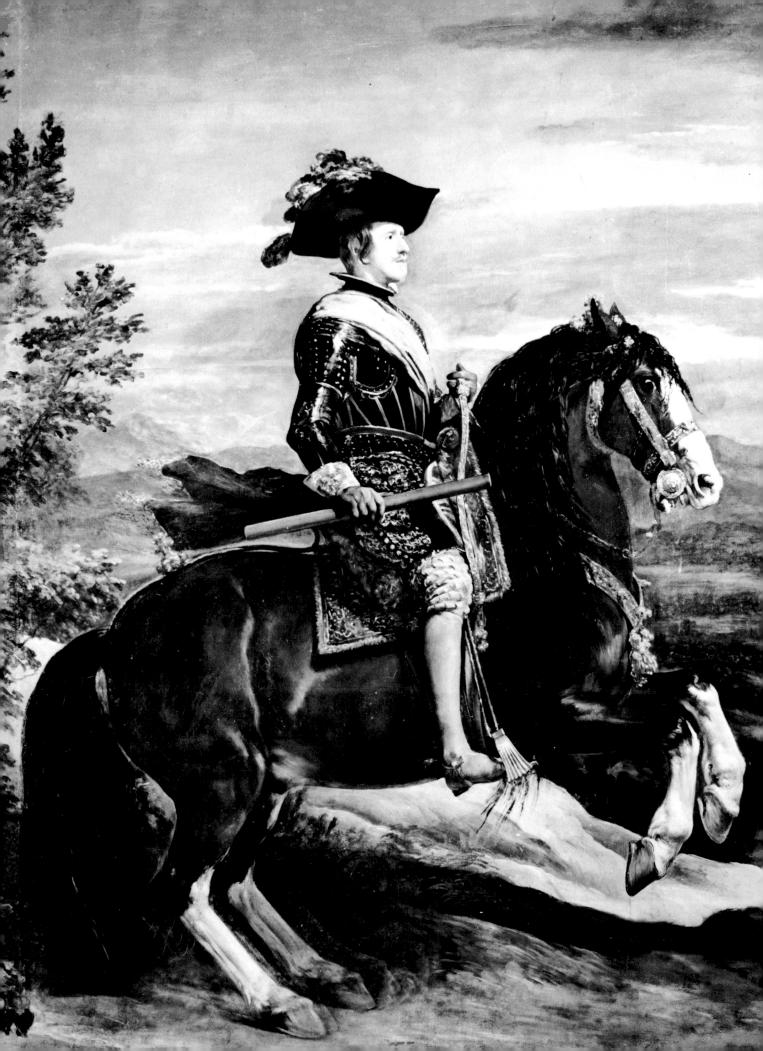

1

RUBENS, VELÁZQUEZ, AND THE SPANISH RIDING SCHOOL

Unlike the terms of *haute école* riding, one word is well — indeed, too well — established in recent writings on equestrian portraiture: the "rear." Horses rear on command, and of their own free will in self-defense, fear or play. In any case, the movement is much higher than that of Velázquez's horse and is essentially unlike almost any pose found in seventeenth-century portraits of sitters on horseback. In most examples, including those in which, as discussed below, the horse may be said to rear, the position is much lower, the movement is more contained, and the rider is seemingly more in control than he would be on a horse that reared spontaneously. It is worth stressing the simple point that, in contrast to what many familiar images from Romantic art to the television western may lead one to imagine, the horse in European portraiture is doing precisely what the rider tells him to do. This includes not only formal dressage exercises but the simple walk and the rear on command. The artist who failed to convey this impression of authority and ability in an equestrian portrait would have opened himself and his patron to ridicule.

The pose that Olivares requested and Baldinucci praised is the *levade*, one of the seemingly effortless but exceedingly difficult movements practiced today at the Spanish Riding School in Vienna.[1] The horse bends his haunches deeply, in a manner more similar to sitting or squatting than to the standing movement of a rear. The body is held at no more than a 45-degree angle, and often less. The forelegs are tucked in close to the body, a point observed fairly consistently in the plates of seventeenth-century treatises but less closely followed in some contemporary equestrian portraits.[2] The head is held straight and close to the body. The rider's pose is similarly frontal, erect, and motionless. The

Pls. 218, 219; Fig. 5
Pl. 112; Fig. 4

Pl. 129

Pl. 213

Pl. 220; Fig. 6

Figure 4 Velázquez, Equestrian Portrait of Philip IV, 1634-35. (Plate 112)

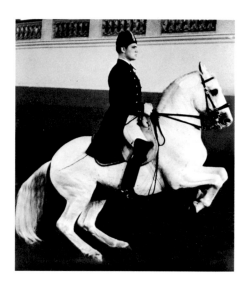

Figure 5
"Raise a Native"
rearing (1979).
Photo courtesy
Fasig-Tipton Co.,
Elmont, N.Y.

Figure 6
A levade
performed at the
Spanish Riding
School, Vienna.

Pl. 74; Fig. 3

Pl. 220

Pls. 106A, 186, 220

movement, or rather position (since there is nothing transitory about it), is held for as long as the strength and skill of the horse allow (usually about five seconds). Wittkower very aptly describes Tacca's horse as "reserved and immobile," "composed for the silhouette," and lacking in "Baroque momentum." That he mistakenly considers these qualities as faults is an example of how our expectations of seventeenth-century art are conditioned by artists such as Rubens and Bernini, and overlooks the fact that an equestrian monument is a very grand example of a very formal kind of art: the state portrait.

Baroque courtiers were keenly aware of contemporary developments in dressage as a renaissance of the ancient art of riding. They knew from the early fourth-century treatise of Xenophon that the Greeks were the first to refine the art, which declined in Rome and was effectively lost in medieval times.[3] Unlike the Greek horse, trained to facilitate the rapid thrusts and parries of lightly armed cavalrymen, the medieval horse met the requirements of a delivery truck: it was bred large to carry a heavy load and trained to run in a straight line.[4]

Something subtler was required after the introduction of firearms made the armor and weaponry of medieval combat less intimidating. In a plate from Wallhausen's *Art militaire à cheval* (1616), for example, the rider shields himself behind the head of his rearing and unfortunate mount while the better armed marksman is dispatched with a lance. The *levade* is a steadier form of this rear on command. The extent to which the "airs above the ground" (including the *levade*) derive from movements employed in mounted combat is a question that has been answered variously by writers on the history of riding and is better left to my colleague, Alexander Mackay-Smith (see Appendix). According to some authors, the *courbette*, in which the horse rises to a high *levade* (called a *pesade*) and then makes a series of leaps forward on its hindlegs, was originally intended to plow through ranks of infantry. In the spectacular *capriole*, the horse leaps straight up from a *levade* and then sharply kicks the hindlegs before landing on all fours at the same spot. This movement was supposedly designed to clear out a space in the thick of battle, and, if so employed, must have made a deep impression on the foot soldier. Horses

perform something close to these movements in nature, but the highly refined airs of the *haute école* go beyond the play of young stallions and the aggressive postures of Baroque cavalry, and constitute one of the great performing arts of the seventeenth and eighteenth centuries. These movements require outstanding skill and discipline in the horse and rider and reflect the considerable aesthetic sense of the founders of the art.[5]

The history of *haute école* riding cannot be told here,[6] but mention must be made of the most important illustrated treatises on equitation. The first, Federico Grisone's *Ordini di cavalcare* (Naples, 1550), came out in new editions almost every year during the 1550s and by 1568 had been published in France, Germany, and Spain in the native languages. Grisone was riding master at the earliest known school of the Renaissance, opened by the nobleman Giovanni Battista Pignatelli after a visit to Constantinople. Like the Crusaders before him, Pignatelli must have been impressed by the small but fast and agile Arabian horses that, imported to the West, were used to develop new breeds, especially in Italy and Spain.[7] The breeding and training of fine horses became an integral part of courtly life in the sixteenth century. Noblemen from all over Europe admired the horses raised by the Este and then Gonzaga families (Gonzaga horses were celebrated by Giulio Romano in the Sala dei Cavalli of the Palazzo del Te), and went to Naples and later Rome to study equitation and bring the art back to their own courts. Grisone's methods, developed to deal with horses that were still large and unresponsive, were already considered heavyhanded in the early seventeenth century. His plates, apart from those bristling with whips, manacles, spurs, and brutal bits, illustrate forms of the *levade* and *capriole* that are distinctly less refined than those that appeared in the outstanding plates published by Pluvinel in 1623. Only Grisone's trot was likely to make an impression on painters and sculptors of the later sixteenth century, and in this case numerous other printed sources could also have served as models.[8]

The most important treatise for the history of art was certainly that of Antoine de Pluvinel (1555–1620). Pluvinel and Salomon de la Broue were trained in Naples by Pignatelli and were the most important agents in bringing *haute école* riding to France.

Fig. 7

Pl. 44

Pls. 106–108

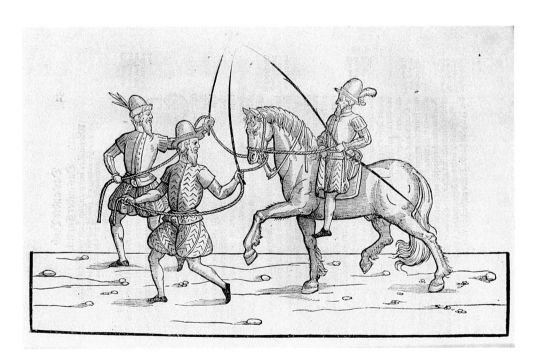

*Figure 7
Federico Grisone,
Gli ordini di
cavalcare, Naples,
1550, woodcut
illustration.
(Plate 106B)*

Like several other riding masters of the period, Pluvinel was highly placed at court. He began as "First Master of the Horse" to the Duke of Anjou, and later became the *écuyer* of Henry IV and governor of the Dauphin. The latter, as Louis XIII, made Pluvinel his squire, adviser, state councillor, chamberlain, vice-governor, and ambassador to Prince Maurits of the Netherlands.

Pluvinel's *Maneige royal...*(Paris, 1623) was one of the most successful and influential treatises on equitation ever published. Under the title of *L'Instruction du roy en l'exercise de monter à cheval*, it was published in Paris in 1625, 1627, and 1629, and in Braunschweig in 1626 (in German and French). The text follows the tony convention of a conversation between the author and the king, but it advanced a method distinctly more progressive than the one Pluvinel had learned in Naples (not mentioned in the book). Following Xenophon, Pluvinel considered the horse a highly developed animal that must be taught to think, and this was to be achieved by a system of rewards and a sparing use of the whip and spurs. Thus the rider would arrive at a closer union with the horse, and "grace and elegance, in addition to science and intuition."

The sixty outstanding plates by Crispijn de Passe the Younger were made in Paris under Pluvinel's supervision between 1617 and 1620.[9] Pluvinel, the king, and distinguished courtiers are shown (and labelled) demonstrating the proper execution of various airs. *Pls. 107, 108; Fig. 8* The pillars, a training aid effectively introduced by Pluvinel and still in use today, are shown in many of the plates, as are the trot and the *levade*, the two forms found so frequently in Baroque portraits and monuments. Nothing comparable to Pluvinel's text and *Pl. 145* plates dates from the seventeenth century. (The Duke of Newcastle's well-known treatise

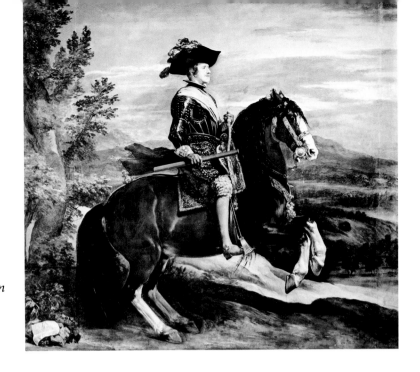

Figure 8
Antoine de Pluvinel,
L'Instruction du
roy..., Paris, 1625,
engraving by Crispijn
de Passe the Younger.
(See Plates 107–08)

Figure 9
Velázquez, Equestrian
Portrait of Philip IV,
1634–35. Madrid,
Museo del Prado.
(Plate 112)

of 1658 — although superbly written by the lyric poet and attractively illustrated with engravings by Lucas Vorsterman after Abraham van Diepenbeeck — does not supersede Pluvinel as a visual source and is less enlightened in its argument.)[10] Other authors enjoyed great reputations in their own countries: for example, Georg von Löhneyss, the Braunschweig Master of the Horses at Wolfenbüttel; the Chevalier de St. Antoine, a Pignatelli pupil and Master of the Horses to James I and Charles I; Paolo d'Aquino and Bernardo de Vargas Machuca, the Grisone disciples who introduced *haute école* riding in Spain. But Pluvinel's treatise must have been known throughout Europe as the most desirable source of information available to horsemen and the most useful pattern book available to artists after 1623.

Pl. 131

The picture of noble horsemen at the French court found in Pluvinel's plates also added a new dimension to the old association of equestrian portraiture and absolute rule.[11] For the first time a particular monarch, indeed an ambitious young king much on the minds of his royal neighbors, was acclaimed as a master of modern horsemanship. One can imagine the impression this made in Madrid. Just a few years before, Vargas had observed that "great princes of all nations have treasured the name of Philip as a friend of the horse."[12] Olivares, appointed *General de la Caballeria de España* in 1625, was reportedly "the best horseman in all of Spain."[13] Spanish horses were famous throughout Europe,[14] and the riding school in Madrid had close ties with the schools in Naples and Vienna. The rôle played in Pluvinel's plates by Louis XIII, Philip IV's own brother-in-law, must have seemed to the latter very much his own, so that the representation of *haute école* riding in the subsequent royal portraits by Rubens, Tacca, and Velázquez comes as no surprise.[15]

The leading rôle of Rubens in this development is suggested by the present state of Rubens research. Frances Huemer — one of the few modern scholars to recognize that in "the portrait of Philip IV the horse is shown in the difficult Italo-Spanish levade (curvette)" — maintains that "in 1634 when Olivares wrote to Tacca..., Velázquez had not yet produced a 'curvetting' or 'galloping' horse"; she concludes that "the seventeenth-century horse...did not have to do with the Titian type but rather with Leonardo, and that, as Burckhardt proposed, Velázquez followed Rubens in the curvetting pose which he then made famous."[16]

Pl. 112; Fig. 9

Pls. 51, 31

This hypothesis would seem very plausible to anyone familiar with the relationship between Rubens and Velázquez during the Flemish painter-diplomat's mission in Madrid (September 1628 to April 1629). Rubens was fifty-one, Velázquez twenty-nine, *Pl. 94* and Rubens had been painting important equestrian portraits since that of the Duke of Lerma of 1603.[17] He had, of course, worked at Mantua, Rome, and recently in Paris, *Pl. 130; Fig. 10* had painted the equestrian portrait of Buckingham shortly before, and had known Buckingham's Master of Horse, Balthasar Gerbier (better known to us as another painter-diplomat, Buckingham's confidential agent, and Rubens's frequent correspondent) since they met in Paris in the spring of 1625 (Buckingham himself was Master of Horse to Charles I).

However, a review of Rubens's earlier equestrian portraits and of what we know *Pl. 116* about royal Spanish examples up to 1628, the date of Rubens's *Equestrian Portrait of Philip IV*, makes one wonder whether that painting really was the first to explicitly relate art and equitation in Madrid. In the view of Philip IV and Olivares, this would have been like "carrying coals to Newcastle." As an educated courtier, Rubens certainly would have been informed about the art of riding.[18] His equestrian art, nonetheless, goes back to a very different source: Leonardo.[19] True, Rubens's interest in Leonardo is more evident *Pl. 97* in his *Saint George and the Dragon* than in his early equestrian portraits of Lerma and *Pls. 94, 96* Giancarlo Doria.[20] Both portraits, however, are remarkable not for the action of the horse and rider, but for the viewpoint from which the action is seen.[21] The pose of Lerma's *Pls. 8, 61* horse goes back to Giambologna and antiquity, while that of Doria's horse is not a rear,

Figure 10
Rubens, Equestrian Portrait of George Villiers, Duke of Buckingham, 1625. Fort Worth, Kimbell Art Museum.
(Plate 129)

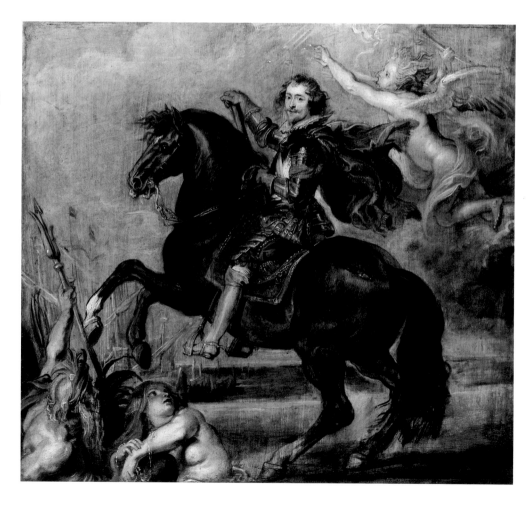

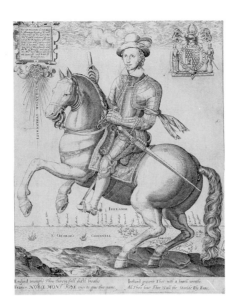

Figure 11
Thomas Cockson,
Charles Blount,
Earl of Devonshire,
on Horseback,
about 1604.
Rome Piazza
del Quirinale.
(Plate 86)

but the same gallop found throughout late medieval and Renaissance art, now seen dramatically *di sotto in su*.[22] *Pls. 17, 37, 51*

Twenty years later, and following a long development from the *Saint George* to numerous history, battle, and hunting scenes that support the supposition of Leonardo's influence, the position of the horse in Rubens's *Buckingham* appears to respond to representations of the *levade*, but is better described as a rear on command (an appropriate movement for a military figure).[23] Though the pose resembles a *levade*,[24] contemporary critics such as Pluvinel probably would have faulted the position of the forelegs and the head, the height of the rump (the weight is supposedly balanced on the hindlegs), and the turn of the rider's head. These and other aspects of the composition seem to be derived from a print by Thomas Cockson dating from around 1604, except that there the hindlegs of the horse bend more deeply.[25] *Pl. 130; Fig. 10* *Pl. 108* *Pl. 86; Fig. 11*

Obviously, it is not easy to draw categorical distinctions between a rear and a *levade* in images like these. The similarity of the pose of Cockson's horse to a *levade* probably depends ultimately, as discussed below, on Stradanus's experience at the riding school in Naples. But it seems doubtful that the *levade* is meant to be specifically recognized as such in any print by Stradanus, Tempesta, or Cockson, and quite unlikely that this is intended in Rubens's *Buckingham*. The more one examines equestrian imagery of the Baroque, the more one realizes that in addition to the very specific influence of *haute école* riding on artists such as Tacca and Velázquez, it had a very general influence on portraits and monuments throughout Europe, and even on battle pictures, hunts, and scenes of everyday life .[26] Not every pose that resembles an air of the *haute école*, therefore, should be interpreted as an image explicitly intended to be read in this way. An artist may have gone to a treatise, an actual riding school, or some example several times removed from the original source simply because it was a very accessible model for a drawing of a horse that might then be used in various kinds of compositions. *Pl. 54A* *Pls. 100, 164*

Turning, finally, to Rubens's first equestrian portrait of a royal sitter, the lost *Philip IV* of 1628, the pose of the horse and rider (and the use of allegorical figures) is very similar to that in the finished painting of the Duke of Buckingham which probably dates from the year before,[27] but differs in the somewhat lower position of the horse, the frontal position of its head, and the more-nearly frontal position of the king's head as well. These changes result in a position that can more confidently be described as a *levade*,[28] and *Pl. 116; Fig. 13*

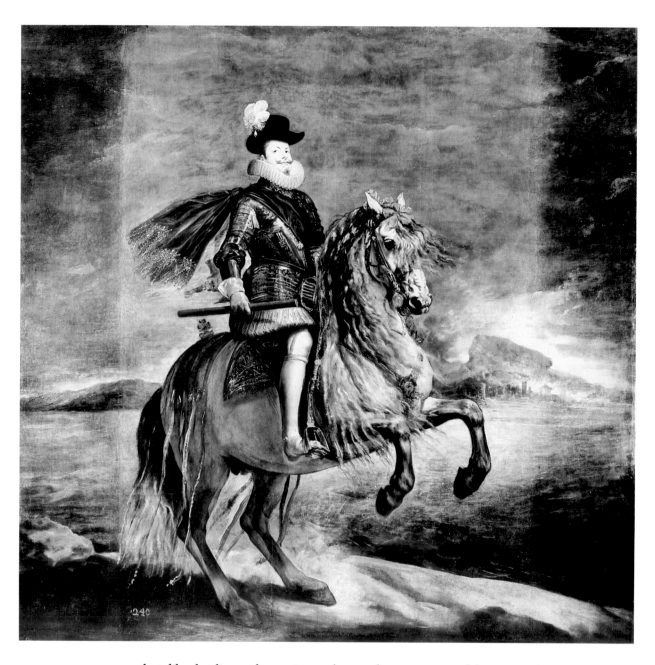

that, like the diagonal recession and general arrangement of the composition, comes very
close to Velázquez's *Equestrian Portrait of Philip III.*

Pl. 110; Fig. 12

The relationship between these two paintings throws much light on the parts played
by Rubens and Velázquez in introducing *haute école* forms into equestrian portraiture.[29]
The *Equestrian Portrait of Philip III* and two others, that of Margarita of Austria (wife
of Philip III) and that of Isabella of Bourbon (wife of Philip IV), were incorporated into
the program of equestrian portraits and battle scenes in the Salón de Reinos of the Buen
Retiro palace.[30] Unlike the equestrian portraits of Philip IV and Prince Baltasar Carlos
that Velázquez painted in 1634-35 for the "Hall of Realms," those of Philip III and the
two queens are clearly by Velázquez together with one or two other unidentified assistants
(in the costumes of the queens and other parts of the main figures, not merely in the ad-

Pls. 111, 113

Pls. 112, 114, 115

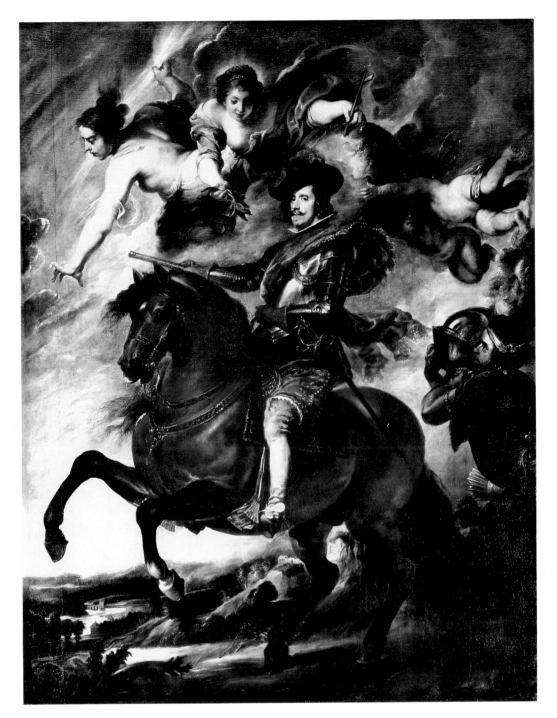

Figure 12
Velázquez and
assistants,
Equestrian Portrait
of Philip III,
completed about
1634. Madrid,
Museo del Prado.
(Plate 110)

Figure 13
Copy after Rubens,
Equestrian Portrait
of Philip IV
(original 1628).
Florence, Uffizi.
(Plate 116)

ditions to the sides of the canvases which probably date from the eighteenth century).

Until very recently, an attractive hypothesis, advanced by several authors and seemingly supported by documents, was that the equestrian portraits of Philip III and the two queens (the latter on trotting horses) were begun in 1626 by older court artists—González, Carducho, and Cajés (Caxés)—and were intended for the Sálon Nuevo of the Royal Palace (the Alcázar) in Madrid.[31] There they would have joined Titian's *Charles V at Mühlberg* and an equestrian portrait of Philip IV (now lost) painted by Velázquez in 1625. However, Orso's new book on the decoration of the Alcázar now reveals that the canvases by González, Carducho, and Cajés, although given "three pine-wood frames the size of the portrait of His Majesty on horseback," were not even portraits but history paintings, two of which are identified.[32]

Pl. 51

We are left, then, with the simpler assumption that the equestrian portraits of Philip III and the two queens are by Velázquez and his assistants around 1634-35, and that the only known example of an earlier equestrian portrait by a Spanish court artist is effectively Velázquez's lost painting of "His Majesty on horseback" dating from 1625. Huemer speculates that the horses in a painting by Gaspar de Crayer and in an anonymous Spanish painter's equestrian portrait of the king constitute "some indications that the early equestrian portrait of Philip IV by Velázquez was ["featured"?] a walking white horse."[33] However, a long *Elogio* by Jéronimo de Villanueva describes an equestrian portrait of the king by Velázquez in which the rider "strongly reins in" his horse above a fallen Persian warrior and at the same time threatens a Turk with his sword (the poem also mentions allegorical figures of Spain and Faith).[34] The praise lavished upon the picture, the indication that the horse was almost certainly in some kind of elevated position,[35] and

Fig. 13 the fact that the king, as in Titian's *Charles V* and in Rubens's *Philip IV*,[36] was portrayed as a defender of the Faith, suggest that the painting described by Villanueva is identical with the lost canvas by Velázquez that was replaced by Rubens's version in 1628. We do not know how closely the pose of Rubens's horse reflects that of the horse in the painting by Velázquez.[37] But all the circumstantial evidence favors the idea that Rubens followed Velázquez, as he did in a full-length portrait of Philip IV (Genoa, Galleria Durazzo-Pallavicini) of about the same time.[38] Rubens's painting was a replacement, while Velázquez's was a pendant to Titian's canvas and an overdoor. These considerations,

Fig. 12 Villanueva's description, and the later evidence of Velázquez's *Equestrian Portrait of Philip III* suggest that the horse in the lost Velázquez was raised up on its hindlegs.

One might ask, finally, whether the composition of Rubens's *Equestrian Portrait of Philip IV* is characteristic of him or more reminiscent of Velázquez.[39] This is easy to

Pls. 94, 96, 129; Fig. 10 answer for Rubens. After the equestrian portraits of Lerma, Doria, and (in 1625) Buckingham, the horse and rider in Rubens's painting of 1628 seem surprisingly stiff, the king rigid and reserved, the horse subservient and nearly symmetrical. Similar criticism may

Pl. 117 be applied to Rubens's *Equestrian Portrait of Philip II*, which also dates from about 1628.[40]

*Figure 14
Stradanus, Equus
Hispanus, from
the Equile, 1581.
(Plate 54A)*

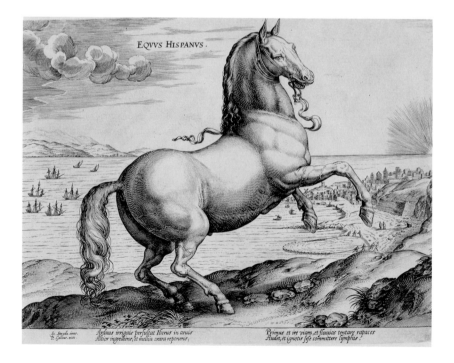

EQVVS HISPANVS.

It is hard to think of these pictures — that is, of the horses and riders — as next steps after the *Buckingham*, but they are perfectly comprehensible as diplomatic adjustments to the tastes and etiquette of a foreign court. Rubens's design was determined not so much by Velázquez as by Olivares and Philip IV.

Thus, Rubens, as in the case of the *Buckingham* which responds to an English engraving, made use of an "applicable type" within the Spanish tradition.[41] Borrowings from earlier artists, or lesser artists (in the case of a reference to prints), a cause for concern and disbelief among scholars of past times, are expected of artists such as Rubens and Velázquez especially when courtly conventions were in force.[42]

Figs. 10, 11

R ubens must have recognized that ultimately there was a common source for the prints of Cockson, Velázquez's equestrian portrait of Philip IV, and Rubens's own equestrian portraits of Buckingham, Philip II, and Philip IV in the engravings of his older fellow countryman, Jan van der Straet (Bruges 1523–1605 Florence). Giovanni Stradano, or Stradanus, was trained in Antwerp by Pieter Aertsen and others, joined the guild in 1545, and went to Florence a few years later.[43] He met Vasari, worked with him in the Vatican Palace between 1550 and 1553, and then returned to Florence to design 132 cartoons for the tapestry works of Cosimo de' Medici. These hunting scenes for Poggio a Caiano are generally recognized as the strongest examples of the Fleming's native talent. The further course of his very successful career in Florence was rarely interrupted, except for work in Rome in 1559, a trip to Naples in 1575, a very probable trip to Flanders in 1576–78 in the entourage of Don Juan of Austria, and work in Naples in 1579–80. In 1581 Philips Galle published the *Equile Joannis Austriaci...*, a set of forty engravings by Galle, Goltzius, Adriaen Collaert, and Jerome Wierix after drawings by Stradanus that record, rather like Giulio Romano's room full of Gonzaga horses, the "Stable of Don Juan of Austria."[44]

Fig. 14

The question of when an interest in the new art of riding first enters the history of art has never been answered, or indeed even raised, which is understandable since riding was such an integral part of sixteenth- and seventeenth-century culture, and its influence on art is evident at many times and places. At the same time, however, there are clear lines of development in the late sixteenth and early seventeenth centuries (e.g., the one involving Rubens, Velázquez, Tacca, and other artists described above), and the prints of Stradanus and his pupil Antonio Tempesta come up again and again as likely sources. It would seem, then, that Stradanus's work recorded in the *Equile* engravings was a decisive moment for the development of Baroque equestrian portraits and monuments.

The *Equile* engravings mostly represent single horses in a landscape. They are seen from various angles (but mostly in profile or nearly so) and stand, walk, trot, rear, or gallop. A rider appears only on one of the galloping horses. All the other horses appear to act at will, but the fact that one nevertheless frequently encounters a stately trot or a rather restrained rear must reflect Stradanus's familiarity with the riding school rather than his observations in a pasture. The horses in about half of the plates could have served as models for some kind of equestrian portrait. The *Equus Hispanus* is a very likely model in reverse (meaning that it was copied on the plate the same way around) for Cockson's *Earl of Devonshire*. Rubens probably referred to both the Cockson print and the Stradanus since the anatomy of the horse (especially the head) in the latter comes closer

Pls. 54–56

Pl. 54A; Fig. 14

Pl. 86; Fig. 11

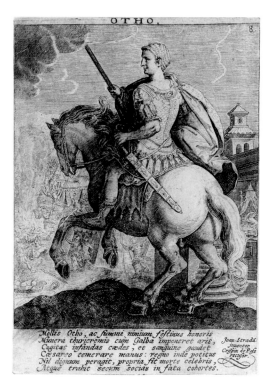

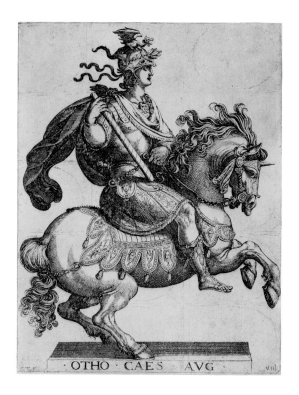

Figure 15 After Stradanus, Otho,
from The Twelve Caesars,
about 1590. (Plate 83A)

Figure 16 Tempesta, Otho,
from The Twelve Caesars,
1596. (See Plate 85)

Pl. 130; Fig. 10
Pls. 84A, 113
to that in his portrait of Buckingham.[45] Similarly, while one author's suggestion of Stradanus's *Galba* as a model for the *Isabella of Bourbon* may be correct,[46] a few horses in the same position in the *Equile* plates would have served the artist better as a model for the horse alone.

Though the *Equile* engravings deserve recognition as the earliest set of prints that were certainly important for Baroque equestrian portraits, and as the most reliable source for equine anatomy at least until the plates in Pluvinel, three more sets of engravings that in one way or another depend on the *Equile* were employed by later artists. Two Pls. 82, 83A; Fig. 15 of them (the *Twelve Caesars* sets) were more directly important for the paintings under discussion, and for many other printed and painted images of the early seventeenth century. These sets are Tempesta's *Horses of Different Lands* of 1590,[47] Stradanus's own Pls. 83B, 84, 85; Fig. 16 *Twelve Caesars* of about 1590,[48] and Tempesta's *Twelve Caesars* of 1596.[49]

The first of these is based directly on the *Equile* but may be said to animate the latter with "une sorte de 'furia'" that in turn inspired Callot in his spirited drawings after nine of Tempesta's plates.[50] The Stradanus *Caesars* introduce a very different subject which in form and content was a more likely model for royal equestrian portraits. They were probably engraved by their publisher, Crispijn de Passe the Elder, and illustrate an edition of *De Cesarum XII Vitis* by Suetonius.[51] A second set engraved by Adriaen Collaert and published by Philips Galle repeats the figures and backgrounds but substitutes substantial pedestals for the hillocks in the foreground of the de Passe set, thus transforming action portraits into equestrian monuments.[52] The *Caesars* of Fig. 16 Tempesta, finally, are original inventions inspired by the Stradanus set. The execution is less fine, the backgrounds are blank, and the base employed is a simple plinth.[53]

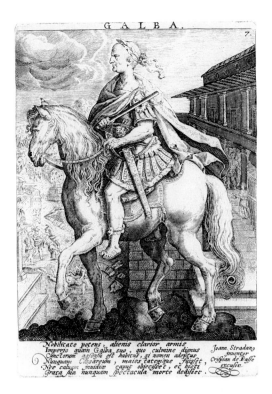

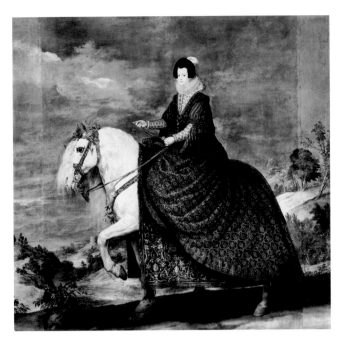

Figure 17 After Stradanus, Galba,
from The Twelve Caesars,
about 1590. (See Plates 82–83)

Figure 18 Velázquez and assistants,
Equestrian Portrait of Isabella
of Bourbon, completed about 1634.
Madrid, Museo del Prado. (Plate 113)

The Stradanus *Caesars* were certainly made with classical monuments in mind, but the action of the horses (and perhaps the ground beneath their feet) in at least a few of the plates recalls the *Equile* in its suggestion of the riding school. Neither Stradanus or Tempesta meant to claim that Julius Caesar and the eleven emperors from Augustus to Domitian were masters of dressage. Riding schools were simply more available than classical remains as a source of equestrian forms. Tempesta, the Florentine pupil of Stradanus, had also worked for Vasari and at the papal court, but his specialty was the representation of battles and hunts.[54] He surely knew courtly riding at first hand, as well as his master's work, and the *Caesars* of Tempesta are, in fact, generally more reminiscent of *haute école* airs than either the *Equile* or the *Caesars* of Stradanus.

A quantitative survey of the engraved equestrian portraits dating from the early seventeenth century that derive from these prints by Stradanus and Tempesta would require a long article.[55] This must be kept in mind when citing the Stradanus or Tempesta print that comes closest to the equestrian portraits painted at the Spanish court. A comparison of the latter to the series of engravings discussed here may nevertheless give a fair idea of how the painted compositions came about.

As mentioned above, a reference to the *Galba* by Stradanus is plausible for the Isabella of Bourbon.[56] For the *Philip II*, Rubens could have referred to the equestrian portrait of Isabella, to the *Galba* print itself,[57] and to a plate from the *Equile*. The printed sources show the pose of the horse unobscured by the long caparison, and the *Equile* horses in particular may have, so to speak, sired the light, elegant steed that strikes such an inharmonious note beneath the armored bulk of Philip II. The suggestion of Stradanus's *Caligula* as a model is convincing for the *Margarita of Austria*, but again one of Don

Pls. 84A, 113; Figs. 17,18

Pls. 117, 55B, 56A

Pl. 111

Figure 19
Tempesta, Titus, from
The Twelve Caesars, 1596.
(See Plate 85)

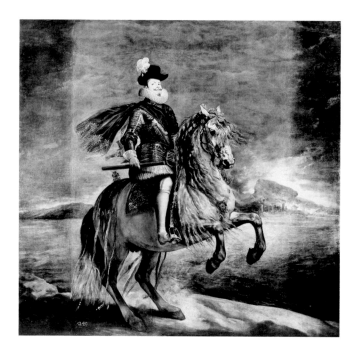

Figure 20
Velázquez and assistants, Equestrian Portrait
of Philip III, completed about 1634.
Madrid, Museo del Prado. (Plate 110)

Pl. 49

Juan of Austria's horses may have been involved.[58] For the *Philip II*, and especially for the portraits of the queens, it should be observed also that the older equestrian portraits of the Valois court must have been well known to the sitters and the artists.[59]

Figs. 19, 20

Tempesta's *Titus* is closer to the *Philip III* than the *Nero* by Stradanus proposed as a model by Martin Soria, who correctly suggested that another printed equestrian portrait deriving from Stradanus or Tempesta was probably the immediate source.[60] Rubens's

Pl. 116; Fig. 13

Philip IV was discussed above as derived from the *Buckingham* and the *Philip III*, no doubt with a knowledge of their sources, and it is closer than the *Philip III* to Tempesta's *Titus* in that the horse seen obliquely from the front faces the same way.

It was, of course, the male members of the court for whom *haute école* riding was an important part of a proper education, and it is in the portraits of the male sitters mentioned above that formal dressage comes to mind.[61] The similarity between the poses found in the various printed sources and in the actual riding school must have been apparent to the patrons in particular, so that the possibility of verbal advice to the artists should be considered also when comparing the paintings to the prints. Nevertheless, the printed sources alone seem to have served well enough for the paintings discussed so far. When we turn, however, to the equestrian portraits designed by Velázquez in the 1630s, the possibility that the artist referred to Pluvinel's book and to actual riding (as well as to the prints discussed above) seems to be more important.

Figs. 22, 16

For example, in Velázquez's *Equestrian Portrait of Philip IV*, the pose bears some resemblance to that of Tempesta's *Otho*, but differs markedly in the very restrained bearing of the horse and rider.[62] An engraving by Michel Lasne with a background by Callot

Pl. 109

represents a triumphant Louis XIII again performing a *levade*, although the positions of the horse's head, the king's head, and his hands are a demonstrative departure from

Pl. 108

proper form.[63] Otherwise Lasne has clearly referred to Pluvinel. Velázquez probably refer-

red to this or another of Pluvinel's plates, and comes closer to it than Lasne does in the points just mentioned. In fact, the often-observed *pentimenti* reveal that Velázquez moved the king's left hand from a shoulder-high position, a more commonplace tug on the reins that will indeed make a horse rear up, to the place where it belongs in a *levade* (for which the rider's legs are more important).[64]

It will be recalled that the Salón de Reinos in the Buen Retiro palace was decorated by Velázquez's equestrian portraits of Philip III, Philip IV, and the pendant portraits of the two queens, by the Baltasar Carlos overdoor, and by various battle scenes including *The Surrender of Breda*; and that the palace was a gift to the king from "the greatest horseman in all of Spain," Olivares. Tacca's monument of Philip IV, set up outside in 1642, was in a way the final and most public part of the program of royal equestrian imagery.[65] The *Equestrian Portrait of Olivares*, which dates from around 1635-38, was not part of the Salón de Reinos decorations but was certainly conceived with them in mind.[66] Soria hesitantly proposed Stradanus's *Otho* as a source,[67] but it is somewhat less similar to the *Olivares* than Tempesta's *Julius Caesar*.[68] Again, a reference to Pluvinel (e.g., for the somewhat different position of the hindlegs) may well have been suggested to Velázquez or made on his own initiative.[69] It would be wrong to assume that Velázquez's interest in equitation was solely due to the influence of his patrons. His position at court, his accurate study of horses, and the two books on riding in his personal library speak to the contrary.[70]

The Marqués de Lozoya has discussed the Prado *Olivares*, the version in the Metropolitan Museum, and other pictures in connection with three large paintings of horses — one chestnut, one white, and one gray — that were listed in Velázquez's estate at his death.[71] The *White Horse* has evidently survived in a formerly repainted and now restored canvas in the Royal Palace in Madrid. The pose of the *White Horse* is very close to that of Olivares's horse and probably served as a model for the white horse in the New York version. Taking the latter into account, the *Chestnut Horse* need not have been in the same position to have modelled for the horse in the Prado picture. Nothing is known of the *Gray Horse* and its use. It seems likely, however, that the paintings were studies

Pl. 114

Pl. 75

Pl. 119

Pl. 83A
Figs. 23, 24

Pl. 119
Colorplate 23

Pl. 120

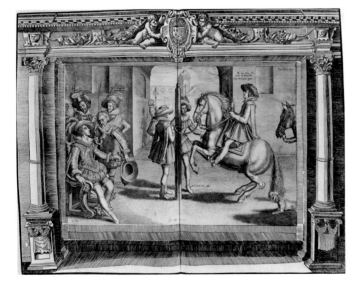

Figure 21
Antoine de Pluvinel, *L'Instruction du roy...*, Paris, 1625.

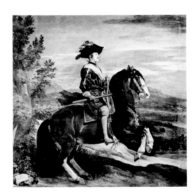

Figure 22
Velázquez, *Equestrian Portrait of Philip IV*, 1634–35. Madrid, Museo del Prado. (Plate 112)

Pl. 99

rather than portraits, and — if the horses were in different positions — they might have formed a group similar to that in the lost *"Riding School"* from Rubens's studio.[72] In any case, the *White Horse* recalls the common practice, especially for Rubens and Velázquez, of refining a motif found in the work of an earlier artist by making a study from life.

Pl. 122; Fig. 25

Pl. 110; Fig. 20

Another painting directly related to the Buen Retiro decorations and to Olivares's ambition is Velázquez's *Prince Baltasar Carlos in the Riding School*.[73] Enriqueta Harris commendably cites Pluvinel's treatise as a source.[74] But it has been observed that "the pose of the horse repeats exactly that of the animal in the equestrian portrait of Philip III."[75] Michael Levey mentions that the setting is the grounds of the Buen Retiro palace and discusses the rôle of Olivares (on the far right) and the king and queen on the balcony.[76] Harris, finally, more precisely defines the action about to take place as running at the ring with a tilting lance. Olivares was responsible for the boy's education, and in 1637 he proudly wrote to the Cardinal-Infante Ferdinand about the young rider's love of tilting.[77] Numerous contemporary accounts such as this reveal the earnest attention devoted at court to the art of riding well and the fact that the Prince is seen doing just that (whether or not he could actually make his horse perform a *levade*, which is very unlikely) is essential to the picture's meaning.[78]

It might be said that the art of riding, which has been discussed above as a

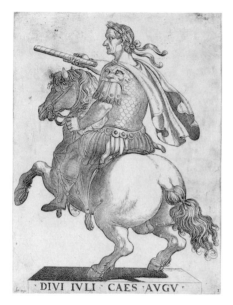

*Figure 24
Tempesta, Julius Caesar,
from The Twelve Caesars,
1596. (See Plate 85)*

*Figure 23
Velázquez, Equestrian
Portrait of the Count-Duke
Olivares, about 1636.
Madrid, Museo del Prado.
(Plate 119)*

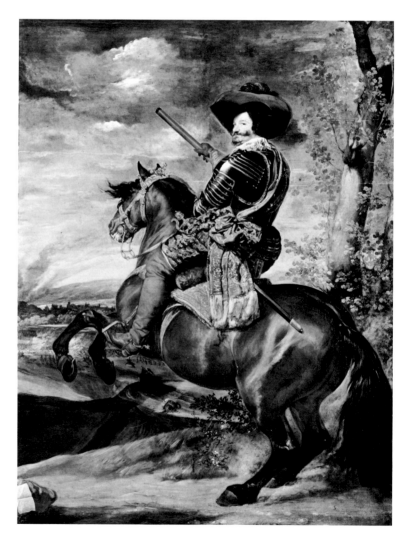

34

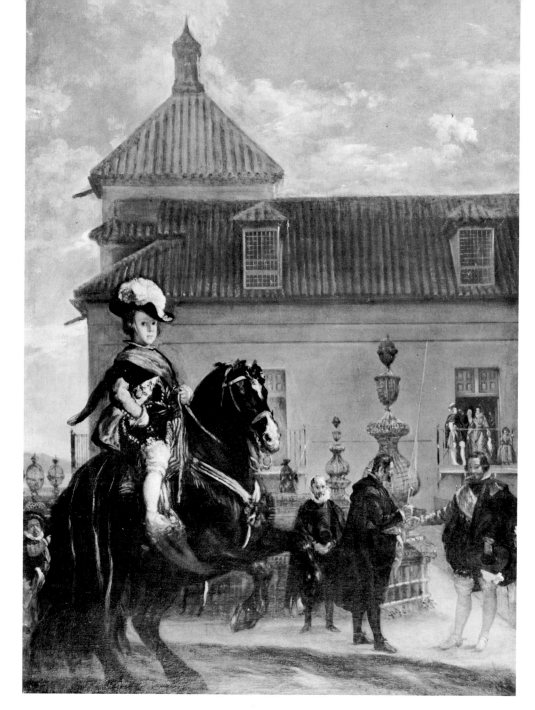

Figure 25
Velázquez, Prince
Baltasar Carlos
in the Riding School,
about 1636–37.
The Duke
of Westminster.
(Plate 122)

background to equestrian portraits, has come forward as the subject of Velázquez's painting of the prince, Olivares, and other court figures in the riding school. But to say so would reveal too much sympathy for those wonderful old German articles in which history conforms to the structure of a fugue. It would also underestimate the significance of *haute école* riding in the portraits by Rubens and Velázquez and in the monument by Tacca.[79] In those works as well, a form of fine riding is not just an artistic source or an aspect of the cultural context, but a form that was understood in both a literal and a metaphorical way as an indication of the sitter's station and character. Vargas, the Grisone disciple noted above for his praise of Philip IV's equestrian interests, underscored the importance of good riding form in royal equestrian portraits when he recorded the widely held view that "the highest one can say of a Prince is this, that he rides well, a phrase which embraces his virtue and bravery."[80] Some reasons why riding should be considered so revealing of a ruler's character are considered in the following chapter.[81]

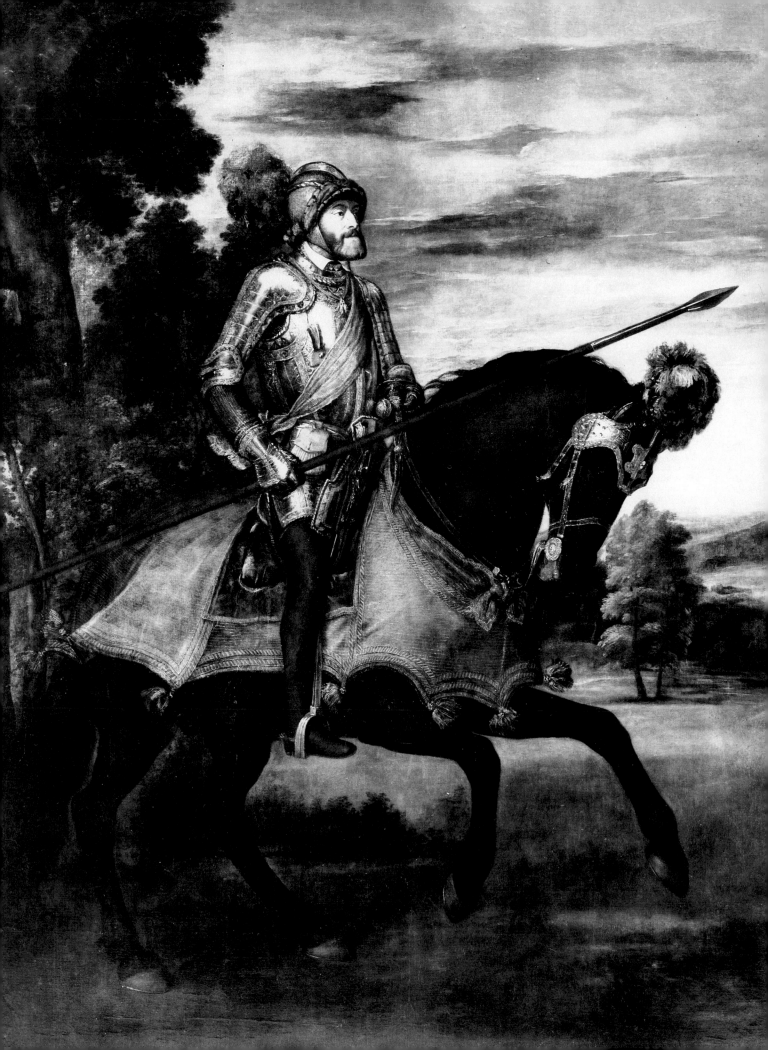

2

SYMBOLIC THEMES
IN EQUESTRIAN PORTRAITURE
FROM 1550 TO 1650

As one spurs on a horse and leads it where he wants,
so shall the rider lead the people according to his will.[1]

The lines quoted from Vargas at the end of the preceding chapter and from an earlier source, above, sum up the meaning of numerous emblems, metaphors, and opinions offered as objective observation in equestrian treatises and other literature dating mostly from the late sixteenth and early seventeenth centuries. The same period saw a great advancement in absolute rule and with it the imposition of religious orthodoxy and rigid class distinctions. These factors clearly relate to the meanings of equestrian portraiture that are briefly discussed in this chapter, and, indeed, seem especially relevant to the two nations that most consistently reveal parallels between the art of riding and equestrian art: Spain and France. The line of Vargas's thought is hard for the modern mind to follow, but it still commands respect, since the discipline, patience, and pride required to master the horsemanship of the *haute école* could not but have had some refining effect upon a courtier's character.

Meaning in equestrian art has been the subject of much recent and continuing, if widely dispersed, research.[2] In the present context we can only outline this material and relate it to the subject at hand. Three themes dominate in equestrian portraiture from about 1550 to about 1650,[3] and can be broadly distinguished as imperial, Christian, and rulership themes. In other words, the rider is seen as a monarch reminiscent of Constantine (i.e., Marcus Aurelius) or another emperor, as a Christian knight, or as, among other things (e.g., courtier, commander, or king), an accomplished horseman who thereby demonstrates his ability to rule.

Pls. 8, 43, 121

Titian, Charles V at Mühlberg, 1548. (Plate 51)

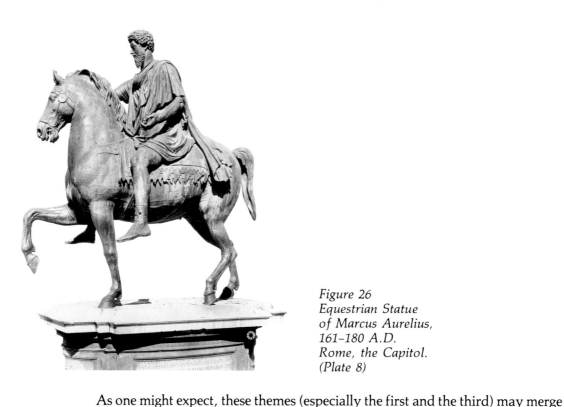

Figure 26
Equestrian Statue
of Marcus Aurelius,
161–180 A.D.
Rome, the Capitol.
(Plate 8)

As one might expect, these themes (especially the first and the third) may merge in one image, and other meanings (for example, that of a prince attaining majority)[4] may combine with or form exceptions to a more common reading. The oldest and most familiar is the imperial theme, which suggests a dynastic right to rule by associating the sitter with emperors of the past, and secondarily by identifying the sitter with the contemporary ruling class, which made aristocratic use of the horse (hunting, dressage, military command, etc.). Horst Janson's survey of equestrian monuments discusses the ancient Roman origins of the form (and the related images of statuettes and coins) first as "the prerogative of the *eques*, the aristocrat," and then, during the Empire, as the privilege of the emperor alone.[5] Medieval monarchs such as Charlemagne and Can Grande followed this usage, but it is Janson's important observation that the common quality of Renaissance monuments (up to Leonardo's designs for the Trivulzio monument) was "the emphasis on *virtù*, the prowess of the individual hero."[6] It seems consistent with this meaning that the Renaissance equestrian monument is essentially naturalistic, and that the classical models were approached from this point of view.[7]

With the rise of absolute monarchies around the middle of the sixteenth century, the equestrian monument assumed, in Janson's words, "a different flavor and a different purpose: in conscious imitation of Roman imperial practice, it becomes a public assertion of dynastic authority."[8] For reasons of space Janson discussed only one example, but his choice of Mochi's *Alessandro Farnese* is misleading because, whatever its antique associations, the statue represents a Baroque transformation of the classical trot and suggests movement with the natural force of Leonardo's stallions.[9] The point to make was that whereas Donatello could study the stately trotting horses of antiquity and, nevertheless, arrive at the heavy walk of Gattamelata's great war-horse,[10] Giambologna in his *Cosimo I* and other monuments followed the collected trot of the *Marcus Aurelius* and other antique models. Giambologna must have done this not only to make Cosimo resemble a Roman emperor, but also because he recognized the classical pose for the formal movement it was and realized that Cosimo would not want to look, by con-

Pls. 13, 16

Pl. 151

Pl. 24

Pl. 60; Fig. 27

Fig. 26

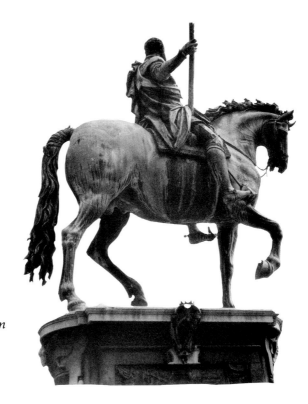

Figure 27
Giambologna, Equestrian
Monument of Cosimo I,
1587–99. Florence,
Piazza della Signoria.
(Plate 60)

trast, like a child on a pony at a country fair. This period of revival for the classical form of equestrian monument coincided with the rise of absolute rule and with the rise of *haute école* riding. Giambologna and Stradanus were working in Florence at the same time and for the same patron. Riding in a formal manner, then, must have been recognized as not merely an aristocratic, but even an imperial distinction.

Except for the closely related development of the triumphal entry in the sixteenth and seventeenth centuries,[11] scholars have sufficiently studied the imperial significance of equestrian portraits and monuments in this period, and no more than a passing reference to their research need be made here. In connection with Giambologna, Pope-Hennessy recalls that the moving of the *Marcus Aurelius* in 1538 was critical to its interpretation: "By virtue of its new position in the centre of the Campidoglio it became a symbol of imperial rule."[12] Roy Strong discusses the *Marcus Aurelius* and the equestrian form in general as applied to English monarchy,[13] and in a few paragraphs on the imperial significance of the equestrian portrait in Spain, Julián Gállego considers triumphal entries, an important emblem of Alciati, the Spanish Riding School, Tempesta's *Twelve Caesars*, and the rôle of Louis XIII in Pluvinel's *Maneige royal*.[14] Ulrich Keller's dissertation on equestrian monuments by Giambologna, Mochi, Girardon, and Schlüter concentrates entirely upon their references to the absolute monarch and the state.[15] There is no study of painted equestrian portraits[16] comparable to Keller's dissertation or that of Jörg Traeger on "the riding pope," which discusses many aspects of the imperial theme as adopted by the papal courts of the Middle Ages and the Renaissance.[17] Finally, Heinrich Lützeler reviews the many ideas, both conventional and peculiar, of Pinter von der Au (1688) on the mystical place of the horse in the scheme of creation, on its appropriateness to the ruler above all, and on various religious implications of the royal equestrian image.[18] Perhaps more telling than all of Pinter's speculations, however, is the fact that when Jost Amman illustrated the king in his "Book of Trades" (*Ständebuch*) of 1568 he put him on a horse, the only horse in this survey of all the ranks of man.[19]

Pl. 121; Fig. 31
Pls. 85, 107, 108

Pl. 40

Fig. 28

That the Christian rôle of an absolute monarch could be conveyed by an equestrian monument was an idea that derived principally, of course, from the survival of the

Pl. 8; Fig. 26 equestrian monument of Marcus Aurelius as a portrait of Constantine. The figure of the Christian knight, by contrast, descended from the Crusades to become, in the six-teenth century, a hero who fought against any enemy of the Church, be it a Moor, a

Pls. 42, 43 Protestant, or the Devil himself. This theme was especially dear to the Spanish court, and the equestrian portrait was but one of many pictorial forms in which the fight against heresy was celebrated.

Pl. 51; Fig. 29 Contrary to the received view of the literature on Titian's *Charles V at Mühlberg*, the pose of the horse is not a rear, nor was it very influential for Rubens and Veláz-quez.[20] The painting was, however, very important for artists at the Spanish court as one of the earliest examples of painted equestrian portraiture on a monumental scale

Pls. 20, 21 (and not a substitute for an intended monument, like the frescoes of Uccello and Castagno), and as one that embraced a Christian theme. The painting was made be-tween April and September, 1548, to commemorate the decisive defeat of the Protes-tant League of Schmalkalden at Mühlberg on April 24, 1547. Panofsky has shown that the spear, reminiscent of St. George, is "in a wider application... the weapon of the 'Chris-tian Knight' — the *Miles Christianus* described by Erasmus of Rotterdam and glorified

Pl. 43 in Dürer's famous engraving of 1513."[21] At the same time, Panofsky notes, the spear rather than the scepter was the principal symbol of supreme power for Roman emperors

Figure 28
Jost Amman and Hans Sachs,
Eygentliche Beschreibung
Aller Stände auff Erden,
Nuremberg, 1568, "Der König."

Figure 29
Titian, Charles V
at Mühlberg,
1548. Madrid, Museo
del Prado. (Plate 51)

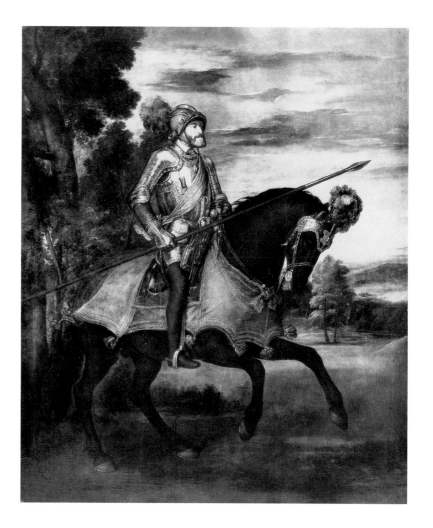

and was borne "when opening a campaign or setting out for an important battle, a ritual known as *Profectio Augusti*." Panofsky compares two ancient coins, one of Trajan and one of Marcus Aurelius, on which the emperor is shown mounted and equipped with a spear, and, finally, mentions that Aretino thought it would be a good idea for Titian to include personifications of Religion and Fame (thus underscoring the spear's dual significance for the savior of both the Faith and the Empire).[22]

Pl. 6

In the next century the most important equestrian portraits of a monarch in the rôle of a Christian knight represent Philip IV. The earliest must have been the lost painting by Velázquez, discussed above, in which the king is said to have reined in his horse over a fallen Persian warrior and threatened a Turk with his sword.[23] It will be recalled that the picture hung with Titian's *Charles V at Mühlberg* in the Salón Nuevo of the Alcázar, and was replaced by the lost Rubens of 1628 recorded in the Uffizi copy. Larry *Pl. 116; Fig. 30* Ligo has published poems by Lope de Vega and Francisco de Zarate that discuss the allegorical meaning of the Rubens, and while Ligo works too hard to make pendants of the Rubens and the Titian, it is clear that they share a similar theme.[24] Zarate's poem tells us that the Indian with a helmet represents the New World "as if he were supporting the cost of the wars."[25] Lope de Vega identifies the globe on the king's shoulders as "a burden" placed there by Faith and "accepted with pleasure from two winged children who lightened the concern of the kings" (Charles V and Philip IV). Zarate notes that Faith "gives him a crown with her right hand and drives a cross into the globe of the earth

Figure 30
Copy after Rubens, Equestrian
Portrait of Philip IV
(original 1628). Florence, Uffizi.
(Plate 116)

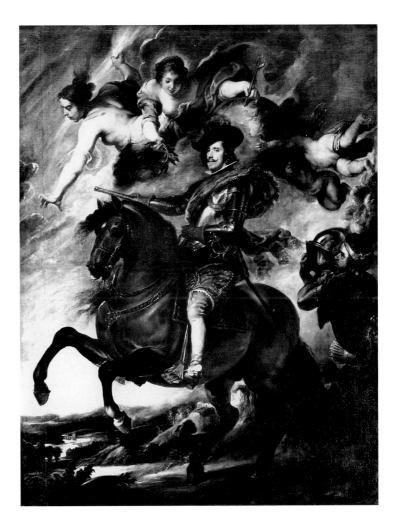

Figure 31
Alciati, Emblemata,
Antwerp, 1581,
"In Adulari Nescientum."
(Plate 121)

with her left hand,"[26] while "Divine Fury strikes at his enemies with lightning." Lope de Vega sees the latter figure as "Catholic Obligation…striking at a heretical monster formed of the very cloud." Ligo says of the cloud that "there is no real substance to the Protestant heresy," but then goes on to identify the serpent in the lower left corner as the "monster of heresy."[27] This identification is not offered by the poets, but seems plausi-

Pls. 37, 38, 42 ble and recalls St. George whose horse rears above or tramples the dragon.

With all this going on, one might wonder whether we should really follow Huemer in reading the pose of the horse as "the difficult Italo-Spanish levade," an idea cautiously supported above.[28] The interpretation of the pose should depend upon the meaning of the picture as a whole. On the one hand, it could be argued that Rubens was adop-

Pl. 110 ting (possibly from Velázquez) the pose found later in the *Equestrian Portrait of Philip III*, and thus a formal similarity occurs in a painting with a different theme and with a different action intended (e.g., trampling the serpent). On the other hand, one might observe that the baton is a symbol of rulership and suspect that the pose of the horse is meant to be recognized as very controlled, for, to recall the thought quoted at the head of this chapter, "so shall the rider lead the people according to his will."[29]

That the latter interpretation at least deserves consideration is confirmed by Zarate,

Fig. 30 for in the same poem he speaks of Philip's horse as representing the people under his rule. Philip "is rewarding the horse which he is controlling more than if he should fix him among the stars." The horse should be admired for "that motionless valor that you see content in obedient submission; admire the strong discipline of his energy — do not doubt his wisdom, for he surrenders his fierce wrath to the bit. Rubens, in short, shows with a horse how you ought to be a vassel to your Prince."[30] Would Zarate, let alone a modern viewer, read the action of the horse in this picture as "motionless…in obedient submission," or even as revealing "strong discipline," if he did not have an air of *haute école* riding in mind? And would Zarate expect to be understood if this metaphor for rulership were not commonplace?

The image of a rider mastering a horse was popularized as a symbol of rulership by

Alciati in his famous *Emblemata* of 1531.[31] The horse was a common Renaissance symbol of "unbridled passion";[32] the bridle, an attribute of Temperance,[33] is frequently featured in sixteenth-century emblem books.[34] Alciati, whose work was well known in Spain,[35] illustrates a rider on a rearing horse under the title *In Adulari Nescientum*.[36] The meaning of this image and title, "To him unable to flatter," is explained by *Fig. 31* Alciati's verse and commented upon extensively by Diego Lopez in his influential *Declaración magistral sobre las emblemas de Andrés Alciato* of 1615.[37] The horse does not know how to flatter his master: "he treats all alike; he will throw anyone but he who truly knows how to rule and govern him in a firm and decisive manner." Since antiquity, Lopez reflects, philosophers have stressed the importance of learning to ride well, but riding masters tend to flatter their royal pupils before they know how to control the horse. The author makes the same point again and again: the horse respects the rider not out of any regard for his rank but for his ability, so "the Prince must learn this fundamental art of equitation, or he will be judged unworthy to rule...." Variations on this theme are found in the emblems collected from several sources by Henkel and Schöne; it need only be noted here that the rider is often a prince or king.[38] Similar lines of thought were naturally adopted from the emblem books by the authors of treatises on horsemanship.[39]

In Alciati's emblem and others with similar meaning, the rider controls a rearing horse.[40] It seems likely that the same theme of rulership is addressed in some of the equestrian portraits of kings, princes, and perhaps military commanders that date from the seventeenth century, especially those in which the horse rears or performs a *levade*. In a formal analysis, the *levade* appears to be a special case within the tradition of the rearing horse. But from the viewpoint of a contemporary who had the theme of rulership in mind, the *levade* would have been a special case in the sense of being typical rather than exceptional, since the *haute école* defined the art of riding well. It would appear, then, that in certain royal portraits, and especially in those of the Spanish court, Alciati's *Pls. 110, 112, 116, 122* image was refined to meet the new standards of aristocratic horsemanship, quite as seventeenth-century commentators expounded upon his ideas in ways that revealed their own, and quite as his images were adopted by later artists in ways that responded to changing political and social situations.[41]

At least in the royal equestrian portraits of Spain, the monarch's ability to rule was thus given a new emphasis through a more precise form. If the result strikes us as somewhat contrived, this is not the effect of *haute école* conventions (not, that is, once they have become familiar), but of most Baroque allegories on royal themes, and of poems like those by Zarate and Lope de Vega. The insistence with which they convey an idea betrays an uncertainty of its truth.

OLIVARES: THE CASE OF A LESS THAN ROYAL RIDER [42]

Like the *Equestrian Portrait of Philip IV* by Rubens, the *Equestrian Portrait of the Count-Duke Olivares* by Velázquez is a special case within the context of the themes discus- *Pl. 119; Fig. 32* sed in this chapter. In this instance, however, it is special not because of any elaborate symbolism, but because the usual theme of rulership and the comparatively simple symbolism of riding in sovereign style are apparently applied to a man who did not rule. And yet he did, of course, if not with the same sanctions of God and country that were assumed by the king. Despite the Count-Duke's actual control of the government and his policy of militant Catholicism, an equestrian portrait of Olivares could not have

had any obvious imperial or Christian meanings. Among the many risks taken in commissioning such a picture would have been that of deflecting glory from the king to his minister — glory that the latter, a shrewd propagandist, was constantly at pains to attribute to his lord.

The theme of rulership, however, was not so restricted to the monarch himself by the symbolic forms (and interpretations of them) that date from the period. Men like Olivares, Buckingham, and others that are portrayed in important equestrian portraits (though never, significantly, in equestrian monuments) were, though not royal, the cream of the ruling class. If there was any ambiguity about just how much an equestrian portrait could mean, they were inclined to take advantage of it.

Pl. 94

Pl. 95

Pl. 114

Pls. 110, 112

Pl. 139

Fig. 32

The equestrian portrait of a man who was socially (if not physically) less elevated than a monarch is generally expected to be an occasional piece, a sign of royal favor at a particular moment, or the commemoration of some special event. Rubens's *Equestrian Portrait of the Duke of Lerma*, for example, has been discussed with reference to the Duke's extraordinary power and "imperial pretentions," as well as to more particular meanings.[43] Rubens's reference to a printed equestrian portrait of Charles V makes it clear that he and no doubt Lerma were aware of how bold the painting was. Much depends on where such a picture hung, and this is often not known. The *Equestrian Portrait of Olivares* was, as mentioned above, not part of the decorations of the Salón de Reinos in the Buen Retiro palace, and could not have been properly included in that program of royal equestrian portraits and battle scenes.[44] At the same time, the Count-Duke's portrait must have been inspired by those of Philip III and Philip IV, and it makes similar claims for his ability and authority.

Several scholars have associated the *Equestrian Portrait of Olivares* with the battle of Fuenterrabia, a victory of the Spanish over the French in the autumn of 1638 that was credited to Olivares's long, exhausting preoccupation with its strategy.[45] The hypothesis is perfectly plausible, even though Olivares never appeared on the field, and there is nothing in the painting that resembles the battlefield itself.[46] The portrait could possibly date from as late as 1638–39, and similar works were commissioned to celebrate the success of important campaigns. On the other hand, there is no documentary evidence that relates the painting to the battle of 1638, and a number of scholars argue for an earlier date.[47]

Whether the battle of Fuenterrabia is relevant or not, its frequent mention in the literature has not encouraged appreciation of the richness of meaning such a picture would have had for Olivares himself and for contemporary viewers. The general reading of the portrait as that of a military commander and the more specific reading with reference to the battle of Fuenterrabia are both too simple for an age that, especially at the courts, took pride and pleasure in the perception of layers and shades of significance.

We have seen that Olivares was no stranger to the art of riding and its representation in art. He may have had something to say about the equestrian portraits that decorated the Salón Nuevo in the Royal Palace during the mid- to late 1620s (discussed in the preceding chapter). There is no known record, but the program as a whole has been related to the "reassertion of imperial policy by the energetic Olivares,"[48] and

Figure 32
Velázquez, Equestrian
Portrait of the
Count-Duke Olivares,
probably about
1636. Madrid,
Museo del Prado.
(Plate 119)

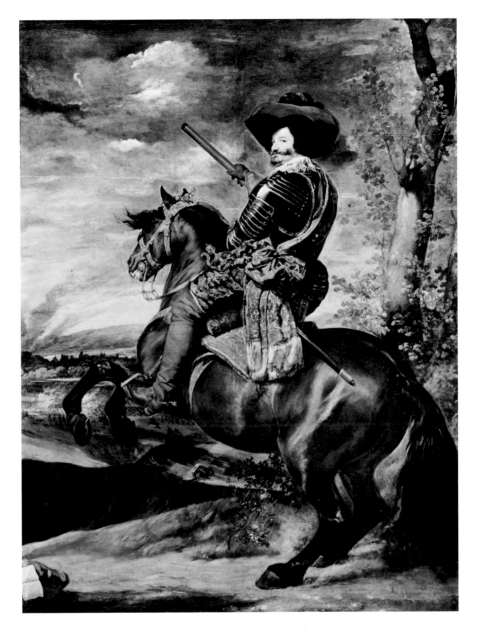

the *Equestrian Portrait of Philip IV* by Rubens represents the king in a role, defender *Pl. 116*
of the Faith, that the Count-Duke strongly urged as part of his foreign policy. Olivares
was certainly responsible for the program of equestrian portraits and battle scenes that
was planned in the early 1630s to decorate the Salón de Reinos in the Buen Retiro. He
paid (or was billed) for the palace and gave it to the king at a time when the Count-
Duke was besieged by nearly universal blame for the financial and other disasters suf-
fered by Spain, and even for the recent death of the Infante Don Carlos.[49] The Salón
de Reinos was finished about two-and-a-half years later, in the spring of 1635. At the
time, Olivares was corresponding with Pietro Tacca about the *Equestrian Monument* *Pls. 74, 75*
of Philip IV which was to be placed on the grounds of the palace.[50]

The same setting is seen in Velázquez's innovative group portrait, *Prince Baltasar* *Pl. 122; Fig. 25*
Carlos in the Riding School.[51] Harris has discussed the meaning of this large and unusual
work, and persuasively suggests that it was painted for Olivares (again, he appears on
the right), and dates from around the end of 1636.[52] The pose of the Prince's pony is

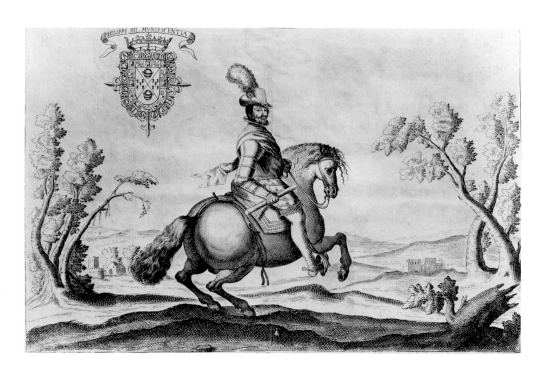

Figure 33
Juan Mateos, Origen
y dignidad de la
caza, Madrid, 1634,
frontispiece.
(Plate 118)

essentially the same as that found in the equestrian portraits of Philip III and Philip IV which were in the Salón de Reinos, and as the pose in the *Equestrian Portrait of Olivares*.

Pl. 119; Fig. 32 All the known evidence for a dating of the latter work is circumstantial, and the chronology of Velázquez's oeuvre is notoriously difficult to establish on the basis of style.[53] With these reservations understood, the portrait probably dates, to take a firm stand, from around 1636. Its style and the apparent age of the sitter support this view.[54] The hypothesis that the picture, like that of the Prince and the Count-Duke in a "riding school," was inspired by the Salón de Reinos portraits, was probably commissioned by Olivares himself, and celebrates, among other things, his considerable reputation as a rider, is more persuasive than any other.

The most impressive equestrian portrait of Olivares was not the first. The point is overlooked by those who, in search of its meaning or the cause of its commission, relate the painting to the battle of Fuenterrabia. Closest in date to the picture is the plate Pl. 118; Fig. 33 depicting Olivares on horseback in Juan Mateos's *Origen y dignidad de la caza*. As mentioned above, some scholars, assuming that Velázquez never learned from lesser artists, have advanced this print of 1634 as evidence that the equestrian portrait was painted even earlier.[55] The pose of the horse and rider is already found in many prints and paintings of the previous decade, and goes back, as discussed by Soria and here Pls. 82–85 in the preceding chapter, to prints by Stradanus and Tempesta.

Another equestrian portrait of Olivares is recorded as having been painted by Velázquez around the beginning of 1627. Alessandro Striggi, the ambassador of the Mantuan court in Madrid, mentioned in a letter dated 24 March, 1627, that to flatter Olivares he "had made by the most famous painter of these parts the two portraits on horseback, the one of his majesty, the other of the Count-Duke, that shall be enclosed here" (included in the same post).[56] Receipt of the portraits was acknowledged in Mantua on 22nd May.[57] Evidently they were small (*ritrattini*) and are now lost.[58]

At about the same time in Antwerp, Gaspar de Crayer made at least two equestrian Fig. 34; Pl. 99 portraits of Olivares, which depend upon Rubens's *Riding School*. Pontius's print of

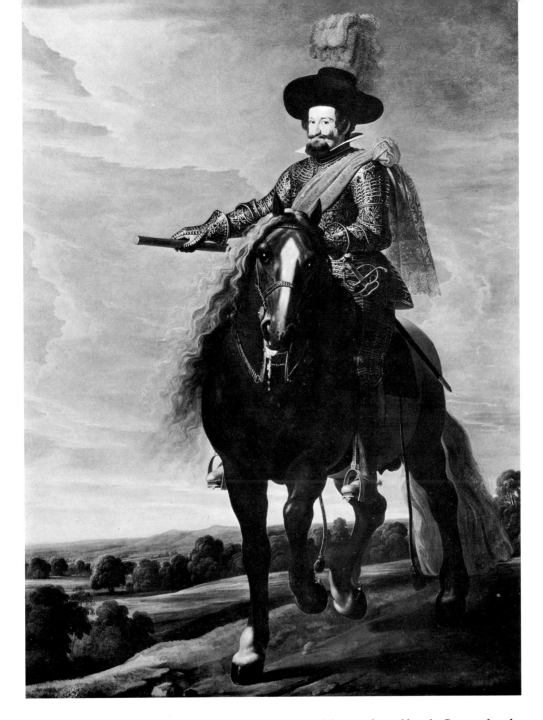

Figure 34
Gaspar de Crayer,
Equestrian Portrait
of the Count-Duke
Olivares, about
1627–28. Present
location unknown
(Plate 102)

1627 after Rubens's portrait of Olivares was probably employed by de Crayer for the features of the Count-Duke.[59]

In all of these equestrian portraits of Olivares he appears as a military commander. His only obvious attribute is the commander's baton. But the modern reading that perceives no more than this ignores the more complex and more fundamental meanings of Baroque equestrian portraits. For the contemporary viewer, the *Equestrian Portrait of Olivares* would have been a realistic record of his skill in an aristocratic pursuit, and of the discipline, patience, and pride required to master it. At the same time, the painting was an emblem of Olivares's authority, which is expressed by the way the rider rules the horse and by the very fact that he appears in this kind of portrait. Much of what Olivares was to Spain is summed up in this work, including the fact, recognized by Olivares himself in his later years, that in the long run his abilities and achievements did little more than form an image of Spanish glory.

Fig. 32

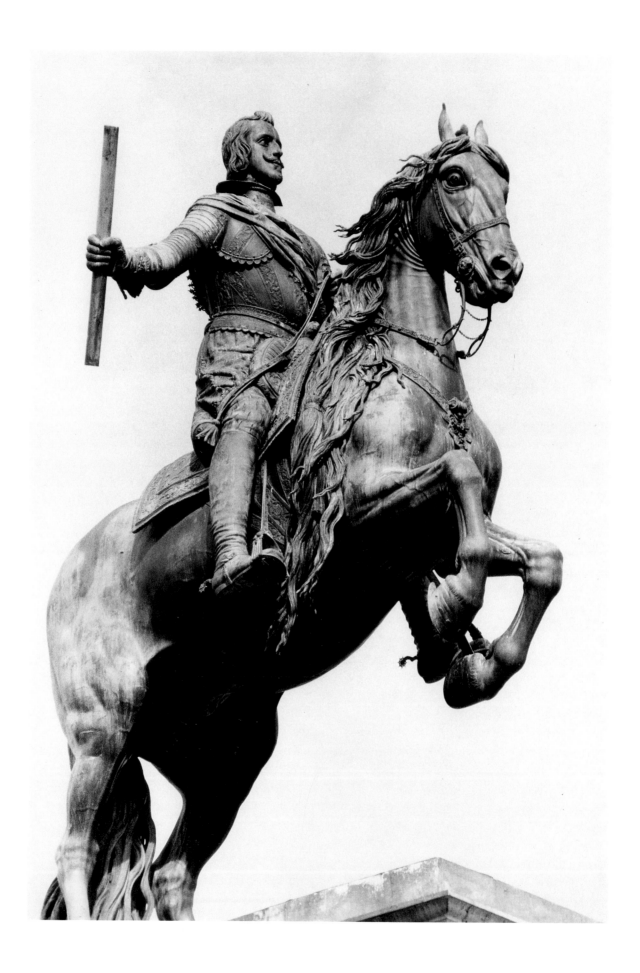

3

THE REARING HORSE
FROM
LEONARDO TO TACCA

In the chapters above we have principally been concerned with only one form of equestrian portrait, a restricted sphere of patronage, and the most common meanings of royal equestrian portraits from about 1550 to 1650. Particular attention has been given to the *levade,* and to horsemanship as a metaphor for rulership. The reader will be well aware that in other outstanding portraits and monuments of the sixteenth and seventeenth centuries — for example, those by Leonardo, Giambologna, Mochi, van Dyck, Bernini, and Girardon — the horse is found in a different pose. There are also important exceptions to the conventional meanings of the imperial, Christian, and rulership themes. It would go far beyond the scope of the present study to survey all the major examples of equestrian portraiture that date from this period, but an attempt can be made in the concluding chapters to place the works discussed above in a broader context.

It has often been observed that the subject of the horse was a Florentine specialty that bore its greatest fruit not in Tuscany but to the north: Donatello's *Gattamelata* in Padua, Verrocchio's *Colleoni* in Venice, Leonardo's projects for the Sforza and Trivulzio monuments in Milan, and, one could add, the Farnese monuments in Piacenza by Mochi (born near Florence, trained there and in Rome).[1] This roster reminds us that at least until Titian's *Charles V at Mühlberg,* and for the most part, until Rubens's early equestrian portraits, sculptors of the subject took the lead over painters. This predominance, extending back to classical monuments and medieval tomb sculpture,[2] began to change not with Rubens's reference to Titian, but with Rubens's response to Leonardo.[3] The naturalistic studies of Leonardo were the most important source for the horse that truly

Pls. 24, 25

Pls. 28, 30, 32–34

Pls. 151, 152

Pl. 51

Pls. 16–18

Tacca, Equestrian Portrait of Philip IV, 1634–35. (Plate 74)

Pl. 31; Fig. 35
Pl. 39

rears in Baroque art. Rubens knew the equine imagery of Leonardo from the *Battle of Anghiari* and from the numerous small bronzes by sixteenth-century Italian artists that ultimately depend upon Leonardo's models for equestrian monuments.[4] This development from Leonardo to Rubens could be described as the genesis of the image that Wittkower and many others have seen as so characteristic of the Baroque.

The evolution over one hundred years was, of course, more complex than this might suggest, but it remained fairly consistently a Florentine affair. The horse runs, or rather trots and rears, along a steady course from Leonardo on, through the studios of the sculptors Rustici, Tribolo, Leone Leoni, Giambologna, Adriaen de Vries, Tacca, and the Susini.[5] The other principal route through which the Italian Renaissance preoccupation with the horse descended to Baroque painters such as Rubens and Velázquez was, as we have seen, the engravings of Stradanus and Tempesta [6] (again, then, artists who were active in Florence between about 1550 and the early seventeenth century; Stradanus, of course, was, like Giambologna and de Vries, part of the Flemish colony).[7] With Rubens, these artists formed a network of Italians and Italian-oriented Flemings who, during the early seventeenth century, made a Florentine specialty into an international art form.

Both of the dominant types of equestrian statue in the sixteenth century — that with a trotting and that with a rearing horse — have antecedents in ancient, medieval, and early Renaissance art: that is to say, during the long history of this central subject in Western art, these poses and others (standing, walking, galloping, etc.) occurred many times before. Making historical sense of this development requires a constant consideration

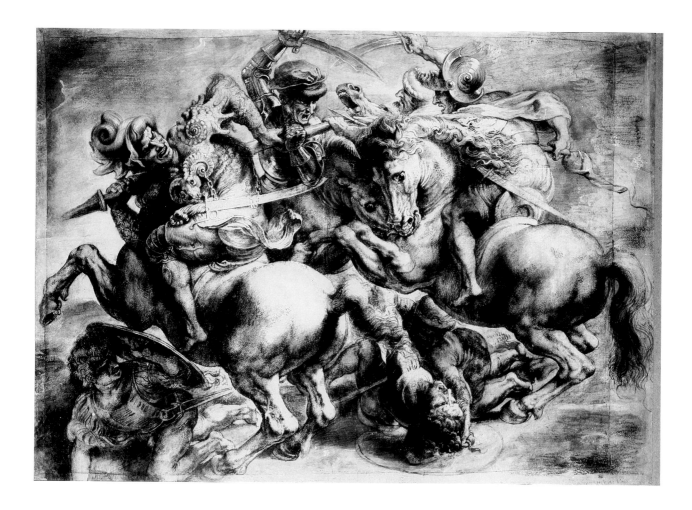

of artistic intentions. For example, Grossmann has convincingly shown that medieval artists frequently represented a trotting horse when the slower movement of a walk was meant.[8] In many examples this is clearly due to the influence of classical models, but whether this was the case or not, the artist's goal was simply to indicate a forward movement of the horse. Classical influence of this kind is very different than a classical reference, which occurs, for example, in the equestrian statuette of "Charlemagne" in the Musée Carnevalet.[9]

Pl. 13

Classical associations are also intended in late medieval and Renaissance works (indeed, the equestrian form itself sufficed to recall antiquity), but in a broad view the horse

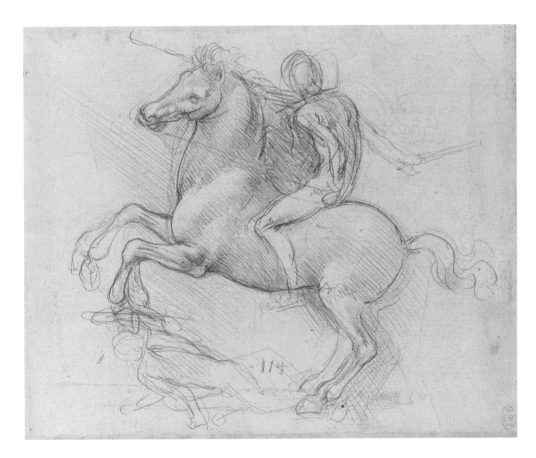

Figure 35 Rubens's drawing of about 1602–05 after Leonardo da Vinci's Fight for the Standard, the central section of The Battle of Anghiari, 1503–06. Paris, Louvre. (Plate 31)

Figure 36 Leonardo da Vinci, Study for an Equestrian Monument of Francesco Sforza, probably about 1487–90. Windsor, The Royal Library. (Plate 28)

from around the time of Alberti's treatise, *De Equo Animante*, to Leonardo's studies for the Trivulzio monument was, like the human figure, a form in nature that was approached directly and through classical examples.[10] The walking horses of Donatello and other Renaissance sculptors reveal this appreciation of classical monuments in essentially naturalistic terms,[11] and the same may be said of both the trotting and rearing horses of Leonardo. But after Leonardo (or perhaps beginning with him, if the trotting versions of the Sforza and Trivulzio monuments were suggested by his patrons because of the form's stronger classical associations),[12] and especially with Giambologna, classical monuments were recalled for their imperial significance. This association—and the technical difficulties of the rearing position—must account for the fact that, during the second half of the sixteenth century (with the exception of provincial works), monuments with horses that walk or rear virtually disappear. The rearing horse makes a strong comeback in the early seventeenth century (against the technical odds), but, unlike before,

Pls. 32–34

Pls. 30, 34, 61

Figure 37
Sestertius of Trajan,
a Roman coin
of 104–111 A.D.
New York,
The American
Numismatic Society.
(Plate 5)

the example of courtly riding and the emblematic reference to rulership popularized by Alciati now played important parts. After the middle of the seventeenth century the rearing horse had, so to speak, its ups and downs, but the trotting horse remained a strong favorite throughout the seventeenth and eighteenth centuries.

The rôle of Leonardo in eventually establishing the rearing horse in equestrian portraits and monuments cannot be overestimated. Earlier sculptors, including Pollaiuolo, *Pl. 26* in his own plans for the Sforza monument,[13] had employed the motif of the rearing horse, but for Leonardo it became a profound preoccupation, and his enthusiasm and ideas were directly transmitted to other artists in Florence. The technical difficulties of the pose *Pl. 28; Fig. 36* and the scale (the horse alone in Leonardo's Sforza monument was to be twenty-two feet high)[14] must have been characteristically welcomed by the artist as a fascinating challenge. Like Pollaiuolo, Leonardo was also keenly interested in the study of anatomy in motion. But apart from these formal interests, Pollaiuolo and Leonardo probably saw the rearing horse as appropriate to the figure of Francesco Sforza. James Ackerman reminds us that the subjects of early Renaissance equestrian portraits, including Uccello's *Pls. 20, 24, 25* *Hawkwood*, Donatello's *Gattamelata*, and Verrocchio's *Colleoni*, were "all soldier adventurers of low birth rather than prelates or princes,"[15] and Pope-Hennessy recalls that Francesco Sforza, "Colleoni's erstwhile colleague… had been a condottiere in the service of the Visconti Dukes of Milan, and in 1450 was elected Duke."[16] Battle scenes and representations of St. George were common in Florentine art, and included many examples of a rearing horse.[17] Pope-Hennessy specifically relates Leonardo's studies for the Trivulzio monument to one of the rearing horses in Uccello's panels commemorating *Pl. 22* the *Battle of San Romano*.[18] In the London panel, the central figure, in effect an equestrian portrait of the Florentine captain Niccolò da Tolentino, anticipates Pollaiuolo's draw- *Pls. 26, 32* ing for the Sforza monument and Leonardo's first ideas for the Trivulzio monument not only in the rearing horse, but in the rider's forward thrust of the field marshal's baton.

Uccello's battle scenes and the rearing horses in other Florentine paintings[19] also would have been of interest to Leonardo for the fighting horsemen in the background of the Uffizi *Adoration* (1481–82) and ultimately, of course, for the *Battle of* *Pl. 31; Fig. 35* *Anghiari*,[20] although his studies from nature would have transformed any borrowed motif.[21] Pollaiuolo and Leonardo clearly made use of classical sources as well.[22] Especially important for Leonardo were Roman coins that featured an emperor mounted *Pls. 5, 7; Fig. 37* on a rearing horse with, in some examples, a fallen warrior below. Some very convincing comparisons have been made between Leonardo's studies for an equestrian monument and Roman Imperial coins of the first century A.D.; such coins were com-

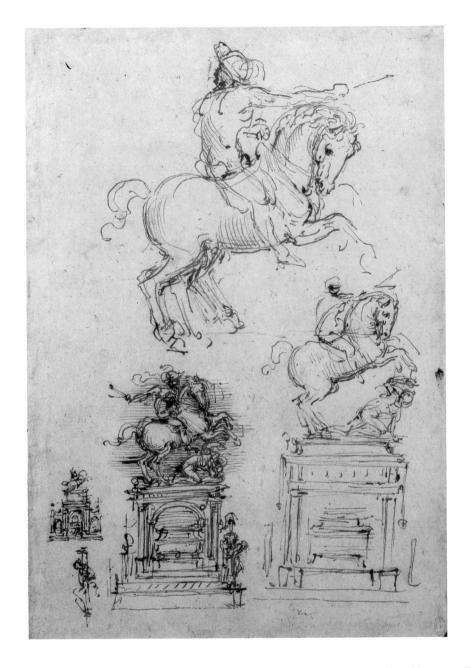

*Figure 38
Leonardo da Vinci,
A Study for the
Trivulzio Monument,
about 1510. Windsor,
The Royal Library.
(Plate 32)*

monly to be found in Renaissance collections, including that of the Sforza.[23] The equestrian portrait of antiquity that features a rearing horse must have been known during the Renaissance and Baroque periods principally through coins and medals, and while our association of men like Sforza and Trivulzio with battle scenes would seem to hold true (the trotting horse, after all, was more familiar from antique coins and monuments), this example of imperial imagery was certainly not lost on sixteenth- and seventeenth-century patrons and artists (including, of course, Stradanus and Tempesta in their portraits of the Twelve Caesars).

Gian Giacomo Trivulzio was the Milanese commander of the French forces and, upon the expulsion of Ludovico il Moro, served as Regent of Milan.[24] As in the case of the Sforza monument, Leonardo began with ambitious plans for a rearing horse (1506–07), but later (1508–13) turned to the trotting form.[25] In addition to the inspiration of antique coins[26] and the work that Leonardo had just abandoned on the *Battle*

Pls. 5A, 7A, 22A

Pls. 82–85

Pl. 32; Fig. 38
Pl. 34

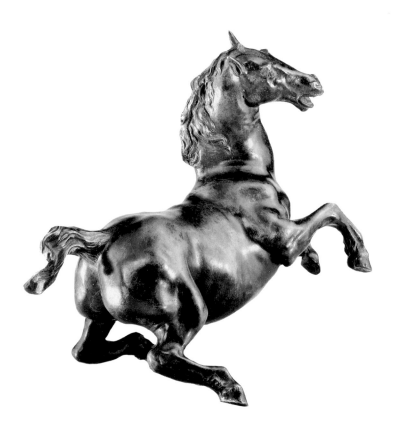

Figure 39
After Leonardo
da Vinci, A Rearing
Horse, perhaps
second quarter of the
16th Century. New
York, Metropolitan
Museum of Art.
(Plate 39)

of Anghiari (1503–06; curiously enough, the enemy of the Florentines in this incident was Milanese), Trivulzio's own interest in the rearing form should be taken into account, since two medals (one dated 1508) with the marshal represented on a rearing horse are known.[27] After Leonardo had returned to the trotting form (his trotting horses are discussed in the next chapter) and his hopes for producing a great equestrian monument were again dashed, he made, according to recent writers, some late, free "reflections on the unrealized 'Idea'" of the rearing horse and rider.[28] Altogether, Leonardo's preoccupation with the motif of the rearing horse spanned more than thirty years and included preparatory studies well known to sculptors in Florence; the *Battle of Anghiari* was known through the original cartoon, perhaps a *modello*, and the incomplete painting on a wall in the Sala del Gran Consiglio in the Palazzo Vecchio. Until 1557, when Vasari began to paint over *"The Fight for the Standard"* (the central section of the battle scene begun by Leonardo), it must have served as an "academy" for the drawing of the horse in action, quite as Michelangelo's *Battle of Cascina* cartoon served for the study of the human figure in the same room.[29]

Notwithstanding the importance of the rearing horse in antique coins, medals, and statuettes representing victorious emperors,[30] interest in the motif during the sixteenth and early seventeenth centuries was above all due to Leonardo's authority, and to the close interrelationships between the artists involved. Not only Leonardo's pupils and followers, but great contemporaries such as Raphael and Jacopo Sansovino must have been impressed by his example in Florence.[31] Sansovino is said to have executed a statue of a rearing horse in 1514 as part of festival decorations in Florence (evidently for the entry of Pope Leo X in 1515).[32] Rustici, Verrocchio's pupil and Leonardo's close associate, made reliefs and statuettes of fighting riders on rearing horses, and possibly himself addressed the problem of the rearing horse on a monumental scale.[33] Niccolò Tribolo, a pupil of Sansovino, repeated his master's task of making equestrian monuments for festival decorations, on the occasions of Charles V's triumphal entry into Florence in

Pl. 35

Pl. 36

54

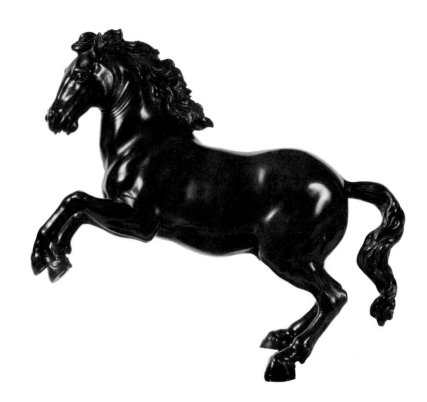

Figure 40
Giambologna, A
Rearing Horse. Her
Majesty the Queen.
(Plate 69)

1536,[34] and of Cosimo I's wedding in 1539; in the latter instance the horse was reportedly in a rearing position above fallen figures.[35] Charles V was also celebrated by an impermanent equestrian statue with a rearing horse and personifications of conquered provinces below it when he entered Siena in 1536, six years after he was first expected and Beccafumi made the mobile monument.[36]

There must have been other equestrian monuments, planned and never executed or made of impermanent materials, in which the horse was in a rearing position. For example, all we know of two equestrian monuments of Charles V and Francis I proposed for the square of St. Peter's during the papacy of Clement VII (1523–34) is that the monarchs were to be represented as defenders of the Faith.[37] The motif of a rearing horse above a fallen warrior would have been expected for this theme. Similarly, an equestrian statue of Charles V by Leone Leoni was considered during the mid-1540s; again the pose is not recorded.[38] But the sculptor's position as master of the imperial mint at Milan from 1542 to 1545 would have made him aware of Leonardo's projects there, and of antique and modern coins and medals.[39] Bronze statuettes based on Leonardo's studies of the rearing horse have at least plausibly been attributed to Leone.[40] Finally, in 1549–50 Guglielmo della Porta designed an equestrian monument of Charles V for the Capitol in Rome, and revived the plan in 1558: this time, it is known that the horse was rearing above prisoners.[41] Della Porta's design has been closely related to the ideas recorded in Leonardo's drawings.[42]

Pl. 39; Fig. 39

Except for the designs of Leonardo and the small sculptures derived from Leonardo by Rustici, none of the works mentioned above could have been very well known, although together they form a fairly consistent tradition. Paradoxically, a few less ambitious examples of the rearing horse, by Giambologna, may have a much more important place in the historical development. Giambologna arrived in Florence (1556?) shortly before Vasari painted over *"The Fight for the Standard;"* he must have known the composition, Rustici's work, and something of Leonardo's designs for equestrian monuments.

Pl. 69; Fig. 40

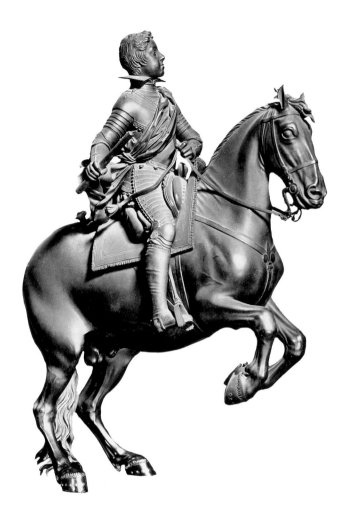

Figure 41
Pietro Tacca,
Equestrian Statuette
of Louis XIII, 1617.
Florence, Bargello.
(Plate 72)

Figure 42
Pietro Tacca,
Equestrian
Monument of Philip IV,
1636–40. Madrid,
Plaza de Oriente.
(Plates 74–75)

It was observed in the 1978 *Giambologna* exhibition catalogue that "a relief of a rearing horse with rider on the shoulder of the Grand Duke's armour" in the equestrian monument of Cosimo I—a work that profoundly reinforced the tradition of the trotting horse—"seems a commentary on Leonardo's studies for the Trivulzio and Sforza monuments," and "suggests that Giambologna felt the challenge of Leonardo's unfinished commissions for equestrian statues."[43] Giambologna had already employed a rearing horse (actually a centaur) in the *Rape of Deianira* statuette, and perhaps also on a triumphal arch in 1565.[44] One statuette of a rearing horse without a rider is also attributed to Giambologna by Charles Avery, who notes that it "fits well into the development of equestrian sculpture at the time, for it provides a possible prototype for Pietro Tacca's rearing horses."[45]

Pl. 61

Fig. 40

Something of Leonardo's fascination with this subject seems to have been rekindled in Tacca, and indeed, his career, although hardly restricted to equestrian subjects, was continually devoted to the horse. In his mid-teens (1592) he entered Giambologna's studio and worked on the *Equestrian Monument of Cosimo I*; by 1605 he was Giambologna's principal assistant and the acknowledged heir to his studio (Giambologna died in 1608).[46] Tacca carried out Giambologna's designs for three more equestrian monuments, works that immediately became "symbols of authority known throughout Europe"[47]: the *Ferdinando I* in Florence (1601–8), the *Henry IV* in Paris (c. 1604–10), and the *Philip III* in Madrid (1606–16; commissioned by Ferdinando I).[48] In all four monuments, of course, the horse trots; but in independent commissions—the statuette of Louis XIII

Pl. 61

Pls. 66–68, 71A

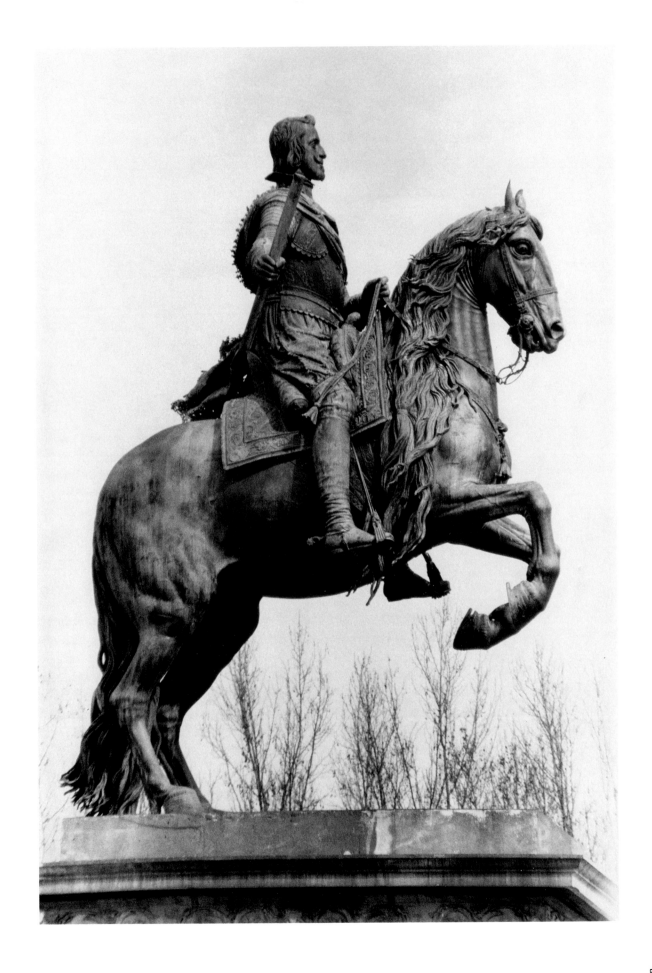

Pl. 72; Fig. 41
Pl. 73

Pls. 74, 75; Fig. 42
dating from 1617 (accompanied by an extra rearing horse) and the statuette of Duke Carlo Emmanuele of Savoy (1619), a model for an equestrian monument planned for Turin—Tacca promptly returned to the problem of the rearing horse.[49] That it was a "problem" still, as it was for Leonardo, is indicated by the differences between the two statuettes and Tacca's *Philip IV* of 1634-40, and by the originality of the smaller works. They do not seem to follow very closely the designs of any earlier sculptor (Leonardo, Rustici, and probably Giambologna), and in the case of the work for Turin we recall that the Duke's riding master gave advice (we can only suggest that Tacca might have been similarly advised in the case of the *Louis XIII*, and recall that emphatic instructions for the *Philip IV* were sent from Madrid).[50]

Tacca's study of the rearing horse was only the most prominent part of a general development centered in, but hardly limited to, Giambologna's workshop. To try to work out the interrelationships between Giambologna, Tacca, Antonio Susini, Adriaen de Vries, Stradanus, Tempesta, and others who favored the motif in late sixteenth- and early seventeenth-century Florence would probably be impossible, and inevitably neglectful of the complexity of an artistic milieu and its background in earlier work. By the time Tacca was winning commissions for equestrian portraits, the rearing horse had figured

Pl. 54A
extensively in the prints of Stradanus (some of which recall Leonardo's designs to some extent), and in those by Tempesta; the motif had probably interested Tacca's older associate in Giambologna's studio, Antonio Susini;[51] and had been represented in slightly earlier equestrian statuettes by another Giambologna pupil, Adriaen de Vries (*Heinrich*

Pls. 70, 71
Julius of Braunschweig, c. 1607–13),[52] and supposedly by an anonymous sculptor in France (*Henry IV*).[53] Approximately contemporary with Tacca's equestrian statuettes is Andrea Rivalta's marble statue of the same Carlo Emmanuele on a rearing horse (later changed into a portrait of Vittorio Amedeo I),[54] and as early as 1628–30 (that is, before Tacca began his *Philip IV*) Caspar Gras completed his imposing statue of Archduke

Pl. 76
Leopold V of Tirol on a horse that performs a *levade*. The large fountain with this and several other figures in bronze was not set up until 1894, but it is an important example of the increasingly international influence of Florentine artists.[55]

The evolution of the rearing horse from Leonardo to Tacca is difficult to summarize in a few words, but there is a clear tendency in the works of Giambologna, his contemporaries, and followers to formulate standard types that, in an academic manner, leave both the exploratory and the inventive spirit of Leonardo behind. The rearing horses of around 1500 recall those in the battle scenes of antique reliefs and Renaissance paintings, while those of around 1600 recall the plates and instructions of Grisone and the riding masters who followed him.

It is difficult to say what, for example, the riding school in Naples meant to Stradanus, what the one in Turin meant to Tacca, or what the one in Florence meant to both of those artists, to Giambologna, and to Cosimo I. In a broader view, however, the more formal style of riding and the more conventional nature of equestrian art may be described as directly related aspects of courtly culture.[56]

The great social distance between men like Gattamelata, Colleoni, Sforza, and Trivulzio on the one hand, and Philip IV, Louis XIII, and even Buckingham and Olivares on the other, must be taken into account before one can discuss the differences between

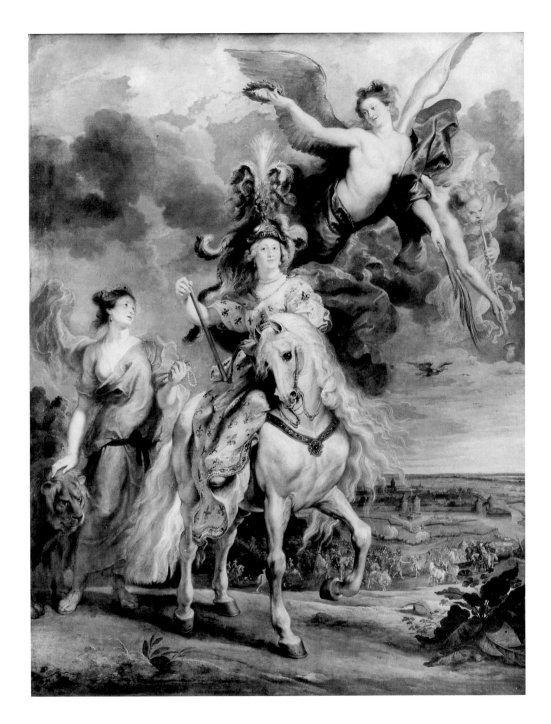

*Figure 43
Rubens, The
Triumph of
Juliers, 1622–25.
Paris, Musée
du Louvre.
(Plate 104)*

the ways in which their horses move. Baroque equestrian portraits and monuments — it is worth saying again — were state portraits of an especially traditional and usually public kind. The formality of state portraiture is not easily reconciled with the modern notion of an active horse, but it is consistent with the reserved nature of courtly riding.

Of course, there were exceptions. Among them are the better portraits of queens on horseback, such as those by Velázquez and by Rubens. These women, riding side-saddle on slow-stepping mounts, seem more at ease as a group than the men on their less subdued horses. In this light, the equestrian portrait of Marie de Médicis appears to be one of the least stilted compositions in Rubens's cycle of decorations for the Luxembourg Palace. In art as in life, riding like a man was not expected of a lady.

Pls. 111, 113, 104

*Fig. 43
Colorplate 14*

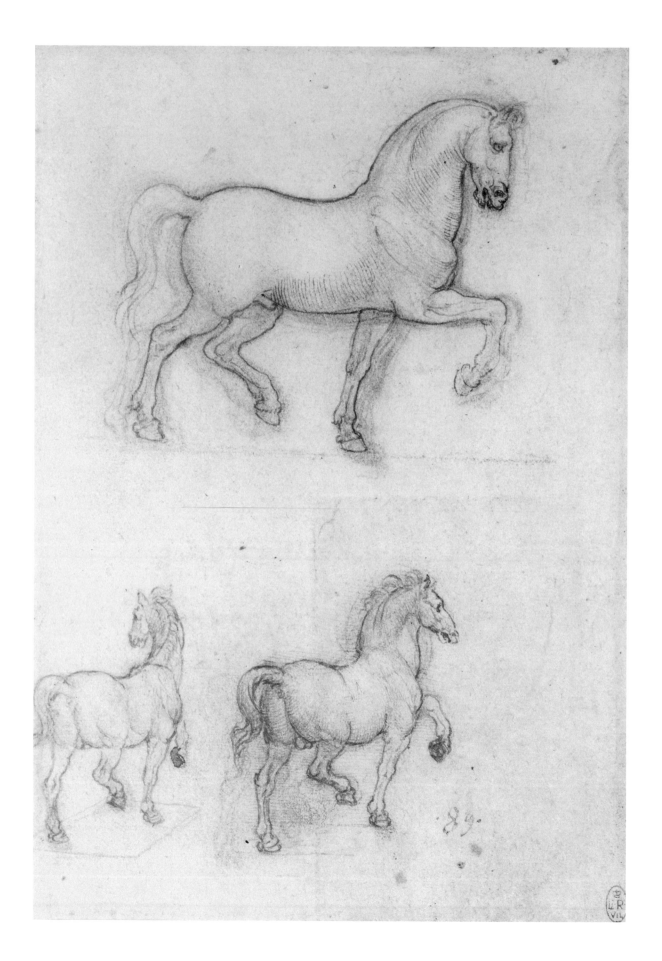

4

THE TROTTING HORSE
FROM
LEONARDO TO GIRARDON

The importance of the trot in equestrian portraits and monuments dating from about 1500 onward has been mentioned several times above. By around 1530, the profile view of a trotting horse was so common in northern European prints representing particular potentates (foreign and domestic, alone or in triumphal entry processions), as well as popes, soldiers, saints, and sinners (usually Turks), that any other pose can be considered as a significant departure from the norm.[1] We have seen that the trotting horse was the type most familiar from the equestrian images of ancient Rome, which served as important formal and, in the case of some portraits of monarchs and popes, iconographic models in medieval times. After the walking horses of Donatello, Verrocchio, and other artists of the early Renaissance, the trot became the dominant type in sixteenth-century portraits and monuments, and was almost exclusively preferred after the middle decades of the century. During the Baroque period the trot continued to dominate, despite the importance of the rear or the *levade* in the work of major artists such as Rubens, Velázquez, and Bernini. Exceptions like these became much less important and numerous in the following two centuries.

Explaining why the trot was such an important form in the period from about 1550 to 1700 (and much of what may be said here holds for later examples) is a much more difficult task than tracing its formal development, or discussing the significance of the rear and the *levade*. One may reasonably expect that the riding schools and treatises were influential for this form as well, that a finely executed trot also suggested the sitter's highborn station, and that this gait too could have occasionally suggested an ability to rule (although here one would note the common currency of the idea in books and

Figure 44 Leonardo, Three Studies of a Trotting Horse, about 1510–12. (Plate 33)

61

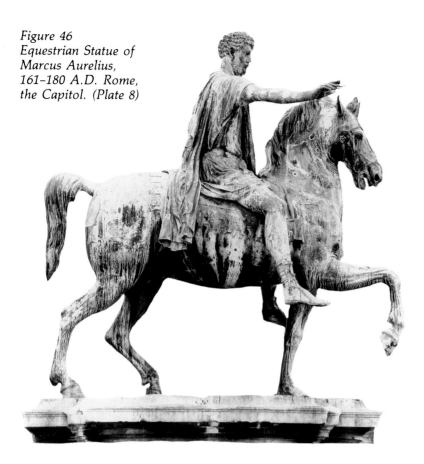

Figure 46
Equestrian Statue of
Marcus Aurelius,
161–180 A.D. Rome,
the Capitol. (Plate 8)

Figure 45
Three kinds of trot:
working trot,
collected trot,
passage. From W.
Müseler, Riding
Logic (Reitlehre),
New York (Arco),
1978.

correspondence, rather than the example of specific emblems). But it must be kept in mind that the trot is much more common than the rear in nature and in everyday riding, that the *Marcus Aurelius* was (especially after the 1530s) esteemed by artists and patrons throughout Europe, and that Leonardo and especially Giambologna had designed very influential monuments employing the trotting horse. As always, artists responded to these models with adaptations ranging from rote repetition to the subtle comprehension of multiple meanings.

Pl. 8; Fig. 46

Pls. 30, 34, 61

Richness of meaning can be attributed to an equestrian portrait — often rightly — by bringing classical precedents, emblematic literature, equestrian treatises, and empirical observation into discussion all at once. But the intentions of the artist and the patron may be more closely understood only by questioning the importance of each one of these factors for a particular painting or monument. In the present chapter especially, our purpose cannot be to provide all the answers, or even more than a few, but to raise questions that would best be considered in studies of individual careers and works of art.

While the *levade* is a very specific position, and rearing movements can be differentiated only in broad terms, the trot is a movement that varies from the long, loose strides of the "working trot" to the shorter, higher steps of the "collected trot" to the very collected "Spanish trot," or *passage*.[2] The first gait, of course, is commonplace, the second is common in good riding, and the last is an air of the *haute école* (a point of "maximum collection" is reached when the horse is made to trot in place, an air called the *piaffe*). The *passage*, in loose, everyday language, might be described as a parade gait, the movement most expected of a ruler's horse in a triumphal entry or in a brisk review of troops.

Fig. 45

Pls. 107B, 220

It should be observed that in any trot, but especially in the more collected forms, the raising of the foreleg somewhat anticipates that of the hindleg, so that while the

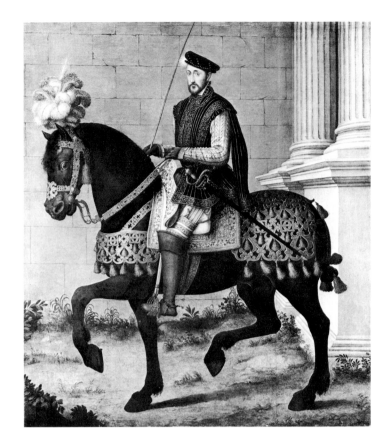

Figure 47
Workshop of
François Clouet,
Henry II on
Horseback, 1550s.
New York,
Metropolitan
Museum of Art.
(Plate 49)

diagonally opposed legs are both off the ground during most of the movement, the hindleg can be represented correctly as still just touching the ground while the foreleg is raised. This fact must have been given serious consideration by sculptors; it was much easier to balance a monumental bronze on three slim supports rather than two.

The stately, quite collected movement of the *passage* is favored both in antique statues such as the *Marcus Aurelius*, and in sixteenth- and seventeenth-century equestrian portraits and monuments. It was observed above that an interest in the equestrian images of imperial Rome flourished with the rise of absolute governments in the sixteenth and seventeenth centuries, and that the art of riding became increasingly cultivated at the same courts during the same period. Obviously, these interests are complementary, but they cause problems for the scholar eager to discover whether either interest played an important part in the design or meaning of a particular work. An artist and his patron may have been very well aware that Marcus Aurelius and modern monarchs were depicted as good horsemen, but perhaps all that mattered in their new portrait was the idea of a Christian emperor. By contrast, a patron may have cared little for the conventional comparison to "Constantine" but relished his own rôle in riding at court. It seems likely that such one-sided views of the trotting horse were exceptional, but an emphasis on one or the other would not have been.

We should therefore consider carefully to what extent a horse in a sixteenth-century or later equestrian portrait really resembles that of the *Marcus Aurelius* (the idea that all trotting horses were sired in Rome is one of convenience rather than curiosity), and whether the pose of the rider reveals a similar source. In Girardon's *Louis XIV*, for example, not only the pose of the horse and rider, but the lack of a saddle and stirrups, the fall of the drapery, and the type of horse recall the *Marcus Aurelius*.[3] In the portraits

Pl. 8; Fig. 46

Pl. 160; Fig. 48

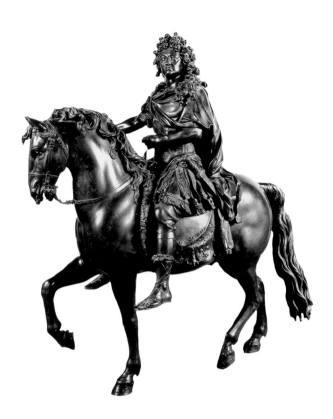

Figure 48
François Girardon,
Equestrian Statuette
of Louis XIV, about
1696–1700. Paris,
Musée du Louvre.
(Plate 160)

Colorplate 7
Pl. 49; Fig. 47

of Francis I and Henry II that are often associated with the studio of Clouet,[4] however, the pose of the horse, although probably related to that of the *Marcus Aurelius* through other works, differs from it in that the left foreleg leads, and the opposite hindleg is raised off the ground in a high step (the latter is exaggerated; compare fig. 45). The horse bears less resemblance to the classical type. The rider, unlike Marcus Aurelius, turns engagingly towards the viewer, and holds both arms close to the body in a natural way (compare fig. 45, especially the rider in the *passage*). In the painting in the Metropolitan Museum, the king holds a whip rather than the usual baton,[5] but all the pictures of this type feature detailed descriptions of contemporary riding gear. Horses in the same pose and riders with similar equipment occur frequently in earlier prints, but the whip and

Pl. 106

the high-stepping hindleg are reminiscent of Grisone's plates . The whip is also employed in a Spanish emblem book of 1640 as a symbol of the firm hand that must temper a ruler's kindness to his people (represented by a horse).[6]

Whether or not the early French equestrian portraits are symbolic of an ability to rule, they present the king as an able rider. Marcus Aurelius (Constantine) and other earlier monarchs such as Charlemagne may be recalled, but not in an obvious way that refers directly to the imperial predecessor, or that dryly copies the classical form. The French portraits, despite their conventional compositions, have an immediacy which is reminiscent of Clouet's other portraits and which must have been sensed more strongly by contemporaries than it is today.

In this respect, a painting such as *Henry II on Horseback* looks forward to some seventeenth-century works — for example, Velázquez's picture of the French-born Isabella

Pl. 113

of Bourbon.[7] With the increasing authority of the monarchy in France, the equestrian portrait tends to become more allegorical, but the importance of good horsemanship

Pl. 109

remains perfectly clear. Thus, in Michel Lasne's engraving, Louis XIII deftly demonstrates the training he was given by Pluvinel. Louis XIV, who took up riding at the age of seven and was considered a prodigy at nine,[8] would have recognized, in looking back from

Girardon's statue to the portraits of Francis I and Henry II, that the image of the king as a good horseman was a French tradition already more than a century old. Fig. 48

Given the familiarity of the trot from many examples in classical and medieval art and from everyday experience, one cannot expect to define the beginning of its rise in early sixteenth-century art as precisely as in the case of the rear. Again, however, Leonardo's contribution was extremely influential, and again, although he must have found early Renaissance examples interesting,[9] classical models were more decisive for his designs. Most important was the *Regisole*, an equestrian statue in Pavia that was probably a Roman work of the third century A.D.[10] The *Regisole* is generally thought to have inspired Leonardo's second design for the Sforza monument; a large clay model was made, but it was used for target practice by the French in 1499 and is now known only through a few sketches of ideas for casting and transporting it.[11] Pls. 9, 29 Pl. 30

Heydenreich, however, suggests that it was only later (1508–13 in Milan), during Leonardo's work on the second trotting version of the Trivulzio monument, that the artist closely studied the *Regisole* and responded to it sympathetically.[12] The same author carefully considers the kind of trot represented in the *Regisole*, draws attention to early accounts of its especially natural and animated pose,[13] and discusses Leonardo's specific appreciation of the gait as a "trot like that of a free horse."[14] Heydenreich concludes that this greater movement, which perhaps can be described as more "free" and certainly as more energetic,[15] distinguishes the trotting horse of the Trivulzio monument from that of the Sforza monument, and that of the *Regisole* from that of the *Marcus Aurelius*. Pls. 33, 34 Fig. 49 Fig. 50

Thus, an historical picture comes into focus that recalls the progress of the rearing horse in the sixteenth century. Leonardo's trot was a spirited pose derived from the *Regisole* and his study of the living horse. Its lively step recalls the vivacity, if not the gait of Verrocchio's horse, quite as the character of his sitters recalls that of Colleoni.[16] Fig. 49 Pl. 25

By the middle of the sixteenth century, however, the *Marcus Aurelius* had become the most important source by far for equestrian monuments, and an absolute monarch had become the usual rider. Heydenreich's research would suggest that it was not only the subject and location of the *Marcus Aurelius*, but the stately gait of the horse that made the monument such a persuasive symbol of authority. Mochi's *Alessandro Farnese* is the exception that proves the rule (to assume, for a moment, that there are any in the history of art), for Alessandro was a "fearsome and aggressive commander in the field,"[17] and his horse recalls those of Verrocchio, Leonardo, and the *Regisole*, rather than that of the *Marcus Aurelius*.[18] Surprisingly, it has not (to my knowledge) been observed in this connection that Pavia is just up the Po from Piacenza (and Milan is not much farther to the north). Mochi's *bozzetto* in the Bargello is even closer to the *Regisole* in that the advancing hindleg is off the ground.[19] Pl. 151; Fig. 51

Another monument possibly influenced by the *Regisole*, and, curiously, located in another city down the Po (much farther this time), was the equestrian statue of Ercole d'Este, Duke of Ferrara. Commissioned by the city in 1492, and possibly designed by Ercole de' Roberti (died 1496), the monument recalls the *Regisole* in the trotting pose, the raised right arm of the rider, and especially in the tall columnar base.[20] In 1501 the Duke requested the remains of Leonardo's clay model of the Sforza monument, but

*Figure 49
Leonardo da Vinci,
A Trotting Horse,
about 1490.
Windsor, The
Royal Library.
(Plate 29)*

Figure 50
Leonardo da Vinci, Study for the
Trivulzio Monument, about 1510–12.
Windsor, The Royal Library. (Plate 34)

whether it was sent to Ferrara and work on the d'Este monument continued beyond the base is unknown. An interesting footnote to the story of what might be called the *Regisole's* rôle in the Po Valley is the abduction of the statue itself in 1527, after the fall of Pavia. Destined for its hometown of Ravenna, it went no farther than Cremona and was returned to Pavia in 1531.[21]

The equestrian monument of Francis I, Rustici's principal work in France between his arrival there from Florence in 1528 and the king's death in 1547, was probably inspired by Leonardo's work on the trotting horse.[22] Virginia Bush suggests that the colossal statue was probably posed "in a fashion similar to the *Marcus Aurelius*, of which Primaticcio had made a cast for Francis in 1540."[23] But the influence of Leonardo, evident in Rustici's small sculptures featuring a rearing horse, dates earlier, and must have been more important.

Pl. 36

Mention of Primaticcio's cast, however, recalls the sudden new importance of the *Marcus Aurelius* around 1540. At the insistence of Pope Paul III (over the artist's own

Fig. 53

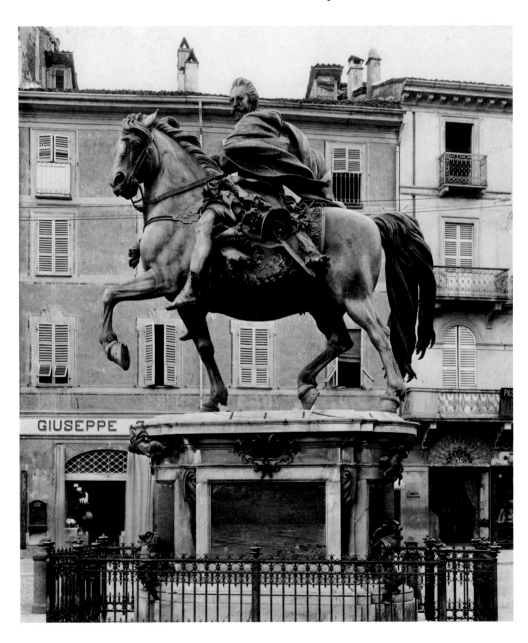

*Figure 51
Francesco Mochi,
Equestrian
Monument of
Alessandro Farnese,
1620–23. Piacenza,
Piazza Cavalli.
(Plate 151)*

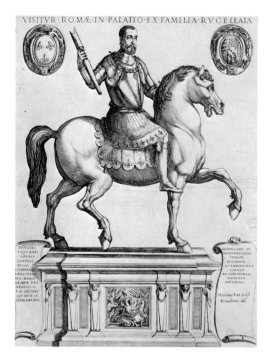

Figure 52
Antonio Tempesta, Equestrian Monument
of Henry II (the horse after Daniele
da Volterra). New York, Metropolitan
Museum of Art. (Plate 58)

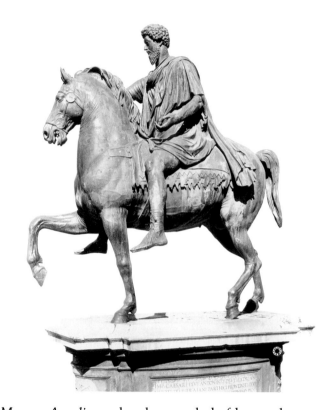

Figure 53
Equestrian Statue of Marcus Aurelius,
161–180 A.D. Rome, the Capitol.
(Plate 8)

objections), Michelangelo made the *Marcus Aurelius* — already a symbol of law and government in its former setting in front of the Lateran — into the centerpiece of the Capitoline Hill. The great significance of the statue in the architectural complex is reflected in the fact that its placement on a new base by Michelangelo in 1538 preceded the construction of the surrounding architecture and to some extent the design of the piazza.[24]

Pl. 59 Earlier copies in the form of bronze statuettes are known,[25] but during the second half of the sixteenth century a great number were made, some of which clearly come from Giambologna's circle.

 The first sculptor inspired by the relocated *Marcus Aurelius* seems to have been Michelangelo himself. A letter of 1544 records that Michelangelo offered to make an equestrian statue of Francis I in exchange for the freedom of Florence. It has been suggested that Catherine de Médicis had this offer in mind when she wrote to Michelangelo in November 1559 about a bronze statue of her husband, Henry II of France, who had died four months earlier from wounds received in a tournament.[26] The aged Michelangelo

Pl. 58; Fig. 52 was to design the monument and supervise its execution, for which he chose Daniele da Volterra. The final model of the horse alone was finished in 1561 and cast successfully on the second try in 1565. Tempesta made — significantly, as a pendant to an engraving of the *Marcus Aurelius* — an engraving of Daniele's horse with a portrait of Henry II invented for the print.[27] But Henry was never to mount the horse. Daniele died in 1566, Catherine's request (in 1567) that Giambologna finish the monument came to nothing because of the wars in France, and in 1586 Henry III gave the horse to Orazio Rucellai, who had it placed on a pedestal at his palace on the Corso. Sometime after the palace

Figure 54
*Stefano della Bella, The Place Royale with the Equestrian
Monument of Louis XIII (horse by Daniele da Volterra,
rider by Pierre Biard). New York, Metropolitan
Museum of Art. (Plate 149)*

became the French embassy in 1622, the horse was taken to Paris, where in 1639 it was
mounted by Pierre Biard's figure of Louis XIII and set up in the Place Royale.[28] The statue
was officially destroyed in 1792. From Girardon to Bouchardon the monument must
have been one of the most important of the many channels through which the type of
horse and gait found in the *Marcus Aurelius* influenced equestrian art in France.[29]

Pl. 149; Fig. 54

As Ilse Dahl expressed it, by this time the desire for equestrian monuments was so
great that in every case the project was completed. This had much to do with the organiza-
tion of Giambologna's studio, but indeed, even more to do with the long-standing Medici
tradition of patronage in the service of politics.[30] Evidently both Cosimo I and his son
Francesco I (r. 1574–87) had planned equestrian monuments to their fathers,[31] and
Catherine de Médicis, as discussed above, commissioned that of Henry II from
Michelangelo. Cosimo's second son, Ferdinando I (r. 1587-1609), commissioned Giam-
bologna's *Cosimo I* (1587), *Ferdinando I* (1601), and *Philip III* (1606), and Ferdinando's
niece, Marie de Médicis, ordered the *Henry IV* from Giambologna around 1600.[32] Once
again, then, it was the Medici who set an example that other important patrons could
not ignore.

Pls. 61, 66, 68, 71A

The statue presumed to have been an equestrian monument of Cosimo I commis-
sioned by Francesco I is known from a letter of 1581 from Simone Fortuna to the Duke
of Urbino. He describes as among the works in progress by Giambologna *"un cavallo
Traiano"* in bronze, twice the size of the *Marcus Aurelius*, to stand opposite Michelangelo's
David in the Piazza della Signoria.[33] Pope-Hennessy describes the term "Trajan horse"
as ambiguous, but suggestive of an antique model.[34] Dhanens suggests that perhaps a

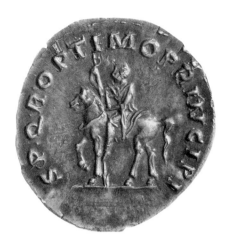

Figure 55
Denarius of Trajan,
a Roman coin
dating from 114 A.D.
London, The British
Museum. (Plate 6)

"Trojan horse" was meant[35] — that is, a colossus.[36] It is well known that the word *cavallo* alone was used to describe equestrian monuments, so it seems likely that Fortuna meant an "equestrian monument of the Trajan type," that is, a type he and presumably the Duke of Urbino knew from a Roman coin. Coins of Trajan represent the Emperor both on a trotting horse and on a horse leaping above a fallen enemy, but only the former is known to relate to an equestrian monument, indeed a famous "*Traiani equum*" erected shortly before the Emperor's death in 117 A.D., and admired by the Emperor Constantius II when he visited the Forum of Trajan in 357.[37] It would seem likely that Giambologna was familiar with such an antique coin, and that (along with the *Marcus Aurelius*, and the homage to it of Daniele da Volterra's horse) it firmly established the most common type of Roman equestrian monument as Giambologna's model.

Pls. 5, 6; Fig. 55

Giambologna, however, in a manner reminiscent of Leonardo before him and Bouchardon much later, combined this reference to the antique with his own close study of the living horse. One Giambologna scholar too emphatically rejects the notion that the *Cosimo I* of 1587 derives from the *Marcus Aurelius*,[38] but rightly draws attention to the rôle of the many statuettes, including perhaps one of a flayed horse, in the artist's preparatory work.[39] Giambologna's first great horse could be described, to borrow Cézanne's phrase, as a classical form done over from nature (this is more true for Giambologna than for Donatello and Verrocchio).[40] It became the essential model for most of the major monuments with a trotting horse to date from at least the next hundred years.

Pls. 60, 61; Fig. 56

These include far too many examples to discuss them all here, but it should be observed that the type was soon reinforced in Florence and dispatched to Paris and Madrid in the form of Giambologna's *Ferdinando I* (finished by Tacca; unveiled in 1608), his *Henry IV* (finished by Tacca; sent to Paris and erected in 1614), and the *Philip III* (executed by Tacca; unveiled in January 1617).[41] A faithful reduction of the monument to Cosimo I, but representing Rudolf II, may have been known in Prague even earlier.[42] The type was also well known in Vienna (e.g., a statuette of Leopold Wilhelm),[43] and in Milan,[44] and in England through Hubert Le Sueur's *Equestrian Monument of Charles I* (1630–33).[45] To include, with Dhanens, Mochi's Farnese monuments and Schlüter's *Equestrian Monument of the Great Elector* in Berlin would be to stretch the point,[46] but the importance of the monuments cited above for painted equestrian portraits should not be underestimated (e.g., the *equestriennes* depicted by Velázquez and the portrait of the young Louis XIV attributed to Vouet at Versailles).[47]

Pls. 66–68, 71A

Pl. 64

Pl. 148

Pls. 151, 152, 187

Pls. 111, 113

By the end of the seventeenth century, European artists were looking to Paris, not

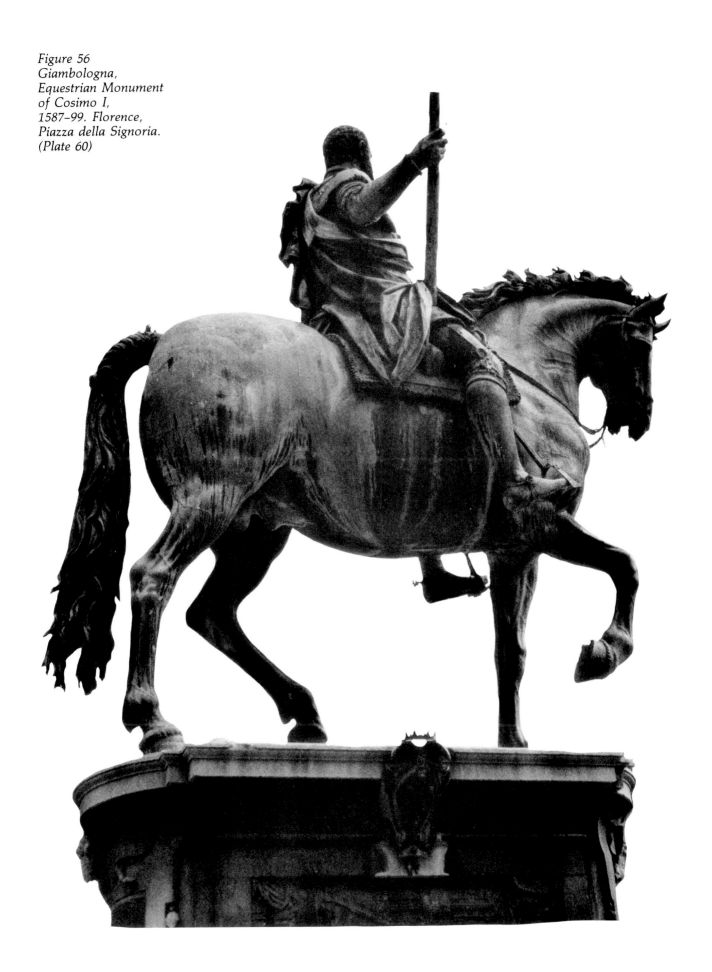

Figure 56
Giambologna,
Equestrian Monument
of Cosimo I,
1587–99. Florence,
Piazza della Signoria.
(Plate 60)

Florence, for models of equestrian monuments. There were more than twenty projects in France for equestrian monuments to Louis XIV alone; six of them were realized.[48] Of these, only Bernini's monument did not represent the horse *en passage*; Girardon, Coysevox in Rennes, Desjardins in Lyons, and Le Hongre in Dijon represent the king riding the horse in this very collected trot reminiscent of the *Marcus Aurelius*, Giambologna's *Henry IV* on the Pont-Neuf, and the *Louis XIII* in the Place Royale.[49] The plates of Pluvinel should be seen not so much as another source for this pose, but as a record of the social context in which it was appreciated. No one at the time would have described — as a modern writer has — a monument of Louis XIII or Louis XIV as representing the horse "at a slow walk," or as suggesting no forward motion.[50] Forward motion of a very stately kind was essential to one of the ideas invariably associated with these monuments, that of triumphal entry, and was obvious to anyone who looked at the statue not as a mass of bronze but as an image of a horse and rider.

Paris became the international center of courtly riding during the seventeenth century. The various editions of Pluvinel, Delcampe's *L'art de monter à cheval* (1658, 1663-64,

Pls. 160–163

Pls. 71A, 149

Fig. 57

Figure 57
François Girardon,
Equestrian Statuette
of Louis XIV, about
1696–1700. Paris,
Musée du Louvre.
(Plate 160)

etc.), and, finally, François de la Guérinière's authoritative *École de cavalerie* (1733) were *Pl. 188; Fig. 58* Parisian products that in the case of the last book especially became standard reference works for all of Europe — even for the Spanish Riding School in Vienna.[51] The decline of the *levade* and the importance of the trot in late seventeenth- and eighteenth-century *Pl. 189* monuments — and perhaps even the increasing lightness of movement in these works — may be related not only to classical sources and the artistic tendencies of the time, but to progress away from "airs above the ground" and toward increasing refinement in the art of riding as it was practiced by La Guérinière and other riding masters of the period.

It is always hazardous to say what a style might mean. Here, however, a stylistic transformation in the arts may be compared directly with something actual and physical: how a rider handles a horse. One is tempted to suggest, as did contemporary authors, *Pls. 74, 75, 189* that riding style was a reflection of behavior in society. In contrast to the strict discipline *Pl. 192; Fig. 59* imposed upon his horse by Philip IV, Louis XV's style of riding seems more like an art of persuasion, a system of subtle suggestions and thoughtful rewards. "So shall the rider lead the people according to his will"?

Figure 58
François de la Guérinière, École de cavalerie, Paris, 1733, the "shoulder-in" at the trot. Middleburg, Va., The National Sporting Library. (Plate 188)

l'Épaule en Dedans.

Figure 59
Edme Bouchardon, Equestrian Statuette of Louis XV, about 1760. Paris, Musée du Louvre. (Plate 192)

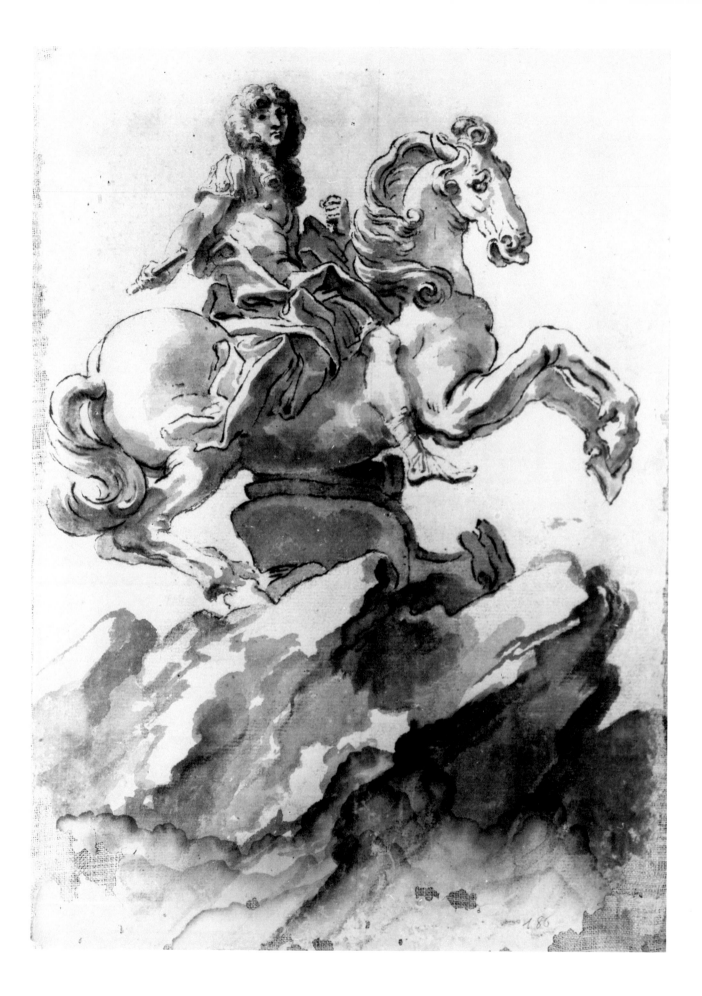

5

OTHER FORMS
AND MEANINGS
FROM BERNINI TO FALCONET

The preceding chapters do not discuss all the equestrian portraits and monuments of the sixteenth and seventeenth centuries, but only those that relate closely to the art of riding, and those that, having been influential in their time, define the context in which this relationship evolved. There are some major works, however—above all Bernini's *Equestrian Monument of Louis XIV*—that stand apart from the main development and seem to contradict the central thesis of this book. There are also those works that follow the form of the state portraits and monuments discussed above, but, since the sitters come from very different sectors of society, could hardly have the same significance. Dutch pictures provide the most striking examples, and, in a broad view, mark the beginning of the end of the equestrian portrait as a privilege of the *eques*, the aristocrat.

Pls. 154–157; Fig. 60

Bernini's statue of Louis XIV on horseback transcends reality even as it was conceived by artists such as Rubens, Velázquez, and Pietro Tacca. As Wittkower observed in his study of the sculpture's iconography, Bernini "devised his *Louis XIV*, too [like his statue of Constantine], as a dynamic history-piece rather than as a purely representational dynastic monument."[1]

Pl. 153

The monument's novelty did not please a French visitor to Bernini's studio, according to the artist's son Domenico: it was argued that the smiling expression given to the sitter in the final phase of carving conflicted with the martial bearing of the horse and rider, and suggested that the king was dealing out kindness, not grief, to his enemies. The idea of conquest was, as discussed in Chapter Two, common in seventeenth-century

*Figure 60 Bernini, Sketch for the Equestrian Monument of Louis XIV,
probably about 1673. (Plate 155)*

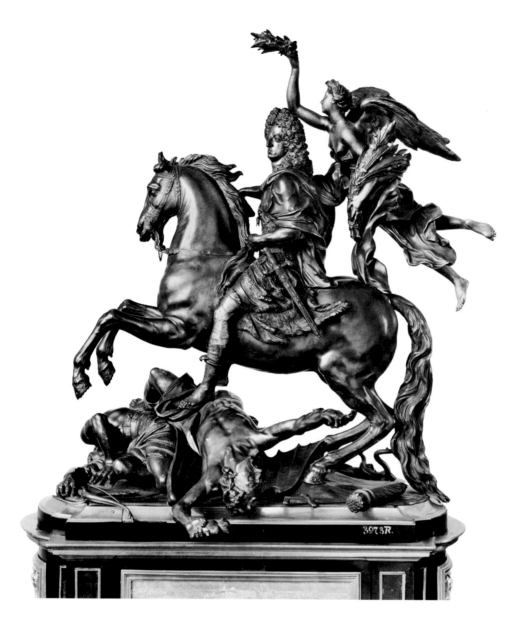

Figure 61
Guillielmus de Grof,
The Elector
Maximilian II Emanuel
of Bavaria as Victor
over the Turks,
signed and dated
1714. Munich,
Bayerisches
Nationalmuseum.
(Plate 169)

Figure 62
Anton Losenko,
Drawing after Falconet's
Plaster Model for the
Equestrian Monument
of Peter the Great,
1770. Nancy, Musée
des Beaux-Arts.
(See Plates 202, 203)

equestrian portraits and monuments (depending on the enemy, it relates to the imperial or Christian themes or both). Predictably Lebrun went right back to it when he borrowed Bernini's motifs of a rearing horse and a base in the form of a mountaintop.[2]

Pl. 158

Bernini had originally conceived the more conventional idea of the mounted monarch in an "attitude of majesty and command."[3] It seems in accord with this plan that the horse's rearing pose resembles — in the deep bend of the hindlegs, the bent but extended forelegs, and the turn of the head and body — the statuettes of horses that derive from Leonardo's designs for monuments dedicated to *condottieri*.[4] However, in the final work the king is more than a military hero: like Hercules, he triumphs over all human limitations and earthly impediments, and arrives, with an understandably serene expression, at the end of the path of virtue, and at the summit where Glory, "synonymous with his name," resides.[5]

Pl. 39

Leonardo's example is recalled, then, by the form of Bernini's monument and by his "emphasis on virtù, the prowess of the individual hero,"[6] but in Bernini's concept this

Virtue is absolute, like Louis XIV's monarchy. The sculpture's meaning might be described as a variation on the imperial theme: it differs from the many seventeenth-century portraits and monuments in which the king demonstrates his ability to ride, to rule, to defend the Faith.[7] The smile suggests that the struggle is over, the glorious goal attained:

"In Heaven and on earth the honored adorn summits;
God and the monarch mount their throne and steed."[8]

Bernini's monument made an impression, either directly or through the concurrent project of Lebrun, that largely accounts for the number of equestrian monuments and statuettes of Louis XIV and other monarchs that date from the period around 1685 to the king's death in 1715 and that feature a rearing horse.[9] The pose of the horse in most of these works — as Nicodemus Tessin the Younger described it in 1687, when he saw Desjardin's model for an equestrian monument of Louis XIV intended for Aix-en-Provence — is "a gallop, but [rendered] in a way that allows the larger part of the weight to be supported by the hindquarters."[10]

This is something different than the pose of Bernini's horse. One scholar who has surveyed equestrian sculpture of around 1700 concedes that this springing pose is hard *Pl. 169; Fig. 61*

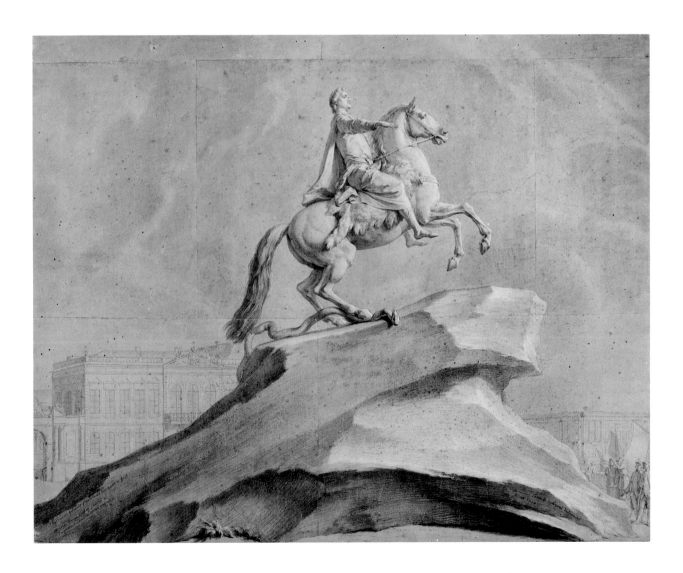

to define and that it departs from the example of formal equitation.[11] He suggests that the goal was *grandezza*, a term borrowed from Justi. It seems more likely that the pose was arranged to accommodate the figures of fallen enemies, and of Victory above, that occur, or did occur, in many of the statuettes of Louis XIV on horseback and in Coysevox's relief in the Salon de la Guerre at Versailles.[12]

Pl. 159

Pls. 202, 203; Fig. 62

"The last dynastic monument of the Baroque," Falconet's *Peter the Great* in Leningrad, has been shown to descend through Lebrun's work, and a suggestion made by Diderot, from Bernini's image of Louis XIV on a mountaintop.[13] The emperor's horse has climbed the path of Virtue and trampled the serpent of Envy; the rider, as Falconet insisted, assumes the pose of a legislator, not a conqueror. There is no spear or baton,

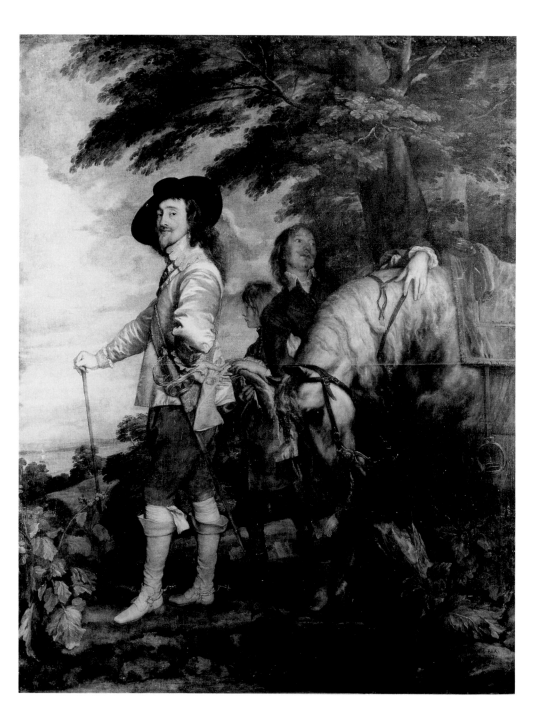

Figure 63
Anthony van Dyck,
"Le Roi à la ciasse,"
1635. Paris, Musée du
Louvre. (Plate 126)

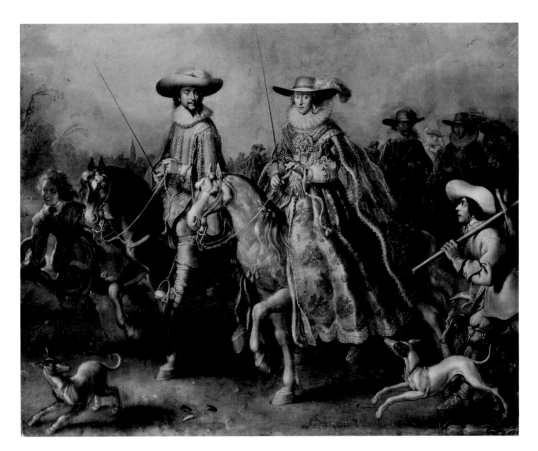

but a bare hand extended in an oratorical or perhaps protective gesture.[14] Only in this does the monument recall the *Marcus Aurelius*, whereas Girardon, in his equestrian statue of Louis XIV, followed the Roman example emphatically except in the gesture. *Pl. 160* Peter seems to ask the people for support. Louis commands it — or did, until the statue was destroyed in the Revolution.[15]

"I wish our Courtier to be a perfect horseman."[16] This was part of Castiglione's definition of a gentleman in 1516, and to judge from equestrian portraiture alone, there would seem to have been more of them around in the seventeenth and eighteenth centuries. If Mochi recalls Leonardo in his conception of Alessandro Farnese as a *condottiere*, van *Pls. 151, 126; Fig. 63* Dyck recalls Castiglione in his view of Charles I as, among other things, a *cortegiano*.[17] Something of the latter was probably read into Rubens's equestrian portraits of Giancarlo Doria and the Duke of Buckingham, and other equestrian portraits by van Dyck.[18] And it is obvious that by the middle of the seventeenth century the equestrian portrait was one of the many ways in which a member of the bourgeoisie or lesser gentry could resemble his social superiors.

The emulation of courtly conventions in Dutch and Flemish portraits of middle-class sitters, and in other subjects (e.g., genre interiors from about 1650 on), has often been observed. This was, of course, only one reflection of a changing style of life cultivated by the bourgeoisie in the seventeenth century, especially in northern Europe.[19] Riding, hunting, or owning a fine country house was proper form for those who aspired to what has been called "the seigneurial ideal."[20]

The recent exhibition *In het zadel* ("In the Saddle") now provides a comprehensive catalogue of Dutch equestrian portraits dating from 1550 to 1900.[21] The catalogue makes

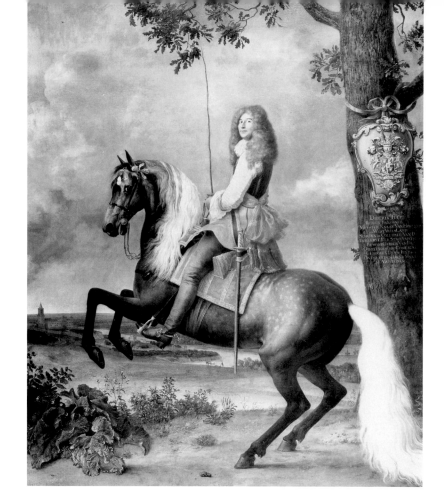

Figure 65
Paulus Potter,
Dirck Tulp on
Horseback, 1653.
Amsterdam,
Six Collection.
(Plate 179)

it clear that the Dutch equestrian portrait was at first, as elsewhere in Europe, a form of court art dating from about 1550 onward that was indebted to prints, and (usually indirectly) to the early examples of Italian artists. For example, Adriaen van de Venne's equestrian double-portrait of *Frederick V of the Palatinate and his wife Elizabeth Stuart* recalls printed "cavalcades" such as Jacob Cornelisz's *Counts and Countesses of Holland* (1518), and French royal portraits of the preceding century.[22] Already, however, the Dutch approach forsakes any obvious reference to traditional themes (although many of the "cavalcades" by van de Venne, Pauwels van Hillegaert, and Hendrik Pacx are dynastic group portraits) for an emphasis on the courtly occasion of riding out to hunt. It is remarkable that, despite this more informal meaning, so many of the Dutch royal horses execute a *passage* or *levade*.[23]

These poses were employed almost invariably in single and double equestrian portraits of Dutch princes,[24] and occur almost as frequently in portraits of aristocratic and bourgeois sitters dating from after 1650. In other countries, we rarely find a sixteenth- or seventeenth-century equestrian portrait representing someone of a lower rank than, for example, Olivares, and evidently it was expressly forbidden at some courts. In Holland, the equestrian portrait of someone outside the court was probably considered at least bad form until the 1650s. It seems very significant that the first equestrian portrait of a prominent Dutch burger is Paulus Potter's superb, lifesize painting of *Dirck Tulp on Horseback* dated 1653, the year in which Johan de Witt, Grand Pensionary of Holland, took the place of the Princes of Orange as leader of the United Provinces. The composition, including the *levade* of the horse, the turn of the rider, the tree, the crest, and the inscription, is modelled directly upon state portraits such as those by Velázquez, Rubens, and van Dyck. But the mood is entirely different. Tulp's horse and his ability

Pl. 175; Fig. 64

Pl. 49; Colorplate 7

Pl. 174

Pl. 179; Fig. 65

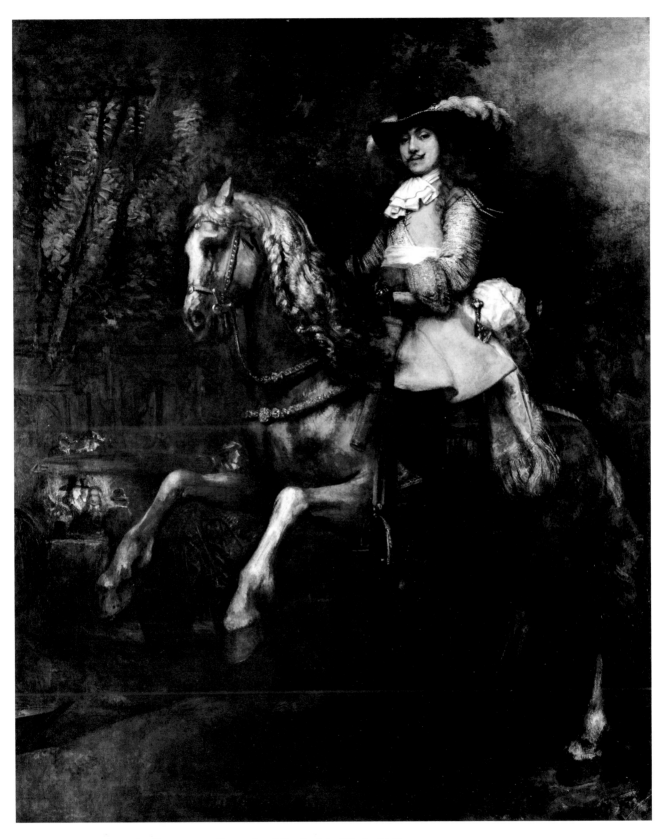

Figure 66 Rembrandt, Equestrian Portrait of Frederick Rihel, 1663.
London, The National Gallery. (Plate 181)

Figure 67
Thomas de Keyser,
Two Unknown
Riders, 1661.
Dresden,
Gemäldegalerie.
(Plate 180)

to ride are not metaphors for royal subjects and rulership, but status symbols in which the rider frankly takes pleasure and pride. Baton and breastplate have been turned in for a riding crop and a ribbon at the horse's ear.

Like the princely Dutch portraits, but to a much greater extent, this new sign of the upper middle class quickly took on an engaging variety of forms. Frederick Rihel, the

Pl. 181; Fig. 66 rich Amsterdam merchant who is probably the sitter in Rembrandt's lifesize equestrian portrait of about 1663, pretentiously adopts the air of a prince, and Rembrandt, working later than Potter but so clearly, here, an artist of an older generation, conforms to a kind of composition that dates back to the turn of the century.[25] Ter Borch, in rare

Pl. 178 moments of weakness, was equally conventional and much less successful ,[26] but Thomas de Keyser, and especially Aelbert Cuyp, made refreshing contributions to what one might now call the genre, rather than the type. Despite his representation of the *passage* and *levade*, de Keyser suggests something more informal by his placement of equestrian sitters in open countryside, by his occasional suggestion of the hunt, and, in one example, by

Pl. 180; Fig. 67 his inclusion of a château. The double-portrait in Dresden is more interesting for the seigneurial image it attempts to be than for what the artist actually achieved; the forced effect was caused by quoting court art.[27] The obvious stamp of such a source was more

Pls. 184, 185 successfully erased by Cuyp, even when he, too, depended upon it. His painting in the

Louvre is most likely an equestrian group portrait; to contemporary viewers (unpreoccupied with formal analysis), the gait of the horses probably suggested nothing of the likes of Louis XIV, but simply that the sitters were at home in the saddle (literally, here, to judge from the setting). In other examples by Cuyp, courtly conventions seem to relax as the horse does himself: in the impressive portrait of Pieter de Roovere as lord of his manor (the so-called "Salmon Fishing" in the Mauritshuis), the sitter's horse simply stands with a natural, slight shift of weight onto one fore- and one hind leg.[28] A bourgeois counterpart to Pluvinel's plates illustrating *"l'Instruction du roy"* is found in Cuyp's portrait of the brothers Pompe van Meerdervoort, their riding master, and a valet, where the young equestrians seem as pleased with themselves as does "Prince Baltasar Carlos in the riding school."[29]

Pl. 184; Fig. 68

Pl. 122

*Figure 68
Aelbert Cuyp,
Starting for the Hunt:
Michiel and Cornelis
Pompe van
Meerdervoort with
their Tutor and
Coachman, about
1653. New York,
Metropolitan
Museum of Art, The
Friedsam Collection.
(Plate 184)*

Cuyp's picture in New York is one of the most important examples of Dutch equestrian portraiture not only for its quality but in its anticipation of a common kind of "conversation piece" painted by French and especially English artists of the next century. With regard to royal equestrian portraits, the eighteenth century was a period of continuation (Schlüter, Lemoyne, Bouchardon, and many others); of culmination (Falconet); and of usually unintended parody (Goya's equestrian portraits of Carlos IV, Maria Luisa, Ferdinand VII, and Wellington).[30] By contrast, new forms and a new life were given to the tradition by portraits of aristocratic and bourgeois figures that — certainly with Dutch sources which remain to be explored — represent the sitters resting with their horses in a picturesque landscape,[31] or riding out from their country house,[32] or at the hunt.[33] In the best of these pictures, the horse stands not only for social rank,

Pls. 187, 189, 192
Pls. 202, 206

Pls. 196, 198

Figure 69
Jacques-Louis David,
Napoleon Leading
his Army over the Alps,
1805. Versailles, Musée
de Versailles.
(Plate 204)

Figure 70
Sir Edwin Landseer,
Queen Victoria
at Osborne, 1866.
Reproduced by
Gracious Permission
of Her Majesty the
Queen. (Plate 217)

but for the pleasures of country life.[34]

In the same decades that middle-class patrons increasingly favored pictures like these, the Romantic image of the horse revealed a very different kind of appreciation.[35] Both views, the popular and the poetic, were opposed to the meaning of the horse in royal equestrian portraits and were especially unsuited to the models provided by the *haute école*. The rearing horses represented by Géricault and Vernet in their pictures of riderless horse races, and more faithfully by Rosa Bonheur in her great *Horse Fair*, finally attribute the action of the horse to the power and, one might add, the nobility of the animal, not of his master.

Pls. 211, 212

Napoleon himself subscribed to the Romantic view of the horse (and the mountain) when he requested that David represent him *"calme sur un cheval fougueux."*[36] The composition could be compared with countless examples of the rearing horse from Leonardo to Falconet. In contrast to what one might say of the patrons of those artists, it has been claimed that "Napoleon, who is committing every fault known to equitation, was a notoriously poor horseman."[37] And yet the rider, though in a different style and in stormier circumstances than those portrayed in Baroque pictures, is presented by David as in absolute control.[38]

Pl. 204; Fig. 69

The modern view of royalty on horseback began with Queen Victoria and others of her time.[39] In the equestrian portraits of Victoria dating from her unmarried years, she gallops at the hunt, exchanges greetings with other riders, and casually commands a *levade*.[40] The point of these pictures principally concerns the young queen's vivacious personality. Sir Francis Grant's *Queen Victoria Riding Out at Windsor Castle* follows a formula found in portraits of bourgeois as well as aristocratic sitters dating back to the seventeenth century.[41] Among the many scenes of domestic life at the English court are some that happen to be equestrian portraits.[42] If the meaning of equestrian portraits began to change when less-than-royal patrons adopted the form, it had changed completely when royalty adopted bourgeois ideals.

Pl. 215

Pl. 217; Fig. 70

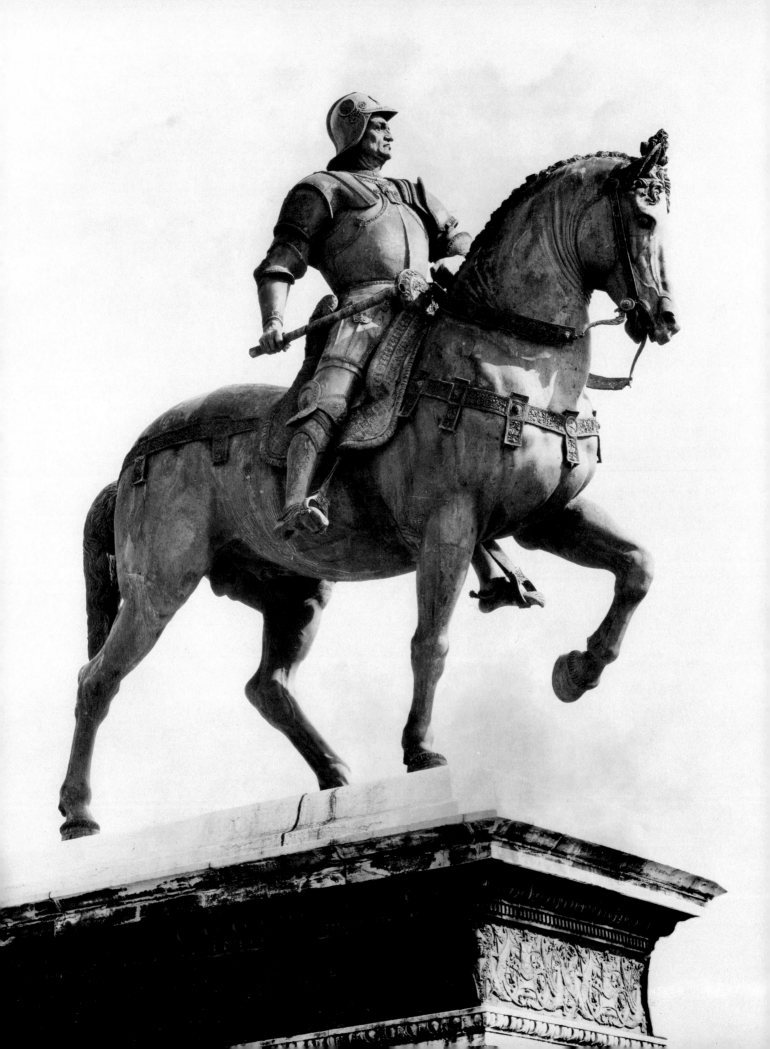

RIDING IN THE RENAISSANCE
AND
IN THE BAROQUE PERIOD

By Alexander Mackay–Smith

A book published in Naples in 1550 has never been surpassed in its influence on the art of equitation: Federigo Grisone's *Gli ordini di cavalcare* (*The Principles of Riding*). In order to appreciate the importance of Grisone's contribution, it is necessary to review the nature of riding in earlier times.

The first equids to be domesticated — the Asiatic wild ass, known as the onager, and then the horse — were used as pack animals and for pulling chariots and carts. Their uses under saddle came later on. Styles of riding were unavoidably adapted to the natural gaits of the horse, as demonstrated by the sequence in which the feet strike the ground. These include the slow four-beat walk (right hind, right front, left hind, left front), and the fast three-beat canter or gallop (right hind, left front, and — simultaneously hitting the ground — left hind and right front, or vice versa). These two gaits are common to all horses. There are also two natural intermediate gaits, one diagonal, the other lateral. The first is the diagonal two-beat trot (right hind and left front hitting the ground simultaneously, followed by left hind and right front, also hitting the ground simultaneously). The second consists of the lateral gaits. There is the two-beat pace or amble (right hind and right front hitting the ground simultaneously, followed by left hind and left front hitting the ground simultaneously). And there is the four-beat broken pace, known as the rack or singlefoot, in which the sequence is much the same as in the walk: right hind, followed by right front, followed by left hind and then left front. A familiarity with the gaits, as determined by the sequence of foot-falls, is essential to an understanding of the horse in art.

These gaits are perceived by the rider in a very different way. In the diagonal trot

Figure 71 Verrocchio, Equestrian Monument of Bartolommeo Colleoni, about 1481–96.

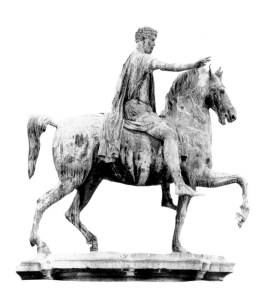

Figure 72
Equestrian Statue
of Marcus Aurelius,
161–180 A.D.
Rome, the Capitol.
(Plate 8)

the horse's back rises and falls, whereas in the lateral pace and rack the back remains level and sways slightly from side to side. Before the introduction of "posting" (discussed below) in the middle of the eighteenth century, the trot was a decidedly uncomfortable gait. On the other hand, it provided more stability: the horse has one foot on the ground to either side. Consequently, the trotter was preferred for military use; soldiers placed security above comfort.

Pl. 8; Fig. 72
Thus, in classical times — in Babylon, Egypt, Greece, and Rome — military leaders depicted in works of sculpture, in frescoes, and in vase paintings were most often shown riding at the gallop or the trot; a notable example of the latter is the equestrian monument of Marcus Aurelius in Rome. The war-horse, or destrier, of the medieval knight (who rode in heavy armor) was usually a trotter.

The origin and dissemination of the stirrup continues to be a topic of research and controversy among hippologists. Stirrups were unknown during the Roman Empire and in earlier centuries. A bas-relief from the tomb of the Chinese emperor Tai Tsung (died A.D. 648) depicts a Mongolian warrior removing an arrow from his horse's chest; the saddle is equipped with stirrups. A Sasanian silver cup of the seventh century, in the Hermitage, Leningrad, shows a mounted bowman in a saddle with stirrups. An ivory chessman by an Indian artisan, in the Bibliothèque Nationale, Paris — part of a set presented to Charlemagne by the Caliph of Bagdad — represents an elephant surrounded by four horsemen whose saddles have stirrups. It appears certain, then, that the stirrup was known in the West by about A.D. 800.

A millennium passed before road improvements — particularly those engineered by Telford and McAdam in mid-eighteenth-century England — made it possible for wheeled vehicles to move at much faster speeds. It was then that the desperately uncomfortable "post boys" — riding on the trotting "post horses" that pulled chaises along the post roads — began rising in the stirrups, which is otherwise known as posting to the trot.

During the preceding thousand years, stirrups had been employed principally to steady the rider in the saddle, and to increase his comfort and sense of security. The amble (pace) and the rack thus continued to be preferred for travel and sport. Many military horsemen were also inclined to the more comfortable gaits. William the Conqueror and the Saxon King Harold both ride pacers at the Battle of Hastings, as it is portrayed in the Bayeux Tapestry (late eleventh century). The succeeding English kings appear to have followed this practice. The Great Seal of Richard the Lion Hearted (1196) shows the

monarch in armor on a pacer. This is also the way King John is presented on the Great Seal with which he signed the Magna Carta in 1215.

Many continental works of art dating from the same period and somewhat later depict laterally gaited horses under saddle. To cite but a few examples, there is the equestrian portrait of Constantine on a Burgundian silver medal of about 1402 in the Museum of Fine Arts, Boston; Uccello's fresco in the Cathedral of Florence; Baldassare Estense's portrait medal of Ercole d'Este, Duke of Ferrara, dated 1472, in the Kunsthistorisches Museum, Vienna; and Verrocchio's Colleoni monument in Venice. *Pl. 20*

Pl. 25; Fig. 71

Riding first flourished as an art in Renaissance Italy. The only manual of riding to survive from classical antiquity, the *Hippeke* written early in the fourth century B.C. by the Greek historian Xenophon, was summarized by Grisone in his remarkably popular treatise of 1550. Xenophon addressed himself to military horsemen. Grisone's readers were mostly civilians.

Gli ordini di cavalcare was published with the privilege of the King of Naples and the patronage of Pope Julius III; it was dedicated to Hippolyte d'Este, Cardinal of Ferrara. The book went through sixteen Italian editions between 1550 and 1620. In 1559 it was translated into French; eleven French editions appeared by 1610. Spanish and German translations were printed in 1568 and 1570, respectively. Thomas Blundeville's English edition came out in 1560. *Pl. 106; Fig. 73*

Grisone's *Principles*, and the author himself, set waves of riding masters and manuals in motion. His pupil Claudio Corte wrote *Il Cavalerizzo*, which was published in Venice and Marseilles in 1573, and in London in 1584 (Thomas Bedingfield and John Astley were responsible for the English translation). Giovanni Battista Pignatelli, a pupil of Cesare Fiaschi of Ferrara (whose own *Trattato* of 1556 went through eight Italian and five French editions by 1628), joined Grisone's academy in Naples and, though not an author, became the most celebrated riding instructor of his time. His own pupils included the Chevalier de St. Antoine, who was sent by the King of France to England in 1603 and remained there as royal riding master and equerry, and the two most important exponents of equitation in late sixteenth- and early seventeenth-century France, Salomon de la Broue and Antoine de Pluvinel. *Pl. 131*

De la Broue crowned his Parisian career with the publication, in 1593, of his *Préceptes principaux que les bons cavalerisses doivent exactament observer in leurs éscoles.* Six editions appeared by 1620. Even more successful and influential was Pluvinel, who, after six years in Naples, founded an academy in Paris in 1594, became director

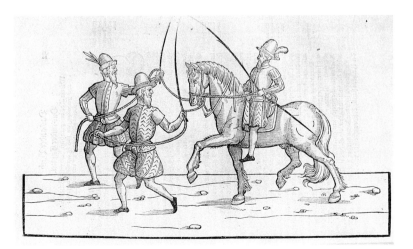

Figure 73
Federico Grisone,
Gli ordini di
cavalcare, Naples,
1550. (Plate 106B)

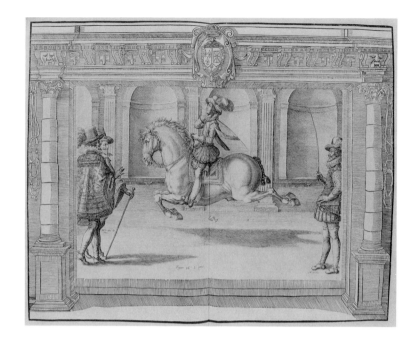

Figure 74
Antoine de Pluvinel,
L'Instruction
du roy...,
Paris, 1625.

Figure 75
The passage (trot)
at the Spanish
Riding School,
Vienna.

Pl. 107; Fig. 74

of Henry IV's Grandes Ecuries, and was appointed riding instructor of the Dauphin, later Louis XIII. Pluvinel's treatise, *L'Instruction du roy...,* was published in 1625, five years after the author's death; it was lavishly illustrated by Crispijn de Passe, and became the most significant work of its kind to date from the seventeenth century. (As one would expect, the book was reprinted many times — until 1706 — and was translated into several languages.) Second place should probably be awarded to the Duke of Newcastle's *Méthode Nouvelle et Invention Extraordinaire de Dresser les Chevaux*, published in Antwerp (where the author was in exile) in 1657-58.

The riding academies established by Grisone (in 1532) and by his followers were much more than riding schools in the modern sense. They were courtly institutions in which formal refinement became the mark of a gentleman (indeed, commoners were excluded). *Haute école* riding spread to the noble houses of Europe in a way familiar from the history of dance, and of other performing arts.

Pl. 220

This equestrian art, known today as dressage (the French word for training), was designed to display both the horse and the rider. It included not only the ordinary gaits (called collected, extended, and lateral), but also the spectacular "airs above the ground," those exercises in which the horse lifts the forehand alone (*levade*), and those in which both the forehand and the hindquarters are off the ground (*courbette* and *capriole*). These

Fig. 75

airs are still practiced at the Spanish Riding School in Vienna.

An important aspect of dressage is the transition from one gait to another. The pace was expelled from the *haute école* because transitions between it and the canter are difficult. By contrast, transitions from the trot to the canter and back again are easy and smooth. Before Grisone, military riders argued for the trot on account of its stability. After Grisone, the trot became the favored intermediate gait for civilians practicing riding as an art.

From about 1550 onward, then, the monarch, the nobleman, or other customer of equestrian portraiture could be expected to request one of three poses for the horse: standing still; a sedate trot; or a more dashing "air above the ground" (usually the *levade*). The plates in the present book bear this out. When they do not, there are special reasons which are discussed fully in the chapters above.

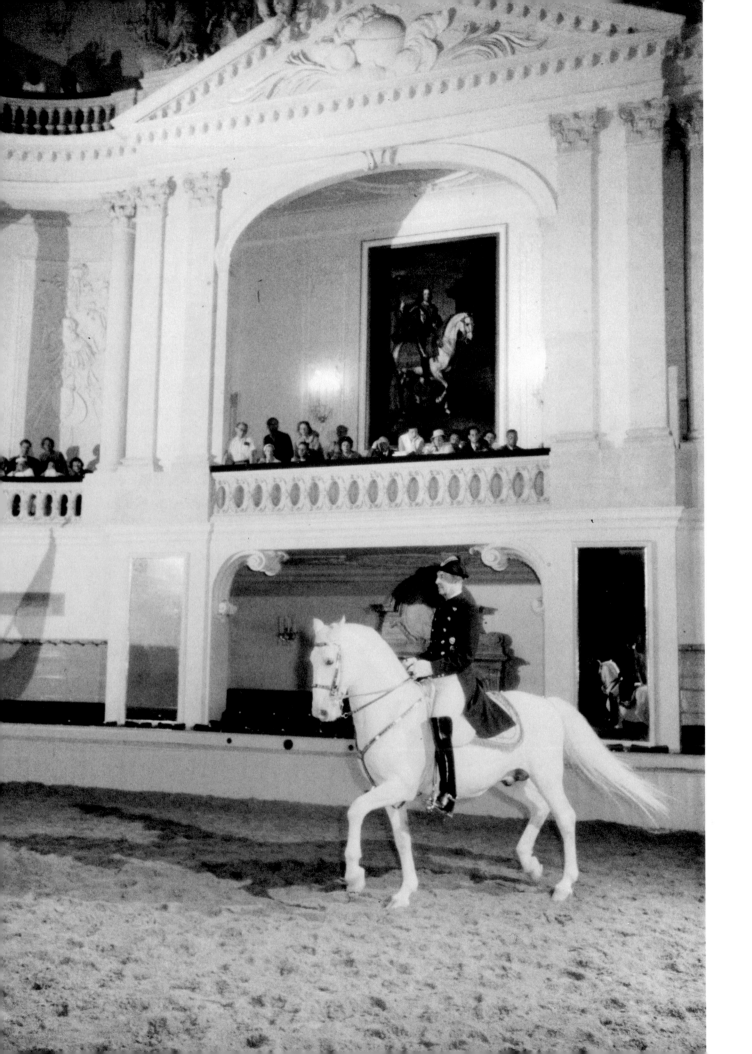

NOTES

INTRODUCTION

1 E.g., see Livingstone-Learmonth 1958, p. 17, on Velázquez, and captions to plates; Seth-Smith 1978, p. 55, pl. XX.

2 E.g., Müseler 1978, p. 102: "Velásquez, the great Spanish painter, and David, Napoleon's French portraitist, invariably represented horses in the Levade."

3 Grossmann 1931, see pp. 81-83 on Velázquez; Friis 1933.

4 Wölfflin 1932: See Roger Fry's review in *The Burlington Magazine*, XXXIX (1921), pp. 145-48.

5 Baldinucci 1846, II, pp. 570-71; Ruelens and Rooses 1887-1909, I, p. 428 (Oct. 28, 1608). According to Baldinucci, an Italian peasant praised Giambologna's horse for its realism, but noted the lack of *calli delle gambe* (called "chestnuts," these are the roughly oval callosities on the inside of the leg).

6 Pope-Hennessy 1958, p. 64. The author continues, "Alberti, while in Ferrara, wrote an essay *De Equo Animante* (so called to distinguish it from the bronze horse under discussion at the time), and painters from Pisanello down to Leonardo gave the rendering of the horse the same close attention as the rendering of the human form."

7 Wölfflin 1932, does not himself cite the rearing horse as a Baroque motif, but writers who do (e.g., Dahl; see n. 8) employ Wölfflin's distinctions between "plane and recession," "closed and open form," etc., in respect to the "Renaissance" walking or trotting horse, as opposed to the "Baroque" rearing horse. In his discussion of sculpture in the chapter on plane and recession, Wölfflin, pp. 110-11, 114, contrasts the viewing conditions, not the forms, of Renaissance and Baroque equestrian monuments.

8 E.g., Dahl 1935, pp. 18, 21-23, etc., despite the author's indebtedness to the studies cited in n. 3.

9 E.g., Glück 1916, pp. 3-30.

10 See Kahr 1976, pp. 47, 52-53.

11 *Ibid.*, p. 84.

12 See Lewy 1928, pp. 77-80; Huemer 1977, pp. 153-54. See Chapter One, n. 79, on the most recent study of Tacca.

13 Wittkower 1965, p. 87.

14 Baldinucci 1846, IV, pp. 92-97.

15 Lewy 1928, pp. 67-69; Friis 1933, p. 198; Pope-Hennessy 1970, pp. 105-06, etc.

16 Except in the discussion of Grossmann 1931, pp. 81-82, 84. Grossmann's terms and definitions of *haute école* riding forms (pp. 24-25, pl. IV) vary slightly from those now employed at the Spanish Riding School. The latter should be used as a standard for art historical literature, and may be found in the books of Alois Podhajsky, or Hans Handler and Erich Lessing, and other publications directly connected with the School. For Grossmann's "Kurbette," read *levade*.

17 Baldinucci 1846, IV, pp. 94-95.

CHAPTER 1

1 See Introduction, n. 16; Bundesministerium für Land- and Forstwirtschaft 1970 (with bibliography, p. 82). One should also mention the riding school at Saumur; see Louis-Auguste Picard, *Origins de l'Ecole de Cavalerie et de ses Traditions Equestres*, Paris, 1890; Charles–Alfonse Duplessis, *L'Equitation en France...depuis le 15ème siècle*, Paris, 1892. The only recent book of value is Etienne Saurel's *Histoire de l'Equitation*, Paris, 1971. I am indebted to Mme. Lily Froissard for these references and many helpful comments.

2 Spanish and Italian examples often represent the forelegs in a more extended position. Jordaens (Pl. 143), following Pluvinel (see Chapter Five, n. 29), and Giacomo Serpotta in his *Equestrian Monument of Carlos II* in Messina (Friis, figs. 139-40) tuck the forelegs in.

3 On Xenophon, see J.K. Anderson, *Ancient Greek Horsemanship*, Berkeley, 1961. Saurel, op. cit. (n. 1), for later riding. Xenophon is constantly cited by Renaissance and Baroque authors (e.g., John Astley, *The Art of Riding*, London, 1584, preface, pp. 4, 9-10, etc.), and was paraphrased by Thomas Blundeville, *A New Booke Containing the Arte of Rydinge and Breaking Great Horses*, London, 1560. Andrea Sacchi had an Italian edition of Xenophon in his library (A.S. Harris, *Andrea Sacchi*, Princeton, 1977, p. 124, no. 75: *La Perfettione del Cavallo*, tr. by Francesco Liberati, Rome, 1639). An earlier edition was that of Evangelista Ortense, *Il Modo del Cavalcare*, Venice, 1580.

4 See Gianoli 1969, pp. 94-95, on the "unsophisticated, utilitarian equitation" of the Middle Ages.

5 See Handler and Lessing 1975 for excellent color plates and sequential photographs of the airs described here.

6 See the sources cited in n. 1.

7 Gianoli 1969, p. 95: "The Arabian equestrian world of Spain...was to contribute its creation of the Andalusian breed, the root stock for the finest saddle horses." The riding school in Vienna is named for the Spanish horses introduced into Austria in 1562 by Archduke Maximilian (the son of Ferdinand I). The term "Spanish Riding School" first appeared in a document of 1572 concerning the building of an exercise hall in Vienna. The Lipizzaner stallions are named for the stud farm at Lipizza (Yugoslavia) founded in 1580 by Archduke Charles of Inner Austria.

8 See the many examples illustrated in Amsterdam, Rijksprentenkabinet, *Vorstenportretten uit de eerste helft van de 16de eeuw*, 1972, and in Max Geisberg, *The German Single-Leaf Woodcut: 1500-1550*, revised and ed. by Walter L. Strauss, New York, 1974 (4 vols.). It would appear that none of the treatises published between those of Grisone and Pluvinel (see text following) were very useful to artists. The books by Astley and Blundeville (see n. 3) and Pasquale Caracciolo, *La Gloria del Cavallo*, Venice, 1566, etc., are not illustrated. Georg Engelhard von Löhneyss, *Della Cavalleria*, Gruningen, 1588 (and Remlingen, 1609-10, 1624), is extensively illustrated with scenes of tournaments, processions and so on, but in terms of dressage represents no advance beyond the plates of Grisone. Jean Jaques von Wallhausen, *Art militaire à cheval*, Frankfurt, 1616, has many plates illustrating horses rearing and charging in combat, but is not concerned with dressage. Salomon de la Broue, *Le Cavalerice François*, Paris, 1602, illustrates only bridles and bits, and diagrams of riding patterns. Grossmann 1931, pp. 112-13, provides a useful table summarizing the contents and importance of treatises from Grisone to about 1800.

9 D. Franken, *L'Oeuvre gravé des van de Passe*, Amsterdam, 1881, pp. 279-90, no. 1360.

10 William Cavendish, Duke of Newcastle, *La Méthode Nouvelle et Invention Extraordinaire de Dresser les Chevaux*, Antwerp, 1657-58

(the 1743 London edition, *A General System of Horsemanship*, was reprinted at The Hague, 1972, with an introduction). On the Duke, see R. Browning, *The Duke of Newcastle*, London and New Haven, 1975; and G. Trease, *Portrait of a Cavalier*, New York, 1979.

11 Discussed in Chapter Two.

12 Bernardo de Vargas Machuca, *Teoria y Exercicios de la Jineta*, Madrid, 1619, introduction, quoted in translation by Warnke 1968, p. 221. Vargas (1557-1622) is further cited below, and is important for his contribution to and comments on courtly riding in Spain. The Spanish soldier is best known for his *Milicia y Descripción de las Indiás* (1599), but published three books on riding, the other two being *Libro de Ejercicio de la Jineta* (1600), and *Compendio y Doctrina Nueva de la Jineta* (dedicated to Philip IV; Madrid, 1621). See *Enciclopedia Universel Illustrada*, LXVII (1958), pp. 11-12; and Enrique Otero d'Costa, "Biografica disertación sobre el capitán don Bernardo de Vargas Machuca," *Revista de las Indiás*, XII, 47 (Jan.-Mar., 1952), pp. 49-79. The name Philip, as Vargas was aware, means an admirer of horses.

13 Justi 1953, p. 215, recorded this observation of a French visitor to the Spanish court. However, in a letter of 1633 to the Marquis of Aytona, Olivares wrote, "I am so racked by illness that when I tried to mount a horse the other day I simply could not manage it" (kindly brought to my attention by Jonathan Brown).

14 See n. 7. Tempesta's "Horses of different lands" (Bartsch 1854-76, XVII, nos. 941-68), Stradanus's *Equile* (see n. 44 below), and authors such as Löhneyss, op. cit. (n. 8), and others who describe horses of different countries always feature the Spanish horse prominently, and they were to be found in the finest stables throughout Europe, including that of the Duke of Buckingham (Charles R. Cammell, *The Great Duke of Buckingham*, London, 1939, pp. 192, 375).

15 See also Chapter Two on the symbolism of riding well.

16 Huemer 1977, pp. 21-25, 76-78 (pp. 77-78 for the passage quoted). Justi 1889, p. 315, similarly felt that the pose "was probably derived from the school of Rubens." Huemer, p. 21, n. 2, unfortunately follows Glück 1960 in listing four "horse types" (poses), and quotes Wittkower's ingenuous description of "curvetting." "Larsen" (Larsson 1968) and Glück are incorrectly cited.

17 Huemer 1977, pp. 132-38 (no. 20).

18 See Glück 1916, pp. 15-26, and Held 1976, pp. 548-51, on the *Riding School* from Rubens's studio (Pl. 99).

19 As pointed out by Huemer 1977, p. 78. See Chapter Three.

20 Glück 1916; Müller-Hofstede 1965, pp. 69-112; Müller-Hofstede 1977, pp. 84-93. Müller-Hofstede's early dating of the Doria portrait (Pl. 96) remains unconvincing; see Huemer 1977, p. 117 (no. 10: c. 1606), and Müller-Hofstede 1977, p. 304.

21 See Huemer 1977, p. 25; Müller-Hofstede's articles (n. 20); Warnke 1965, pp. 13-14.

22 For this pose, see Grossmann 1931, pls. XIII (no. 4), XIV (nos. 5-7, 18), XVII (nos. 10-12, 16-18), etc. (Pls. XVIII, XIX). On Tempesta's *Henry IV* (Pl. 90) as a source for the Doria (Pl. 96), see Müller-Hofstede 1965 and 1977, and Larsson 1968, pp. 34-42, which illustrates several very similar prints and discusses this galloping pose seen from a low point of view. Both of Müller-Hofstede's articles illustrate Rubens's drawings after Giambologna's trotting horse and relate them to the portrait of Lerma (Pl. 94).

23 See Strong, p. 54 ("galloping along"); Huemer 1977, p. 57 ("a pessade [sic], the most concentrated [?] of horse images").

24 As observed indirectly by Held 1976, p. 551, who describes the pose as "almost identical" to that of the horse in an equestrian por-

trait, perhaps of Archduke Albert, now lost but known from a small copy in the Akademie, Vienna (G. Glück, *Rubens, Van Dyck und ihr Kreis*, Vienna, 1933, p. 45, fig. 30). Held observes that "some scholars assume that [Rubens] had applied" one of the poses found in the Berlin *Riding School* (Pl. 99).

25 Huemer 1977, p. 58, fig. 34, compares another engraving by Cockson (the *Earl of Nottingham*), but concludes that Rubens did not use it as a model but "sought to repeat an applicable type within the English tradition." Cockson's *Earl of Devonshire* (Pl. 86), however, is much closer to Rubens's *Buckingham* (Pl. 130) in the pose and profile view of the horse and rider, the setting, and in details like the position of the sword (this is not to say that Rubens did not know Cockson's *Earl of Nottingham*, who, like *Buckingham* and the sitters in many early seventeenth-century printed equestrian portraits, sports a fluttering cape). The use of Cockson's prints as models also seems indicated by the similarity between Willem de Passe's engraving, an *Equestrian Portrait of the Duke of Buckingham as Lord High Admiral*, dated 1625 (Pl. 88; Huemer, pp. 57-58) — the year in which Rubens's *Buckingham* was commissioned — and Cockson's engraving of the *Third Earl of Cumberland*, c. 1598-99 (Pl. 87; Hind 1955, part I, cat. 7). Hind, p. 239, relates the horse in both the *Cumberland* and *Nottingham* prints to that in Leonard Gaultier's *Henry IV*, an engraving of 1596. As discussed below, it would seem that most of the numerous printed equestrian portraits of monarchs that date from the very end of the sixteenth century and the early seventeenth century depend on the two *Twelve Caesars* series by Stradanus and Tempesta.

26 There are almost countless examples, beginning with Stradanus's battle scenes engraved by Philips Galle, the *Mediceae Familiae...victoriae et triumphi*, 1583, and later including battle and hunt scenes by Rubens and his contemporaries, and the painting by Bakhuizen cited in Chapter Five, n. 23, and in the caption to Pl. 183.

27 Frances Robb, "Fictions of Power: Rubens's *First Duke of Buckingham* and Jacobean Masques," a paper delivered at the 1980 CAA annual meeting, concludes that "the full-scale portrait [Pl. 130] (never securely dated in the scholarly literature) emends the generalized imagery of the sketch [Pl. 129; 1625] to refer, masque-like, to specific events in 1627" (*Abstracts of Papers Delivered*, p. 63). See also Gregory Martin, "Rubens and Buckingham's 'fayrie ile'," *The Burlington Magazine*, CVIII (1966), pp. 613-18.

28 As noted by Huemer 1977, p. 76.

29 It also relates to the design of Tacca's monument (Pl. 74), since the Uffizi canvas (Pl. 116) has been discussed as Tacca's model: see Introduction, n. 15, and Huemer 1977, p. 153. Huemer confusingly mentions Justi's idea that the word *traza* in Olivares's letter of 1634 (according to Huemer the passage reads, "His Majesty wants a Medalla or portrait on a horse, in bronze, in agreement with portraits by Peter Paul Rubens in the same *traza* as that of one which stands in the Casa del Campo") "meant only the size and gait of the horse in Rubens's portrait." However, the original passage (published by Lewy 1928, p. 67) says that "*Su Mag. d. Dios le guarde ha mostrado deseo de q. e se la haga una medalla, o efigie a Cavallo de su real persona que sea de bronze, conforme a unos retratos de Pedro Paul Rubens, y a la traza de la q. e esta en la Casa del Campo...*" In other words, Tacca's statue should look like some portraits by Rubens and be on the scale of that work in the Casa del Campo, which was Giambologna and Tacca's own monument of Philip III on a *trotting* horse (Pl. 68; see Friis 1933, p. 212ff, figs. 126-27). Lewy 1928, p. 68, notes that Olivares later clarified that Tacca's statue was to be as big as the one of Philip III in the garden of the Casa del Campo, and Dahl 1935, p. 43, repeats the unambiguous information.

30 Still of basic importance is Elias Tormo's "Velázquez, el Salón de

Reinos del Buen Retiro, y el Poeta del Palacio y del Pintor," Boletin de la Sociedad de Escursiones, XIX (1911), reprinted in Tormo 1949. Warnke 1968 further considers the program in detail. See now Brown 1986, pp. 107-116.

31 Soria 1954, pp. 105-07, dismisses Tormo's argument (n. 30) that such fine compositions must have originated with Velázquez by pointing out their dependence on the prints of Stradanus, and supports the opinions of Villaamil, Justi, and Berete *pére* that the three paintings "were begun (and perhaps finished) by Bartolomé González," who died in 1627. Soria 1954, p. 107, adds the names of Beroqui, Lafuente Ferrari, Trapier, and E. Harris to those scholars who feel that "the *Philip III* and the two *queens* were painted before 1627 by González, and were retouched by Velázquez between 1631 and 1634 (and perhaps also in 1628)." Documents published by Azcárate have been thought to confirm that González, Vincente Carducho, and Eugenio Cajés painted the three equestrian portraits in 1625 for the Salón Nuevo of the Alcázar: J.M. de Azcárate, "Noticias sobre Velázquez en la corte," *Archivo Español de Arte*, XXXIII (1960), pp. 360-62. This interpretation (the document gives the size but not the subject of the pictures) was advanced by Camón Aznar 1964, I, pp. 522-34, and seconded by Gudiol 1974, p. 147.

32 Orso 1986, pp. 49, 79, 110. Brown 1986, p. 112, wrongly states that "a careful reading of the document reveals that these three *portraits...*" (italics mine); but he rightly goes on to dismiss the equestrian portraits of Philip III and the two queens as the works in question, on the grounds of size.

33 Huemer 1977, p. 77. Crawford Volk 1980, p. 175, rejects the anonymous work (her fig. 23) as related to the lost Velázquez.

34 *Valeria Velazqueña* 1960, II, pp. 12-15.

35 The ancient motif of a victorious rider on a horse rearing or otherwise above a fallen warrior (Pls. 5, 5a) is discussed in Chapters Two and Three.

36 Huemer 1977, pp. 152-53; Panofsky 1969, pp. 82-87; Ligo 1970, pp. 345-54; Crawford Volk 1980, p. 171.

37 The view of Camón Aznar 1964, pp. 523, 536-42 (see also Gudiol 1974, pp. 144, 147), that the *Philip IV* (Pl. 112) is the very same equestrian portrait painted by Velázquez in 1625 (see Harris 1970, pp. 368-71) and later "totally repainted" by him cannot be discussed here, except to say that I find the hypothesis incredible. See n. 64.

38 Brown 1986, p. 65, fig. 75.

39 See Huemer 1977, p. 152, fig. 92; and Ligo 1970, p. 346, fig. 3, on another copy of the Rubens.

40 Diaz Padrón 1975, pp. 275-76, no. 1686.

41 See n. 25.

42 On similar borrowings, see J. Brown, "On the origins of 'Las Lanzas' by Velázquez," *Zeitschrift für Kunstgeschichte*, XXVII (1964), pp. 240-45; James F. O'Gorman, "More about Velázquez and Alciati," *ibid.*, XXVIII (1965), pp. 225-28; and Carla Gottlieb, "An Emblematic Source for Velázquez' 'Surrender of Breda,'" *Gazette des Beaux-Arts*, LXVII (1966), pp. 181-86. Soria 1954, p. 104, mentions Anthonis Mor, Sánchez Coello, Pantajo de la Cruz, González, Villandrando, and Vidal as earlier royal portraitists to whom Velázquez referred for his full-length portraits of Philip IV.

43 On Stradanus, see Baldinucci, II, pp. 591-96; H.M. Schwarz in Thieme-Becker; H. Voss, *Die Malerei der Spätrenaissance in Rom und Florenz*, Berlin, 1920, II, p. 326ff; and especially G. Thiem, "Studien zu Jan van der Straet, genannt Stradanus," *Mitteilungen des Kunsthistorischen Institutes in Florenz*, VIII (1958), pp. 88-111.

44 On Stradanus's activity 1570-80: Thiem (n. 43), pp. 97-98; M.N.

Benisovich, "The Drawings of Stradanus...in the Cooper Union Museum...," *The Art Bulletin*, XXXVIII (1956), pp. 249-51. Don Juan of Austria (1545-78) was the illegitimate, acknowledged son of Charles V, and served his half-brother Philip II as an outstanding admiral and general (in 1569 against the Moors in Granada; the defeat of the Turkish fleet at Lepanto in 1571; etc.). In 1575 he was named governor-general of the Netherlands. Don Juan made Naples his home base c. 1572-75 (the Tunis campaign and long trips to Genoa and Madrid date from the same period). See William S. Maxwell, *Don Juan of Austria...*, London, 1883 (2 vols.).

45 See n. 14 on the Duke's horses.

46 Soria 1954, pp. 96-98, Pl. III.

47 Bartsch, nos. 941-68.

48 Hollstein, XVI, pp. 82-83, nos. 309-20 (attrib. to Crispijn de Passe I).

49 Bartsch, nos. 596-607. Pemán 1964, I-III, illustrates nine of the prints.

50 The quote is from Daniel Ternois, *L'Art de Jacques Callot*, Paris, 1962, p. 48, on the relationship of Callot and Tempesta. For the Callot drawings see: idem, *Jacques Callot, catalogue complet de son oeuvre dessiné*, Paris, 1961, pp. 46-49 (nos. 25-41).

51 See n. 48.

52 Hollstein, IV, p. 204, nos. 419-32.

53 See n. 49. A copy of this set by Mattaeus Merian the Elder (Metropolitan Museum 51.501.3486-97) is not recorded in Bartsch, Le Blanc, or Nagler, and not yet in Hollstein.

54 See Larsson 1968, and literature cited therein; A. Calabi in Thieme-Becker; D. Rosand, "Rubens's Munich *Lion Hunt*: Its Sources and Significance," *The Art Bulletin*, LI (1969), p. 34.

55 For a good start, Larsson 1968; Soria 1954, p. 108, n. 31. See also Crispijn de Passe I (Hollstein, XI, nos. 655-66, 727, 788, 790); two of *The Roman Heroes* (see Pl. 89) by Goltzius, 1586 (Hollstein, VIII, p. 36, nos. 165, 168); Pemán 1964; Caturla 1965, pp. 197-201. Compare *A Roman Emperor on Horseback* attributed to Giulio Romano in J. Byam Shaw, *Paintings by Old Masters at Christ Church Oxford*, London, 1967, cat. 132, pl. 98. Soria, p. 104, on the choice of the "Twelve Caesars" theme as a model for royal Spanish equestrian portraits.

56 See n. 46.

57 Soria 1954, p. 98, n. 15.

58 *Ibid.*, p. 96, pl. II.

59 L.-P. Fargue, *Velásquez*, Paris, n.d., caption to pl. 25, approvingly recalls Justi's recognition of something "un peu vieux français." See Strong 1972, pp. 52-54, on the *Equestrian Portrait of Henry, Prince of Wales* (Pl. 124 here), and Chapter Four, n. 4 below.

60 Soria 1954, pp. 96-97, pl. II; p. 108, n. 31.

61 To my knowledge no horse performing a *levade* is ridden by a woman in paintings dating from before the nineteenth century (Grant's picture cited in Chapter Five, n. 40). A collected trot (Pls. 107, 220) is more strongly suggested in Rubens's *Philip II* (Pl. 117) than in the portraits of the Queens (Pls. 111, 113).

62 Pemán 1964, fig. 10; Soria 1954, p. 97 (little to say for a relationship to Stradanus).

63 J. Lieure, *Jacques Callot, Catalog of the Graphic Works*, 1969, VII, p. 24, no. 664 (dated 1634).

64 Less can be said with certainty about the *pentimenti* in the hindlegs, except that they may relate to criticism from the point of view of

equitation rather than to the hypothesis of Camón Aznar (see n. 37).

65 See Levey 1971, p. 142, fig. 118; Camón Aznar 1964, I, pp. 482-84 (ill. p. 484).

66 Harris 1976, p. 272, suggests a date of 1638. López-Rey 1963, p. 197: "about 1634-35." Neither López-Rey's reference to Jusepe Leonardo's *The Taking of Breisach* in the Prado nor Harris's mention of the battle of Fuenterrabia seems convincing as evidence for the date. See Chapter Two on Olivares.

67 Soria 1954, pp. 96, 98, pl. III.

68 A similar pose, angle of view, and high foreground occur in Stradanus's "Mediceae Familiae..." (see n. 26): Liedtke and Moffitt 1981, fig. 48.

69 Compare Pluvinel, *Maneige royal...*, pl. 24.

70 Alonso Martinez de Espinar, *Arte de Ballesteria y Monteria*, 1644, cited by Harris 1976, p. 271, n. 21, referring to M.L. Serrano in *Varia Velazqueña*, I, pp. 503-04; II, p. 398. The other book is an Italian edition of Grisone ("*Modo de andar a caballo, en italiano*"), listed in F.J. Sánchez Cantón, "La Libreria de Velázquez," *Homenaje ofrecido a Menéndez Pidal* (*Miscelánea de Estudios Lingüisticos, Literarios e Históricos*, III), Madrid, 1925, p. 398, no. 83.

71 Lopez de Ayala 1971, pp. 323-27, pls. 71-73. The same information was published in Casa de Velázquez, *Velázquez, son temps, son influence*, Paris, 1963, pp. 123-24, pls. 83-84.

72 See n. 18.

73 Harris 1976, p. 266ff, argues convincingly that the painting in the Grosvenor Estate (Pl. 122) is an original work by Velázquez, and that the version in the Wallace Collection is a copy. She carefully dates the former to 1636. See also Washington 1985, no. 497.

74 Harris 1976, p. 270, referring not to the pose but to Pluvinel's instructions on jousting.

75 F. Watson, *Wallace Collection Catalogues. Pictures and Drawings*, London, 1968, p. 332; Harris 1976, p. 272. See also Seth-Smith 1978, p. 55 (large color photo on p. 54).

76 Levey 1971, pp. 142-44, and Harris 1976, p. 272, must be right in thinking that the picture was painted for Olivares.

77 Harris 1976, p. 271, n. 20. In the same letter he thanks the Prince's uncle for a gift of horses.

78 The pose of the horse and rider in this painting and in those discussed above would seem to differ from that in the other equestrian portrait of Prince Baltasar Carlos, the overdoor painted by Velázquez for the Salón de Reinos (Pls. 114, 115), because, as Warnke 1968 suggests (pp. 221-22), the latter has a more specific meaning conveyed by the outward-springing gallop. On the other equestrian portraits (at least those of the male sitters) and the ability to rule, see Chapter Two. Warnke argues that the action of the pony in the portrait of the Prince signifies, by contrast, his coming of age. He compares Tacca's statuette of Louis XIII (Pl. 72) made in the year, 1617, of the French monarch's majority, and also brings Rubens's portrait "of a young Doria" (Pl. 96) into account in this respect. Giancarlo Doria was actually in his late twenties when Rubens painted this picture (see n. 20), it has a different allegorical significance, and the pose here and in similar images (Pls. 90, 91, mentioned by Warnke; see also Larsson 1968) must go back to a print by Stradanus or Tempesta, or to some other image employing this conventional gallop found throughout Renaissance art (see n. 22). But Warnke's reading of the portrait of Baltasar Carlos in the context of the Salón de Reinos program (where the Prince would face the throne at the opposite end of the hall and be flanked by the equestrian portraits of the Queen to the left and King to the right; see Pl. 114) has much to recommend it. Soria 1954, pp. 96,

99, 102, pl. IV, suggests Stradanus's *Domitian* and Callot's *Prince of Phalsbourg* as sources; see also Larsson 1968, and Warnke 1968, p. 223, n. 22.

79 To conclude our review of the sources of the Spanish equestrian portraits under discussion, it may be observed that the painting sent to Florence (probably Pl. 116) and Olivares's instructions (see Introduction, n. 12) need not have been any more than a general reference for Tacca (Pl. 74). He had already made the equestrian statuettes of Louis XIII (Pl. 72, 1617) and Duke Carlo Emanuele of Savoy (Pl. 73, 1619). Warnke 1968 relates the former to Tempesta's *Henry IV* (Pl. 90), and Baldinucci tells us that the latter, which anticipates the more orthodox pose of the *Philip IV*, was made under the instruction of the riding master Lorenzino in the stable of the Duke (cited by Lewy 1928, p. 76; pp. 62-81 on all three works). Olivares's insistence on the pose found in the *Philip IV* (Pl. 74) and the great difficulty of achieving it in a monumental bronze indicate how significant the pose was felt to be. On the Duke of Savoy statuette, see also K. Justi in *Zeitschrift für bildende Kunst*, XXI (1886), pp. 115-19. The equestrian monument of Philip IV falls outside the scope of Katharine J. Watson, *Pietro Tacca: Successor to Giovanni Bologna. The First Twenty-Five Years in the Borgo Pinti Studio, 1592-1617*, New York (Garland), 1977 (Ph.D. Diss., University of Pennsylvania, 1973), which does not discuss the art of riding in respect to any work by Giambologna or Tacca. However, the book presents a full history of the equestrian monuments of Ferdinand I, Henry IV, and Philip III (ch. VIII-IX, pp. 160-260).

80 See n. 12 for Vargas (quoted by Warnke 1968, p. 221).

81 The present chapter does not attempt an exhaustive survey. For some related works, a few of which are illustrated here, see Nelson 1979 on Jordaens (Pls. 142-44); Diaz Padrón 1975, p. 92, no. 1553, pl. 68 (de Crayer's *Equestrian Portrait of Philip IV*); E.P. Richardson, "A Rediscovered Sketch by Rubens of the Cardinal-Infante Ferdinand," *Miscellanea Leo van Puyvelde*, Brussels, 1949, pp. 135-38; A. de Schryver and C. van de Velde, *Catalogus van de Schilderijen* (Stad Gent, Oudheidkundig Museum), Ghent, 1972, no. 120 (Schut, Pl. 138 here) and no. 174 (anon., *Portrait of Carlos II of Spain*), citing Newcastle's treatise; C. van de Velde and H. Vlieghe, *Stadsversieringen te Gent in 1635*, Ghent, 1969, figs. 26, 27, 39, 40 (the same Schut; de Crayer, Pl. 140 here; prints after both); Camón Aznar 1964, I, p. 466, on the engraving of Olivares on horseback, 1634 (Pl. 118 here); Elizabeth du Gué Trapier, *Ribera*, New York, 1952, p. 198, fig. 133 (etching of *Don Juan of Austria* [1629-79; illegitimate son of Philip IV], 1648); and works discussed in Chapter Three.

CHAPTER 2

1 From the late medieval Legend of Lancelot, cited by J. Le Goff, *Das Hochmittelalter*, Frankfurt am Main, 1965, p. 206, and, along with similar seventeenth-century statements, by Warnke 1968, p. 221. The quotation was mistakenly attributed to Vargas by Liedtke and Moffitt 1981, p. 535.

2 E.g. Held 1958, Janson 1967, Keller 1971, Ligo 1970, Lützeler 1954, Traeger 1970, and Warnke 1968.

3 These limits are very approximate, especially for the imperial theme.

4 See Chapter One, n. 78, and Chapter Five.

5 Janson 1967, p. 75.

6 Janson 1967, p. 82.

7 Pope-Hennessy 1958, p. 63 on Uccello and the Horses of San Marco in Venice, p. 64 on Donatello and the horse of *Marcus Aurelius*, etc. In addition to the monographs on the individual artists, see

The Horses of San Marco 1979, pp. 68-78 (influence of the horses during and after the Renaissance).

8 Janson 1967, pp. 82-83. Pope-Hennessy 1970, p. 104, on the *Marcus Aurelius* as a model: "For Giovanni Bologna, therefore, it was not the paragon of naturalism it had seemed to Donatello, but a supreme commemorative monument...."

9 The exceptional case of Mochi's horse has often been observed: Valentino Martinelli, "Contributi alla scultura del seicento, II. Francesco Mochi a Piacenza," *Commentari*, III (1952), pp. 35-40; Irving Lavin, "Duquesnoy's 'Nano di Créqui' and two busts by Francesco Mochi," *The Art Bulletin*, LII (1970), pp. 132-49 (n. 78). But only Keller 1971, p. 29, gets right to the point at hand in his comparison of Giambologna's *Cosimo I* (Pl. 60): "*Alessandro reitet kein zahmes, an die höfische Reitkunst gewöhntes Dressurpferd, sondern ein temperamentvolles Schlachtross....*"

10 Gianoli 1969, p. 95, on the "ambling" attack of armored horses during the late Medieval and Renaissance periods. At a walk, both legs on one side of the horse advance together. At a trot, the diagonally opposite legs advance together (see Pl. 220).

11 See van de Velde and Vlieghe, op. cit. (Chapter One, n. 81), and J.R. Martin, *The Decorations for the Pompa Introitus Ferdinandi*, London and New York, 1972, pp. 23-24 and literature cited therein. Dhanens 1956, pp. 283-84, mentions the influence of Giambologna's *Triumphal Entry of Cosimo I into Siena* — a relief on the base of the monument to Cosimo I (Pl. 61) — on Baroque triumphal entries, and on Rubens's *Triumphal Entry of Henry IV*. Strong 1972, fig. 27, for Inigo Jones's design of 1636 for a triumphal arch surmounted by an equestrian statue of Charles I.

12 Pope-Hennessy 1970, pp. 103-04. See also Philipp Fehl, "The Placement of the Equestrian Statue of Marcus Aurelius in the Middle Ages," *Journal of the Warburg and Courtauld Institutes*, XXXVII (1974), pp. 362-67; and Ackerman 1961, pp. 67-68.

13 Strong 1972, ch. 3. See also Held 1958, pp. 139-49, on Charles I "both as the *cortegiano* and the *principe*."

14 Gállego 1972, pp. 272-75. Gállego suggests that Pluvinel's book "demonstrates the regal aspect of equitation, and especially of the levade [*corveta*] position."

15 See Keller 1971. Francis Dowley's review in *The Art Bulletin*, LVI (1974), pp. 133-35, offers important criticisms.

16 Remarkably, Marianna Jenkins, *The State Portrait...*, New York, 1947, does not discuss equestrian portraits.

17 Traeger 1970, with a good summary on pp. 117-19.

18 Lützeler 1974. The title is overly promising. See also Pühringer-Zwanowetz 1962.

19 Jost Amman and Hans Sachs, *Eygentliche Beschreibung Aller Stände auff Erden*, Nuremberg, 1568, p. 16. See the Dover reprint introduced by B.A. Rifkin, *The Book of Trades*, New York, 1973. One might see a similar case in the equestrian portrait of a sultan: A.J. Klant-Vlielander Hein, "Het reiterportret van Sultan Soleiman door Jan Swart van Groningen," *Antiek*, VII (1972), pp. 165-72. Similar prints representing equestrian portraits of rulers were commonplace by about 1510-20.

20 Wolfgang Braunfels, "Tizians Augsburger Kaiserbildnisse," *Kunstgeschichtliche Studien für Hans Kauffmann*, Berlin, 1956, pp. 192, 203. Harold Wethey, *The Paintings of Titian*, London, 1969-75, II (*The Portraits*), p. 35, cautiously observes that "the position suggests more of a gallop," but then makes doubtful claims for the painting's influence on Velázquez, "Rubens, van Dyck, and many other painters" (p. 36), and concludes that this representation of a galloping horse "effectively established the type with the rearing

horse, which was to be followed by later painters of the Renaissance and Baroque periods" (p. 87). Friis 1933, p. 197, correctly describes the pose as "a short four-beat gallop."

21 Panofsky 1969, pp. 84-87 (p. 86); see also the earlier version of this discussion in *Festschrift für Herbert von Einem*, Berlin, 1956, pp. 199-200, and the literature cited in both publications.

22 Panofsky 1969, pp. 86-87, figs. 100-01.

23 A fallen warrior beneath the horse and the act of attacking with a sword had imperial significance as well. The former, as Pollaiuolo and Leonardo clearly knew (Pls. 26, 28), was employed in Roman monuments and statuettes of emperors (see Pl. 5; Roques de Maumont 1958, fig. 11, etc.), and the latter occurs on the Third Great Seal of Charles I (Strong 1972, pp. 49-51, fig. 20). See also Pühringer-Zwanowetz 1962.

24 Ligo 1970, and Huemer 1977, pp. 151-52, where Ligo should be more frequently cited. The following account of the poems is based on Ligo's reading, which, he cautiously points out, may be "closely related to the artist's intent, even if it is not his personal statement" (p. 347). Ligo, p. 349, sees the pose of Rubens's horse as a "mirror image" of (and "conscious effort to duplicate") the pose of Titian's horse. It seems significant enough that the two paintings were very prominent works in the same room. See Crawford Volk 1980, pp. 71-72.

25 Ligo 1970, p. 347, misreads Zarate as saying that the helmet represents the wealth of the New World which supports the wars. Comparing Zarate's lines 8–11 and 26–27, it is clear that the helmet represents war, which is supported by (the wealth of) the New World (*un Indio*).

26 *Ibid.*, pp. 347-48. Ligo suggests that the cross is touched down at Santiago de Compostella, an interesting conjecture reminiscent of Santiago "Matamoro," but it would seem that nothing more local than Spain is indicated.

27 *Ibid.*, p. 348, n. 23. See also n. 24 on "sin, symbolized by the thistle."

28 Huemer 1977, p. 76.

29 See n. 1. Panofsky 1969, p. 87, suggests that "the uniqueness of the spear motif" in Titian's *Charles V at Mühlberg* (Pl. 51) is indicated by the fact that Rubens and Velázquez "deemed it necessary to replace the spear with the customary marshal's baton." Of course, different meanings account for the change in attribute. Panofsky is speaking of the later *Philip IV* by Velázquez (Pl. 112), where there is no Christian theme intended, and in Rubens's portrait of 1628 (Pl. 116) the theme is Christian but is not associated with a battle in a manner that would encourage a comparison with the *Profectio Augusti*. Most of the "Emperors" of Stradanus and Tempesta, by the way, are given batons, but Tempesta's *Claudius* carries a spear and his *Galba* carries an arrow.

30 Ligo 1970, pp. 348, 350 (parallel text of Zarate's poem and Ligo's translation).

31 On the many editions of Alciati's *Emblemata* see George Duplessis, *Les Emblèmes d'Alciat*, Paris, 1884; and Henry Green, *A. Alciati and his Book of Emblems*, London, 1872. In this section I am especially indebted to John Moffitt, and to Henkel and Schöne 1967, cols. 497-508, 1069-72.

32 Panofsky 1969, pp. 118-19; E. Wind, *Pagan Mysteries of the Renaissance*, London, 1958, pp. 145-47; George Ferguson, *Signs and Symbols in Christian Art*, London, etc., 1976, p. 20. On the horse on the sarcophagus in Titian's *Sacred and Profane Love*, see now Edward Fry in *Portfolio*, I (1979), 4 (Oct.-Nov.), p. 39. Fry interprets the meaning of the horse as deriving from but not conforming to the usual Renaissance signification: "this horse stands for chaste but ardent desire. Led by a figure holding its streaming

mane, this steed advances to meet a second, partially obscured figure who will tether it safely to the ribbons on the Aurelio coat of arms: a symbolic act of marriage...."

33 See Guy de Tervarent, *Attributs et Symboles dans l'Art Profane*, Geneva, 1958, I, col. 277; and C. Ripa, *Iconologie*, Paris, 1644, pp. 184, 187.

34 The bridle as a metaphor for control over one's passions occurs, for example, in Joachim Camerarius, *Symbolorum et Emblematum*, 1595, no. 3 (Henkel and Schöne 1967, col. 498); and in Achillis Bocchi, *Symbolicarum Questionum...*, Bologna, 1555, no. 105, "semper libidine imperat prudentia" (see J.B. Bedaux in *Antiek*, X [1975], p. 40, fig. 27). In both of these images the horse rears.

35 K.L. Selig, "The Spanish Translations of Alciati's 'Emblemata'," *Modern Language Notes*, LXX (1955), pp. 354-59. See also Gállego 1972, p. 36.

36 Alciati (1550), p. 42 (see Henkel and Schöne 1967, col. 1069). Gállego 1972, p. 273, n. 116, cited this emblem in the first Spanish translation of Alciati: Bernardo Daza Pinciano, *Los Emblemas de Alciato...*, Lyons, 1549, p. 141, no. 106.

37 On this book see A. Sánchez Pérez, *La Literatura Emblemática Española*, Madrid, 1977, p. 67ff.

38 Henkel and Schöne, cols. 497-98, 503-8, 1069-70. See also Warnke 1968, pp. 221-22. The emblem discussed here (see n. 36) was taken over by Geoffrey Whitney, *A Choice of Emblems*, Leiden, 1586, p. 38.

39 Levey 1971, p. 142 on Newcastle; Lützeler 1954, p. 122 on Del Campe; Strong 1972, pp. 56-57 on Morgan.

40 See Henkel and Schöne 1967, cols. 498, 505-07, 1072, for variations on this theme.

41 William S. Heckscher and Karl-August Wirth, "Emblem, Emblembuch," *Reallexikon zur deutschen Kunstgeschichte*, V, Stuttgart, 1959, pp. 85-228. For Dutch examples, see Amsterdam, Rijksmuseum, *Tot Lering en Vermaak*, 1976; and Braunschweig, Herzog Anton Ulrich-Museum, *Die Sprache der Bilder*, 1978.

42 The following pages on the *Equestrian Portrait of Olivares* and similar pictures repeat, in shorter form, my lines in Liedtke and Moffitt 1981.

43 The literature is summarized by Huemer 1977, pp. 21-25. On the *Equestrian Portrait of the Duke of Buckingham* (Pl. 130), in some ways a similar case, see Huemer, pp. 57-61, and Held 1976. Frances Robb discussed the special meaning of the picture at the 1980 annual meeting of the College Art Association.

44 See Tormo 1949, Warnke 1968, and Brown and Elliott 1980, ch. VI. The latter publish excellent photographic reconstructions of the Salón de Reinos (Hall of Realms), but all the authors have to say about the meaning of the five equestrian portraits (see Pl. 114 here) is that they address "the themes of dynastic succession and military might" (p. 156).

45 López-Rey 1963, p. 63, n. 1, cites Cruzada Villaamil, Lafuente Ferrari (see n. 47), Marañón, and Trapier as scholars who relate the painting to the battle of Fuenterrabia; on p. 197 Cruzada is cited as the first. E. Lafuente Ferrari, "Velázquez y los retratos del Conde-duque de Olivares," *Goya*, 1960, nos. 37-38, p. 71, is "inclined" to follow this dating to (late) 1638, and cites Jusepe Leonardo's *Taking of Breisach* (fig. 45 in Liedtke and Moffitt 1981) as a *terminus ante quem*. In placing the portrait in a dependent relationship to Leonardo's picture, Lafuente and others are following Justi 1889, p. 314. Enriqueta Harris, "Spanish Painting from Morales to Goya in the National Gallery of Scotland," *The Burlington Magazine*, XCIII (1951), pp. 310-17 (p. 314), relates the portrait and the ver-

sion of it in the Metropolitan Museum to the battle of Fuenterrabia with "no doubt," but no evidence either. Halldor Soehner, *Gemäldekataloge*, I. *Spanische Meister*, Munich (Alte Pinakothek), 1963, pp. 101-02, tentatively follows the identification of the setting and the date of 1638, and suggests that contemporary copies of the Prado picture would date between 1638 and Olivares's fall in 1643.

46 Compare figs. 41 and 42 in Liedtke and Moffitt 1981.

47 Camón Aznar 1964, I, p. 466, advances as an "incontrovertible argument" his view that the engraving in Mateos's book of 1634 (Pl. 118) was inspired by the *Equestrian Portrait of Olivares*. Gudiol 1974, p. 144, goes so far as to describe the book illustration as "an engraving of it" (the painting). Both scholars feel that the horse in Jusepe Leonardo's *Taking of Breisach* in the Salón de Reinos was modelled on Velázquez's horse. Others who come to the same conclusion and therefore date the portrait to 1633-34 include: K. Gerstenberg, *Diego Velázquez*, Munich and Berlin, 1957, p. 101, n. 86; G. Kubler and M. Soria, *Art and Architecture in Spain and Portugal and their American Dominions*, Baltimore, 1959, p. 385, n. 37; *Museo del Prado, Catálogo de las Pinturas*, Madrid, 1972, p. 734, no. 1181. See also Soria 1954, pp. 98-99. By contrast, E. Lafuente Ferrari, *Velázquez, Complete Edition*, London and New York, 1943, p. 22, no. LXIII, suggests that Velázquez may have adopted the pose of Olivares's horse from the painting by Jusepe Leonardo. Gállego's catalogue entries for the 1989 Velázquez exhibition at the Metropolitan Museum add nothing to the argument.

48 Crawford Volk, p. 171.

49 Gregorio Marañón, *Olivares, der Niedergang Spaniens als Weltmacht*, Munich, 1939, pp. 118-20. Marañón's book was first published as *El Conde-Duque de Olivares*, Buenos Aires, 1939 (6th ed.: Madrid, 1972). See now Elliott 1986.

50 See my Introduction, and n. 15 there.

51 Discussed at the end of Chapter One.

52 Harris 1976, p. 266ff. Harris, p. 271, concludes that the painting does not "appear to be related to any particular occasion; very probably it was intended as a record of the Prince's great enthusiasm for 'las lanzas'" (tilting with a lance); and of Olivares's rôle as Master of the Horse and the boy's mentor (p. 272).

53 On the latter point, see Leo Steinberg's review of López-Rey's book in *The Art Bulletin*, XLVII (1965), pp. 286-88.

54 On the apparent age of Olivares in the later portraits by Velázquez, see Vladimir Kemenov, *Velázquez in Soviet Museums*, Leningrad, 1977, pp. 61-87 (chapter on portraits of Olivares), p. 76ff. In the years around 1640 the Count-Duke aged considerably.

55 See n. 47.

56 *Varia Velazqueña*, II, p. 226, no. 31. The painter is certainly Velázquez, who is named in the following lines.

57 *Ibid.*, p. 227, no. 33.

58 López-Rey 1963, nos. 191 and 215 (both 46 x 39 cm) could possibly record this or a similar pair of paintings.

59 Vlieghe 1972, pls. 229-32, for the equestrian portraits of Olivares and Philip IV.

CHAPTER 3

1 A valuable but rarely cited study which discusses this point is Schlosser, pp. 119-28 ("Der 'cavallino': industrielle Verwertung des Kleinmodells").

2 The tradition may be reviewed in Roques de Maumont 1958; Friis 1933; Panofsky 1964, pp. 83-85.

3 See p. 23, and Chapter One, n. 16.

4 On Rubens's drawing after Leonardo's composition, see Julius Held, *Rubens: Selected Drawings*, London, 1959, I, pp. 157-59 (no. 161). For a few of the bronzes, cautiously consult Agghazy 1971.

5 On these sculptors see the text below and nn.33-35, 38, 43, 51-52.

6 See pp. 28-32.

7 See Chapter One, n. 43, and G.J. Hoogewerff, *Nederlandsche Schilders in Italië in de XVIe Eeuw*, Utrecht, 1912.

8 Grossmann 1931, p. 22. Heydenreich 1959 illustrates Medieval representations of the *Regisole* in which the trot is incorrectly represented as a walk (p. 151).

9 Janson 1967, pp. 75-76, notes that Charlemagne had brought a late Roman monument of Theodoric from Ravenna to Aachen.

10 Heydenreich 1965, pp. 183-84, figs. 6,7, discusses Leonardo's studies of the Regisole in Pavia and of the "living horse." See also Clark and Pedretti 1968, I, pp. xxxii-xli (Appendix A., "Leonardo's Studies of Horses").

11 See Friis 1933, figs. 70, 73, 80, 96-98, 108-10, 112, for some less well-known examples in sculpture. The walking horses of Castagno and Uccello (Pls. 20, 21) should be seen in the context of works like these (see Friis, pp. 137-38, 148-49), particularly in respect to Uccello's controversial foreshortening of the original version (see Schmitt 1959).

12 Pope-Hennessy 1958, p. 69, on the change from a rearing to a trotting horse in the designs for the Sforza monument, and Heydenreich 1965, pp. 183-84, on the same in the case of the Trivulzio monument. Heydenreich simply credits the "renewed consideration of the Regisole" for this change, but the patron's wishes or the great technical difficulties of mounting a rearing horse on the hindlegs alone may have been important factors. See also Bush 1976, p. 168.

13 On Pollaiuolo's project for the Sforza monument (probably dating from the early 1480s), see Pope-Hennessy 1958, pp. 66-67; Bush 1976, p. 167; and Meller 1934. For earlier equestrian monuments with a rearing horse, see Friis 1933, fig. 69 (tomb of Piero Farnese, Pl. 17 here) and fig. 82 (tomb relief in Bologna).

14 Bush 1976, p. 166, citing Luca Pacioli, *De divina proportione* (1498), Milan, 1956, p. 4.

15 Ackerman 1961, p. 68. Ackerman relates this fact to the identification of the *Marcus Aurelius* as *il gran' villano*, a "low-born folk hero" of republican Rome.

16 Pope-Hennessy 1958, p. 66.

17 On Uccello, see Larsson 1968, p. 37, fig. 12. For examples by Leonardo, see Ludwig Goldscheider, *Leonardo da Vinci: Life and Work*, London, 1959, pp. 176-77. The common medieval theme of St. George and the Dragon was strongly reinforced by Donatello's famous relief (1415-17). See F. Volbach, *Die Darstellungen des Heilige Georg zu Pferd*, Strasbourg, 1917.

18 Pope-Hennessy 1969, pp. 20-21, citing "the kicking horse of the Uffizi panel."

19 Especially in the background of Pollaiuolo's *Martyrdom of St. Sebastian* (National Gallery, London; 1475, for the Pucci chapel in Santissima Annunziata), where the two rearing horses look — as do the archers in the foreground — like the same figure seen from opposite points of view.

20 See Suter 1937; and Held (op. cit., n. 4).

21 See Heydenreich 1965, p. 184. The crouching position of Leonardo's horses is especially pronounced in the *Battle of Anghiari* (Pl. 31), and must be based upon the observation of, or advice about,

mounted horses in combat. The similarity to the *levade* in this case has nothing to do with *haute école* riding, but recalls the fact that its airs are similar to movements executed in combat and, as books on dressage frequently point out, to movements that horses perform naturally.

22 Pope-Hennessy 1958, p. 67, noting the action in battle scenes on classical sarcophagi; Heydenreich 1959, pp. 158-59.

23 Soós 1956, and sources cited therein. Soós's figs. 9 and 10, "for the Sforza monument," reproduce studies for the Trivulzio monument: see Heydenreich 1965, and Müller-Walde 1899.

24 Pope-Hennessy 1958, p. 70.

25 See n. 12, and Bush 1976, p. 168, n. 13, summarizing the thoughts of other scholars on the reason for the change.

26 See n. 23.

27 This point is stressed by Heydenreich 1965, p. 183 (n. 20 on the medals).

28 See Heydenreich 1965, p. 189, figs. 16, 17 (also figs. 15, 16, for trotting versions).

29 See H. Travers Newton and John R. Spencer, "On the location of Leonardo's *Battle of Anghiari*," *The Art Bulletin*, LXIV (1982), pp. 45-52. Goldscheider, op. cit. (n. 17), pp. 178-79 (no. 108) and literature cited therein, on what was known of Leonardo's composition, and for drawings after parts of the cartoon by Michelangelo and Raphael. Müller n.d. (c. 1948), p. 10, mentions that Leonardo supposedly also wrote a lost treatise on the horse which Vasari cited and Rubens knew.

30 See Roques de Maumont 1958.

31 Compare the horses in Raphael's *St. George and the Dragon* (Louvre), in the *Expulsion of Heliodorus*, and in Pls. 38, 40, 40a here (see John Pope-Hennessy, *Raphael*, New York, 1970, figs. 97, 102, 112-15).

32 Mentioned by Weihrauch 1943, p. 109, n. 1; see the Lorenzetti edition of Vasari, Florence, 1913, p. 98.

33 Vasari records that Rustici modelled a great number of horses (statuettes) which could still be found in many Florentine houses (Schlosser 1913-14, p. 120). Pope-Hennessy 1970, p. 340, for Rustici's biography and literature. Reliefs and statuettes attributed to Rustici are illustrated in Loeser 1928; Hall 1973; and H. Ost, *Leonardo-Studien*, Berlin and New York, 1975, pp. 48-49, fig. 29. Hall's article attributing the Louisville bronze to Leonardo (the museum currently calls the work "Italian, 15th Century") can hardly be considered as sincere scholarship. Reports of research in progress cannot be repeated here but would place the statuette's origins later and in northern Europe. Vasari records that Rustici completed a large model of an equestrian monument for Francis I, but the work was abandoned at the King's death in 1547 (Friis 1933, pp. 250-51; Dahl 1935, pp. 27-28; Bush 1976, p. 174). It is generally felt that the horse must have been in a trotting position, but W.R. Valentiner, "Rustici in France," *Studies in the History of Art Dedicated to William E. Suida...*, London, 1959, pp. 216-17, argues for a rearing horse and gives the rearing horse over the entrance of the Château d'Écouen (Pl. 52) to Rustici as well. Hall, p. 57, suggests that the "equestrian statue of Francis I was inspired by Leonardo's equestrian drawings, and may have been similar in composition to the Écouen statue" (see his n. 83 on the literature concerning the latter work's authorship).

34 Dahl 1935, p. 27; Bush 1976, p. 172, citing Vasari-Milanese, VI, p. 68. For biography and literature, Pope-Hennessy 1970, p. 358.

35 Dahl 1935, p.27; Bush 1976, pp. 181-82. Bush suggests that Tribolo's plans for a tomb of Giovanni delle Bande Nere, Cosimo's father,

may have included an equestrian statue in marble.

36 Bush 1976, p. 172 (and n. 25, fig. 168, for another rearing horse and rider made for Charles V's entry into Milan in 1541).

37 Bush 1976, p. 172, citing this reference in a letter of Guglielmo della Porta dating from c. 1559-60 (Werner Gramberg, *Die Düsseldorfer Skizzenbücher des Guglielmo della Porta*, Berlin, 1964, I, p. 120, no. 224).

38 Bush 1976, p. 173; E. Plon, *Leone Leoni...*, Paris, 1887, pp. 37-38.

39 Pope-Hennessy 1970, pp. 400-1, for biography and literature. See n. 27.

40 Aggházy 1971, p. 76; also in *Arte Lombarda*, XXXVI (1972), pp. 91-99, 121-27. Aggházy (and Schlosser 1913-14, p. 120), following Plon, op. cit. (n. 38), cites a clay model of a horse attributed to Leonardo in Leone's collection in Milan.

41 Dahl 1935, pp. 29-31. Bush 1976, pp. 173-74, figs. 169-70, who, following Gramberg, op. cit. (n. 37), pp. 118-19, mentions that della Porta himself cited antique precedents for the later base (a "tempietto" tomb for Charles V) and prisoners. Pope-Hennessy 1970, p. 396, for a biography and literature.

42 See the entry on a bronze statuette of Henry IV, Pl. 71 here, in *Jahrbuch der Hamburger Kunstsammlungen*, IX (1964), p. 227.

43 Katharine J. Watson in *Giambologna*, no. 163. On the equestrian monument of Cosimo I see Dhanens 1956, pp. 274-85.

44 Dhanens 1956, p. 280. For the statuette, see Planiscig 1924, no. 263; Dhanens, pp. 200-03; *Giambologna*, pp. 109-17. *Giambologna*-Vienna, no. 168a, on the triumphal entry decoration.

45 *Giambologna*, p. 175, no. 153.

46 Pope-Hennessy 1970, p. 393, for biography and comments on Lewy.

47 Katharine J. Watson in *Giambologna*, p. 186; see also pp. 172-73, 178-80.

48 Dahl 1935, pp. 32-43, and Dhanens 1956, pp. 297-300.

49 See Chapter One, n. 79. The statuettes are discussed in Lewy 1928, pp. 76, 62-81, and *Giambologna*, pp. 182-83. See also Schlosser, 1913-14, pp. 121-24.

50 See the Introduction. *Giambologna*, nos. 164-68, for rearing and leaping horses attributed to Pietro or Ferdinando Tacca. The mention of the term *corvetta* in no. 165 was properly omitted in *Giambologna*-Vienna, where, however, the change from "rearing" to "levade" in no. 168 is questionable.

51 Thieme-Becker, XXXII (1938), pp. 305-06, on Susini and his nephew Francesco, who cast *cavallini* after Antonio's models; *Giambologna*, nos. 151 and especially 162 on the importance of Susini for Giambologna's equestrian monuments.

52 Larsson 1967, pp. 44-45, figs. 84-85, where the pose is properly distinguished from the more formal pose of Tacca's *Philip IV*, and associated with both Leonardo's studies for equestrian monuments and Tempesta's *Twelve Caesars*.

53 See n. 42. The work is very much in the recent Florentine tradition, and may be of special interest for Tacca's *Louis XIII* (Pl. 72).

54 Friis 1933, pp. 228-30, fig. 138; Larsson 1967, n. 65.

55 Weihrauch 1943 for a full discussion of the monument and its relationship to Florentine art and patronage. Weihrauch, p. 109, n. 1, mentions the unfinished equestrian monument of Ferdinand I (also on a fountain), designed about 1590 for Munich by the Dutch artist Frederik Sustris (brother and pupil of Lambert; active 1563-69 in Florence), as a probable source of inspiration for Gras (probably through his teacher, Hubert Gerhard). The leaping horse (buttressed by a mound of rocks) recalls the same very common motif in Stradanus, in early printed portraits of princes on leaping or galloping horses by Tempesta and others (see Larsson 1968), and in bronzes by Giambologna's followers (*Giambologna*, nos. 164-65).

56 Pühringer-Zwanowetz 1962, p. 105, n. 39, sees "the wish to represent the ruler as master of the Haute Ecole" in Tacca's *Philip IV*, and compares this to the portraits and actual riding of Leopold and Joseph (see pp. 104-05 on "horse ballets," etc.). Perhaps nothing is so indicative of the conformity achieved in equestrian portraits of princes during the early seventeenth century than the virtually identical statuettes, some with exchangeable heads (Pl. 77), that have been attributed to the studio of Francesco Susini, but recently to that of Caspar Gras (see *Giambologna*-Vienna, nos. 163a-e).

CHAPTER 4

1 See Geisberg 1974 for examples by Niklas Stoer, Erhard Schoen, Jörg Breu the Elder, H.S. Beham, and many others.

2 See Müseler 1978, pp. 107 ff, or a similar source. The "Spanish trot" is not the same as the "Spanish step" (a kind of goose-step for show horses), which is not an *haute école* air. The Spanish step and the "extended trot" are very rarely, if ever, represented in equestrian portraiture, although something close to the latter is introduced in Garrard's painting, *The Eighth Duke of Hamilton riding along the shore* (Livingstone-Learmonth 1958, Pl. 43).

3 See n. 49 below.

4 Mellen 1971, p. 243, nos. 151-52, rejects the equestrian portraits of Francis I in the Uffizi and the Louvre, (Colorplate 7 here) and the *Henry II* in the Metropolitan Museum (Pl. 49, fig. 47).

5 A whip also occurs in the *Equestrian Portrait of Henry, Prince of Wales*, attributed to Robert Peake (Pl. 124), and is held in many seventeenth-century northern European portraits of royal riders (e.g., Pl. 175).

6 Diego de Saavedra Fajardo, *Idea de un Principe Politico Christiano*, Munich, 1640 (second ed.: Milan, 1642, reprinted in Amsterdam, 1659), no. 38 (see Henkel and Schöne 1967, col. 504).

7 See Chapter One, n. 59.

8 Mentioned by P.D. Massar, *Presenting Stefano della Bella*, New York, 1971, p. 88.

9 For example, Gozzoli's high-stepping horse in the *Procession of the Magi* (Pl. 23).

10 Heydenreich 1959, pp. 148-49, n. 3, on the name, provenance and travels of the monument, which was destroyed in 1796. See also G. Bovini, "'Il Regisole'...," *Corsi di Cultura sull'Arte Ravennate e Bizantina*, X (1963), p. 51ff.

11 Bush 1976, pp. 168-70, summarizes and cites all the important literature on the designs for the Sforza monument (figs. 165-66 for the sketches). See also Clark and Pedretti 1968, p. xxxvi.

12 Heydenreich 1959, p. 158; Heydenreich 1965, p. 183ff; Clark and Pedretti 1968, pp. xxxviii-xli. The sketches of the trotting Sforza horse (see n. 11) show three legs on the ground, whereas the studies after the *Regisole* and most of the sketches for the trotting horse of the Trivulzio monument show a foreleg and a hindleg raised (in some cases supported by props).

13 Heydenreich 1959, pp. 149-50; p. 155 and n. 23. See also n. 15 below.

14 Heydenreich 1959, p. 158 ("*trotto di qualità di cavallo libero*," from the *Codex Atlanticus*, fol. 147).

15 Heydenreich 1965, p. 184, uses the term "*trotto libero*," his own

contraction of Leonardo's phrase (see n. 14), and (1959, p. 155, n. 23) distinguishes the "short trot" from the "free trot" (which would correspond, it seems, to the *passage* and the "collected trot," respectively, in fig. 45). Heydenreich observes the former in the *Marcus Aurelius* and the latter in the *Regisole*. It seems unclear whether the trots in these two monuments differ in kind or simply in degree, i.e., speed (Heydenreich seems to think that the walk, the "free trot," and the *passage* can be distinguished by counting the number of feet on the ground, but a glance at Muybridge's photographs will show that this depends on the moment of view).

16 Heydenreich 1959, p. 158, stresses the relationship between the Sforza and Colleoni monuments, despite the difference in gait.

17 Lavin, op. cit. (Chapter Two, n. 9), n. 78.

18 It is usually suggested that only Verrocchio's rider was important for Mochi's design. On the artist's trip to Padua and Venice in 1616, see Lavin, op. cit.; Martinelli, op. cit. (Chapter Two, n. 9), p. 37; Pope-Hennessy 1970, p. 105.

19 The best illustrations of all Mochi's horses are in L. Dami, "Francesco Mochi," *Dedalo*, V (1924), 1, pp. 99-132.

20 Bush 1976, p. 170, and literature cited, and fig. 167 for a seventeenth-century copy of the design.

21 Heydenreich 1959, pp. 148-49.

22 See Chapter Three, n. 33. See also Schlosser 1913-14, pp. 120-21, on the influence of Leonardo's trotting horse on Rustici and on northern European artists, including Dürer; Planiscig 1924, p. 138, no. 237, on the bronze horse illustrated by Schlosser.

23 Bush 1976, p. 174.

24 See Chapter Two, n. 12. Bush 1976, pp. 82-97, gives a useful survey of the reconstruction and redecoration of the Capitol and cites the most important literature.

25 The earliest known is Antonio Filarete's of 1465 (Dresden). This and especially the late sixteenth-century copies are discussed by 'LM' in the entry on the one in Hamburg (Pl. 59), in *Jahrbuch der Hamburger Kunstsammlungen*, II (1952), pp. 83-84. See also Planiscig 1924, pp. 138-39, no. 238.

26 The following information on Michelangelo and Daniele da Volterra is all in Bush 1976, pp. 174-78. Roberto Strozzi, the recipient of Luigi del Riccio's letter of 1544 recording Michelangelo's offer of an equestrian monument of Francis I for Florence, was Catherine's cousin and handled the details of the *Henry II* commission (Bush, pp. 174-75). See now Paul Barolsky, *Daniele da Volterra, A Catalogue Raisonné*, New York (Garland), 1978.

27 Compare Bouchardon's drawings of the monument, cited in Paris, Musée du Louvre, Cabinet des Dessins (*LII^e exposition*), *La Statue équestre de Louis XV, Dessins de Bouchardon...*, 1973, under no. 36.

28 See Steinmann 1917, pp. 340-43; Dahl 1935, pp. 54-55.

29 See also n. 38 on Giambologna. Dowley, op. cit. (Chapter Two, n. 15), p. 134, observes that "The role of precedents is underplayed by Keller, although it could throw light on pertinent political attitudes. In Girardon's statue itself, such features as the gesture of Louis XIV reflect not only the antique prototype of Marcus Aurelius, but also the more modern one of Louis XIII... in Biard fils's statue."

30 Dahl 1935, p. 32. Bush 1976, pp. 179-93, for a survey of this tradition up to 1587, when Ferdinando de' Medici became Grand Duke of Tuscany and commissioned Giambologna's *Cosimo I*.

31 Bush 1976, pp. 181-82, 193, and literature cited.

32 *Giambologna*, p. 178, no. 159, on the last commission, and pp. 173, 180, for literature on the preceding two.

33 Pope-Hennessy 1970, p. 387, for the passage in Italian and English.

34 Pope-Hennessy 1970, p. 103.

35 Dhanens 1956, p. 275, n. 1.

36 Bush 1976, p. 193, n. 99.

37 Roques de Maumont 1958, pp. 52-53 and figs. 27a-b, illustrates the two coins and discusses the "*Equus Traiani*," citing Ammianus Marcellinus as a source. The last great Roman historian (ca. 330-95) actually says "*Traiani equum*" in his *History*, XVI, 10, 15. In paragraph 13 he mentions equestrian games, and in paragraph 15 describes Constantius's realization that he could never build anything like the Forum of Trajan, but "Trajan's steed alone, which stands in the centre of the vestibule, carrying the emperor himself" (*Ammianus Marcellinus*, with a translation by John C. Rolfe, Cambridge, Mass., 1935, I, p. 251).

38 Dhanens 1956, p. 279, claiming that "nothing is less true," and describing the horse as "built short and solid, able to carry a heavily armored rider." Keller 1971, p. 29, sees the same horse rather differently when comparing it to Mochi's (Pl. 151): "Alessandro rides no docile dressage horse of the kind common in the courtly art of riding, but a battle steed full of spirit." Both authors exaggerate. Baldinucci, II, p. 592, records that Giambologna worked in the Belvedere with Daniele da Volterra.

39 Dhanens 1956, pp. 278-79. See *Giambologna*, pp. 174, 181, on Susini and the models, and pp. 185-86 on the flayed horse.

40 Pope-Hennessy 1970, p. 104, observes that Giambologna's attitude towards the *Marcus Aurelius* "was more respectful than that of his predecessors in the fifteenth century... but his horse is not a servile copy of that in Rome."

41 Dhanens 1956, p. 297ff; *Giambologna*, nos. 150, 159, 161.

42 *Giambologna*, no. 149, on this bronze statuette in Stockholm.

43 Schlosser 1913-14, p. 127, fig. 53, as by the workshop of Francesco Susini; Planiscig 1924, p. 171, no. 281 (ill.).

44 *Giambologna*-Vienna, no. 161a (*Carlo Emanuele*; "Antonio Susini?").

45 Strong 1972, p. 57, fig. 26 (fig. 27 for a similar horse and rider in a rejected design of 1636 for a triumphal arch by Inigo Jones). See also Charles Avery, *Hubert Le Sueur's Portraits of King Charles I in Bronze...*, National Trust Studies, I, 1978, and *Giambologna*-Vienna, no. 163ff.

46 Dhanens 1956, p. 280. On Schlüter's monument, see Keller 1971, ch. IV; and H. Voss, "Andreas Schlüters Reiterdenkmal des Grossen Kurfürsten und die Beziehungen des Meisters zur italienischen und französischen Kunst," *Jahrbuch der preussischen Kunstsammlungen*, XXIX (1908), p. 146ff. Keller acknowledges the importance of Mochi and Girardon for the monument in Berlin, and attributes its differences to "Protestant state-theory" (p. 103). On p. 143, n. 92, he mentions the symbolic significance of the art of riding.

47 The "Vouet" is illustrated in Livingstone-Learmonth 1958, pl. 13. R. Crelly, *The Paintings of Simon Vouet*, New Haven and London, 1962, p. 220, no. 149, rejects the work.

48 Gardes 1975, p. 91. Gardes, pp. 136-37, provides a useful table of twenty-two equestrian monuments of Louis XIV planned for French cities c. 1665-95; it includes the dates of the project, casting, unveiling, and destruction when known, the pose of the horse, dimensions, and weight.

49 See literature cited in Gardes 1975, bibliography on pp. 144-51, especially S.A. Callisen, "The Equestrian Statue of Louis XIV in Dijon and Related Monuments," *The Art Bulletin*, XXIII (1941),

pp. 131-40; and Steinmann 1917, pp. 340-43. Callisen, pp. 136-37, discusses the history and documentation of the casts of the *Marcus Aurelius* that were set up at Fountainbleau (c. 1550-1626) and at the Louvre (1685 - before 1735), and relates this source to his idea that in the monuments by Girardon, Desjardins, and Le Hongre, "the sculptors represented the horses at a slow walk, [but] motion forward was not implied."

50 See the last line of the preceding note.

51 See Unger 1926, pp. 66-74, and the French sources cited in Chapter One, n. 1.

CHAPTER 5

1 Wittkower 1961, pp. 497-531 (p. 503).

2 Wittkower 1961, p. 503, for the Frenchman's objections and Bernini's response, and pp. 509, 513-14, figs. 22, 33, for Lebrun's designs for an equestrian monument of Louis XIV.

3 Wittkower 1961, pp. 501, 503, quoting Bernini's letter to Colbert of December 30, 1669.

4 That the similar horse in Bernini's *Constantine* (Pl. 153) appears to be startled by the vision does not speak against the possibility that Bernini looked to Leonardo's designs or found them appropriate to his victorious *Louis XIV*.

5 Wittkower 1961, p. 503, quoting Domenico Bernini's record of his father's words; pp. 505-11 on Hercules, Pegasus, and Glory.

6 Janson 1967, p. 82.

7 This is true despite the "religious overtones" mentioned by Wittkower 1961, p. 56.

8 J.C. Pinter von der Au, *Neuer vollkommener verbesserter und ergäntzter Pferd-Schatz*, Frankfurt a.M., 1688, p. 121, quoted by Lützeler 1954, p. 120.

9 On the response to and treatment of Bernini's monument see: Wittkower 1961, pp. 497, 511-14; Berger 1981; Berger 1985, chapter six and appendix two; Gould 1982, Ch. XVIII. On French and other equestrian monuments and statuettes that feature a rearing horse, see Gardes 1975, pp. 91-92, and the table on pp. 136-37; Volk 1966, pp. 61-90; P. Volk, "Zwei Reiterstatuetten des Louis Quinze in der Tradition des 17. Jahrhunderts," *Pantheon*, XXVIII (1970), pp. 309-13.

10 Quoted by Volk 1966, p. 67. Gardes 1975 erroneously follows this use of the term *galop*.

11 Volk 1966, p. 80. Volk wrongly relates these works to Tacca's *Philip IV*, which Baldinucci, it will be recalled, described precisely in terms of *haute école* riding.

12 In addition to Bernini's monument, the bronzes of the Tacca and Susini studios were clearly important for these late seventeenth- and early eighteenth-century French statuettes. The bronze horses engraved in Girardon's *Galerie* (Volk 1966, figs. 37, 59) are probably Italian, not French: compare *Giambologna*, nos. 163-68.

13 Wittkower 1961, pp. 515-16 (the gesture is not mentioned); Friis 1933, pp. 430-37. See H. Dieckmann and J. Seznec, "Horse of Marcus Aurelius, a controversy between Diderot and Falconet," *Journal of the Warburg and Courtauld Institutes*, XV (1952), pp. 198-228. Falconet strongly criticized the gait as unnatural.

14 M. Levey and W. Kalnein, *Art and Architecture of the Eighteenth Century in France*, Baltimore, 1972, p. 90, describe the figure as "protecting his city with outstretched hand."

15 See Steinmann 1917 on the destruction of this and other monuments, and the remarks of Alfred Neumeyer, "Monuments to 'Genius' in German Classicism," *Journal of the Warburg Institute*, II (1938-39), p. 159.

16 B. Castiglione, *The Book of the Courtier* (C.S. Singleton, ed.), New York, 1969, p. 38.

17 Held 1958, pp. 147-49. In most examples of the "dismounted equestrian portrait," traditional meanings are abandoned or take second place in favor of the theme of hunting or riding as a noble occupation. After van Dyck's *Le roi à la ciasse* and other paintings discussed by Held, Dutch examples become common (e.g., Johannes Mijtens's *Maria, Princess of Orange with her horse*, Pl. 182; Adriaen van Nieulandt's very large *Portrait of a Man with His Horse and Groom*, 1624, in the Walters Art Gallery, Baltimore). See the exhibition catalogue *In het zadel: het Nederlands ruiterportret van 1550 tot 1900*, Leeuwarden (Fries Museum), 1979-80, pp. 23-24, nos. 17, 18, 20, etc.

18 Strong 1972, p. 56, sees "an allusion to the *cortegiano* theme" in the *Charles I on Horseback* (Pl. 132). In paintings like the one in Antwerp (1970, cat. no. 892 as a portrait of the Flemish painter Cornelis de Wael) the theme seems less obscured by others.

19 See F.P. Dreher, "The Artist as Seigneur: Châteaux and their Proprietors in the Work of David Teniers II," *The Art Bulletin*, LX (1978), p. 689 and sources cited.

20 *Ibid.*, p. 689; see fig. 1 for Pieter Thys's portrait of David Teniers II before his own château, which is, in a way, a perfect parallel to the bourgeois equestrian portrait.

21 *In het zadel*; the catalogue includes a register of three hundred and sixteen surviving examples, forty-four entries on representative works, an introduction by Charles Dumas, and an extensive, if incomplete, bibliography.

22 *Ibid.*, p. 14, fig. 13, for Cornelisz's prints, and p. 38, no. 5, for the earliest known equestrian portrait in the northern Netherlands, a canvas by an anonymous artist representing Reinoud III van Brederode. It copies a woodcut by Cornelis Anthonisz and already anticipates the composition of Velázquez's *Philip IV* (Pl. 112) to some extent.

23 *Ibid.*, figs. 15 (Hillegaert), 16 (Pacx), 3 (Bakhuizen's *Arrival of Willem III*, 1692, where the future king has no excuse for making his horse perform a model *levade* on the beach other than to strike a royal pose).

24 *Ibid.*, figs. 18, 19; nos. 8, 10, 11, 13, 15, 23, etc.; nos. 5, 47, 52, 110, 112, 115, 118, 122, 146, 151, 224, 230, 252, all illustrated on pp. 100-16. It may be recalled that Pluvinel was the ambassador of Louis XIII to Prince Maurits (during the 'teens).

25 *Ibid.*, p. 18, and literature cited (p. 30, n. 22). Compare the prints illustrated in Larsson 1968.

26 See *In het zadel*, no. 16; S.J. Gudlaugsson, "Een ruiterstuk van Gerard ter Borch" and "Een ander ruiterstuk van Gerard ter Borch," *Kunsthistorische Mededelingen van het Rijksbureau voor Kunsthistorische Documentatie*, II (1947), pp. 19-28, 40-43.

27 On de Keyser's equestrian portraits see Rudolf Oldenbourg, *Thomas de Keysers Tätigkeit als Maler*, Leipzig, 1911, pp. 61-65, pls. 24-25; *In het zadel*, pp. 22-23, 111; 1976 Rijksmuseum Cat. no. A697 (p. 319). Compare Camphuysen's use of a *passage* and *levade* in the equestrian portrait of Prince Willem II dated 1649 (*In het zadel*, no. 60, ill. p. 102). The more expansive settings of de Keyser look forward to those in the somewhat later equestrian portraits of Louis XIV by Adam Frans van der Meulen, although the Flemish painter, like many earlier artists, usually represents a battle in the background.

28 *In het zadel*, pp. 18-23, 103 on Cuyp (fig. 20 on p. 20 for the Maurits-

huis picture; figs. 69, 70 on p. 104 for those in Washington and Dordrecht).

29 See S. Reiss, "Albert Cuyp," *The Burlington Magazine*, XCV (1953), p. 45, on the sitters. Closely related to the Dutch equestrian portraits discussed above are the many paintings by Cuyp (see Pl. 185; Toledo Museum of Art, *European Paintings*, 1976, pp. 46-47, color pl. VII), and especially those by (or attributed to) Philips or Pieter Wouwerman, that represent "riding schools" (see also Pl. 186). These recall the treatises of Pluvinel and others, Jacob de Gheyn's twenty-two prints representing the "Exercise of Cavalry" ("The Riding School" is a misnomer, although a few of the plates recall the *passage* or *levade* in the same approximate manner of Stradanus's *Equile*), the similar prints of Stefano della Bella (see Chapter Four, n. 8), and the Flemish tapestries designed by Jacob Jordaens and others (see Pls. 142-43) that represent *haute école* schooling and depend on Pluvinel. The last date mostly from the second quarter of the seventeenth century and are fully discussed in Nelson 1979, ch. V.

30 See A. Braham, "Goya's equestrian portrait of the Duke of Wellington," *The Burlington Magazine*, CVIII (1966), pp. 618-21.

31 For examples, see Mario Praz, *Conversation Pieces*, University Park and London, 1971, figs. 95 (Stubbs's *Colonel Pocklington and his Sisters*, in Washington), 122, 148, 149, etc.; and Ellis Waterhouse, *Painting in Britain 1530 to 1790*, Baltimore, 1962, pls. 180, 182, etc. See also Oliver Millar, *The Later Georgian Pictures in the Collection of Her Majesty the Queen*, London, 1969, pls. 75 (Gainsborough), 93 (Reynolds), 139-46 (Stubbs), etc.

32 See Stubbs's *The Duke of Portland Riding Out* at Welbeck Abbey, fig. 51 in Bühler 1949.

33 For examples, see F.G. Roe, *Sporting Prints of the Eighteenth and Nineteenth Centuries*, London, 1927, and many similar sources.

34 See Waterhouse's observation, quoted in the caption to Pl. 198 here.

35 See Hugh Honour, *Romanticism*, New York and London, etc., 1979, pp. 309-11.

36 Levey and Kalnein, op. cit. (n. 14), p. 196; Levey 1971, p. 174.

37 Livingstone-Learmonth 1958, caption to pl. 36.

38 In this respect the painting is anticipated by David's equestrian portrait of Count Potocki (Pl. 195); see New York, Metropolitan Museum of Art, *French Painting 1774-1830: The Age of Revolution*, 1975, pp. 363-64 (no. 29). The story that David represents the count mastering an untameable horse is apocryphal but expectable. The catalogue cites sources in Rubens and van Dyck. See also A. Ryszkiewicz, "Portrait équestre de Stanislas Kosta Potocki par Jacques-Louis David," *Bulletin du Musée National de Varsovie*, IV (1963), p. 77ff.

39 See Judith Campbell, *Royalty on Horseback*, Garden City, N.Y., 1974, for a photographic survey of English royal riders.

40 For Alfred Dedreux's *Victoria at the Hunt*, see Bühler 1949, fig. 58. For Sir Francis Grant's *Queen Victoria on Horseback*, which was derived from Velázquez's *Olivares* (Pl. 119), see Levey 1971, pp. 203-04 and n. 27. Levey's ch. VI, "At Home at Court," provides some useful background information for the decline of equestrian portraiture as a court art. A side-saddle *levade*, or *pesade* (as seen in Grant's picture) is not impossible: see John Swire, *Anglo-French Horsemanship*, London, 1908, ill. facing p. 63.

41 Compare the painting by Stubbs cited in n. 31. For earlier Dutch examples, see *In het zadel*, nos. 20, 28, etc.

42 See Oliver Millar, *The Queen's Pictures*, New York, 1977, p. 183, for the photograph on which Landseer's painting is based, and Campbell Lennie, *Landseer*, London, 1976, pp. 217-19, on the picture's cool reception at the Royal Academy exhibition of 1867.

BIBLIOGRAPHY

Ackerman, J., *The Architecture of Michelangelo*, London, 1961

Aggházy, M.G., "La statuette équestre de Léonard de Vinci," *Bulletin du Musée Hongrois des Beaux-Arts*, XXXVI (1971), pp. 61–78

Amsterdam, Rijksprentenkabinet, *Vorstenportretten uit de eerste helft van de 16de eeuw*, 1972

Avery, C., "Hubert Le Sueur, the 'unworthy Praxiteles' of King Charles I," *Walpole Society*, XLVIII (1980–82) pp. 135–209

———, "An equestrian statuette of Louis XIII attributed to Simon Guillain (1581–1658)," *The Burlington Magazine*, CXXVI (1984), pp. 553–54

——— : see *Giambologna*.

Azcárate, J.M. de, "Noticias sobre Velázquez en la corte," *Archivo Español de Arte*, XXXIII (1960), pp. 357–85.

Baldinucci, F., *Notizie dei Professori del Disegno...*, Florence, 1846 (first ed.: 1681–1728)

Bartsch, A., *Le Peintre-Graveur*, Leipzig, 1854–76

Benot, Y., *Diderot et Falconet*, Paris, 1958

Berger, R.W., Bernini's *Louis XIV Equestrian*: A Closer Examination of its Fortunes," *The Art Bulletin*, LXIII (1981), pp. 232–48 (see also Guy Walton's supportive letter in *AB* 1982, pp. 319–20)

———, *In the Garden of the Sun King: Studies on the Park of Versailles under Louis XIV*, Washington, 1985

Berjeau, P.C., *The Horses of Antiquity, Middle Ages, and Renaissance*, London, 1864

Blunt, A., *Art and Architecture in France 1500 to 1700*, Baltimore, 1973 (2nd revised edition)

Bologna, Museo Civico Archeologico, *I Bronzi di Piacenza: Rilievi e figure di Francesco Mochi dai monumenti equestri farnesiani*, 1986 (exhibition catalogue)

Bottenheim, M.H., "Keizerlijke en Koninklijke boekkunst in de eerste helft van de 16e eeuw," *Bulletin van het Rijksmuseum*, IV (1956), pp. 109–10, for a printed equestrian portrait by Jean Goujon

Bowie, B.M., with photographs by Volkmar Wentzel, "The White Horses of Vienna," *The National Geographic Magazine*, CXIV (1958), pp. 401–19

Brookner, A., *Jacques-Louis David*, London, 1980

Brown, C., *Van Dyck*, Ithaca, N.Y., 1982

Brown, J., *Velázquez, Painter and Courtier*, London and New Haven, 1986, especially ch. IV, "Images of Power and Prestige"

Brown, J., and Elliott, J.H., *A Palace for a King*, New Haven and London, 1980 (on the Buen Retiro)

Bühler, Hans (intro.), *Reiterbilder in der europäischen Malerei*, Zurich, 1949 (small picture book with brief notes)

Bundesministerium für Land- und Forstwirtschaft, ed., *The Spanish Riding School of Vienna*, Vienna, 1970, with bibliography

Bush, V.L., *The Colossal Sculpture of the Cinquecento*, New York, 1976

———, "Leonardo's Sforza Monument and Cinquecento Sculpture," *Arte Lombarda*, L (1978), pp. 47–68

Calabrini, Marchese, "The Gonzaga horses: Their place in history and art," *Connoisseur*, CLXVI, no. 667 (Sept. 1967), pp. 38–40 (also for equestrian statues in wood)

Camins, L., *Glorious Horsemen: Equestrian Art in Europe, 1500–1800*, Museum of Fine Arts, Springfield, Mass., 1981

Camón Aznar, J., *Velázquez*, Madrid, 1964

Carlos, A. de, "El Caballo Español," *Reales Sitios*, IX (1972), pp. 57–64

———, "400 Años de la Escuela Española de Equitación de Viena," *Reales Sitios*, IX (1972), pp. 71–75

Caturla, M.L., "Otros dos cesares a caballo zurbaranescos," *Archivo Español de Arte*, XXXVIII (1965), pp. 197–201

Chiego, W., "Géricault, Carle Vernet, and sour grapes at the Salon of 1812," *Arts*, LVI (1981–82), pp. 96–101, on Géricault's *Portrait équestre de M.D.* (*The Chasseur*), its sources and reception

Chilston, Viscountess, "The Dauphin's Riding Lessons," *Country Life*, LXIII, no. 1638 (9 June 1928), pp. 833–36, on tapestries after Jordaens

Christian IV and Europe, The 19th Art Exhibition of the Council of Europe, Denmark (Foundation for Christian IV Year 1988), 1988

Clark, K., and Pedretti, C., *The Drawings of Leonardo da Vinci in the Collection of Her Majesty the Queen at Windsor Castle*, London, 1968

Colombier, P. du, *Jean Goujon*, Paris, 1949

Coppel, R., "A newly-discovered signature and date for Filarete's 'Hector'," *The Burlington Magazine*, CXXIX (1987), pp. 801–02

Covi, D., "Verrocchio and Venice, 1469," *The Art Bulletin*, LXV (1983), pp. 253–73, with sloppy bibliographical references

Crawford Volk, M., "Rubens in Madrid and the decoration of the Salón Nuevo in the Palace," *The Burlington Magazine*, CXXII (1980), pp. 168–80

Dahl, I., *Das Barocke Reitermonument* (Diss., Ludwig-Maximilians-Universität, Munich), Düsseldorf, 1935

Dent, A., *The Horse through Fifty Centuries of Civilization*, London, 1974

Dhanens, E., *Jean Boulogne*, Brussels, 1956

Diaz Padrón, M., *Museo del Prado, Catálogo de Pinturas*, I. *Escuela Flamenca siglo XVII*, Madrid, 1975

Dordrecht, Dordrechts Museum, *Aelbert Cuyp en zijn familie*, 1977

Duverger, J., "De rijschool of grote en kleine paarden in de XVIIe eeuwse tapijtkunst," in *Het Herfsttij van de Vlaamse Tapijtkunst*, Brussels, 1956, pp. 121–76

Edinburgh, Royal Scottish Museum, and London, Victoria and Albert Museum, *Giambologna 1529-1608 Sculptor to the Medici*, 1978

Eitner, L., *Géricault, his life and work*, London, 1983

Elliott, J.H., *The Count-Duke of Olivares: The Statesman in an Age of Decline*, New Haven and London, 1986 (see R. Carr's review in *New York Review of Books*, Nov. 20, 1986, pp. 39–41)

——— : See Brown and Elliott

Equus Magazine, no. 123 (Jan. 1988), for articles on "Rehabilitating the rearer" (by K. Romeiser) and on "Balance" (by D. Bennett)

Fleitmann, L.L., *The Horse in Art from Primitive Times to the Present*, London, 1931 (long, chatty survey)

Fock, C.W., "Nieuws over de tapijten, bekend als de Nassause Genealogie," *Oud Holland*, LXXXIV (1969), pp. 1–28, with English summary, on equestrian double portraits in the form of tapestries designed by Bernard van Orley around 1530

———, "Goldsmiths at the Court of Cosimo II de' Medici," *The Burlington Magazine*, CXIV (1972), pp. 11–17

Friis, H., *Rytterstatuens Historie i Europa fra Oldtiden indtil Thorvaldsen*, Copenhagen, 1933 (550-page history of the equestrian monument, with 283 good, sometimes rare reproductions)

Froissard, J., *Equitation*, South Brunswick, New Jersey, 1967

———, *Classical Horsemanship for our Time*, Gaithersburg, Maryland, 1988

Gállego, J., *Vision y Simboles en la Pintura Española del Siglo de Oro*, Madrid, 1972

Gardes, G., "Le monument de Louis XIV à Lyon et les monuments équestres de ce roi aux XVIIe et XVIIIe siècles," *L'Art Baroque à Lyon*, Lyons (Institut d'Histoire de L'Art) 1975, pp. 79–161

Geisberg, M., *The German Single-Leaf Woodcut: 1500-1550*, revised and edited by Walter L. Strauss, New York, 1974

Giambologna: see Edinburgh, and Vienna

Gianoli, L., *Horses and Horsemanship through the Ages*, New York, 1969

Glück, G., "Jugendwerke von Rubens," *Jahrbuch der kunsthistorischen Sammlungen des Allerhöchsten Kaiserhauses*, XXXIII (1916), pp. 3–30 ("II. Die Frühen Reiterbildnisse")

Gould, C., *Leonardo. The Artist and the Non-Artist*, London, 1975, ch. 5 on the *Battle of Anghiari* and the Trivulzio Monument

——— , *Bernini in France*, Princeton, 1982

Grisone, F., *Gli ordini di cavalcare*, Naples, 1550

Grossmann, O., *Das Reiterbild in Malerei und Plastik*, Berlin, 1931

Gudiol, J., *Velázquez*, New York, 1974

Guillot, L., *Le cheval dans l'art*, Paris, 1927 (offers less than Fleitmann)

Habich, G., "Das Reiterdenkmal Kaiser Maximilian I. in Augsburg," *Münchner Jahrbuch der bildenden Kunst*, 1913, pp. 255–62

Hall, M., "Reconsiderations of sculpture by Leonardo da Vinci: a bronze statuette in the J.B. Speed Art Museum," *J.B. Speed Art Museum Bulletin*, XXIX (November 1973), fantastically attributing to Leonardo an equestrian statuette of about 1600

Handler, H., and Lessing, E., *Das Schönste aus der Spanischen Hofreitschule*, Vienna, 1975

Harris, E., "Cassiano del Pozzo on Diego Velázquez," *The Burlington Magazine*, CXII (1970), pp. 364–73

——— , "Velázquez's Portrait of Prince Baltasar Carlos in the Riding School," *The Burlington Magazine*, CXVIII (1976), pp. 266–75

——— , *Velázquez*, Oxford, 1982

Haskell, F., and Penny, N., *Taste and the Antique: The Lure of Classical Sculpture 1500–1900*, London and New Haven, 1981, especially nos. 3, 49, 55

Held, J.S., "Jordaens and the Equestrian Astrology," in *Miscellanea Leo van Puyvelde*, Brussels, 1949

——— , "Le roi à la ciasse," *The Art Bulletin*, XL (1958), pp. 139–49

——— , "Rubens's Sketch of Buckingham Rediscovered," *The Burlington Magazine*, CXVIII (1976), pp. 547–51

Henkel, A., and Schöne, A., *Emblemata*, Stuttgart, 1967

Heydenreich, L.W., "Marc Aurel und Regisole," *Festschrift für Erich Meyer*, Hamburg, 1959, pp. 146–59

——— , "Bemerkungen zu den Entwürfen Leonardos für das Grabmal des Gian Giacomo Trivulzio," *Studien zur Geschichte der europäischen Plastik: Festschrift Theodor Müller*, Munich, 1965, pp. 179–94

Hind, A.M., *Engraving in England in the Sixteenth and Seventeenth Centuries*, Part I (*Tudor Period*), Cambridge, 1955

Hollstein, F.W.H., *Dutch and Flemish Etchings, Engravings and Woodcuts, ca. 1450–1700*, Amsterdam, 1949–76

Hoogewerff, G.J., "Het spokend ruiterstandbeeld," *Maandblad voor Beeldende Kunsten*, XVIII (1941), pp. 257–66, on a painting by Weenix depicting an equestrian monument based on designs by Leonardo and Tacca

The Horses of San Marco, Metropolitan Museum of Art, New York, 1979, with essays by several authors

Horster, M., *Andrea del Castagno*, Ithaca, New York, 1980

Huemer, F., *Portraits I (Corpus Rubenianum Ludwig Burchard*, Part XIX), Brussels, 1977

In het zadel: see Leeuwarden

Jaffé, M., *Jacob Jordaens 1593–1678*, The National Gallery of Canada, Ottawa, 1968

Janson, H.W., "A Mythological Portrait of the Emperor Charles V," *Worcester Art Museum Annual*, I (1935–36), pp. 19–31 (on Pl. 48 here)

——— , "The Equestrian Monument from Cangrande della Scala to Peter the Great," in A.R. Lewis, ed., *Aspects of the Renaissance*, Austin and London, 1967, pp. 73–85

Johns, C.M.S., "Politics, Nationalism and Friendship in Van Dyck's 'Le Roi à la Ciasse'," *Zeitschrift für Kunstgeschichte*, LI (1988), no. 2, pp. 243–61

Junquera, P., "El Caballo en los Tapices del Patrimonio Nacional," *Reales Sitios*, IX (1972), pp. 25–40

Justi, C., *Diego Velázquez and his Times*, London, 1889

——— , *Velázquez y su Siglio*, Madrid, 1953

Kahr, M., *Velázquez: The Art of Painting*, New York, 1976

Kauffmann, C.M., *Catalogue of Paintings in the Wellington Museum*, London, 1982

Keller, U., *Reitermonumente absolutistischer Fürsten (Münchener Kunsthistorische Abhandlungen*, II), Munich and Zurich, 1971

Kelso, R., *The Doctrine of the English Gentleman in the Sixteenth Century*, Gloucester, Mass., 1964, pp. 154–56 on the importance of horsemanship

Keutner, H., *Sculpture Renaissance to Rococo*, Greenwich, Conn., 1969

Konecný, L., "Raphael's Reference of 1519 to Marcus Aurelius" (letter), *The Art Bulletin*, LXVII (1985), pp. 677–78, with M. Mezzatesta's reply

Lafolie, Ch. J., *Mémoires historiques relatifs à la fonte et à l'élévation de la statue équestre de Henry IV sur le terreplein du Pont-Neuf à Paris*, Paris, 1819

Larsson, L.O., *Adriaen de Vries*, Vienna, 1967

——— , "Antonio Tempesta och Ryttarporträttet under 1600-talet," *Konsthistorisk Tidskrift*, XXXVII (1968), pp. 34–42

——— "Bildhauerkunst und Plastik am Hofe Kaiser Rudolfs II.," *Leids Kunsthistorisch Jaarboek*, 1982, pp. 211–35

Leeuwarden, Fries Museum, *In het zadel: het Nederlands ruiterportret van 1550 tot 1900*, 1979–80

Levey, M., *Painting at Court*, New York, 1971

Levey, M., and Kalnein, W., *Art and Architecture of the Eighteenth Century in France*, Baltimore, Maryland, 1972

Levitine, G., *The Sculpture of Falconet*, Greenwich, Conn., 1972

Lewis, D., "Two Equestrian Statuettes after Martin Desjardins," *Studies in the History of Art*, VI (1974), National Gallery of Art, Washington, pp. 143–55

Lewy, E., *Pietro Tacca*, Cologne, 1928

Licht, F., *Canova*, New York, 1983

Liedtke, W.A., *Flemish Paintings in the Metropolitan Museum of Art*, New York, 1984

Liedtke, W.A., and Moffitt, J. M., "Velázquez, Olivares, and the Baroque Equestrian Portrait," *The Burlington Magazine*, CXIII (1981), pp. 529–37

Ligo, L., "Two seventeenth-century poems which link Rubens's equestrian portrait of Philip IV to Titian's equestrian portrait of Charles V," *Gazette des Beaux-Arts*, LXXV (1970), pp. 345–54

Litta, P., *Famiglie Celebri Italiane*, IX, Milan, 1868, on the Farnese family

Livingstone-Learmonth, D., *The Horse in Art*, London and New York, 1958

Llompart, G., "En torno a la iconografia renacentista del 'Miles Christi'," *Traza y Baza: Cuadernos Hispanos de Simbologia, Arte y Literatura*, I (1972), pp. 63–94

Loeser, Ch., "Gianfrancesco Rustici," *The Burlington Magazine*, LII (1928), pp. 260–72

London, Tate Gallery, *George Stubbs 1724–1806*, 1984

Lopez de Ayala, J. de Contreras (Marqués de Lozoya), "El 'Caballo Blanco', de Velázquez," *Varia Velazqueña*, Madrid, 1960, I, pp. 323–27

López-Rey, J., *Velázquez's Work and World, A Catalogue Raisonné of his Oeuvre*, London, 1963

Lopez Serrano, M., and Garcia Morencos, P., "Biblioteca de Palacio: Literatura Hipica Siglos XV–XVII," *Reales Sitios*, XI (1974), no. 39, pp. 29–36

Luttervelt, R. van, "De Grote Ruiter van Rembrandt," *Nederlands Kunsthistorisch Jaarboek*, VIII (1957), pp. 185–219, a rambling essay that wrongly identifies the sitter in the *Equestrian Portrait of Frederick Rihel*

Lützeler, H., "Zur Ikonologie des Pferd in der barocken Kunst," *Festschrift für Karl Lohmeyer*, Saarbrücken, 1954, pp. 118–24

Man and the Horse, Metropolitan Museum of Art, New York, 1984,

on riding and equestrian costume

Martinez de Espinar, Alonso, *Arte de Ballesteria y Monteria*, Madrid, 1664

Mateos, Juan, *Origen y dignidad de la caza*, Madrid, 1634

Mellen, P., *Jean Clouet*, London and New York, 1971

Meller, S., "I progetti di Antonio Pollaiuolo per la statue equestre di Francesco Sforza," in *Hommage à Alexis Petrovics*, Budapest, 1934, pp. 76–79, 204–05

Millar, O., *Van Dyck in England*, National Portrait Gallery, London, 1982

Ministerio de Educación Nacional, *Varia Velazqueña*, Madrid, 1960 (see also Lopez de Ayala)

Mitchell, S., *Dictionary of British Equestrian Artists*, Woodbridge (GB), 1985

Moffitt, J.R., "'Le Roi à la ciasse'?: Kings, Christian Knights, and Van Dyck's Singular 'Dismounted Equestrian Portrait' of Charles I," *Artibus et Historiae*, VII (1983) pp. 79–99

——— , "The Count-Duke of Olivares on Horseback: An Emblematic Equestrian by Velázquez," *Konsthistorisk Tidskrift*, LV (1986) pp. 149–67

Möller, L., "Marc Aurelius zu Pferde...," *Jahrbuch der Hamburger Kunstsammlungen*, II (1952), pp. 83–84

Müller, T., *Leonardo da Vinci, il cavallo*, Berlin, c. 1948, 32-page survey

Müller Hofstede, J., "Rubens' St. Georg und seine frühen Reiterbildnisse," *Zeitschrift für Kunstgeschichte*, XXVIII (1965), pp. 69–112

——— , "Die frühen Reiterbildnisse," in Cologne, Wallraf-Richartz-Museum, *Peter Paul Rubens 1577–1640, Katalog I*, 1977, pp. 84–93 (and entries on later pages)

Müller-Walde, P., "Beitrage zur Kenntnis des Leonardo da Vinci," *Jahrbuch der königlich preussischen Kunstsammlungen*, XX (1899), pp. 81–116

Müseler, W., *Riding Logic (Reitlehre)*, tr. by F.W. Schiller, New York, 1978

Nelson, K., "Jacob Jordaens as a Designer of Tapestries," Ph.D. Diss., University of North Carolina, Chapel Hill, 1979

Nesselrath, A., "Antico and Monte Cavallo," *The Burlington Magazine*, CXXIV (1982), pp. 353–57

Newcastle, William Cavendish, Duke of, *La Méthode Nouvelle et Invention Extraordinaire de Dresser les Chevaux*, Antwerp, 1657–58

New York, Metropolitan Museum of Art, *Liechtenstein: The Princely Collections*, 1985

O'Connell, S. "The Nosts: a revision of the family history," *The Burlington Magazine*, CXXIX (1987), pp. 802–05 (for equestrian monuments of George I)

Orso, S.N., *Philip IV and the Decoration of the Alcázar of Madrid*, Princeton, 1986

Paatz, W. and E., *Die Kirchen von Florenz*, III, Frankfurt am Main, 1952, pp. 371–72, 501–02 (n. 260) on the Farnese equestrian tomb monument (Pl. 17)

Panofsky, E., *Tomb Sculpture*, New York, n.d. (1964), pp. 83–85, figs. 378–92

——— , *Problems in Titian, Mostly Iconographic*, New York, 1969

Paris, Heim Gallery, *Le choix d'amateur*, 1975

Passe, C. van de, *'t Licht der Teken en Schilderkonst*, Amsterdam, 1643 etc. (reprinted Soest, 1973), Part V, pp. 2–21, on the anatomy and drawing of horses

Pedretti, C., and Roberts, J., *Leonardo da Vinci: Drawings of Horses and Other Animals from the Royal Library at Windsor Castle*, National Gallery of Art, Washington, 1985

Pemán, C., "Miscelánea Zurbaranesca," *Archivo Español de Arte*, XXXVII (1964), pp. 93–98

Peter-Raupp, H., *Die Ikonographie des Oranjezaal*, Hildesheim and New York, 1980

Planiscig, L., *Die Bronzeplastiken*, Vienna, 1924

Pluvinel, A. de, *La Maneige royal...*, Paris, 1623

——— , *L'Instruction du roy en l'exercise de monter à cheval*, Paris, 1625, etc.

Podeschi, J.B., *Books on the Horse and Horsemanship: Riding, Hunting, Breeding and Racing, 1400–1941 (Paul Mellon Collection Catalogue, Vol. IV)*, London, 1981

Podhajsky, A., *The White Stallions of Vienna*, London, 1963

Polzer, J., "Simone Martini's *Guidoriccio* Fresco: The Polemic Concerning its Origin Reviewed, and the Fresco Considered as Serving the Military Triumph of a Tuscan Commune," *RACAR (Revue d'art canadienne)*, XIV (1987), nos. 1–2, pp. 16–69

Pope-Hennessy, J., *Italian Renaissance Sculpture*, London, 1958 pp. 66–72 on Leonardo's studies for equestrian monuments

——— , *Paolo Uccello*, London, 1969

——— , *Italian High Renaissance and Baroque Sculpture*, London and New York, 1970, pp. 103–06, etc., on the equestrian statue

——— , *Raphael*, New York, 1970

Pühringer-Zwanowetz, L., "Ein Triumphdenkmal aus Elfenbein: die Reiterstatuetten Kaiser Leopolds I. und König Josephs I. von Matthias Steinl," *Wiener Jahrbuch für Kunstgeschichte*, XIX (1962), pp. 116–32

Radcliffe, A.: see *Giambologna*

Reinach, S., *La Représentation du galop dans l'art ancien et moderne*, Paris, 1925 (broad survey with 160 engraved figures)

Richter, J.P., *The Literary Works of Leonardo da Vinci*, London and New York, 1939

Roques de Maumont, H. von, *Antike Reiterstandbilder*, Berlin, 1958

Ruelens, Ch., and Rooses, M., *Correspondance de Rubens*, Antwerp, 1887–1909

Saurel, E., *Histoire de l'Equitation*, Paris, 1971

Scaglia, G., "Leonardo's Non-Inverted Writing and Verrocchio's Measured Drawing of a Horse," *The Art Bulletin*, LXIV (1982), pp. 32–33

Schlosser, J. von, "Aus der bildnerwerkstatt der Renaissance," *Jahrbuch der kunsthistorischen Sammlungen des Allerhöchsten Kaiserhauses*, XXXI (1913–14), pp. 119–28 on "Der 'cavallino'..."

Schmitt, A., "Paolo Uccellos Entwurf für das Reiterbild des Hawkwood," *Mitteilungen des Kunsthistorischen Institutes in Florenz*, III (1959), pp. 125–30

Schwartz, G., *Rembrandt, his life, his paintings*, New York, 1985

Seth-Smith, M., ed., *The Horse in Art and History*, New York, 1978

Siedentopf, H., *Das hellenistische Reiterdenkmal*, Waldsassen, 1968

Six, J., "Over Paulus Potter: naar aanleiding van zijn ruiterportret van Dirk Tulp, gegraveerd door P. Dupont," *Onze Kunst*, XI (Jan.-June 1907), pp. 3–17

Soós, G., "Antichi modelli delle statue equestri di Leonardo da Vinci," *Acta Historiae Artium: Academiae Scientarum Hungaricae*, IV, nos. 1–2, 1956, pp. 129–35

Soria, M.S., "Las Lanzas y los Retratos Ecuestres de Velázquez," *Archivo Español de Arte*, XXVII (1954), pp. 93–108

Springfield, 1981: see Camins

Steinmann, E., "Die Zerstörung der Königsdenkmäler in Paris," *Monatshefte für Kunstwissenschaft*, X (1917), pp. 337–80

Stendhal, *Memoirs of a Tourist*, tr. by A. Seager, Evanston, Illinois, 1985

Strauss, W. L., *The Complete Engravings, Etchings and Drypoints of Albrecht Dürer*, New York, 1973 (2nd ed.)

——— , *Hendrick Goltzius, 1558–1617, The Complete Engravings and Woodcuts*, New York, 1977

Strong, R., *Van Dyck: Charles I on Horseback (Art in Context)*, London, 1972

Suter, K.F., *Das Rätsel von Leonardos Schlachtenbild*, Strasbourg, 1937

Sutton, D., "Rubens's Portrait of the Duke of Lerma," *Apollo*, LXXVI (1962), pp. 118–23

Thiem, G., "Studien zu Jan van der Straet, genannt Stradanus,"

Mitteilungen des Kunsthistorischen Institutes in Florenz, VIII (1958), pp. 88–111

Thijssen, L.G.A., "'Diversi ritratti dal naturale a cavallo': een ruiterportret uit het atelier van Rubens geidentificeerd als Ambrogio Spinola," *Oud Holland*, CI (1987), pp. 50–64 (entirely erroneous essay)

Tormo, E., *Pintura Escultura y Arquitectura en España*, Madrid, 1949

Torriti, P., *Pietro Tacca da Carrara*, Genoa, 1975

Traeger, J., *Der reitende Papst. Ein Beitrag zur Ikonographie des Papsttums (Münchener Kunsthistorische Abhandlungen, I)*, Munich and Zurich, 1970

—— , "Der Bamberger Reiter in neuer Sicht," *Zeitschrift für Kunstgeschichte*, XXXIII (1970b), pp. 1–20

Unger, W. von, *Meister der Reitkunst*, Bielefeld and Leipzig, 1926, with 147 illustrations, some deliciously obscure

Valentiner, W.R., "The Equestrian Statue of Paolo Savelli in the Frari," *The Art Quarterly*, XVI (1953), pp. 280–93

Vargas Machuca, B. de, *Teoria y Exercicios de la Jineta*, Madrid, 1619

Varia Velazqueña: see Ministerio

Vienna, Kunsthistorisches Museum, *Giambologna 1529–1608 ein Wendpunkt der europäischen Plastik*, 1978

Vito, G. de, "The portraits of Giovan Carlo Doria by P.P. Rubens and S. Vouet," *The Burlington Magazine*, CXXIX (1987), pp. 83–84

Vlieghe, H., "Caspar de Crayer als Bildnismaler, seine Entwicklung bis etwa 1630," *Jahrbuch der kunsthistorischen Sammlungen in Wien*, LXIII (N.F. XXXVII; 1967), pp. 81–108

—— , *Gaspar de Crayer, sa vie et ses oeuvres*, Brussels, 1972

Volk, M.C.: see Crawford Volk

Volk, P., "Darstellungen Ludwigs XIV. auf steigendem Pferd," *Wallraf-Richartz-Jahrbuch*, XXVIII (1966), pp. 61–90

Voss, H., *Die grosse Jagd von der Vorzeit bis zur Gegenwart*, Munich, 1961 (picture book of the hunt in art)

Wall, A.J., "The Statues of King George III and The Honorable William Pitt Erected in New York City 1770," *New-York Historical Society Quarterly Bulletin*, IV (July 1920), no. 2, pp. 37–57

Wallhausen, J.J. von, *Art militaire à cheval*, Frankfurt, 1616 (also in German, Frankfurt 1616; and in Russian, Moscow 1647)

Warnke, M., *Kommentare zu Rubens*, Berlin, 1965

—— , "Das Reiterbild des Baltasar Carlos von Velázquez," *Amici Amico: Festschrift für Werner Gross...*, Munich, 1968, pp. 217–27

Washington, National Gallery of Art, *The Treasure Houses of Britain*, 1985

Watson, K.J., *Pietro Tacca: Successor to Giovanni Bologna...*, New York, 1977

Weihrauch, H., "Der Innsbrucker Brunnen des Kaspar Gras," *Pantheon*, XXXI (1943), pp. 105–11

Weizsäcker, H., "Das Pferd in der Kunst des Quattrocento," *Jahrbuch der königlich preussischen Kunstsammlungen*, VII (1886), pp. 40–57, 157–72

Wittkower, R., "The Vicissitudes of a Dynastic Monument: Bernini's Equestrian Statue of Louis XIV," *De Artibus Opuscula XL: Essays in Honor of Erwin Panofsky*, New York, 1961, pp. 497–531

—— , *Art and Architecture in Italy 1600–1750*, Baltimore, 1965

—— , *Gian Lorenzo Bernini*, London, 1966

Wölfflin, H., *Principles of Art History*, tr. by M.D. Hottinger, New York, 1932

PHOTOGRAPHIC ACKNOWLEDGEMENTS

BLACK AND WHITE PLATES

Photographs were provided by the owners of the works reproduced, except in the following instances.

Fratelli Alinari, Florence: 10, 11, 15, 18, 20, 21, 23, 24, 25, 40, 61, 67, 151, 152, 153, 157, 205

Réunion des musées nationaux, Paris: 13, 31, 104, 126, 154, 159, 160, 166, 167, 204

Author: 16, 17A, 68A-C, 74A-B, 75A-B, 106A, 187A, 202

Other: 2, Hirmer Fotoarchiv; 5A, Metropolitan Museum of Art, New York (MMA below); 7A, MMA; 8, 12, Anderson, Rome; 14, Bildarchiv Foto Marburg; 17, New York Public Library; 22A, 26A, MMA; 36, MMA (ESDA); 40A, Archivo Fotograf. Gall. Mus. Vaticani; 41, Sheldan Collins; 44, Frick Art Reference Library; 52, Bibl. Nat., Paris; 60, Haig Oundjian, Baltimore; 71A, New York Public Library; 72, G.F.N., Rome; 76, Bundesdenkmalamt, Vienna; 94, MAS; 96, G.F.N., Rome; 97, MAS; 102, MMA (EP); 103, Dir. Belle Arti, Genoa; 105, MMA (EP); 116, G.F., Soprintendenza, Florence; 120, Pátrimonio Nácionál, Madrid; 124, National Gallery of Art, Washington; 130, Courtauld Institute of Art, London (CIA); 134, MMA (EP); 137, CIA; 140, ACL, Brussels; 144, Kunsthistorisch Instituut, Rijksuniversiteit Utrecht; 145, Museum of Fine Arts, Springfield, Mass.; 148, CIA; 155, Biblioteca e Archivio di Bassano del Grappa; 156, Robert Berger; 162, Bibl. Nat., Paris; 163, CIA; 178, A. Dingjan, The Hague; 187, MMA (ESDA); 190, Sotheby's; 193, Bruce Jones, New York; 198, Tate Gallery, London; 210, Christie's; 212A, Lichtbildstelle BMfLuF, Vienna; 216, MMA; 220, Volkmar Wentzel, National Geographic Society

TEXT FIGURES

Most of the text figures duplicate plates and are cross-referenced in the captions. The following credits are for photographs reproduced only in the text or repeated without a cross-reference: 4, see Pl. 112; 6, see Pl. 220; 28, MMA; 34, MMA (EP); 44, Royal Library, Windsor; 46, Deutsches Archäologisches Institut, Rome; 71, Alinari; 72, Deutsches Archäologisches Institut, Rome; 75, see Pl. 220; facing Ch. 2, see Pl. 51; facing Ch. 3, author.

COLORPLATES

Transparencies were provided by the owners of the works reproduced, except in the following instances.

Scala, Florence: 1, 3–6, 11

Archivo Oronoz, Madrid: 10, 12, 13, 15–19, 22, 34

Réunion des musées nationaux, Paris: 7, 14, 24, 25

Other: 2, Sheldan Collins; 9, Hamilton-Kerr Institute; 20, National Gallery of Art, Washington.

COLORPLATES

1 Roman, about 150–250 A.D., *The Horses of San Marco*. Venice, Cathedral of San Marco. (Plate 10)

2 Simone Martini, *Guidoriccio da Fogliano*, inscribed 1328. Siena, Palazzo Pubblico, Council Chamber. (Plate 15)

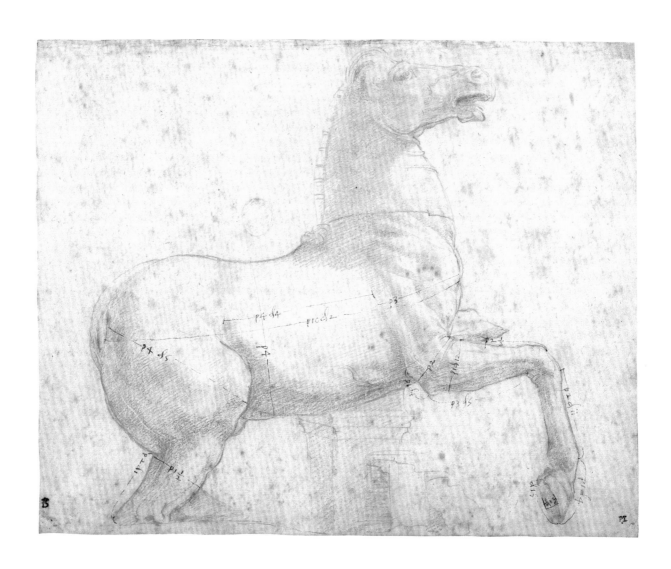

3 Raphael, *Study of one of the Quirinal Horses,* about 1518(?). New York, Ian Woodner Family Collection. (Plate 41)

IOANNES·ACVTV·SEQVES·BRITANNICVS·DVX·AETATIS·S
VAE·CAVTISSIMVS·ET·REI·MILITARIS·PERITISSIMVS·HABITVS·EST

·PAVLI·VGIELLI·OPVS·

4 Paolo Uccello, *Equestrian Monument of Sir John Hawkwood*, 1436. Florence, Duomo. (Plate 20)

5 Andrea del Castagno, *Equestrian Monument of Niccolò da Tolentino*, 1455–56. Florence, Duomo. (Plate 21)

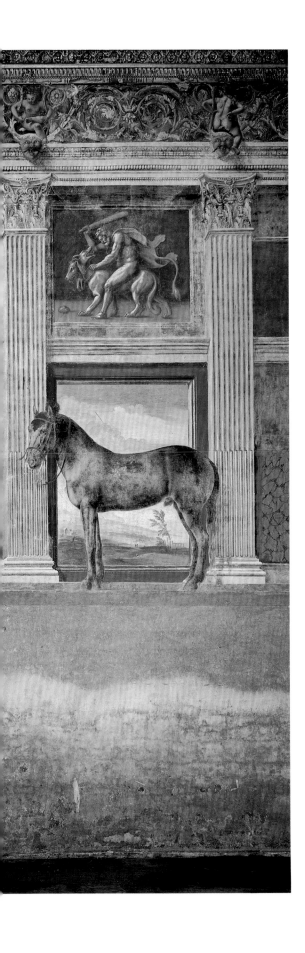

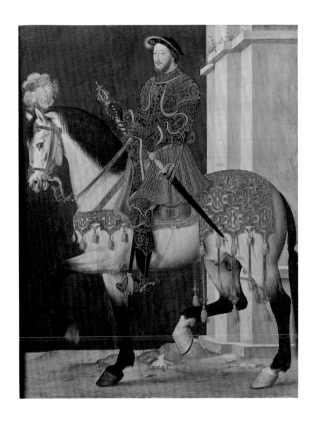

6 Giulio Romano and assistants,
Part of the fresco decoration of the Sala
dei Cavalli in the Palazzo del Te,
Mantua, 1530–35. (Plate 44)

7 Attributed to Jean Clouet,
Equestrian Portrait of Francis I.
Paris, Musée du Louvre.

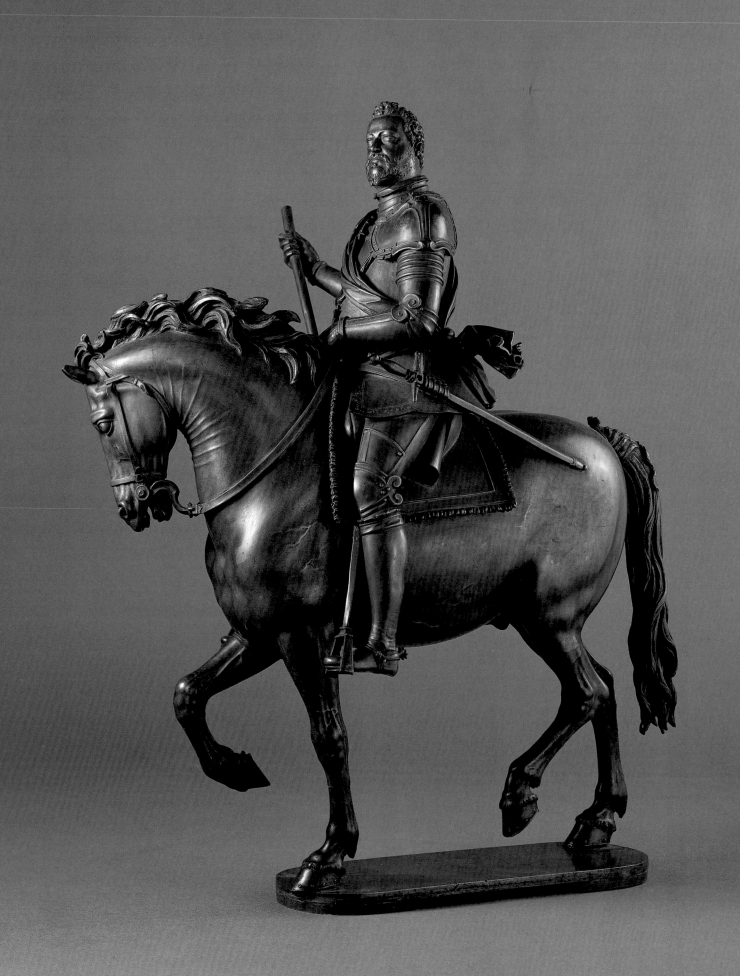

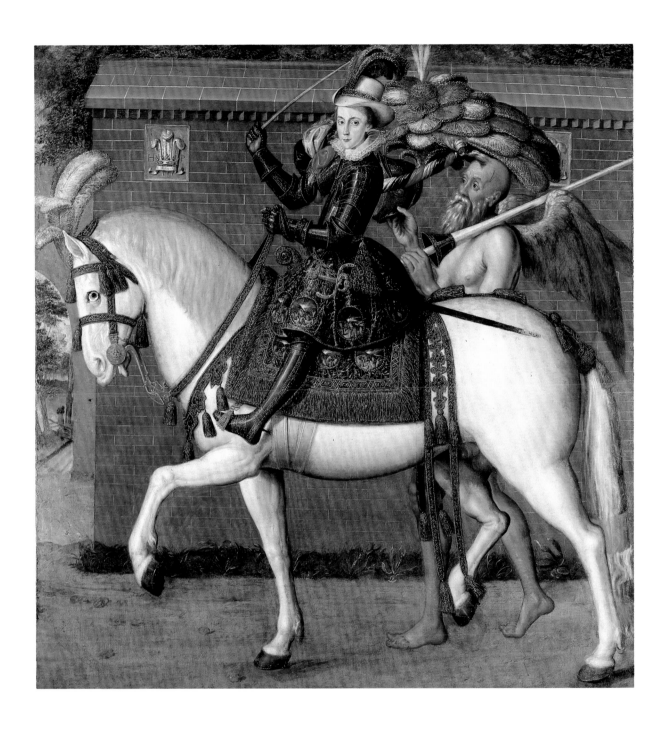

8 Giambologna, *Equestrian Statuette of Ferdinando de' Medici*, cast about 1600, modified from a design of about 1587–93. Vaduz, Collection of the Princes of Liechtenstein. (Plate 65)

9 Robert Peake the Elder, *Equestrian Portrait of Henry, Prince of Wales (1594–1612)*, about 1610. Parham Park, Mrs. P.A. Tritton. (Plate 124)

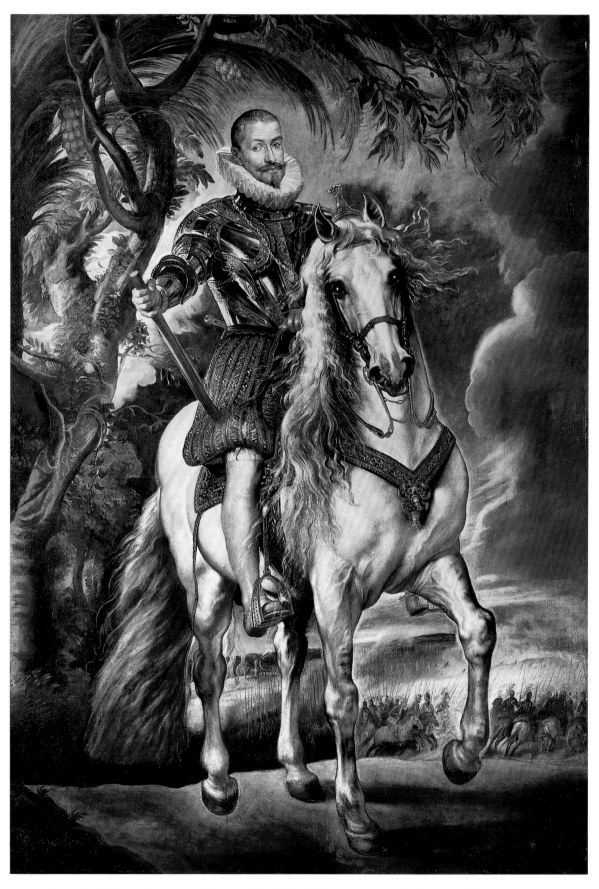

10 Peter Paul Rubens, *Equestrian Portrait of the Duke of Lerma*, 1603. Madrid, Museo del Prado. (Plate 94)

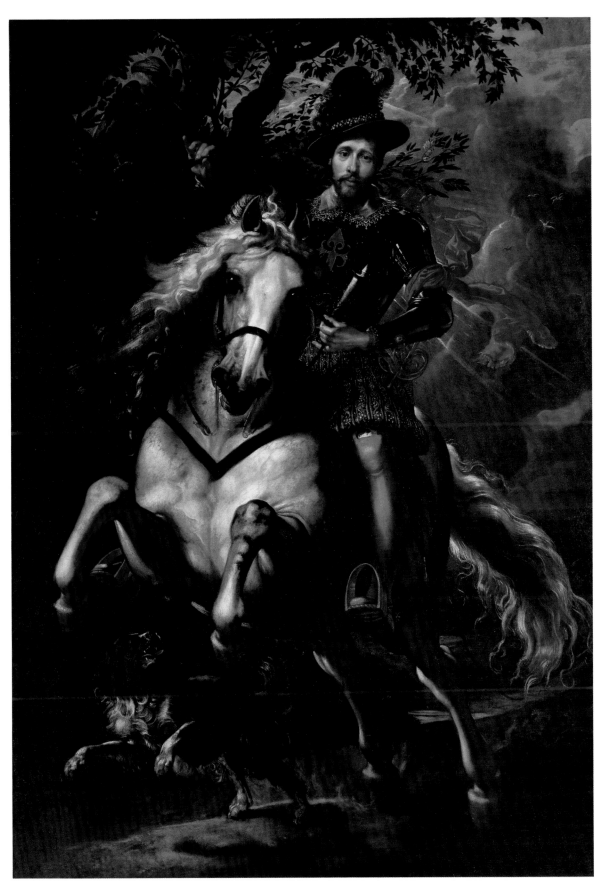

11 Peter Paul Rubens, *Equestrian Portrait of Giancarlo Doria*, about 1606. Florence, Palazzo Vecchio. (Plate 96)

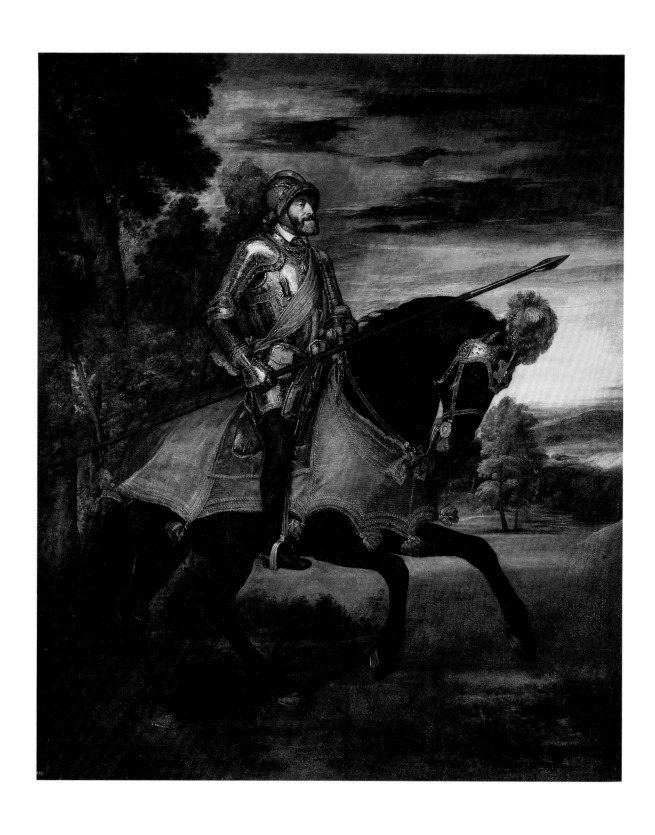

12 Titian, *Charles V at Mühlberg*, 1548. Madrid, Museo del Prado. (Plate 51)

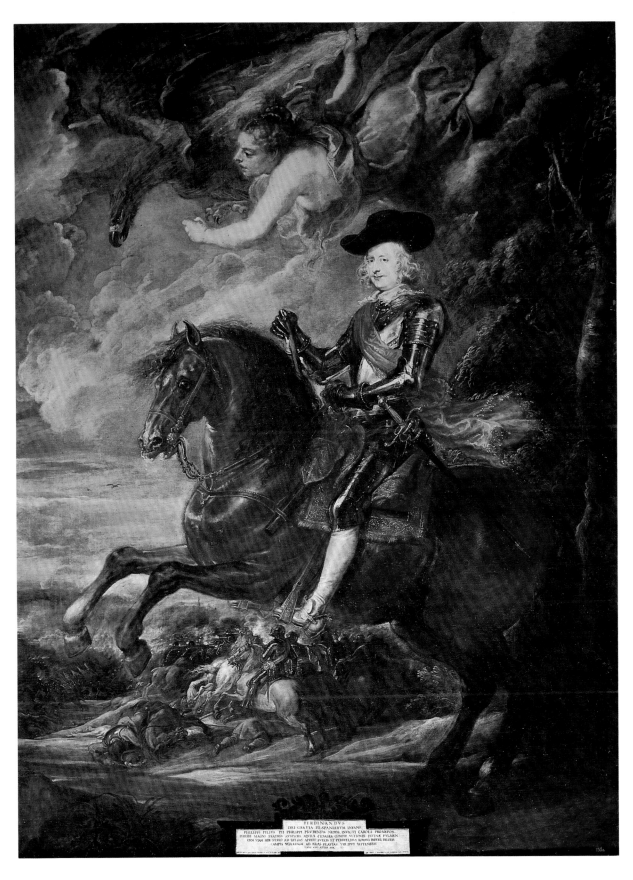

13 Peter Paul Rubens, *The Cardinal-Infante Ferdinand at the Battle of Nördlingen*,
about 1635. Madrid, Museo del Prado. (Plate 139)

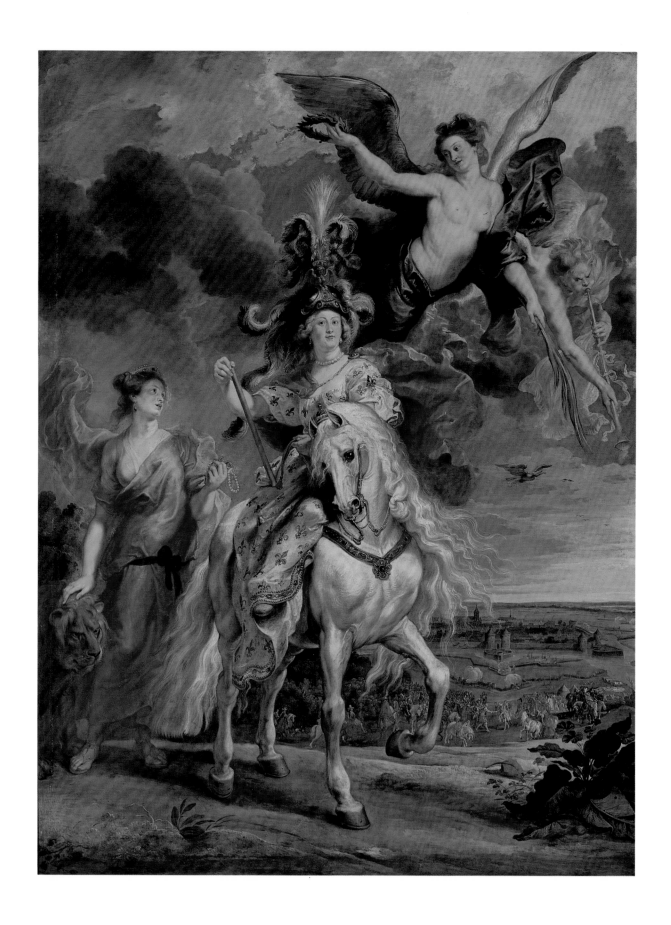

14 Peter Paul Rubens, *The Triumph of Juliers*, 1622–25. Paris, Musée du Louvre. (Plate 104)

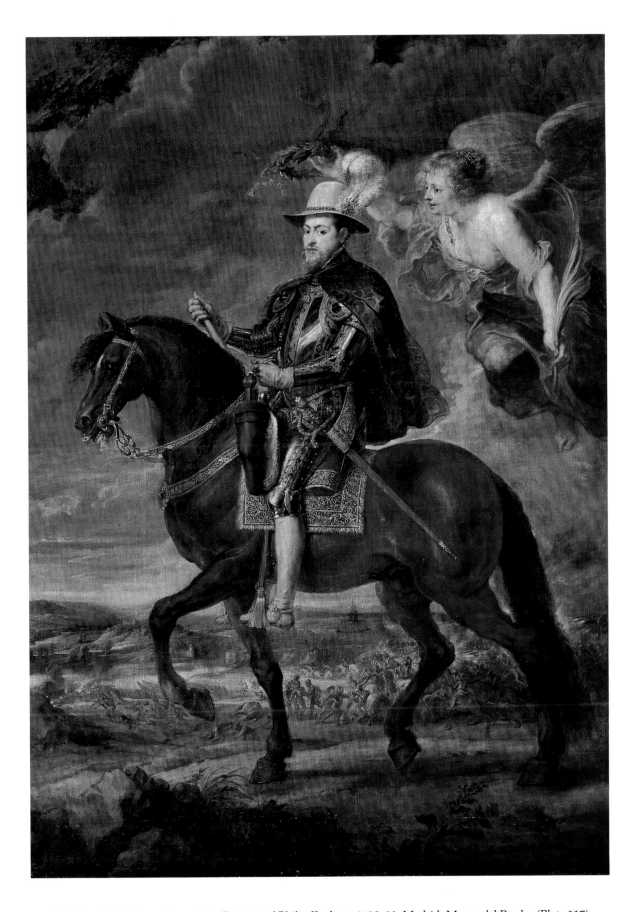

15 Peter Paul Rubens, *Equestrian Portrait of Philip II*, about 1628–29. Madrid, Museo del Prado. (Plate 117)

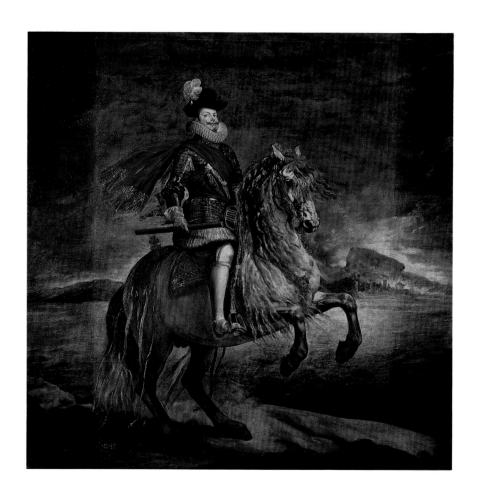

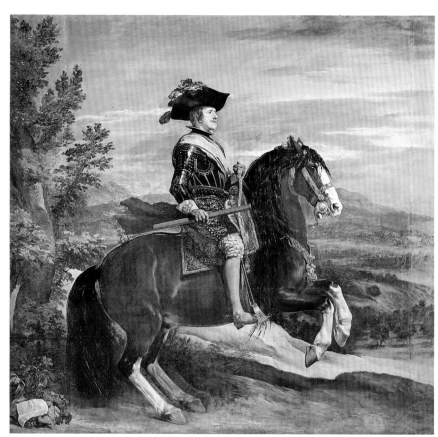

16 Velázquez and assistants,
Equestrian Portrait of Philip III,
completed by about 1634.
Madrid, Museo del Prado.
(Plate 110)

18 Velázquez, *Equestrian Portrait
of Philip IV*, 1634–35.
Madrid, Museo del Prado.
(Plate 112)

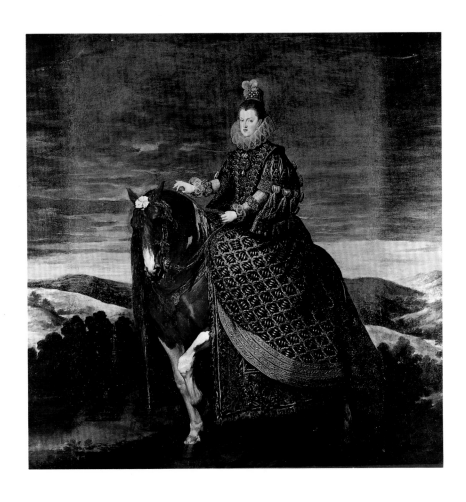

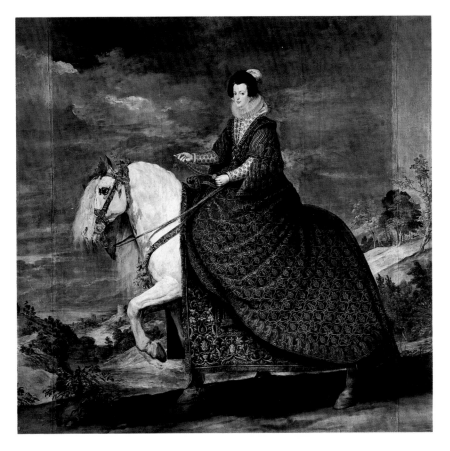

17 Velázquez and assistants,
*Equestrian Portrait of Margarita
of Austria, wife of Philip III*,
completed by about 1634.
Madrid, Museo del Prado.
(Plate 111)

19 Velázquez and assistants,
*Equestrian Portrait of Isabella
of Bourbon, wife of Philip IV*,
completed by about 1634.
Madrid, Museo del Prado.
(Plate 113)

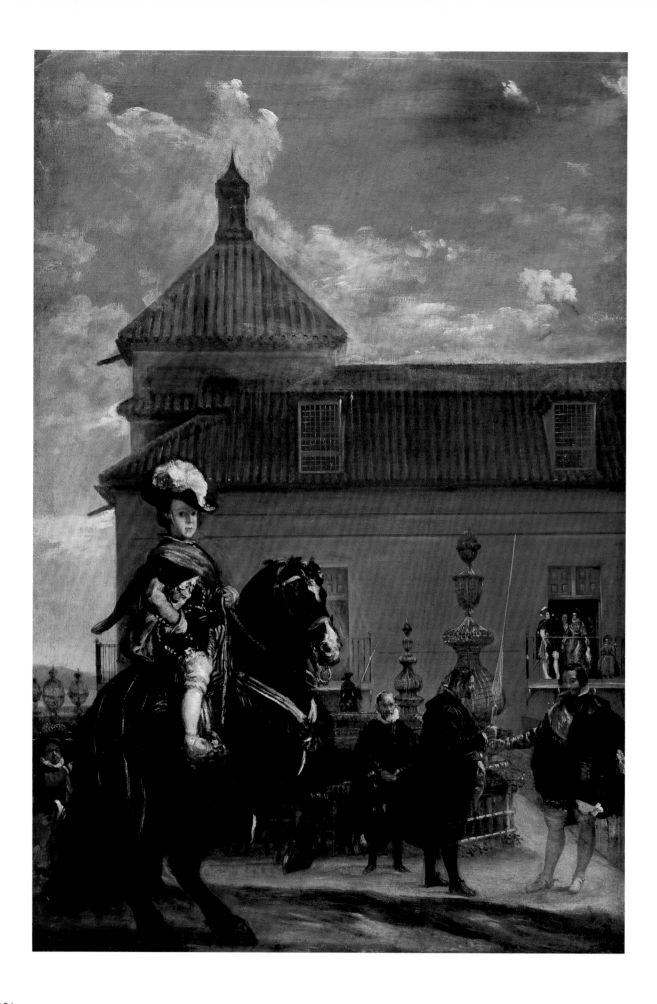

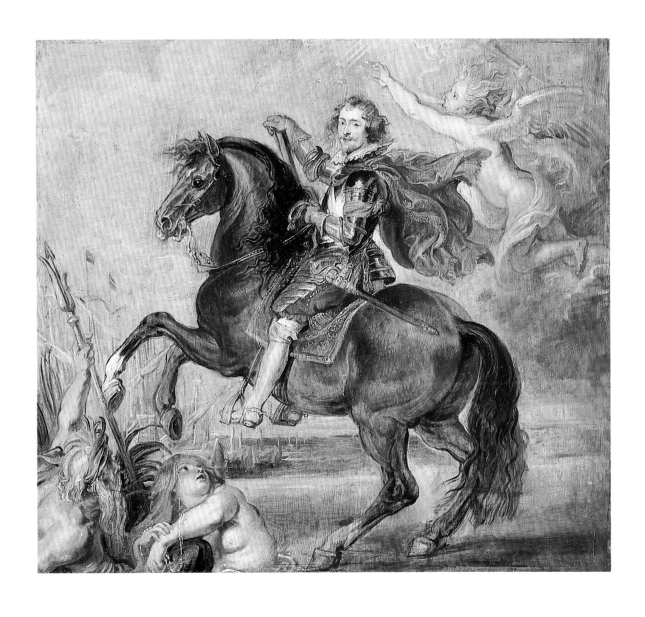

20 Velázquez, *Prince Baltasar Carlos in the Riding School*, about 1636–37. By kind permission of His Grace The Duke of Westminster, DL. (Plate 122)

21 Peter Paul Rubens, *Equestrian Portrait of George Villiers, Duke of Buckingham*, late 1625. Forth Worth, Texas, Kimbell Art Museum. (Plate 129)

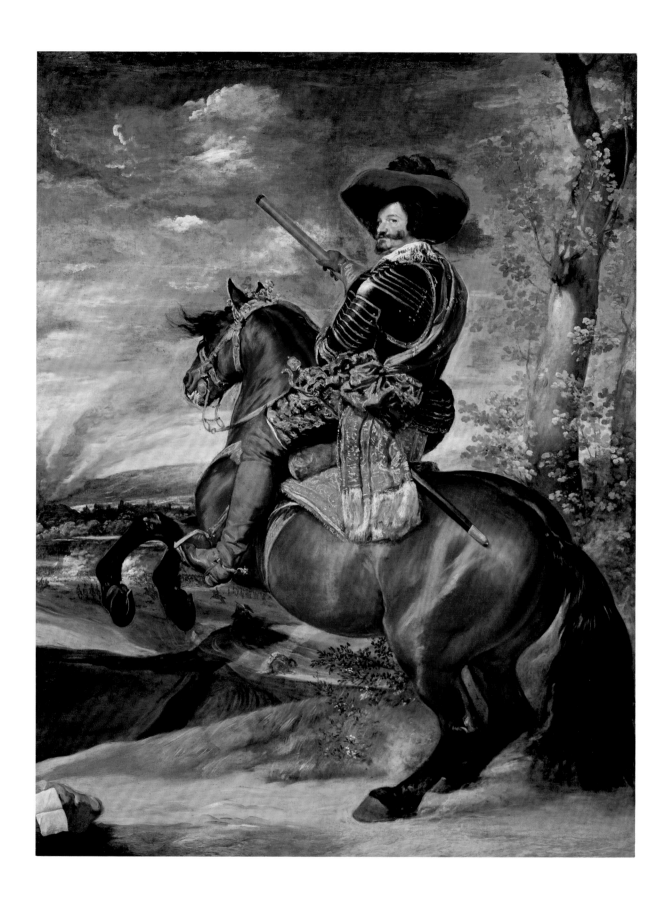

22 Velázquez, *Equestrian Portrait of the Count-Duke Olivares*, probably painted about 1636.
Madrid, Museo del Prado. (Plate 119)

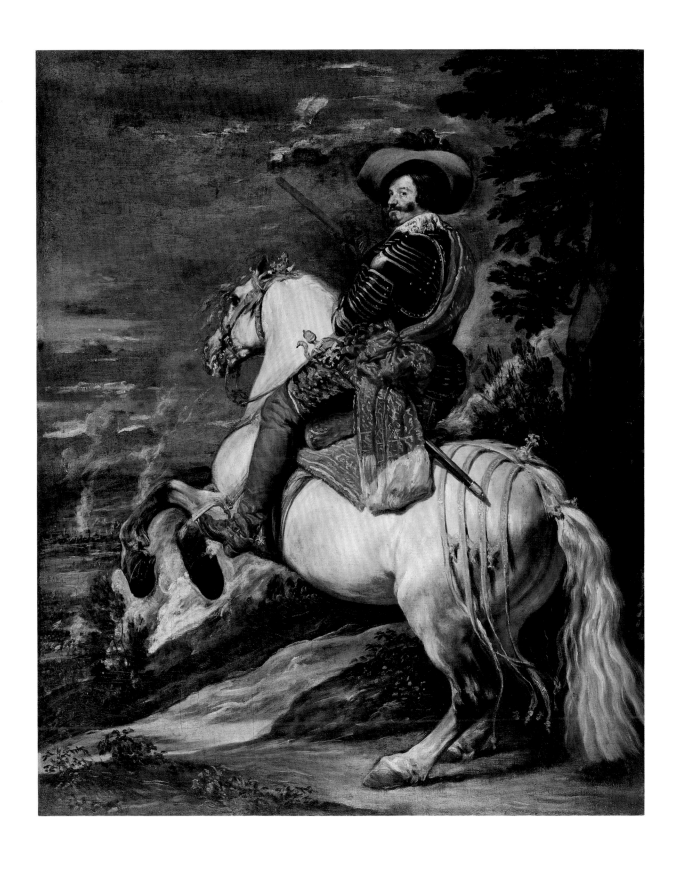

23 A smaller version of the Prado picture (Plate 22) variously attributed to Velázquez, to Mazo, and to Velázquez and studio. Canvas, 50¼×41 in. (127.6×104.1 cm). New York, Metropolitan Musuem of Art.

24 Charles Lebrun, *The Chancellor Séguier on Horseback*, 1661. Paris, Musée du Louvre. (Plate 166)

25 Anthony van Dyck, *"Le Roi à la ciasse" (Charles I at the Hunt)*, 1635. Paris, Musée du Louvre. (Plate 126)

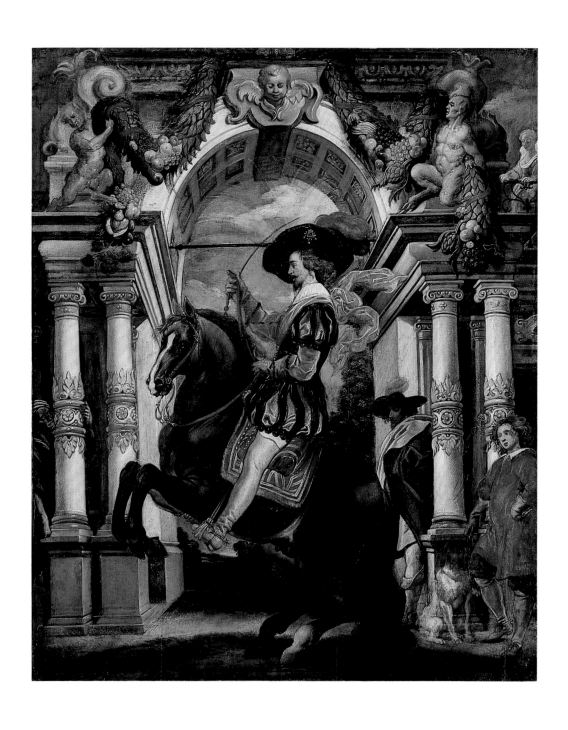

26 Jacob Jordaens, *A Cavalier on a Horse Executing a Levade*, about 1635–45.
Springfield, Mass., Museum of Fine Arts, The Gilbert H. Montague Collection. (Plate 143)

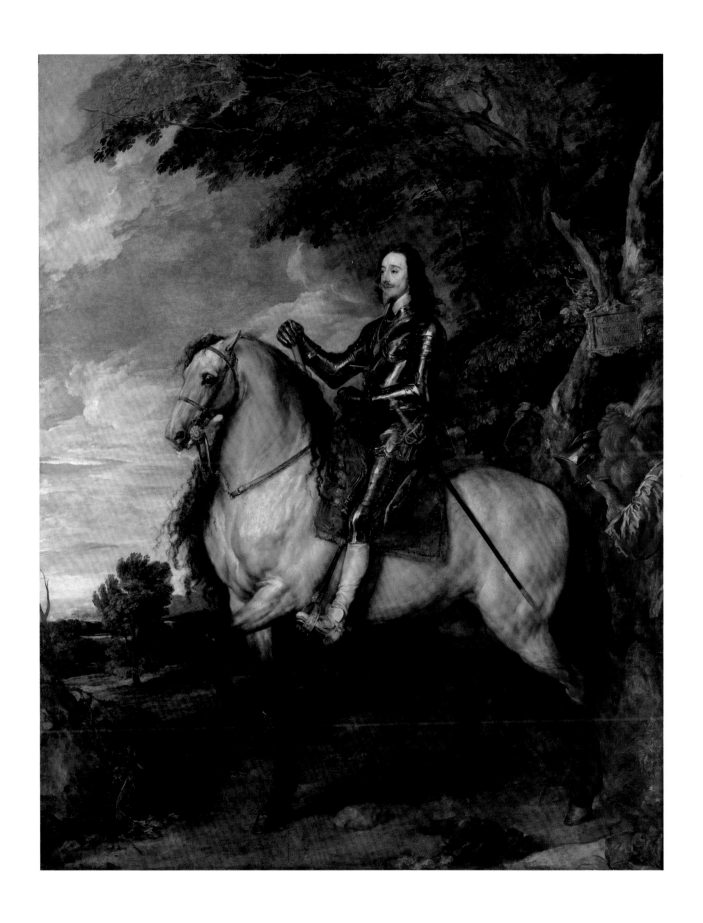

27 Anthony van Dyck, *Equestrian Portrait of Charles I*, about 1638. London, The National Gallery. (Plate 132)

28 Aelbert Cuyp, *Starting for the Hunt: Michiel (1638–1653) and Cornelis (1639–1680) Pompe van Meerdervoort with their Tutor and Coachman*, about 1653.
New York, Metropolitan Museum of Art, The Friedsam Collection. (Plate 184)

29 Rembrandt, *Equestrian Portrait of Frederick Rihel*, 1663. London, The National Gallery. (Plate 181)

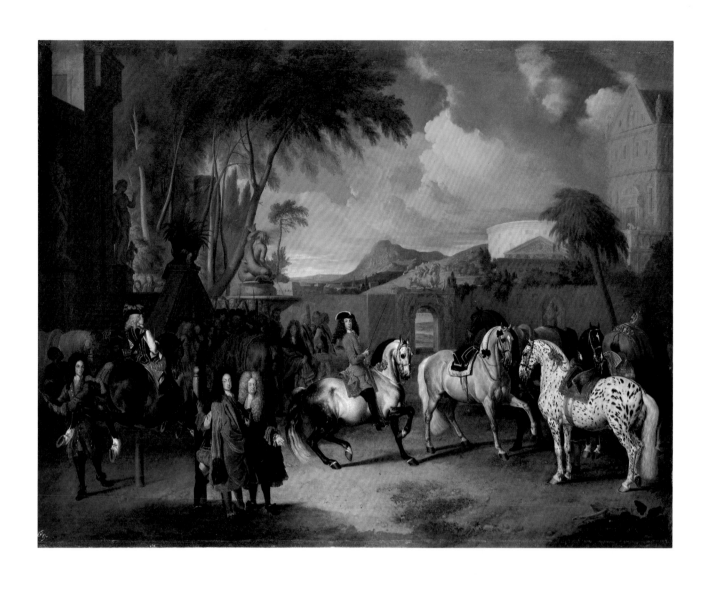

30 Johann Georg von Hamilton, *The Imperial Riding School in Vienna*, about 1700–03.
Vaduz, Collection of the Princes of Liechtenstein. (Plate 186)

31 Johann George von Hamilton, *Portrait of a Piebald Horse from the Eisgrub Stud,* 1700.
Vaduz, Collection of the Princes of Liechtenstein. (Plate 172)

32 Sir Henry Raeburn, *The Drummond Children*, about 1812.
New York, Metropolitan Museum of Art. (Plate 201)

33 Sir Joshua Reynolds, *Colonel George K.H. Coussmaker (1759–1801), Grenadier Guards.*
Canvas, 93¾x57¼ in. (238.1x145.4 cm). New York, Metropolitan Museum of Art.

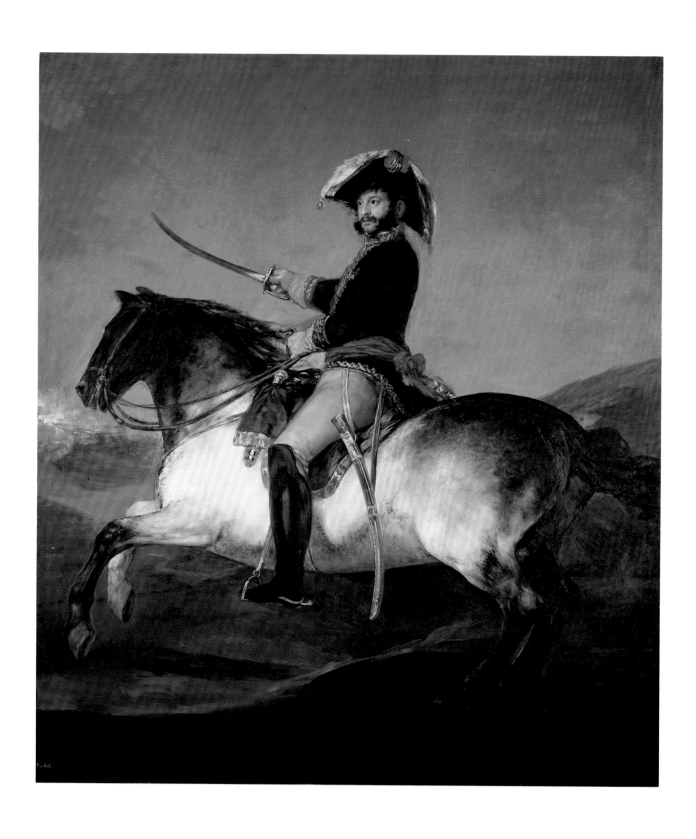

34 Goya, *General José de Palafox*, 1814.
Canvas, 97²⁄₃x88¹⁄₆ in. (248x224 cm). Madrid, Museo del Prado.
(Compare Plate 206)

ANTHOLOGY
OF EQUESTRIAN ART
(300 B.C. TO 1900 A.D.)

PLATES AND COMMENTARIES

1 Probably Greek, 4th Century B.C.,
Horse and Rider.
Marble relief, about 18 in. (46 cm) high.
New York, Metropolitan Museum of Art.

This is probably a decorative, not votive,
sculpture, and is almost certainly a fragment
of a relief that depicted two mounted
horses. A similar relief in Madrid features
essentially the same horse and rider.
Works such as this were ultimately
inspired by the famous cavalcade
on the Parthenon frieze and
by grave stelae by followers of
Phidias. The style here,
however, is Late Classical; as
in the case of the small bronze
horse reproduced in Plate 3,
copies and versions of
this type were produced in
the 1st century B.C. for
the Roman market.

2 Greek, about 300 B.C., detail of the so-called
Alexander Sarcophagus.
Marble relief, 45¼ in. (115 cm) high.
Istanbul, Archaeological Museum.

The sarcophagus was discovered at Sidon and was
probably intended not for Alexander but for his ally,
Abdalonimus, King of Sidon (died 304 B.C.). The
relief's style follows that of Lysippus (active mid- to
late 4th century), Alexander's portraitist, who,
according to Pliny, carved many animals, including
horses in quadrigas. As in the famous cavalcade on
the Parthenon frieze (part of the Elgin Marbles in
The British Musuem; about 440 B.C.), the horses'
poses are somewhat repetitive—and therefore
rhythmic—but naturalistically conceived. In this
section the horses' positions and expressions suggest
the desperation of battle and even the pain inflicted
by the fierce Greek bits (the riders once held reins in
one hand).

3 Greek, 1st Century B.C. to 1st Century A.D.,
Walking Horse. Bronze, 15¼ in. (38.7 cm) high.
New York, Metropolitan Museum of Art.

This work closely follows Early Classical examples
of about 480–470 B.C., and was very likely produced
for the Roman market. The interest of wealthy
private collectors in equestrian art of an earlier
period and the production of deceptively faithful
copies occurred again in the Renaissance and Baroque
periods—in each case at a time when equestrian
monuments flourished as a public art form.

143

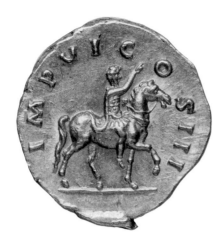

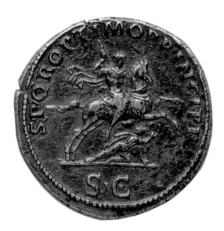

5 Roman, *Sestertius of Trajan,* 104–111 A.D.
Bronze, 3.5 cm. diameter.
New York, The American Numismatic Society.

The "Optimo Principi," as the coin is inscribed, rides
over a fallen enemy at full speed. The type occurs on
other coins and on gems during this period, but it
does not follow (as one recent writer suggests) that
the coin may record the form of the *"Equus Traiani"*
erected in the Roman Forum in 114 A.D. (see Pl. 6).
The leaping action (very different than a rear), which
is to be understood as occurring in mid-gallop (like
clearing fences in an English fox hunt), anticipates
the pose found in many Medieval and Renaissance
paintings and sculptures of St. George battling the
dragon (Pls. 37, 38) and the Baroque re-presentation
of that pose from a more dramatic ("fox's-eye"?)
point of view (Pls. 96, 115).

5A *Discorso di M. Sebastiano Erizzo sopra
le Medaglie Antiche,* Venice, 1559, p. 216.

4 Roman, *Aureus of Marcus Aurelius,*
173–74 A.D.
Gold, 2.2 cm. diameter.
New York, The American Numismatic Society.

Roman coins, which were eagerly collected during
the 16th century, strongly reinforced the
association between equestrian portraiture and
imperial authority and provided examples more
varied than those known from surviving statuary.
Here, as in the contemporary monument of Marcus
Aurelius (Pl. 8), the horse trots; on the reverse of the
otherwise very similar sestertius of Antoninus Pius
(151–52 A.D.) the horse walks and rather resembles
Gattamelata's steed (Pl. 24). The use of ancient coins
by Renaissance and Baroque artists has only begun
to be explored. That avid scholar of ancient
evidence, Rubens, may have had a Roman coin such
as this one before him when he drew his equestrian
portrait of Philip II (Pl. 117).

216 DICHIARATIONE

DI TRAIANO.

IN RAME.

LA MEDAGLIA di Traiano grãde, di
bel metallo, con lettere, che dicono. IMP.
CAES. NERVAE. TRAIANO. AVG. GER. DAC. P. M.
TR. P. COS. V. P. P. Ha per riuerſo vna ſta-
tua equeſtre di Traiano, armato, che va ad-
doſſo à gli inimici, có vn dardo nella deſtra
mano, con lettere di ſopra. S. P. Q. R. OPTI-
MO. PRINCIPI. &. S. C. Queſta medaglia fu
battuta à particolar onore di Traiano.

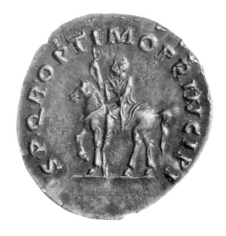

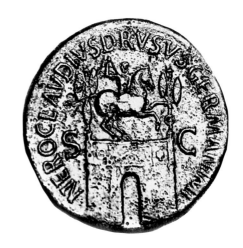

6 Roman, *Denarius of Trajan,* 114 A.D.
Silver, 2 cm. diameter.
London, The British Museum.

This coin, as Roques de Maumont (1958, p. 52) observes, must record the "horse of Trajan," a gilded bronze equestrian statue erected in the emperor's forum in Rome in 114 A.D. The use of a lance, providing a fourth "foot" on the ground, supports this hypothesis. The pose, a trot with a rather high foreleg, is (or became, because of Trajan's monument?) characteristic of the 2nd century A.D. (compare Pls. 8, 9, 10). It was almost certainly this equestrian portrait of Trajan, on his coin or some copy of it, that Simone Fortuna had in mind when he wrote to the Duke of Urbino (27 Oct. 1581) to report that Giambologna was making *"un cavallo Traiano,"* in bronze, for a site by the Palazzo Vecchio in Florence (Pl. 61).

7 Roman, *Sestertius of Claudius,* 46 A.D.
Bronze, 3.7 cm. diameter.
New York, The American Numismatic Society.

The equestrian statue on a triumphal arch is thought to represent the monument to Nero Claudius Drusus (the Emperor Claudius's father) erected between 41 and 45 A.D. The horse is not leaping (as in Pl. 5) but rearing. The poses of both the horse and rider occur in classical Greek monuments, for example the Stele of Dexileos (died 394 B.C.) in the Museum of Ceramics, Athens (Roques de Maumont, 1958, fig. 24), and are recalled by those found in Baroque paintings such as Rubens's equestrian portrait of Buckingham (Pl. 130).

7A *Discorso di M. Sebastiano Erizzo sopra le Medaglie Antiche,* Venice, 1559, p. 161.

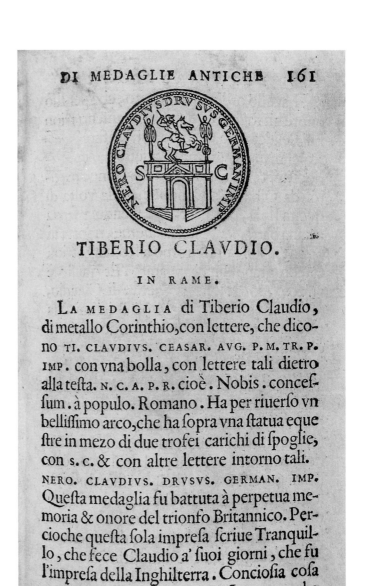

DI MEDAGLIE ANTICHE 161

TIBERIO CLAVDIO.

IN RAME.

La MEDAGLIA di Tiberio Claudio, di metallo Corinthio, con lettere, che dicono TI. CLAVDIVS. CEASAR. AVG. P. M. TR. P. IMP. con vna bolla, con lettere tali dietro alla testa. N. C. A. P. R. cioè. Nobis. concessum. à populo. Romano. Ha per riuerso vn bellissimo arco, che ha sopra vna statua eque stre in mezo di due trofei carichi di spoglie, con s. c. & con altre lettere intorno tali. NERO. CLAVDIVS. DRVSVS. GERMAN. IMP. Questa medaglia fu battuta à perpetua memoria & onore del trionfo Britannico. Percioche questa sola impresa scriue Tranquillo, che fece Claudio a' suoi giorni, che fu l'impresa della Inghilterra. Conciosia cosa

L　　che

145

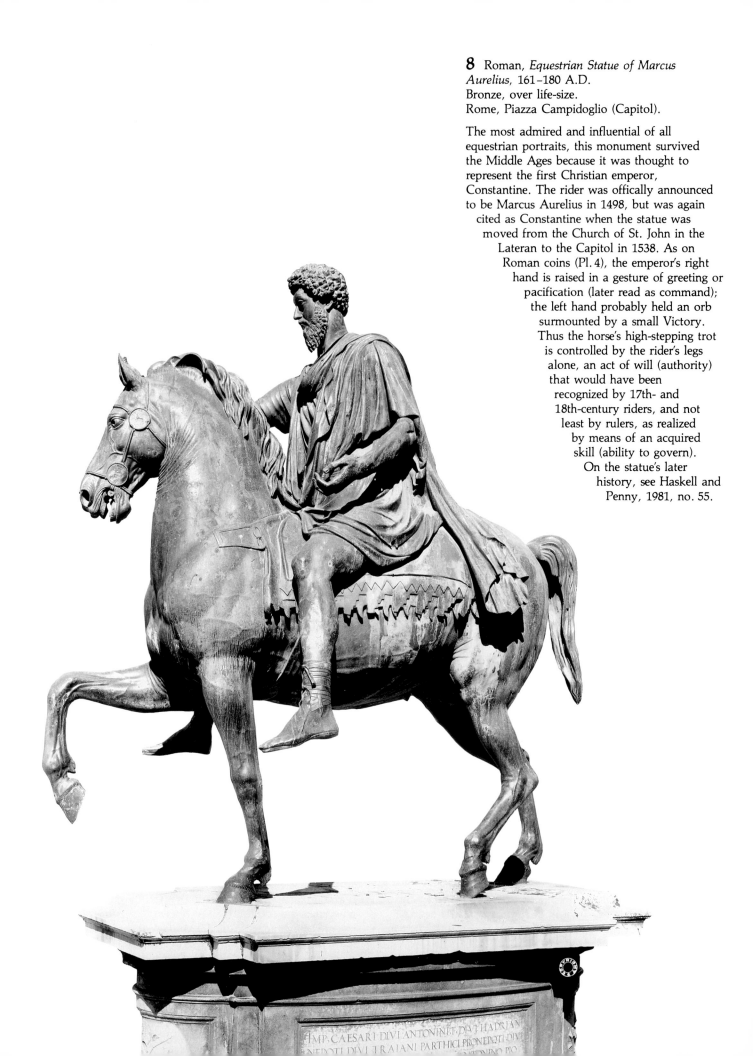

8 Roman, *Equestrian Statue of Marcus Aurelius*, 161–180 A.D.
Bronze, over life-size.
Rome, Piazza Campidoglio (Capitol).

The most admired and influential of all equestrian portraits, this monument survived the Middle Ages because it was thought to represent the first Christian emperor, Constantine. The rider was offically announced to be Marcus Aurelius in 1498, but was again cited as Constantine when the statue was moved from the Church of St. John in the Lateran to the Capitol in 1538. As on Roman coins (Pl. 4), the emperor's right hand is raised in a gesture of greeting or pacification (later read as command); the left hand probably held an orb surmounted by a small Victory. Thus the horse's high-stepping trot is controlled by the rider's legs alone, an act of will (authority) that would have been recognized by 17th- and 18th-century riders, and not least by rulers, as realized by means of an acquired skill (ability to govern). On the statue's later history, see Haskell and Penny, 1981, no. 55.

9 Roman, about 200–300 A.D., the *Regisole* monument in Pavia as illustrated on the titlepage of *Statuta de Regimie Ptatis Civilia...*, Pavia, 1505.
The Houghton Library, Harvard University.

The *Regisole* (Sun King; probably a Roman emperor as Sol) was, until its destruction in 1796, the only equestrian monument to survive antiquity besides that of Marcus Aurelius. It was taken from Ravenna in the 8th century and set up in front of the Cathedral of Pavia as a symbol of Rome. Some scholars (for example, Heydenreich) date the work no earlier than the 6th century A.D. because of the appearance, in this woodcut, of a saddle and stirrups, but these are very probably later additions or the invention of the printmaker (compare the city views of the Nuremberg Chonicle, 1493): indeed, all the tack is obviously modern (compare Pl. 25). Leonardo, in 1490, described the trotting pose as like that of a horse in nature (see Pl. 29); this freedom of movement is evident in the artist's own studies for equestrian monuments (Pls. 32, 33) more than it is in most examples of the 16th and 17th centuries. For other visual records of the *Regisole*, see Friis, 1933, figs. 40–44.

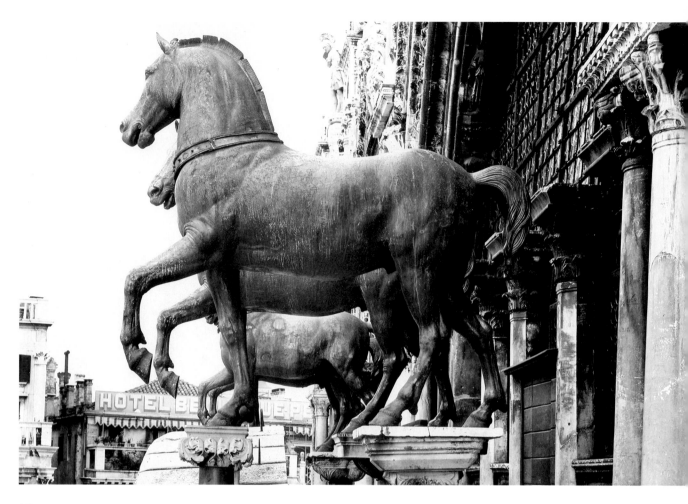

10 Roman, about 150–250 A.D., *The Horses of San Marco.*
Gilded bronze (about 95% copper), each 2.6 m. long, 2.4 m. high.
Venice, Cathedral of San Marco.

This famous quadriga has been dated as early as the 4th century B.C. in Greece and as late as the 4th century A.D. in Rome, but recent scholarship and all the reliable evidence strongly favor Roman authorship from about the time of Antoninus or Marcus Aurelius (see Pls. 4, 8) or within the next hundred years. The horses were seized by the Venetian Doge Enrico Dandolo when the crusaders sacked Constantinople in 1204; they were set up on the facade of St. Mark's during the 1250s or 1260s. Donatello and Verrocchio must have admired the horses, but these Tuscan artists, in their statues of Venetian commanders (Pls. 24, 25), were less influenced by the poised and elegant ancient steeds than were the sculptors who placed equestrian tomb monuments inside Venetian churches (See Pl. 18). However, all of these artists, including Donatello and Verrocchio, created horses that walk, and in this respect they follow the San Marco horses rather than those of Marcus Aurelius or the *Regisole* (Pls. 8, 9). Canova (Pl. 205) adopted the type and gait of the Venetian horses (with obvious variations) and helped arrange their release from captivity in Paris (1798–1815). *Colorplate 1*

11 Roman, about 272 A.D., *The Dioscuri, Castor and Pollux*, known as the "Horse Tamers" on "Montecavallo."
Marble, over life-size.
Rome, Piazza del Quirinale.

From medieval times to the 18th century the so-called Horse Tamers were said to represent Alexander the Great and his horse Bucephalus, one "dismounted equestrian portrait" being ascribed to Phidias, the other to Praxiteles. The sculptures seem to have always been on the Quirinal, where they probably decorated the emperor Aurelian's Temple of the Sun (dismantled in the 6th century). The figures were restored in 1589 and given their present arrangement in 1786. Between the dates that Maerten van Heemskerck (around 1533) and Canova (1780) drew the Dioscuri they were frequently copied (Pl. 41) and discussed (see Camins, 1981, pp. 14–15; Haskell and Penny, 1981, no. 3) and must have encouraged the Late Renaissance and Baroque idea of the horse as a willful spirit requiring rational restraint.

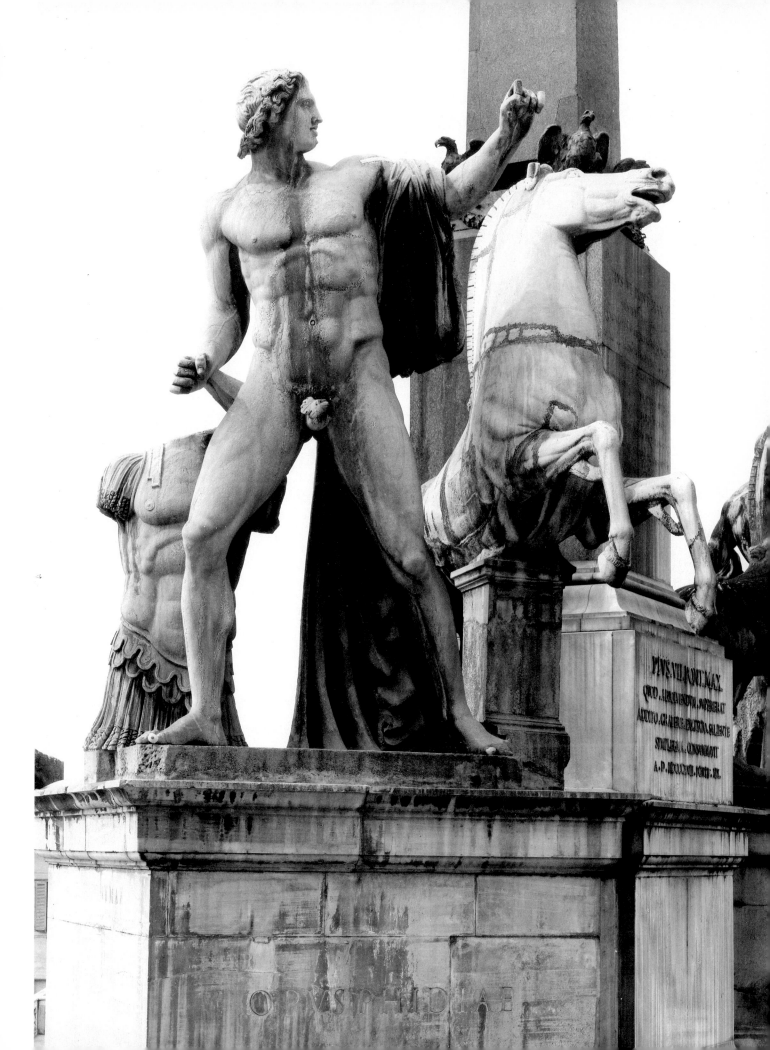

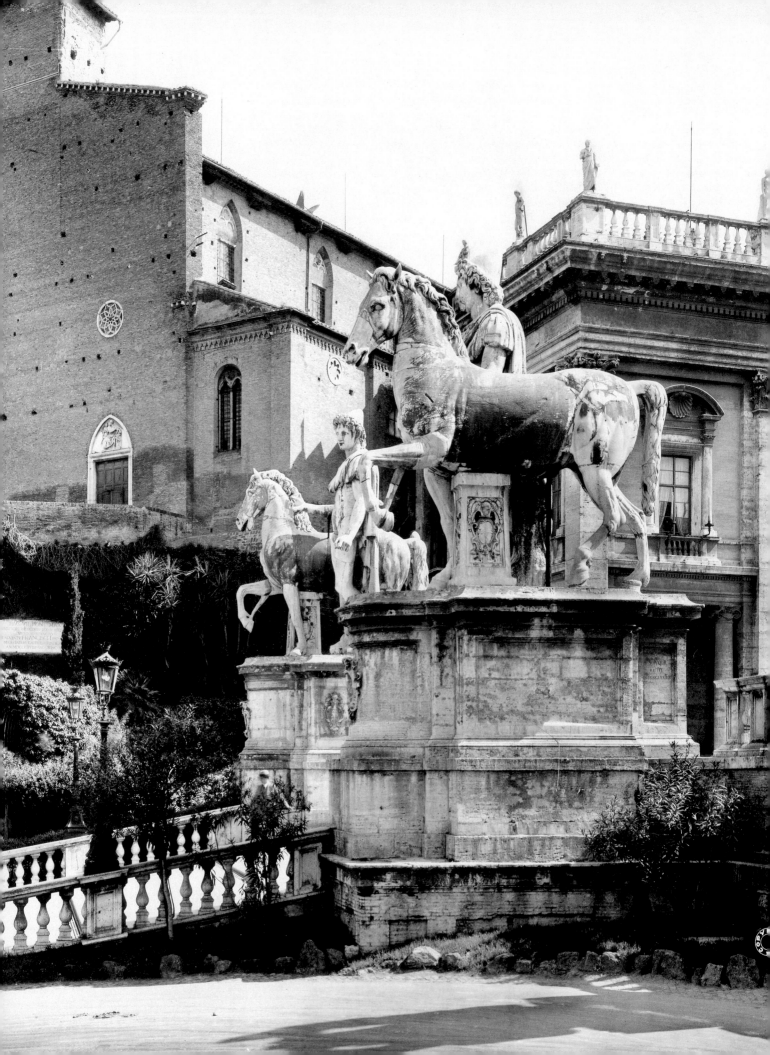

12 Roman, 2nd–3rd Century A.D.,
The Dioscuri, Castor and Pollux.
Marble, over life-size.
Rome, Piazza del Campidoglio (the Capitol).

Michelangelo dissuaded Pope Paul III from moving
the Quirinal Dioscuri (Pl. 11) to the Capitol; this
second pair, discovered nearby in 1560, was brought
there the following year. Castor and Pollux were
considered protectors of Rome and of Liberty.
Further, Alciati (1612) records that Charles V (see
Pls. 48, 50–51) and Paul's predecessor, Clement VII,
were represented as the Dioscuri at the emperor's
coronation in Bologna in 1532 (see Ackerman, 1970,
p. 167 and ch. 6, n. 9). Formally, the statues
anticipate Baroque portraits of horses with grooms
(Pl. 57) and the 17th- and 18th-century practice of
leading "hand horses" in princely processions.

13 Carolingian, about 860–870 A.D.,
Equestrian Statuette of a Carolingian Emperor
(traditionally identified as Charlemagne).
Gilded bronze, 9¼ in. (23.5 cm) high.
Paris, Musée Carnavalet, on loan to the Louvre.

The portrait type corresponds to manuscript and
ivory images of Charles the Bold, not his grandfather
Charlemagne. Medieval artists were usually not
particular about which legs of the horse
advanced together, but here the horse and rider's
proud bearing, and the high foreleg especially, are
significant reflections of imperial Roman forms
(compare Pls. 8, 9).

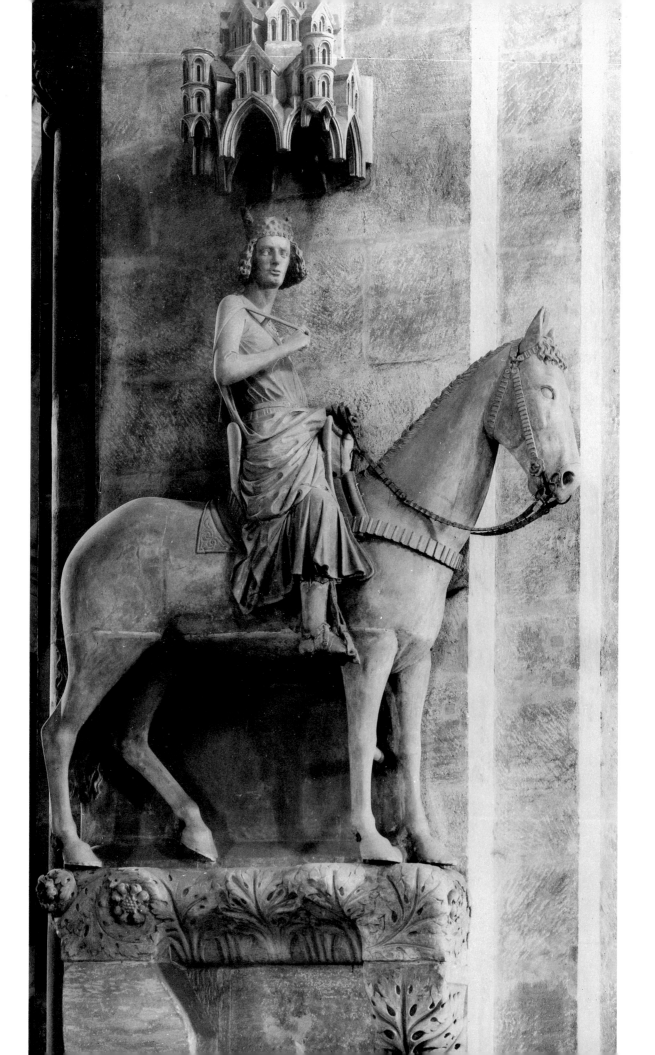

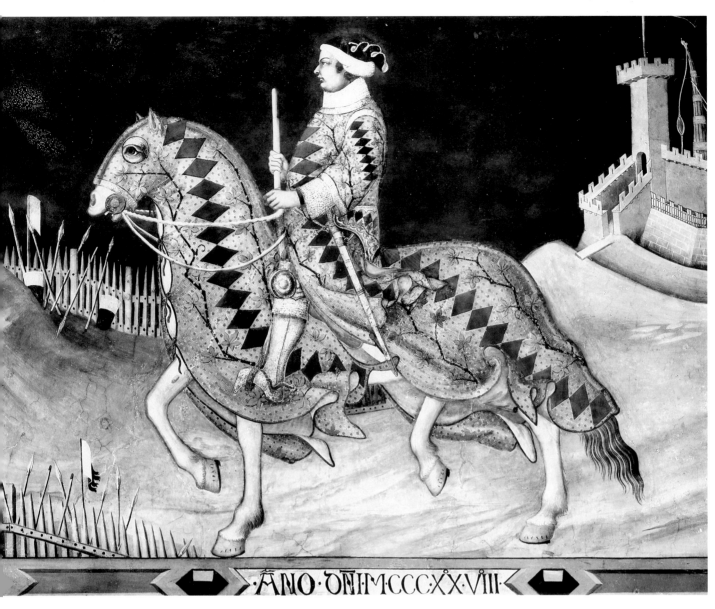

·ĀNO·ŌNI·MCCCXXVIII·

14 German, late 13th Century,
The Bamberg Rider.
Bamberg, Cathedral interior.

As a symbol of secular authority the equestrian
statue virtually disappeared during the Middle Ages,
and, significantly, this Gothic sculpture, though
vividly conceived, remains bound by the structure of
the church (indeed, the horse seems to stop short).
The sitter has been variously identified, for example
as the German emperors Frederick II and Conrad III.
See Traeger, "Bamberger Reiter," 1970.

15 Simone Martini, *Guidoriccio da Fogliano*,
inscribed 1328.
Fresco (detail of center).
Siena, Palazzo Pubblico, Council Chamber.

The sitter was a *condottiere* charged with suppressing
local nobles who rebelled against the Republic of
Siena. Recent arguments against this identification
and against Simone's authorship are circular and
unconvincing (see Polzer, 1987). The fresco is
sometimes discussed as the earliest known painted
equestrian portrait, but it is not unexpected: "Can
Grande" (Pl. 16) dates from precisely the same time,
and the Bamberg Rider (Pl. 14) dates from decades
earlier (see also Janson, 1967, p. 77, on the tomb of
Guglielmus, 1289, in the Church of SS. Annunziata,
Florence). The high-stepping gait recalls the trot
found on ancient coins, but here the horse walks
(both far legs advance). *Colorplate 3*

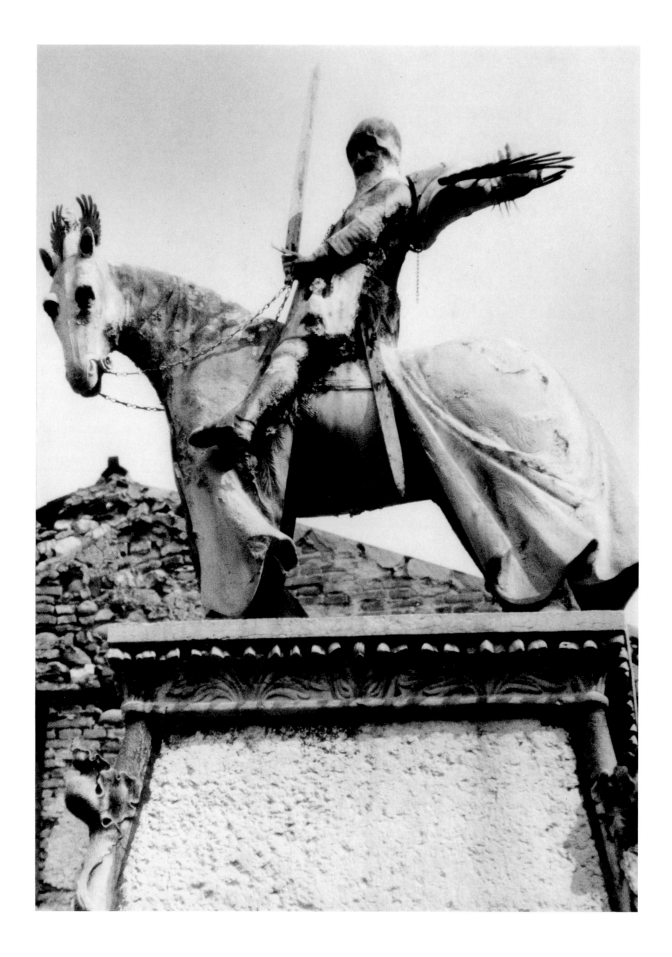

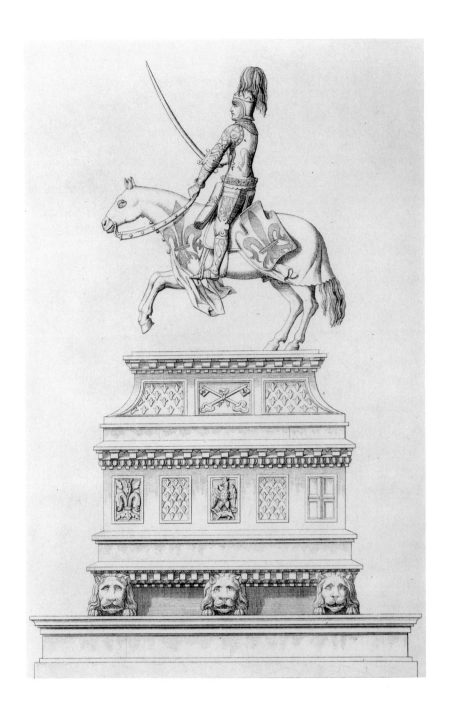

16 Italian, 1330 A.D., *Equestrian Statue of Can Grande della Scala.* Verona, Santa Maria Antica.

"The Great Khan," Lord of Verona, brashly adopted the equestrian statue as a symbol of imperial authority, although it stands above his tomb and is attached to the church's exterior. Military exploits are shown on Can Grande's sarcophagus; in it, his body was wrapped in a Chinese gown. The stance of the horse and the pyramidal base derive from the Brunswick Lion of 1166, a symbol of Duke Henry the Lion of Saxony. A more immediate (if more reticent) precedent is the Bamberg Rider (Pl. 14).

17 Agnolo Gaddi and Giuliano d'Arrigo (il Pesello), *Equestrian Monument of Piero Farnese,* about 1390. Wood, gilded (presumably in part).

Reconstruction in Pompeo Litta, *Famiglie Celebri Italiane*, IX, Milan, 1868, based on the statue itself, which was removed (reportedly in 1842) from its original position over the door of the Campanile and placed in the cathedral's museum (and seemingly discarded later because of poor condition).

The *condottiere* died in 1363. In 1367 a tomb was planned for the south wall inside the Duomo, but the position on the exterior of the bell tower is cited in a document of the following year (see Paatz, 1952). It would appear that both a tomb inside and an equestrian statue (on an empty sarcophagus) outside were intended (see caption to Pl. 20), thus anticipating the arrangements made for "Gattamelata" a half-century later (Pl. 24; compare Panofsky, 1964, p. 85). The supposedly galloping position of Farnese's horse recalls that rendered in relief on the tomb of Guglielmus (d. 1289) in SS. Annunziata, Florence, and on Gothic seals (see Panofsky, figs. 382–83), and the Roman coins upon which these Medieval precedents ultimately depend. The use of wood made this pose possible on a large scale, but it was hardly suited to an exterior site.

17A Cantering.

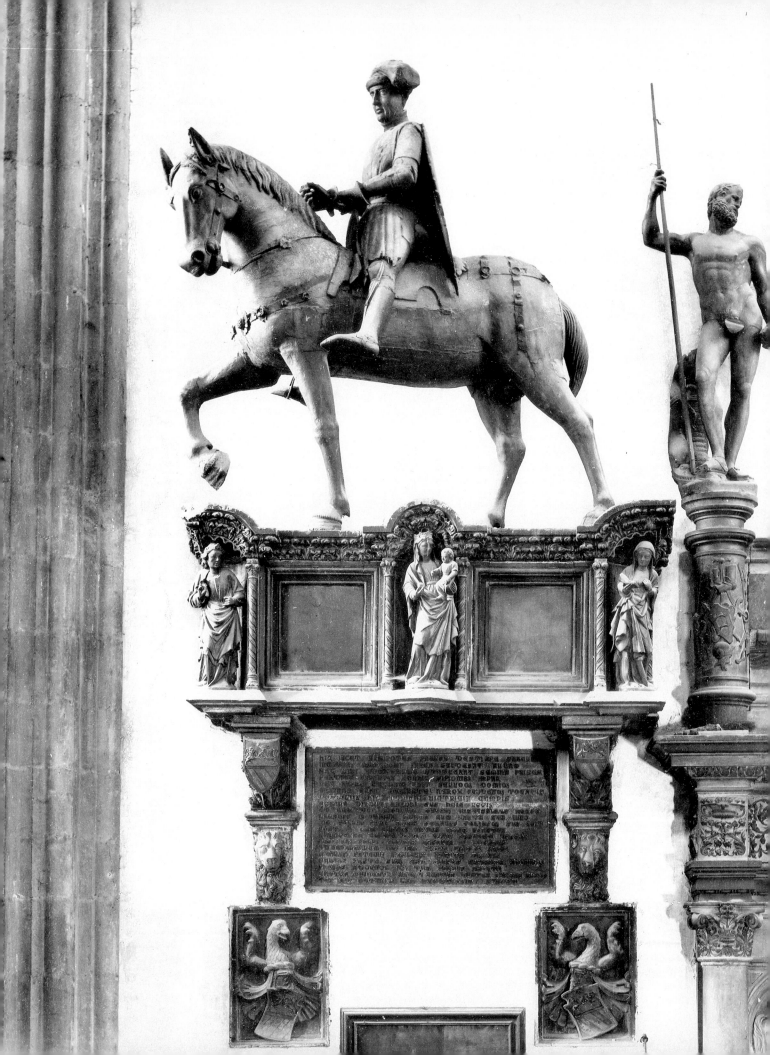

18 Italian, *Tomb Monument of Paolo Savelli*
(died 1405), about 1408.
Wood, partly painted.
Venice, Santa Maria dei Frari.

Equestrian statues made of comparatively inexpensive
materials probably originated in Florence (see Pl. 17);
some may have been carried in funeral processions.
In this rare example, the horse owes much to the
Horses of San Marco (Pl. 10), although their shorter
stride, imposed by a chariot, is here relaxed to a
natural walk. The collected walk of Colleoni's steed
(Pl. 25) is to this mount's gait as war is to peace; too
much has been made of the similarities (Covi, 1983,
p. 261). Equestrian statues very similar to the Savelli
monument include those of Nicola Orsini and
Leonardo da Prato in SS. Giovanni e Paolo, Venice
(*Horses of San Marco*, figs. 98, 99), both of which
date from the first half of the 16th century, and *The
Lumley Horseman*, an English work in wood of
about 1580 (Washington, 1985, no. 1).

19 Antonio Pisano, called Pisanello, *Medal of
Lodovico III Gonzaga, second Marquess of Mantua*
(1414–78, succeeded 1444), 1447. Reverse.
Bronze, 10.1 cm. diameter.
New York, Metropolitan Museum of Art,
Ann and George Blumenthal Fund.

The obverse represents the Marquess bust-length in
profile. Pisanello's medals honoring the rulers and
mercenary generals of Italian city states fuse the
forms of ancient coins and medals with those of
early Renaissance busts and late Medieval images of
knights on horseback. Here the mount is modelled
loosely on the *Horses of San Marco* (Pl. 10).

Within the image:
IOANNES·ACVTVS·EQVES·BRITANNICVS·DVX·AETATIS·S
VAE·CAVTISSIMVS·ET·REI·MILITARIS·PERITISSIMVS·HABITVS·EST

·PAVLI·VCCELLI·OPVS·

20 Paolo Uccello, *Equestrian Monument of Sir John Hawkwood*, 1436.
Fresco (transferred to canvas in 1842), about 27 ft. (8.33 m) high.
Florence, Duomo.

A marble equestrian monument honoring this English mercenary general was planned one year before his death in 1394. A year later Gaddi and Pesello were asked to design equestrian statues of Hawkwood and Piero Farnese (see Pl. 17). All that came of this was Gaddi's fresco substitute for the Hawkwood monument alone. Uccello was commissioned to replace Gaddi's presumably outmoded composition in May 1436 and a month later was instructed to do the horse and rider over. Uccello's first horse and rider must have been painted as sharply foreshortened from below, which would have been consistent with the base seen here and with the viewing situations of such statues as the Farnese and Savelli monuments (Pls. 17, 18). The painted border around Uccello's fresco dates from the early 16th century and is unsympathetic to the idea of an illusionistic space, as was Vasari (1550) to the horse's walking pose. *Colorplate 4*

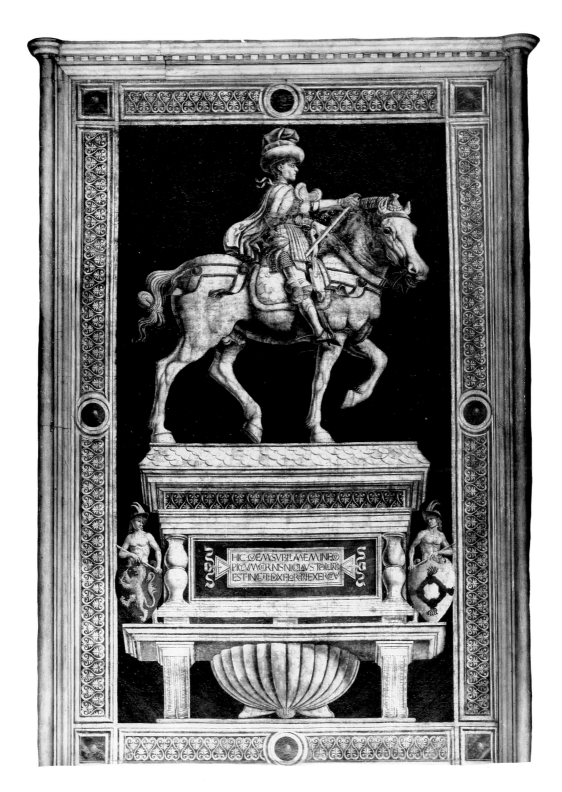

21 Andrea del Castagno, *Equestrian Monument
of Niccolò da Tolentino*, 1455–56.
Fresco (transferred to canvas in 1842), about 27 ft.
(8.33 m) high.
Florence, Duomo.

This equestrian portrait — or rather, this painting of an
equestrian monument — is a substitute for the marble
tomb that was voted by the Opera of the Duomo at
the time of Niccolò da Tolentino's funeral in 1435. By
that date it had already been decided that Gaddi's
fresco of Hawkwood, also an alternative to a marble
monument, would be replaced (see caption to Pl. 20).
The present work, finally assigned to Castagno twenty
years later, is his last surviving dated painting and is
approximately contemporary with Uccello's panels
depicting the Rout of San Romano at which Niccolò
triumphed over the Sienese (Pl. 22). Castagno's
conception might be described as Uccello's design
revised in the spirit of Donatello (compare Pl. 24). See
further Horster, 1980, pp. 36, 182–83, who cannot
seriously mean "Condition: perfect." *Colorplate 5*

22A *Discorso di M. Sebastiano Erizzo sopra le Medaglie Antiche,* Venice, 1559, p. 140.

23 Benozzo Gozzoli, *Procession of the Magi* (detail), 1459.
Fresco.
Florence, Chapel of the Palazzo Medici-Riccardi.

The youthful king is considered a portrait of Lorenzo de' Medici; the laurel plant behind him may refer to his name (Laurentius). The graceful but exaggerated trot of the horse strikes one as a Renaissance revision of Simone's sinuous steed (Pl. 15), with the positions of the horse's head and legs suggested by the *Marcus Aurelius* (Pl. 8).

22 Paolo Uccello, *The Rout of San Romano,* about 1455–56.
Oil on panel, 71¾ x 125⅝ in. (182 x 319 cm).
London, The National Gallery.

This is one of three panels (the others are in the Uffizi and the Louvre) that represent a Florentine victory over Sienese forces in 1432. The paintings decorated a room in the Palazzo Medici; they are first mentioned in 1492 as in Lorenzo de' Medici's bed chamber. The central horseman here is Niccolò da Tolentino, hero of the day (see Pope-Hennessy, 1969, pp. 152–53), and the subject of Castagno's contemporary fresco (Pl. 21).

The fact that Uccello attempted to "rationalize natural forms by assimilating them to a geometric equivalent" (Pope-Hennessy, p. 9) may obscure another reason that his horses seem schematic: their poses derive from images on Roman coins and on Gothic seals. The central horse and the dark horse to the left, for example, may be compared with a type frequently found on Roman coins (such as the one seen here in Erizzo's illustration, Pl. 22A); Uccello's horses are similar in their proportions and in their seemingly playful shift of weight to the rear. The pose of the horse to the far right is also found on some Roman coins and on Medieval medals such as the seal of Count Albrecht III von Görz-Tirol, 1295 (Grossmann, 1931, pl. XVIII, no. 5) as well as in Gothic sculptures of Saint George. The dark horse to the right, by contrast, recalls that in Pisanello's slightly earlier medal (Pl. 19).

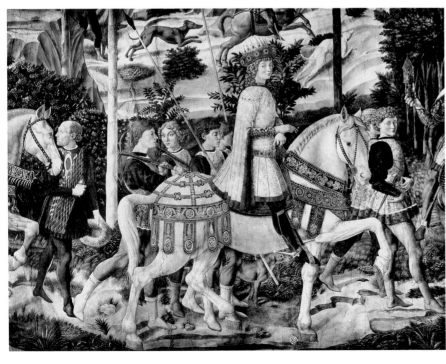

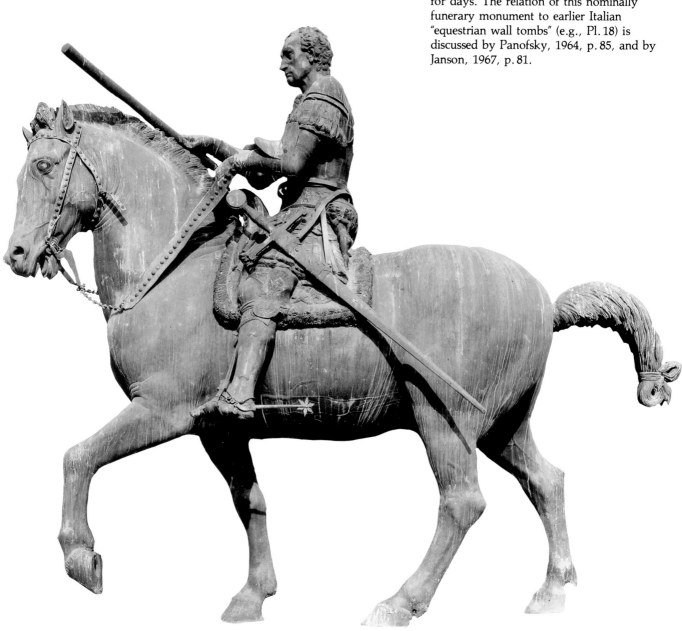

24 Donatello, *Equestrian Portrait of "Gattamelata,"* 1445–50. Bronze, about 11 ft. (280 cm) high. Padua, Piazza del Santo.

The most basic distinctions separate this tribute to a recently deceased Venetian general from the Medieval monument of another military hero, Can Grande (Pl. 16): in its material, scale, and freedom from the wall of a building Donatello's sculpture emulates the *Marcus Aurelius* (Pl. 8). The ancient statue's naturalism, as well as its stately pose, impressed Donatello, but his much larger horse carries more weight and walks firmly forward, as if, like the rider, he could go on for days. The relation of this nominally funerary monument to earlier Italian "equestrian wall tombs" (e.g., Pl. 18) is discussed by Panofsky, 1964, p. 85, and by Janson, 1967, p. 81.

25 Andrea del Verrocchio (completed by Alessandro Leopardi), *Equestrian Monument of Bartolommeo Colleoni*, about 1481–96. Bronze, 13 ft. (4 m) high. Venice, Campo SS. Giovanni e Paolo.

The sitter himself (like "Gattamelata," Pl. 24, general of Venice's land forces) stipulated in his will that an equestrian monument should be raised in his honor with funds that he would provide. Again a Florentine artist was chosen, but Verrocchio rejected Donatello's calm (cenotaphic?) conception—restrained movement, pseudo-classical armor, and the rider's Roman head—in favor of a small, spirited horse that matches the powerful swagger of his master with athletic grace. This Italian blend of raw will and elegant execution conveys the Renaissance notion of *virtù:* the individual's character and ability. In this light, and in the eyes of anyone who rides, Covi's suggestion (1983, p. 262) that Colleoni's thrusting pose is caused merely "by the advance of the horse's left legs" is ridiculous.

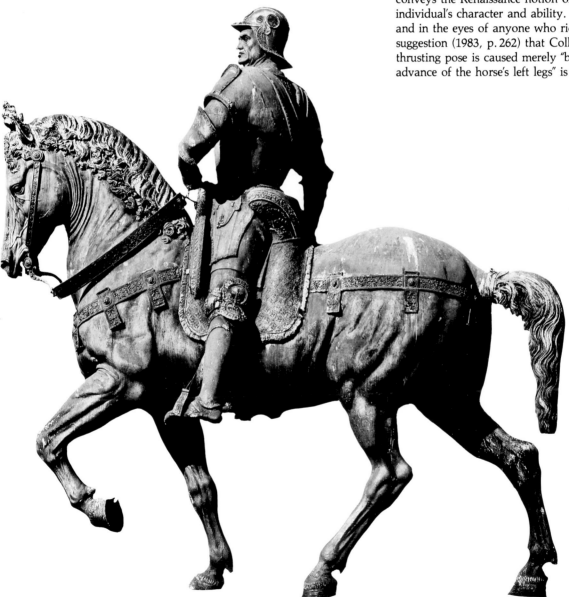

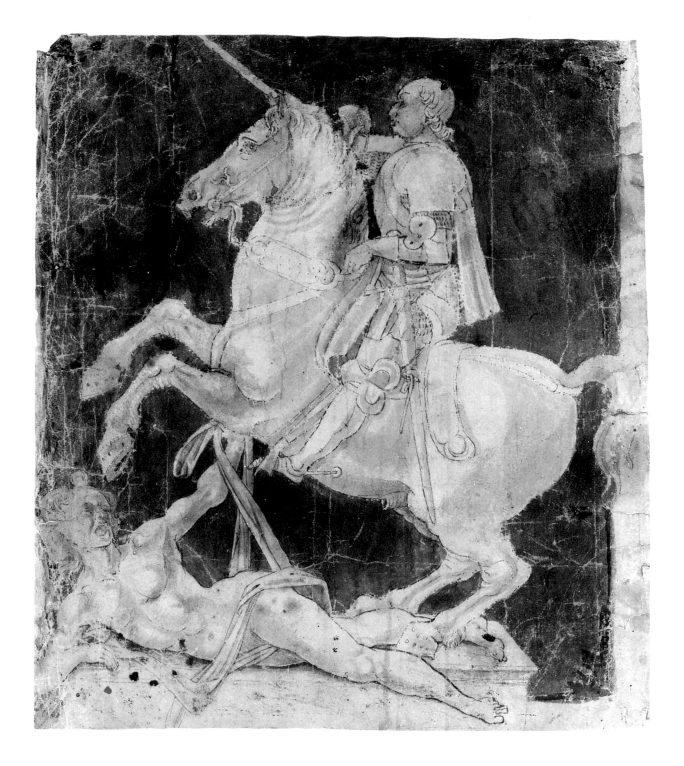

26 Antonio Pollaiuolo, *Study for an Equestrian Monument of Francesco Sforza*, about 1481-82. Pen and brown ink with light brown wash. New York, Metropolitan Museum of Art, The Robert Lehman Collection.

The female figure represents the vanquished city of Verona, and would have helped support what was intended as a large bronze monument to the *condottiere* Francesco Sforza, Duke of Milan from 1450 to his death in 1466. Ludovico il Moro, shortly after becoming Duke in 1479, revived earlier plans for an equestrian monument to his father. Vasari (see Meller, 1934), describes both known drawings for Pollaiuolo's project, which became Leonardo's (see Pl. 28) after he offered his services to Ludovico in a celebrated letter of 1482 (quoted by Pope-Hennessy, 1958, p. 67). Since about 1390 Florentine artists were familiar with an equestrian statue in which the horse was supported on the hindlegs alone (Pl. 17); here the action is changed from a gallop to a rear, no doubt with Roman coins, sarcophagi reliefs, and Uccello (Pls. 22, 22A, 26) in mind. A few years earlier Pollaiuolo studied the rearing pose from two angles in the left and right background of his *Martyrdom of St. Sebastian* (National Gallery, London).

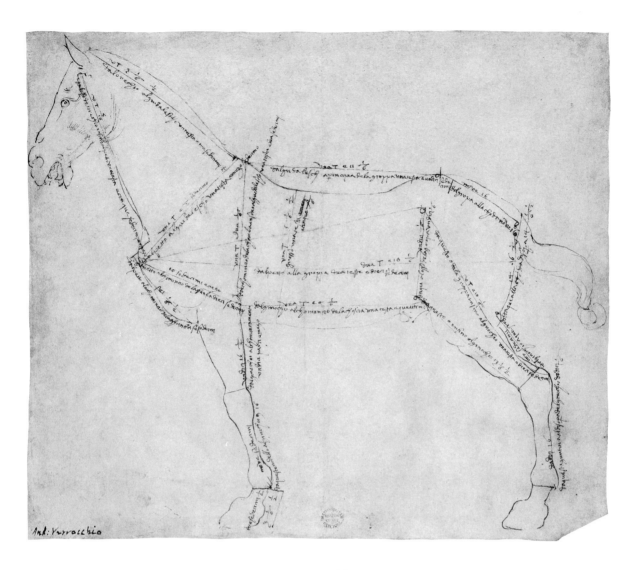

Andi: Verrocchio

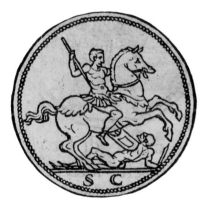

26A *Discorso di M. Sebastiano Erizzo sopra le Medaglie Antiche,* Venice, 1559, p. 191.

27 Attributed to Andrea del Verrocchio, *Study of the Proportions of a Horse,* late 15th Century. Pen and ink over silverpoint. New York, Metropolitan Museum of Art.

This drawing was once owned by Giorgio Vasari, who thought it was by Verrocchio, an attribution that has recently returned to favor (Scaglia, 1982, p. 40; Covi, 1983, p. 262). Renaissance artists attempted to discover systems of proportion in nature by means of measuring numerous live models and appropriate examples of ancient sculpture (compare Pl. 41). The scheme employed here appears to combine Vitruvius's system (the head serves as a standard unit) with corrective fractions (multiples of one-sixth). Vincenzo Foppa and Verrocchio's pupil Leonardo wrote treatises on equine anatomy, and the latter made measured drawings of live horses in Milan (see Pedretti and Roberts, 1985, nos. 8–15).

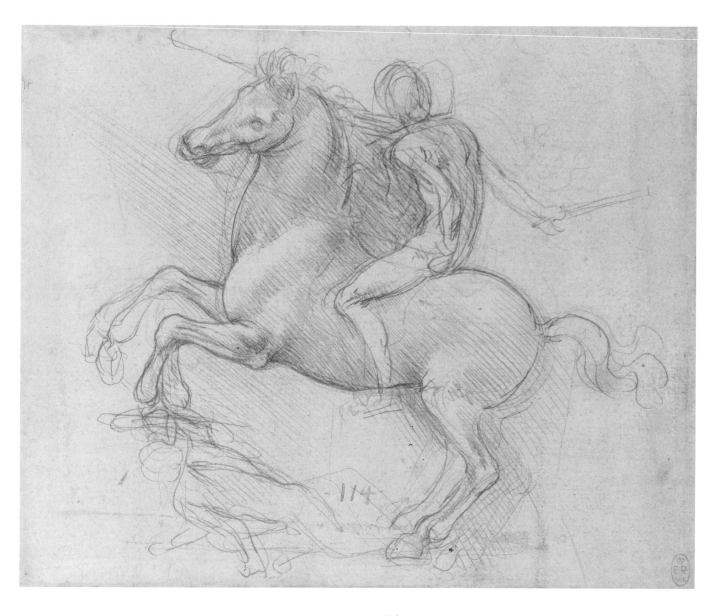

28 Leonardo da Vinci, *Study for an Equestrian Monument of Francesco Sforza*, probably about 1487–90.
Metalpoint on blue prepared paper.
Windsor, The Royal Library.

This is one of a few surviving studies that record Leonardo's first idea for the Sforza monument: a horse rearing above a fallen enemy, as in Pollaiuolo's project (Pl. 26), but with both the horse and the rider in twisting and seemingly more spontaneous poses. This approach extends the late Medieval (and Roman) concept of the hero—an emperor, St. George, or a *condottiere*—in the midst of battle, rather than the recent, more restrained Florentine idea of the equestrian monument as a classical form revived (Pls. 20, 24, 26). Thus the first Sforza studies recall the excited horses in the background of the early *Adoration of the Magi* (1481) and look forward to the *Battle of Anghiari* (Pl. 31) and to Raphael (Pl. 40A), as well as to Rustici, Rubens, and Bernini (Pls. 36, 97, 153).

29 Leonardo da Vinci, *A Trotting Horse,*
about 1490.
Pen and ink, 2.8 x 3.6 cm.
Windsor, The Royal Library.

This tiny drawing of a trotting horse comes from
a sheet of the Codex Atlanticus on which
Leonardo praises the horse of the *Regisole* at
Pavia. Every visual "record" of this monument
(Pl. 9; Friis, 1933, figs. 40–43) shows a trotting
horse and rider rather like the *Marcus Aurelius.*
The more energetic horse reproduced here is
probably an idea for the Sforza monument
inspired by the *Regisole,* in which the horse, in
Leonardo's view, moved with an especially
natural gait. Pedretti (Pedretti and Roberts, 1985,
no. 20) wrongly identifies the *Regisole* gait as an
amble (or pace), describes the horse here as
"walking," and suggests that Leonardo was after
"abnormal vivacity, that is, the amble which
results from training." The contemporary critic
Paolo Giovio had a clearer idea of Leonardo's
intentions (as realized in the clay model) when he
wrote that "the vehement true-to-life action of
this horse, as if panting, is amazing, not less so
the sculptor's skill and his consummate knowledge
of nature" (Richter, 1939, I, p. 3).

30 Leonardo da Vinci, *The Sforza Horse Packed
for Transport,* folio 216v of the Codex Atlanticus,
about 1490–93.
Milan, Biblioteca Ambrosiana.

It is not certain that the Sforza monument was
supposed to be colossal when first planned
(Pl. 28), but when Leonardo resumed work on the
project in the spring of 1490, he and his patron
had in mind a statue twice the size of the
Gattamelata and Colleoni monuments (Pls. 24, 25).
Leonardo worked on the clay model, the moulds
for casting into bronze, and plans for transport
(as seen here), but in October 1499 the French
occupied Milan and destroyed the model, and the
moulds deteriorated over the next few years.
The enormous scale of the intended statue and
Leonardo's viewing of the *Regisole* in June 1490
(Pl. 29) turned his thinking to the trotting horse
and to the opinion that "the imitation of Antique
works is more praiseworthy than that of
modern ones" (quoted by Pedretti and Roberts,
1985, pp. 44, 47).

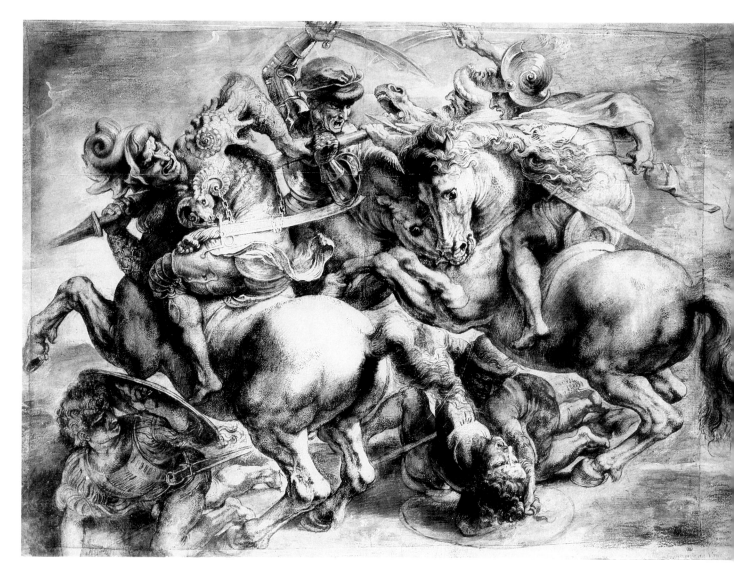

31 Peter Paul Rubens, a study of Leonardo's *Fight for the Standard*, the central section of *The Battle Anghiari* (1503–06), about 1602–05.
Black chalk, pen and ink; washed, heightened with gray and white body-color, 17¾ x 25 in. (45.2 x 63.7 cm).
Paris, Louvre, Cabinet des Dessins.

Leonardo's mural in the Palazzo Vecchio, Florence, served as an "academy" for the study of the horse in action until Vasari painted over it in 1557. A number of paintings and drawings and an engraving of 1558 record the composition. Such second-hand and mostly second-rate material was all that Rubens knew of Leonardo's work, but his drawing goes beyond mere transcription to recapture something of Leonardo's spirit. The original composition and Rubens's empathy were decisive for the development of battle scenes in the Baroque period (see Pls. 97, 98). With a few exceptions, this cannot be said for equestrian portraiture.

32 Leonardo da Vinci, *Four Studies for the Trivulzio Monument*, about 1510.
Pen and ink.
Windsor, The Royal Library.

Giovanni Giacomo Trivulzio (d. 1518) was a *condottiere* who crowned his career in service to the French, for whom he ruled Milan as governor after their entry in 1499. Again, as in the Sforza project, Leonardo planned both a rearing and a trotting horse for the monument; in this case both forms appear to have been considered concurrently around 1508–12 rather than successively (see Pedretti and Roberts, 1985, pp. 61–69). The rearing pose of the Sforza horse is revived here, on a merely life-size scale, along with designs for a base supported by columns and enshrining a sarcophagus. This ensemble (especially in the little drawing to the left) and the not-quite-resolved struggle between the horse and the fallen enemy suggest that Leonardo referred to Roman coins (see Pls. 5, 6).

169

33 Leonardo da Vinci, *Three Studies of a Trotting Horse,*
about 1510–12.
Pen and ink over black chalk.
Windsor, The Royal Library.

As on other sheets, Leonardo studies alternative positions
(using a wax model?): the horse above is very like the one in
Pl. 34 before the head was redrawn, while the two sketches
below seem to study the effect, as seen obliquely from the
rear, of turning the head to the left or right. Considering that
the Trivulzio monument was planned for a chapel in San
Nazaro, Milan (see Pedretti and Roberts, 1985, no. 36 ii), this
point was more critical than it would have been in a piazza.

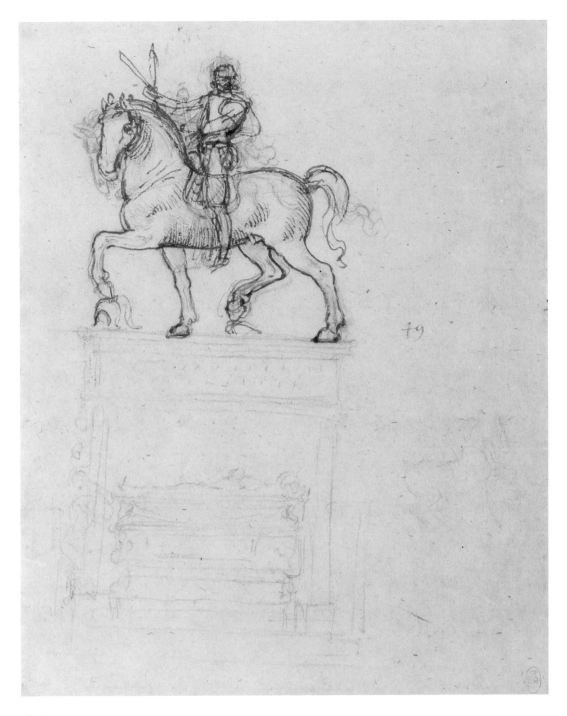

34 Leonardo da Vinci, *Study for the Trivulzio Monument*, about 1510–12.
Red chalk, gone over with pen and ink.
Windsor, The Royal Library.

The pose, as pointed out by Pedretti (Pedretti and Roberts, 1985, no. 38 A),
strongly recalls that of the final Sforza horse, but with a turned head "as in
Donatello's *Gattamelata*." Actually the energetic advance of the horse, its
turned head, the twisting pose and strong gaze of the rider — indeed the
whole ensemble, including the columned base — recall the Colleoni monument
(Pl. 25), setting aside the seemingly incidental difference (in this case) that
here the horse trots, while Colleoni's paces. For all Leonardo's refinement
and respect for classical models, he shared with his teacher Verrocchio an
appreciation of power driven by passion, "as if panting" (see caption to
Pl. 29). This approach was amply appropriate for mercenary soldiers but not
for riders and rulers in "absolute" control (Pls. 61, 160).

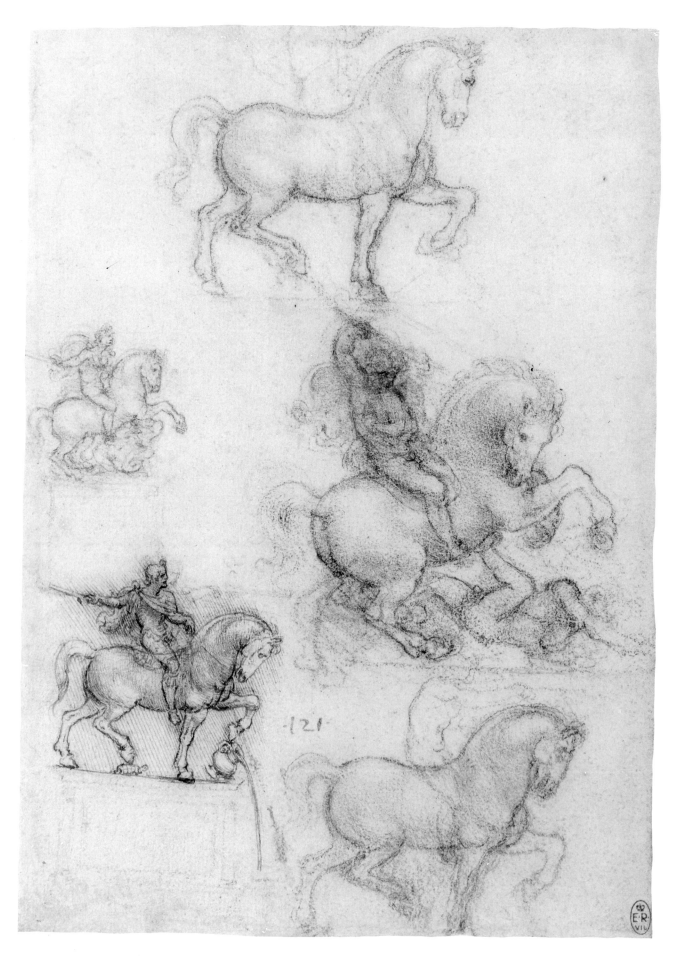

35 Leonardo da Vinci, *Studies for an Equestrian Monument*, about 1512–13?
Black chalk.
Windsor, The Royal Library.

Most Leonardo scholars consider the studies on this sheet as "post-Trivulzio"; recently Pedretti (Pedretti and Roberts, 1985, no. 44), making liberal use of conditional locutions, suggested that these sketches may be for small statuettes and that a similar drawing (his no. 45) could even date from Leonardo's French period, "after 1517." One might wonder whether it is, as Pedretti maintains, difficult to believe that the two rearing horses here could have been intended as designs for monumental sculpture, since this is an artist whose imagination was even greater than his legendary intellect, and whose ambition almost twenty years earlier was to cast an equestrian monument 24 feet high.

36 Attributed to Gianfrancesco Rustici, *A Horseman Fighting Footsoldiers*, early 16th Century.
Terracotta, 17⅜ in. (44 cm) high.
Florence, Museo Nazionale del Bargello.

This is one of four terracotta groups of fighting horsemen attributed to Rustici (1474–1554; see Pope-Hennessy, 1970, p. 340 and literature cited); another is in the Louvre, and two are in the Palazzo Vecchio, Florence (ill. in Loeser, 1928; Hall, 1973, figs. 23–26). These works are remarkable attempts to render in the round — or rather, in high relief — the furious confusion of cavalry in combat as conceived by Rustici's older associate, Leonardo, in the *Battle of Anghiari* (Pl. 31). Rustici's chronology is unclear, but this and the similar groups were certainly modelled in Florence before he left for France in 1528.

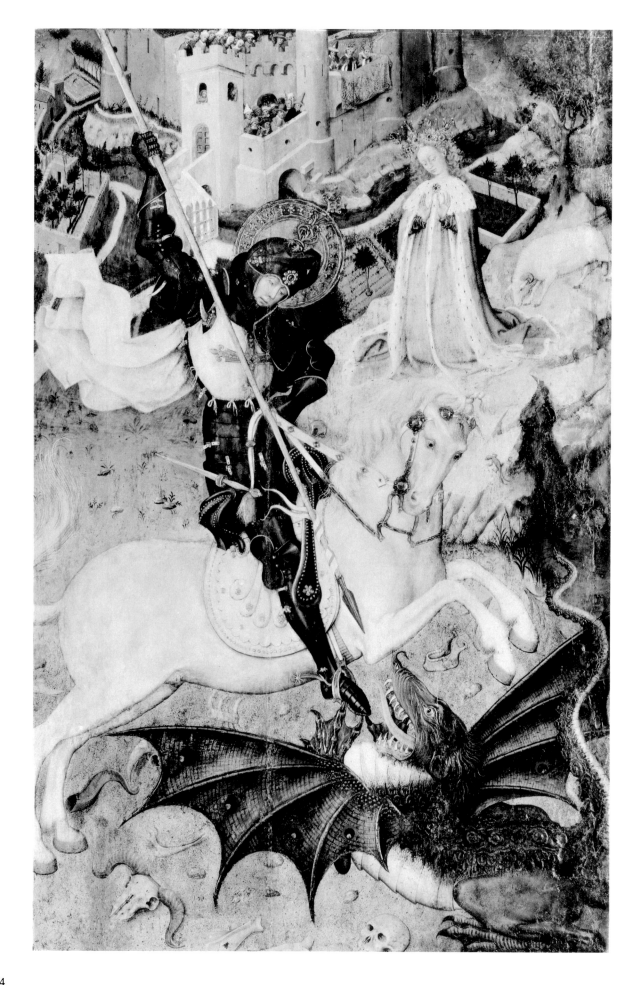

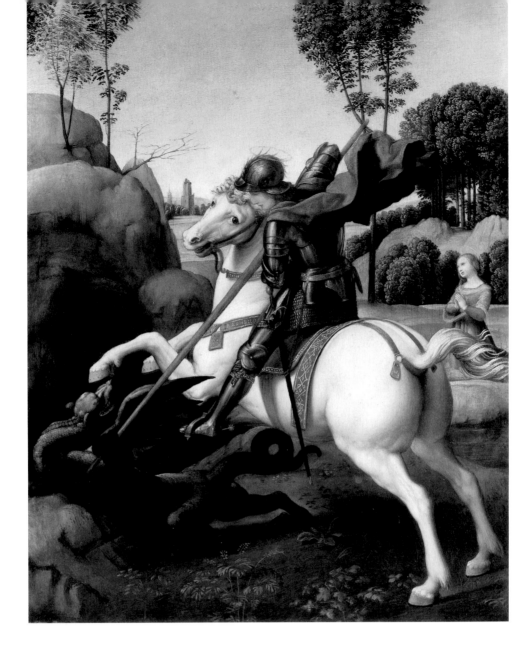

38 Raphael, *St. George and the Dragon*,
about 1505.
Panel, 11⅜ x 8¼ in. (29 x 21 cm).
Washington, National Gallery of Art.

In this early work the horse follows late Medieval
examples (compare Pl. 37). The more plausible pose
of the horse in Raphael's panel in the Louvre
supports Pope-Hennessy's argument that it dates a
bit later (1970, pp. 127–28; figs. 112–15).

37 Attributed to Bernardo Martorell (Catalan),
St. George and the Dragon, about 1430.
Tempera on panel, 22 x 15 in. (56 x 38 cm).
Chicago, The Art Institute of Chicago.

The most immediate precedents for 14th- to 16th-
century representations of riders on galloping and
rearing horses (see Pls. 17, 51, 69, 96) were late
Medieval images of St. George as a mounted knight
fighting the dragon. This late example of the type
may be compared with Donatello's slightly earlier
relief, where the horse's pose is more realistically
rendered, and with the young Raphael's small panel
of about 1505 (Pl. 38), where the elegant design is
surprisingly similar to Martorell's.

39 After Leonardo da Vinci, *A Rearing Horse*
(second quarter of the 16th Century?).
Bronze, 9 1/16 in. (23.1 cm) high.
New York, Metropolitan Museum of Art.

The horse rears and lunges sideward,
spontaneously reacting to something frightful,
such as the kick or bite of another horse. This
bronze and similar statuettes in Budapest (see
Aggházy, 1971) and elsewhere (see Camins,
1981, under no. 30) derive from drawings by
Leonardo (probably studies for the *Battle of
Anghiari*; see Pl. 31; and Pedretti and Roberts,
1985, nos. 22–31) and possibly from wax models

40A Raphael, *The Expulsion of Attila*, 1513–14 (detail of Pl. 40). Compare Leonardo's horses in Pls. 31, 39.

made in connection with these studies. On one sheet at Windsor (RL 12328r; Pedretti and Roberts, no. 26 A), Leonardo wrote above a tiny sketch of a very similar horse, "Have a little one made of wax a finger long." Though inspired by rearing horses on ancient coins (see Soós, 1956), Leonardo's studies of horses are anything but eclectic: this bronze represents an extreme case of a horse rearing as in nature, against which the schooled poses of horses such as those represented by Velázquez, Tacca, and Gras (Pls. 75, 76, 112) may be judged.

40 Raphael, *The Expulsion of Attila*, 1513–14.
Fresco.
Rome, The Vatican, Stanza d'Eliodoro.

Papal equestrian portraits, a minor genre of the
Middle Ages and the Renaissance (see Traeger,
1970), adopted aspects of the iconography and the
more sedate forms of imperial Roman sculpture and
coins. Here this tradition, represented by Leo X (in
the role of Leo III) and his retinue, meets head-on
with the sort of people Leonardo worked for (Attila's
army was understood as an allusion to the French)
and with his much more dramatic ideas about horses
(compare Pls. 31, 39).

41 Raphael, *Study of one of the Quirinal Horses*, about 1518(?).
Red chalk, with measurements in pen.
New York, Ian Woodner Family Collection.

This drawing might be connected with Raphael's survey at the end of his life of the antiquities of Rome. In any case, the drawing ideally exemplifies both the Renaissance interest in proportions (compare Pl. 27) and the inspiration, or challenge, offered by ancient sculpture (Pl. 11) to artists such as Pollaiuolo and Leonardo (compare Pls. 26, 28, 31, 32). On the Quirinal horses after 1500, see Haskell and Penny, 1981, no. 3; see Nesselrath, 1982, on this drawing, on Antico, and on the marble's restoration in the 16th century. *Colorplate 2*

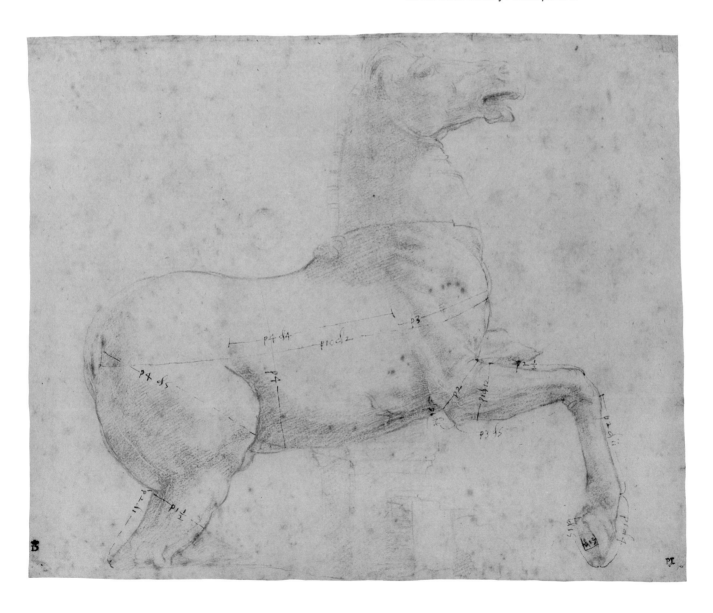

42 Tilman Riemenschneider, *St. George and the Dragon*, about 1495–1550. Limewood, 30¼ in. (77 cm) high. Berlin, Staatliche Museen.

This is a late and exceptionally fine example of a subject that late Medieval sculptors produced for churches throughout Northern Europe. The piece was meant to be seen from one side only and is closely related (in a broad view, reciprocally) to pictorial renderings like Martorell's (Pl. 37). The poses (already found on 12th- and 13th-century seals that derive from Roman coins) and relative scale of the horse and rider (compare *"Gattamelata,"* Pl. 24) mattered little to the artist compared with his treatment of the theme of good and evil and the technical problem of working with a single block of wood.

43 Albrecht Dürer, *Knight, Death and the Devil*, 1513. Engraving. New York, Metropolitan Museum of Art.

Dürer's engraving *The Small Horse* of 1505 applies geometrical measurement to equine proportions, and thus extends his study of human proportions in the *Adam and Eve* of the previous year. Here Dürer again employs his scheme of ideal proportions, but the result is more naturalistic, in response, perhaps, to closer study of Leonardo's sketches (see Camins, 1981, pp. 62–63, and the literature cited in her note 9), and to Verrocchio's horse and rider (Pl. 25), which Dürer would have seen afresh on his second trip to Venice in 1505–06. Earlier horses by Dürer simply stand; this one trots (has the position of the right hind leg been revised upward, making the first outlines of the hoof into a plant?). Joachim Sandrart, in 1675, called this print "The Great Christian Knight," while later writers have referred to Erasmus's *Handbook of the Christian Knight*, 1502, (see further Strauss, 1973, no. 71).

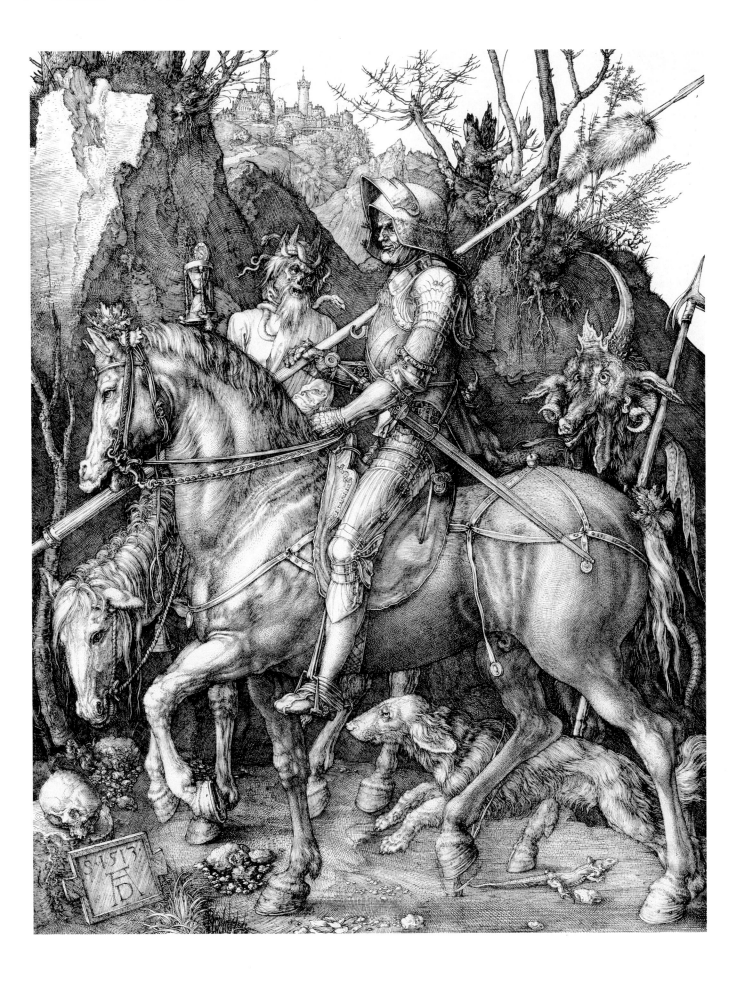

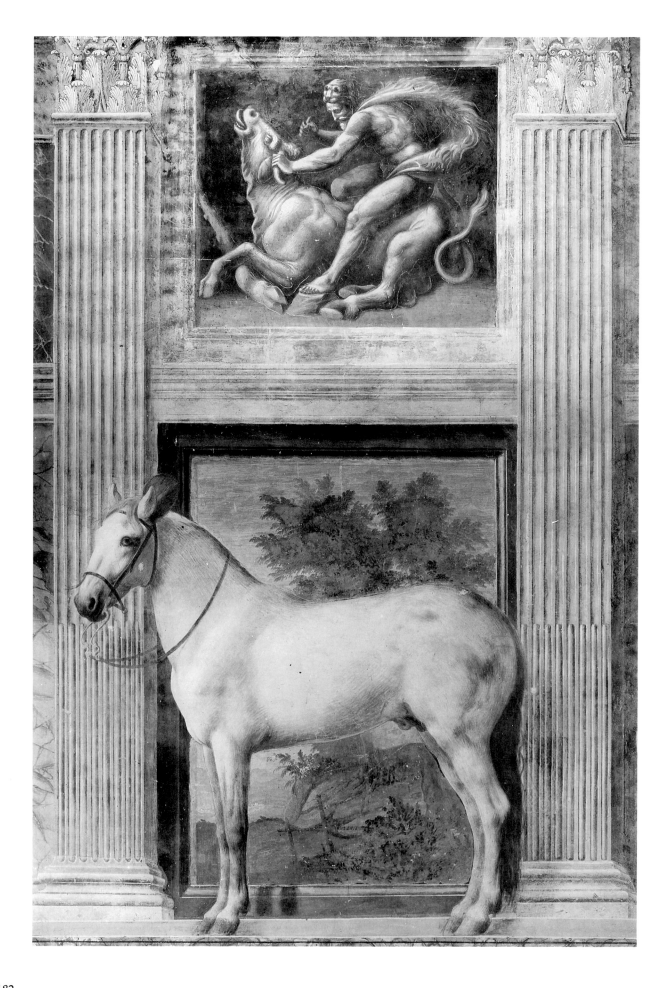

44 Giulio Romano and assistants, Part of the fresco decoration of the Sala dei Cavalli in the Palazzo del Te, Mantua, 1530–35.

Among the many brilliant illusionistic conceits created by Giulio in the Palazzo del Te was the idea of placing portraits of the Gonzaga horses before simulated architecture, relief sculpture, and (in the landscape view) fresco, on the frame of which are shadows cast by the horse's forelegs. The Hall of Horses is one of the earliest examples of portraits of actual steeds. Later examples are often also life-size (Pl. 57) and occasionally comprise a decorative ensemble (Pl. 172). *Colorplate 6*

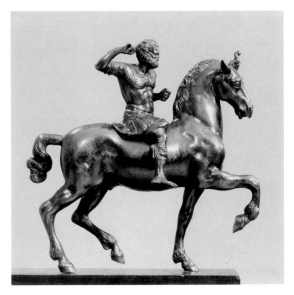

45A North Italian, possibly by Moderno, *Warrior on a Trotting Horse*, about 1525. Bronze, 8⅜ in. (21.3 cm) high. New York, Metropolitan Museum of Art, The Friedsam Collection.

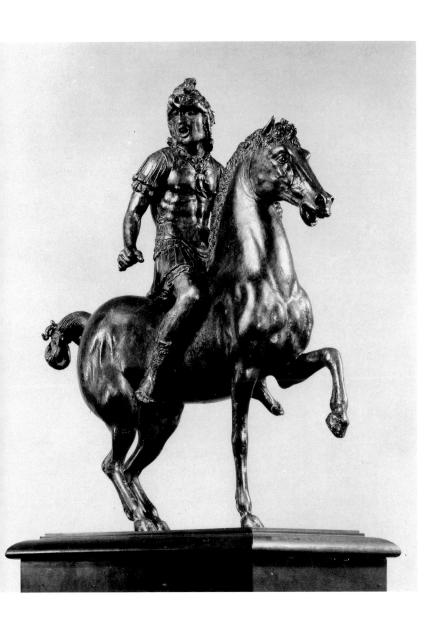

45 Riccio, *A Warrior on Horseback*, 1520s? Bronze, 13⅜ in. (34 cm) high. London, Victoria and Albert Museum.

Andrea Briosco, called Riccio, was probably born in Padua in the early 1470s; he died in 1532. This horse and rider, like Rustici's battle scenes (Pl. 36), develops the tendency of late 15th-century Florentine artists—Donatello, Verrocchio, Leonardo (Pls. 24, 25, 33)—toward more naturalistic and dramatic treatments of equestrian themes. Antique models have little to do with the present work; it might be queried, more broadly, whether any equestrian portrait or sculpture may be called "High Renaissance." Baroque artists such as Rubens and Bernini were, despite their Roman experience, the beneficiaries of a North Italian style.

46 North Italian, early 16th Century, *A Walking Horse* (based on the *Horses of San Marco*). Bronze, 9¾ in. (24.8 cm) high. Detroit, The Detroit Institute of Arts.

What is this horse doing? Camins, (1981, p. 17, no. 31) calls this a *Pacing Horse* that "seem[s] to be walking, although the position of the legs is a modification of the Venetian horses' ["ambling"] gait." This horse and the *Horses of San Marco* (Pl. 10) walk; the ancient horses' walk is more collected (shorter-strided) and the hindlegs, not the forelegs, are engaged (bear the greater weight) because they drew a chariot. North Italian bronzes similar to the Detroit statuette, for example a Paduan piece in the Frick Collection (Pl. 47), may be said to represent a pacing or "ambling" horse because the action is faster (thrust further forward), the foreleg is raised higher, and the hindleg on the same side is also off the ground. If one follows Mackay-Smith's definition of a "two-beat pace or amble" (p. 87 above) to the letter, requiring the foot-falls on one side to be simultaneous, then this is a

"four-beat broken pace" or — more likely — a "two-beat pace" with the left hindleg lowered for aesthetic reasons. In the 1970 catalogue of the Frick Collection it is claimed, by contrast, that "the horse is shown with both legs free of the ground and is therefore cantering, not pacing...." Diagrams and photographs of a cantering horse (see Pl. 47A, where the left legs are drawn in black) show that the legs on one side may indeed be off the ground together, but none of the possible poses bear a close resemblance to the Paduan horse or to any sculpture known to the writer dating from before the 19th century. It is not always easy to answer questions such as these: horses of different breeds, sizes, and conformation move differently; riding styles have changed; only one moment is depicted; works of art cannot be judged like photographs. Arbitrary stylistic qualities (here, in both bronzes, the derivation from the *Horses of San Marco*) and the artist's intentions must be sympathetically considered, and "titles" of works understood to be approximate.

47 Paduan, early 16th Century, *A Pacing Horse* (based on the *Horses of San Marco*).
Bronze, 9⅛ in. (23.1 cm) high.
New York, The Frick Collection.

Like Renaissance reproductions of the *Marcus Aurelius* (see Pl. 59), bronzes based on the *Horses of San Marco* were popular in the 16th century. On the whole they are less faithful to the ancient model and were probably appreciated more exclusively for their decorative appeal. On the gait of the horse see the caption to Pl. 46.

47A Sequential drawings of a cantering horse (in this case on the left lead of a transverse gallop. From K. Romeiser, "Understanding the dynamics of your horse's stride," *Equus,* January 1986, pp. 16–25. (From *Equus* Magazine, copyright 1986, Fleet Street Corporation, Gaithersburg, Maryland. Reprinted by permission.)

47A

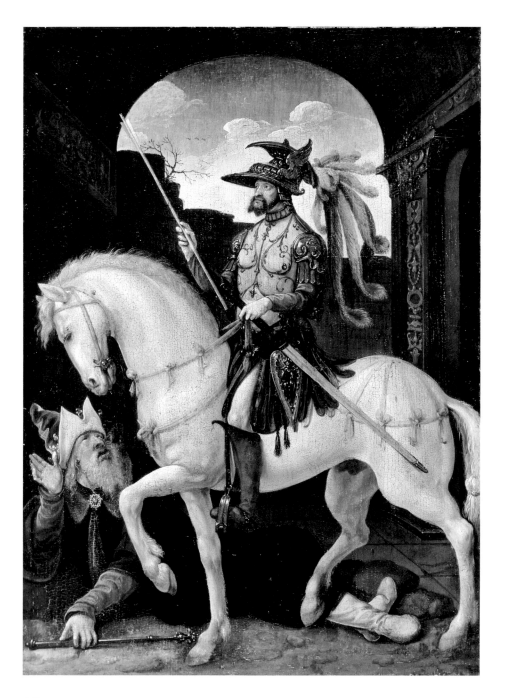

48 Antwerp Artist, *Charles V as Victor over the Turks*, about 1535–40.
Panel, 14⁹⁄₁₆ x 11¼ in. (36.8 x 28.6 cm).
Worcester, Mass., The Worcester Art Museum.

A lot of thin ink has been spilled about this little picture, which in the 1974 catalogue of the Worcester Art Museum is considered to date about 1515–25 and to represent the obscure subject of King Sapor of Persia humiliating the Roman Emperor Valerian (the Persian's captive, who was employed as a mounting block). The style of execution, of the trendy armor—of the architectural ornament alone—suffice to date the painting after 1530, and it is at least equally evident that if one figure is Eastern, the other Western, then the latter is in the saddle. The painting is an early example of that favorite Hapsburg theme, the Emperor—here Charles V before he rounded off his double pointed

beard (compare Pl. 51)—as victor over the Turks, whom he defeated at Tunis in 1535. Janson (1935–36) sees the hero here as Charles V in the guise of Saint James of Compostela, "Killer of the Moors," but there is no need to make the panel's straightforward subject any more complicated than the Emperor's helmet. Not surprisingly, in the case of a second-rate artist hitting upon such a successful design, much of it is borrowed: the idea of framing the horse with an archway from Dürer's *Little Horse* engraving of 1505; the horse and rider's poses (and, seemingly, the weakness for overwrought riding apparel and fancy feathers) from any number of printed Triumphal Entries, such as that of Charles V in 1530 by Jörg Breu the Elder (see caption to Pl. 50). The painter was perhaps also aware of some contemporary French example of royal equestrian portraiture (compare Pl. 49).

186

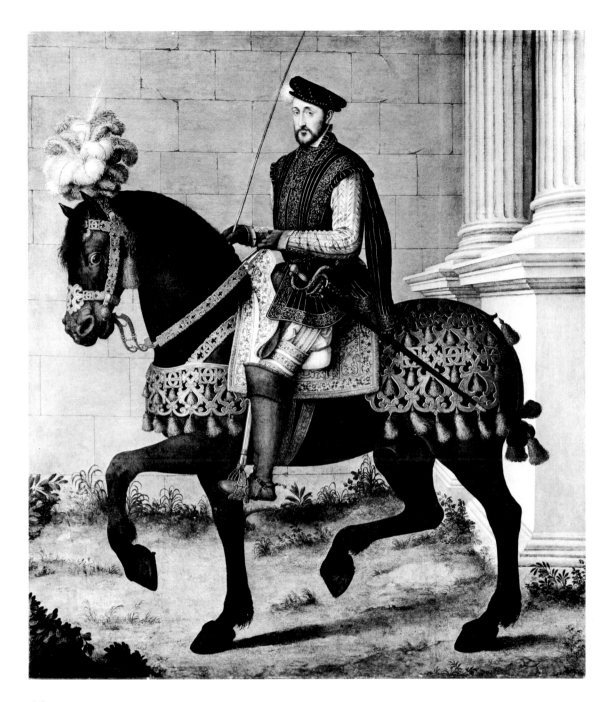

49 Workshop of François Clouet, *Henry II, King of France, on Horseback*, 1550s.
Oil on canvas, transferred from wood, 61½ x 53 in.
(156.2 x 134.6 cm).
New York, Metropolitan Museum of Art.

As in other forms of courtly portraiture employed by Clouet, the type of composition seen in this large picture and in similar equestrian portraits of Henry II's predecessor, Francis I (Uffizi and Louvre; Mellen, 1971, pls. 151–52), was an international convention, but the pattern is filled in with a refreshing naturalism that is northern European. Jean Clouet's small, exquisite panel depicting Francis I on horseback (Louvre) is reproduced here as Colorplate 7.

50 Cornelis Anthonisz, *Charles V on Horseback*, mid-16th Century.
Chiaroscuro woodcut.
Amsterdam, Rijksprentenkabinet.

Throughout the 16th century printmakers produced equestrian portraits of powerful political figures, either as individual images or in a larger context such as a Triumphal Entry (e.g., Jörg Breu the Elder's series of ten woodcuts, of 1530, illustrating Charles V's entry into Augsburg in that year; Geisberg, 1974, I, nos. 357–66; single-sheet equestrian portraits are reproduced

throughout Geisberg's four volumes). In some cases these engravings and woodcuts were derived from paintings and sculpture, and in other cases they served as sources for them, but the stylistic evolution of printed equestrian portraits (along with other subjects) was on the whole remarkably independent of works in other media. Thus there is a great deal of repetition among images like this one, and a persistent naiveté in the rendering of horses; in this medium an equestrian portrait was a routine, not an exceptional assignment, so that the problem was rarely rethought from the ground up. Here the horse supposedly gallops (all four feet touch the ground), or just begins to gallop or canter (as in Cranach's *St. George* woodcut of 1507), but the same pose rocked back onto the hindlegs is clearly meant as a rear in other prints (e.g., the Master BP's *Count Albrecht of Mansfield*, a woodcut of 1548; Geisberg, III, no. 925). A simple walk is rendered wrongly in Burgkmair's nonetheless impressive color woodcut of *The Emperor Maximilian I on Horseback*, 1508 (Grossmann, 1931, p. 78, pl. XX), and the trot is often stylized à la Clouet (Pl. 49) with an eye to the silhouette.

51 Titian, *Charles V at Mühlberg*, 1548.
Canvas, 130¾ x 109¾ in. (332 x 279 cm).
Madrid, Museo del Prado.

This magnificent picture, one of the first great paintings of the genre (it was not a substitute for a monument, though several to Charles were planned), commemorates the Hapsburg emperor's victory over the German Protestants at Mühlberg on 24 April, 1547. According to the contemporary writer Aretino, the horse and the armor (the latter now in the Royal Armory, Madrid) used on that day are depicted here. Titian painted the picture at Augsburg in the spring of 1548. Charles V's sister, Mary of Hungary, brought the picture with her from Brussels to Spain; Philip II inherited her collection in 1558. After a fire at the Royal Palace, called the Alcázar, in 1604, the canvas was moved to El Pardo Palace, where is served as a centerpiece among dynastic battle pictures (victories of Charles V and Philip II). In 1626 the painting was moved to another "Hall of Princely Virtue," the Pieza Nueva in the Alcázar, where it hung with the lost equestrian portrait by Velázquez that Rubens replaced (see Pl. 116). Titian's painting, then, was a sire of sorts for Spanish and, consequently, Flemish equestrian portraits of the 1620s onward, though it was not, as Wethey and other authors have claimed, the model for "the type with the rearing horse" (Huemer) that flourished in the 17th century (see further Ch. 2, n. 20). The galloping gait of the horse in Titian's painting may, on the contrary, be seen as one of the last gasps—or rather, reassertions—of a naturalistic type that was favored from late Gothic (Pl. 17) to late Renaissance times (see also the lost Tomb of Nicolas du Châtelet, d. 1562; Panofsky, 1964, fig. 379). As a comparatively realistic representation of what might be called a "battle motif," Titian's horse and rider are aligned with Leonardo's and with the lost equestrian statue at the Château d'Écouen (Pl. 52). These 16th-century examples, whatever their horses might be doing, differ decisively from later Florentine, French, and Spanish royal equestrian portraits (e.g., Pl. 112) since in the latter the horses' movements are schooled, and the basic conception of the work has changed from a dramatic to a ceremonial staging of history.
Colorplate 12

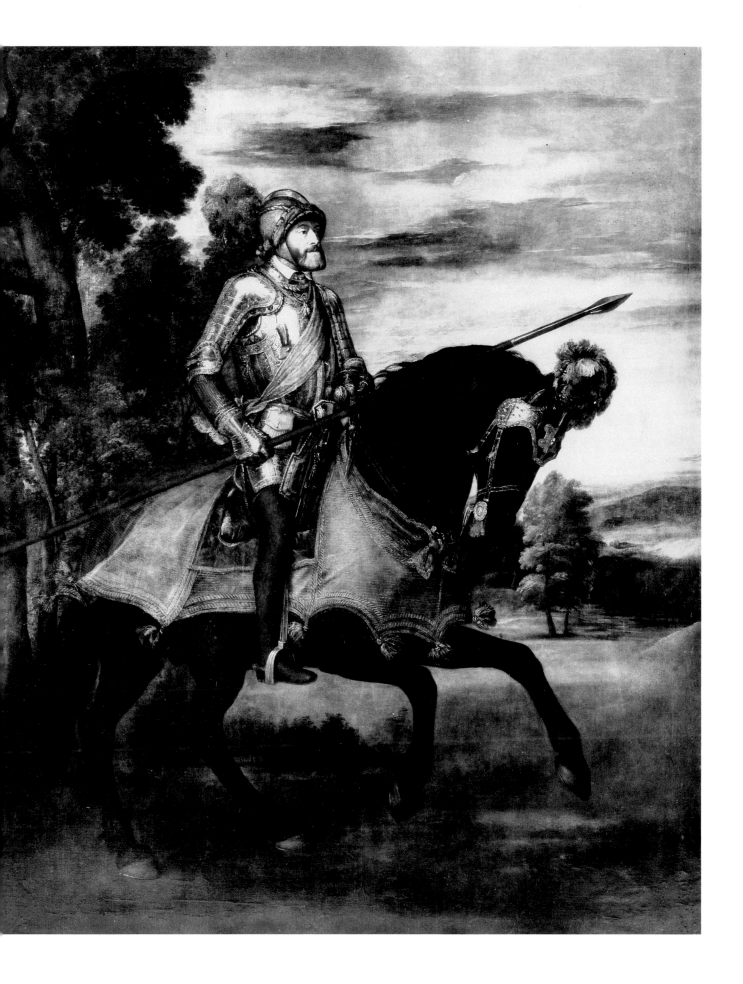

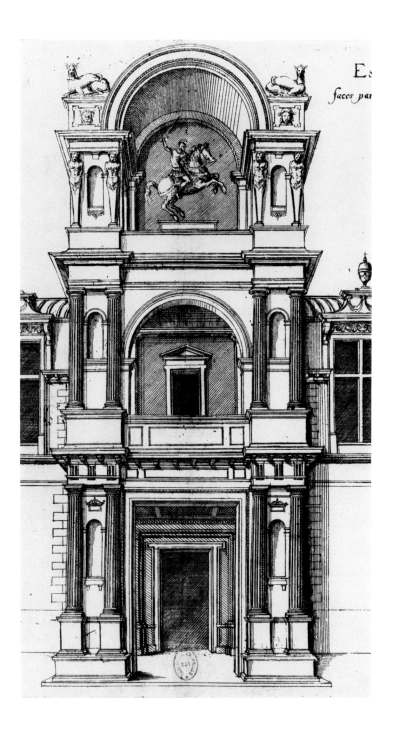

52 *Entrance Portico of the Château d'Écouen* (in Seine-et-Oise, north of Paris), with an equestrian statue of the owner, the Constable Anne de Montmorency, as illustrated in Jacques Androuet du Cerceau's *Les plus excellents bastiments de France*, Paris, 1579.

This part of the château was probably built in the 1550s by Jean Bullant; it was destroyed in 1787. The design of the equestrian statue has been associated with Leonardo's Sforza and Trivulzio monuments (Pls. 28, 32) and with Rustici, who was strongly influenced by Leonardo (see Pl. 36), left Florence for France in 1528, and worked mostly on an equestrian monument of Francis I until the king died in 1547 (for most of the relevant literature see Hall, 1973, pp. 55–57). However, a more likely author than Rustici for the design of the equestrian statue at Écouen would be Jean Goujon, the eminent sculptor who was recorded as architect to Anne de Montmorency, and who was supposedly responsible for sculptures at Écouen (see Colombier, 1949, pl. XL). Goujon participated in the construction of the tomb of Louis de Brézé (c. 1540) in Rouen Cathedral (Panofsky, 1964, p. 83, fig. 378), where an equestrian statue of the deceased is framed in an architectural ensemble very similar to the top story here (on Goujon at Rouen and Écouen, and on the château itself, see also Blunt, 1973, pp. 123–25, 135–36). Goujon also designed the decorations for Henry II's triumphal entry into Paris in 1549 and the commemorative book's woodcut illustrations, which include a portrait of Anne de Montmorency on a trotting horse (Bottenheim, 1956, fig. 2).

53 Cornelis Cort after Johannes Stradanus, *The Art Academy*, 1578.
Engraving.
New York, Metropolitan Museum of Art.

Stradanus arrived in Florence in 1545 and died there in 1605. Leonardo's legacy is sensed here both in the bronze statuette of a rearing horse (Sculptura) and the tumultuous battle scene in the background (Pictura). The statuette is even more intriguing in regard to Giambologna's interest in Leonardo (see p. 55, and Pls. 39, 69). See Stradanus's *Equile* (Pl. 54A), where life imitates art.

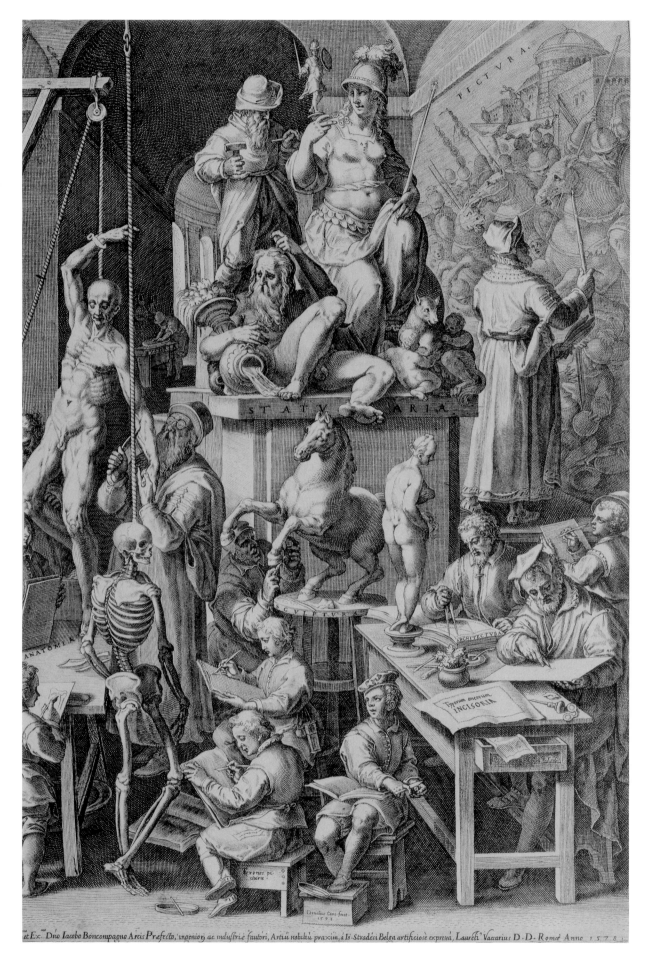

PICTVRA.

STATV·ARIA

ANATOMIA

ARCHITECTVRA

Typorum excernum INCISORIA

Cornelius Cort fecit 1578

...et Ex.mo Dno Iacobo Boncompagno Arcis Præfecto, ingenioq; ac industriæ fautori, Artis nobilis praxim, à Io·Stradensi Belga artificiosè expressa, Laurẽt Vaccarius D·D·Romæ Anno 1578.

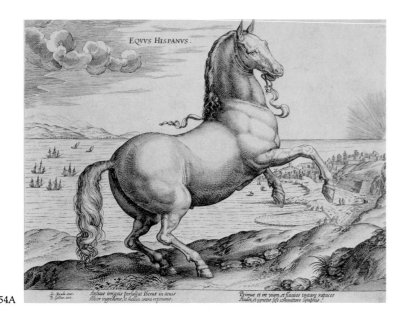

54A

54 H. Wierix after Stradanus, *Equus Hispanus* and *Sicamber*.

54B

54–56 Hieronymus Wierix and Hendrick Goltzius after Stradanus, *The Stable of Don Juan of Austria (Equile Ioannis Austriaci...)*, published by Philips Galle in Antwerp, 1581. Six of the forty plates are reproduced here; twelve plates by Goltzius not illustrated here are reproduced in Strauss, 1977, pp. 184–53, along with the titlepage engraved by Adriaen Collaert.

56A

55 H. Wierix after Stradanus, *Cimber* and *Brito*.

56 Hendrick Goltzius after Stradanus, *Flander* and *Danus*. Goltzius took over the engraving of the *Equile* plates after Wierix fled Antwerp in October 1578. *Danus* rears, *Flander* walks.

193

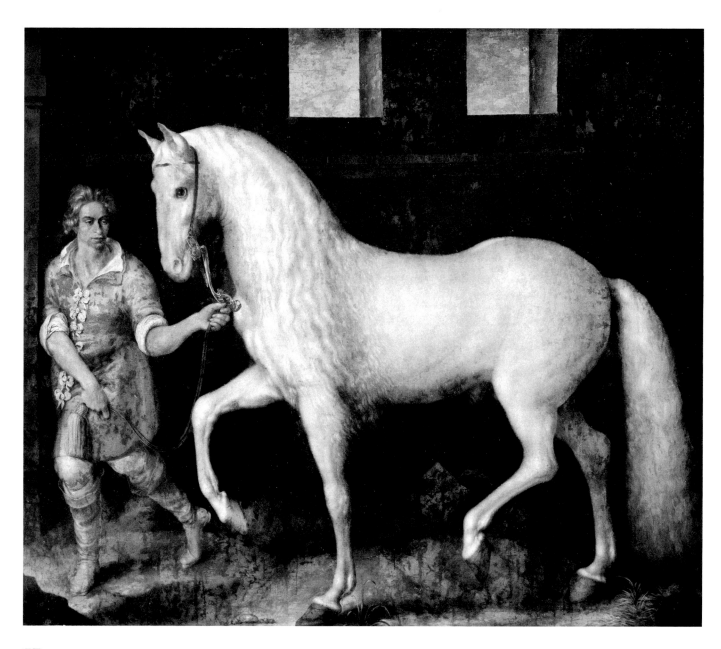

57 Jacques de Gheyn II, *A Spanish Warhorse with a Groom*, 1603.
Canvas, 89¾ x 106 in. (228 x 269 cm).
Amsterdam, Rijksmuseum.

This large canvas, as its inscription records, represents a prize taken by Lodewijk Gunther van Nassau from Archduke Albert of Austria at the battle of Nieuwpoort and presented to Prince Maurits of the United Netherlands. Dutch portraits of horses in particular often include grooms, as in a few contemporary, smaller works by Roelant Savery, and perhaps in *"The Riding School"* by Karel Dujardin in the National Gallery of Ireland (in the latter, and in many 17th-century equestrian portraits, it is uncertain whether the horse is a portrait of a real animal or just a handsome type). A 1622 inventory of paintings owned by Johan Huydecoper in Amsterdam lists a picture of *"My horse... 73"* (guilders; published in Schwartz, 1985, p.138).

58 Antonio Tempesta, *Equestrian Monument of Henry II, King of France*.
Engraving.
New York, Metropolitan Museum of Art.

In 1559 Michelangelo was asked by Catherine de Médicis to design an equestrian monument of her late husband, Henry II. Actual execution of the sculpture was entrusted to Daniele da Volterra, who cast the horse alone in 1565, then died the following year. Some seven decades later the horse was put to use in Paris (see Pl.149). Here, however, Tempesta invents a figure of Henry II in a print made as a pendant to one of the *Marcus Aurelius*, the monument that had been Michelangelo's inspiration (his sketch is illustrated in *AB*, 1983, p.671).

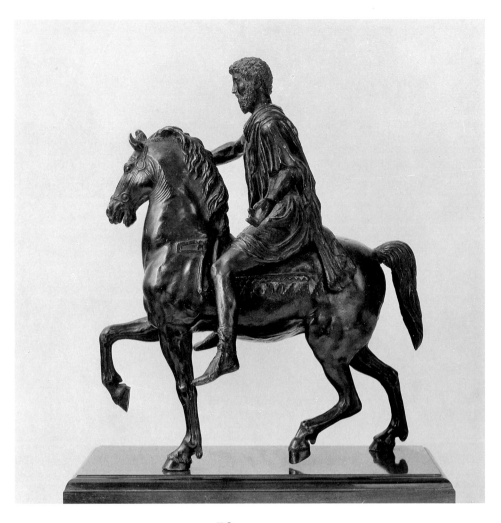

59 Italian, second half of the 16th Century,
Marcus Aurelius on Horseback.
Bronze, 18 in. (45.5 cm) high, with base.
Hamburg, Museum für Kunst und Gewerbe.

A great number of bronze statuettes reproducing
the *Equestrian Monument of Marcus Aurelius* (Pl. 8)
date from the 15th through the 19th centuries; the
earliest known is Filarete's of 1465, in the
Albertinum, Dresden. The Hamburg statuette is
particularly faithful to the original, and, like similar
works (see Möller, 1952), dates from the decades
following the monument's placement on the Capitol
in 1538.

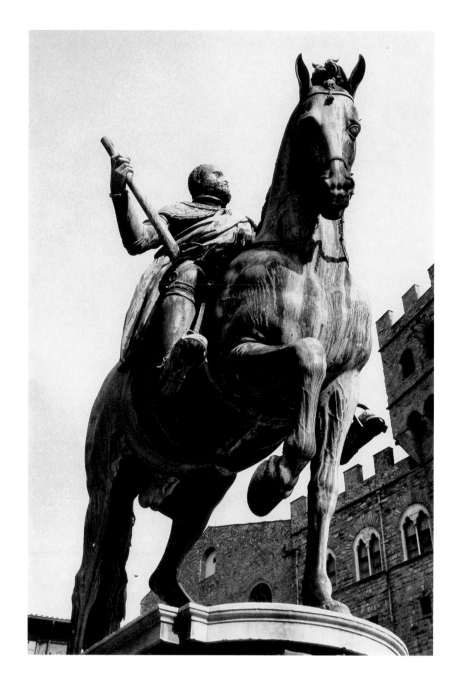

60–61 Giambologna, *Equestrian Monument of Cosimo I*, 1587–99.
Bronze, over life-size (4.5 m).
Florence, Piazza della Signoria.

The horse can be described as a classical form (compare Pl. 8) done over from nature and from the viewpoint of a contemporary riding master: the lowered head and foreleg are significant departures from the *Marcus Aurelius* and result in a more proper *passage*. Giambologna and his patron, Cosimo's son Ferdinando, were especially concerned with the claim to imperial authority made by such a monument. To the average viewer of the time, however, the most striking quality of the work must have been that the horse is so handsome and spirited. Owning such an animal, in the eyes of both courtiers and peasants, would have been a great credit to the Grand Duke or to anyone else. The horses of Ferdinando I (Pl. 66) and Philip III (Pl. 68) pale by comparison.

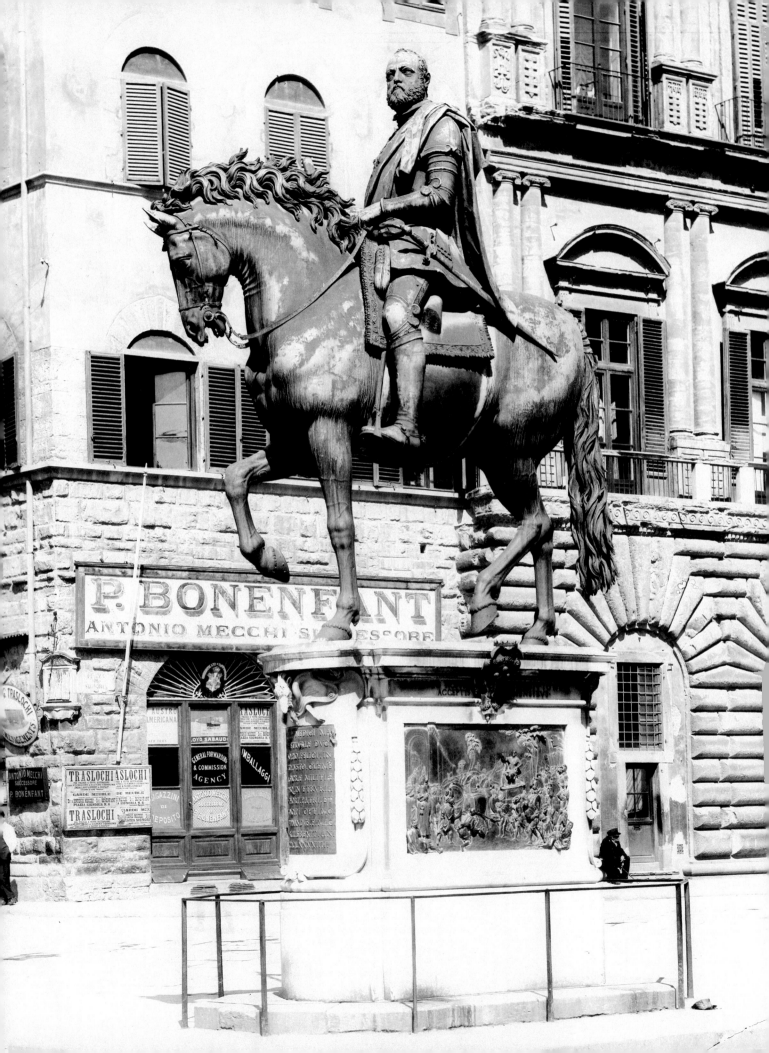

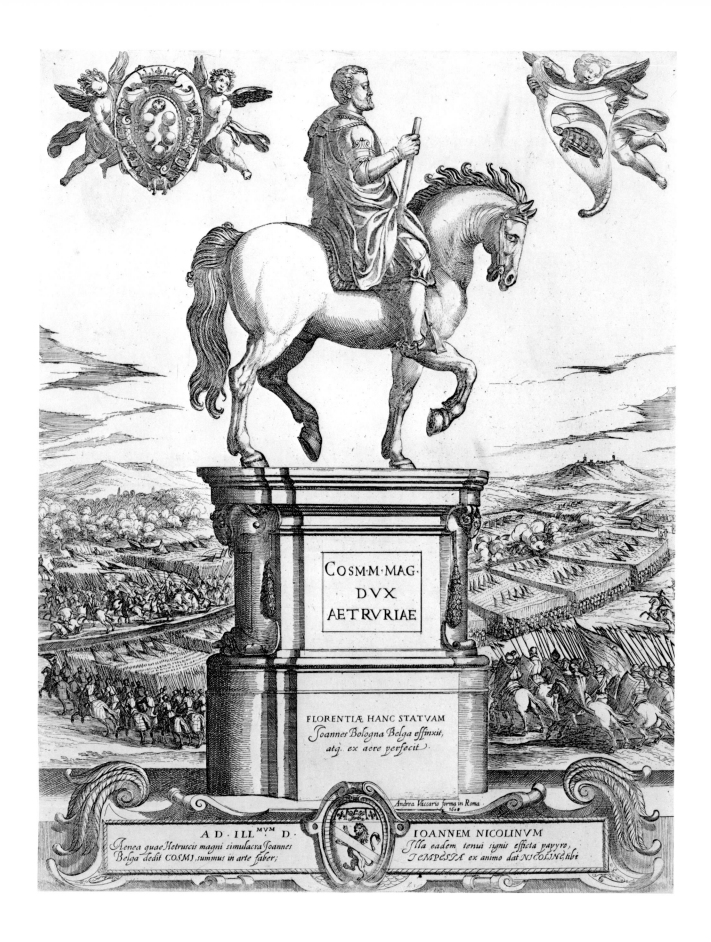

COSM·M·MAG·
DVX
AETRVRIAE

FLORENTIÆ HANC STATVAM
Joannes Bologna Belga effinxit,
atq. ex aere perfecit.

Andrea Vaccario forma in Roma
1608

AD·ILL^{MVM} D. IOANNEM NICOLINVM
Ænea quae Hetruscis magni simulacra Joannes Illa eadem, tenui signis efficta payyro,
Belga dedit COSMI, summus in arte faber; TEMPESTA ex animo dat NICOLINE tibi

62 Antonio Tempesta, *Equestrian Monument of Cosimo I* (after Giambologna), 1608.
Engraving.
New York, Metropolitan Museum of Art.

More than just another printed equestrian portrait (compare Pl. 86), this engraving was the most widespread form of information about the monument in Florence (Pl. 61), which is cited here on the base and described as the work of "Joannes Bologna of Belgium."

63 After Giambologna, *A Trotting Horse with a Clipped Mane*.
Bronze, 9¾ in. (24.8 cm) high.
New York, Metropolitan Museum of Art.

This bronze probably records a model made by Giambologna around 1580 as a study for the *Equestrian Monument of Cosimo I*. The classical style of mane and bound forelock derive from the *Horses of San Marco* or some similar source. One of the reliefs on the base of Cosimo's monument also shows a horse with a clipped mane (see *Giambologna*, 1978, nos. 154–57).

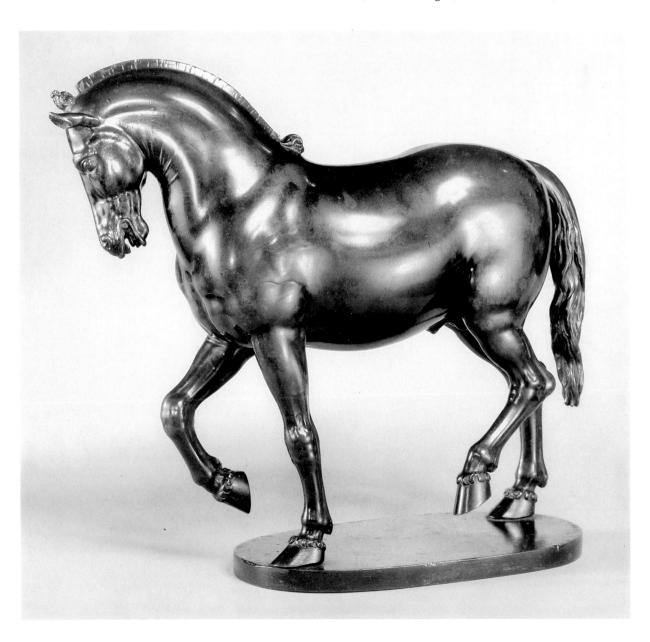

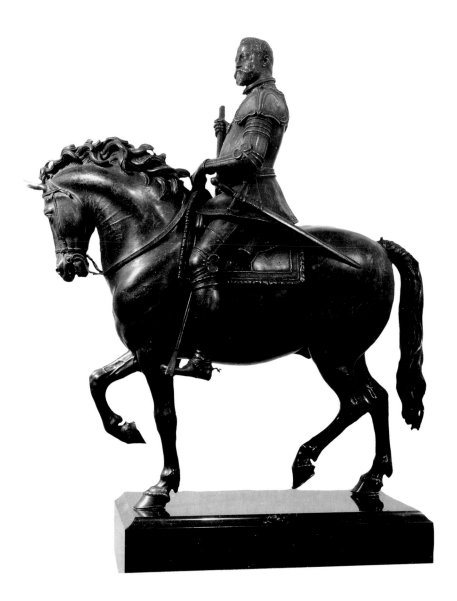

64 After Giambologna, *The Emperor Rudolf II on Horseback.*
Bronze, 24¾ in. (63 cm) high.
Stockholm, Nationalmuseum.

This is another reduction of the monument to Cosimo I, but the head is an idealized portrait of Rudolf II. It has been suggested that this statuette may have been sent to Prague as a present towards the end of the 16th century (*Giambologna*, 1978, no. 149), but the date and the relationship between this piece and the one in Vaduz (Pl. 65) have not been established with certainty (see New York, 1985, p. 68).

65 Giambologna, *Equestrian Statuette of Ferdinando de' Medici,* cast about 1600, modified from a design of about 1587–93.
Bronze, 25¼ in. (64 cm) high.
Vaduz, Collection of the Princes of Liechtenstein.

The statuette derives from Giambologna's *Equestrian Monument of Cosimo I* but represents his son Ferdinando; this signed work may be the *cavallino con figura, servi il Gran Duca Ferdinando* mentioned in a payment notice of May 1600 (*Giambologna*, 1978, no. 150). Until recently the substitution of a waving sash for a cloak (compare Pl. 61) was thought to be Pietro Tacca's idea, but Johanna Hecht (New York, 1985, no. 37) sees the sash as suggestive of Susini's style. Hecht convincingly maintains that the present piece is less likely a model for the Ferdinando monument, which turned out quite differently (Pl. 67), than an independent production intended for private presentation and display.
Colorplate 8

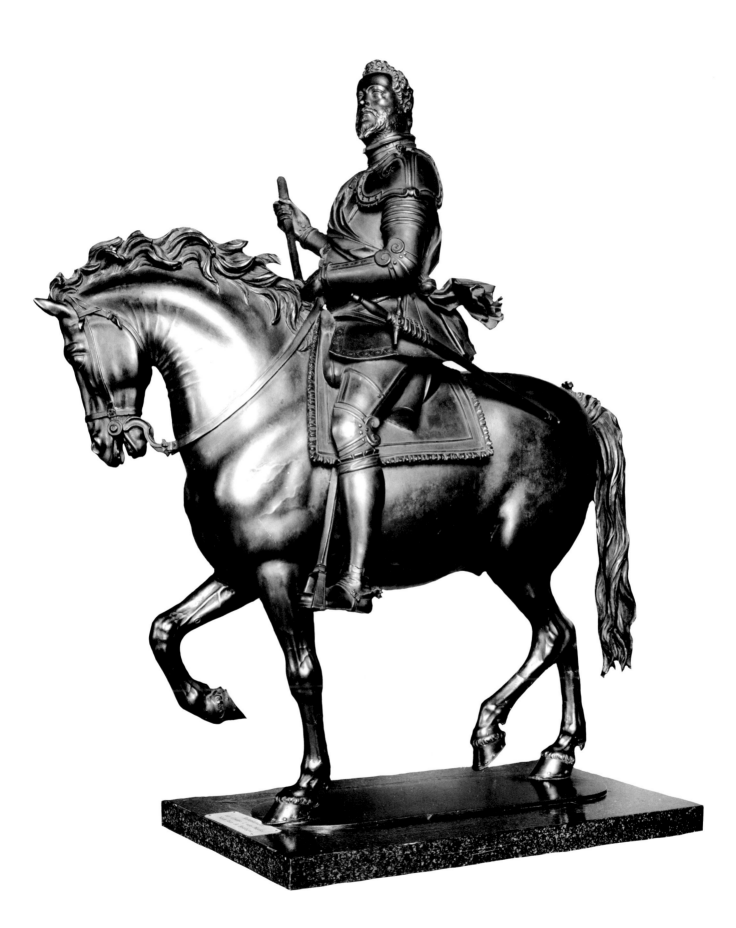

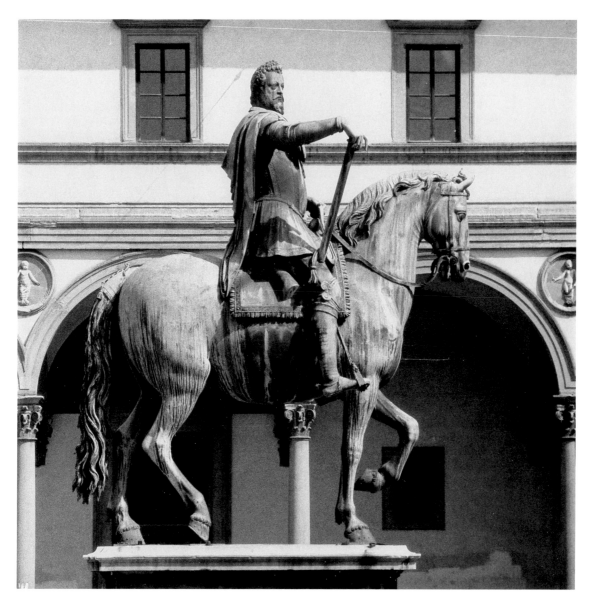

66–67 Giambologna (completed by Pietro Tacca),
Equestrian Monument of Ferdinando I, 1601–8.
Bronze, over life-size.
Florence, Piazza SS. Annunziata.

After the successful completion of the *Cosimo I* (Pl. 61),
the 72-year-old Giambologna was awarded the
commission of a similar statue of his patron, Ferdinando,
on horseback. A model was made in 1601, the horse
was cast in 1603, the rider two years later. Giambologna
died in August 1608; his pupil Tacca could only have
had a small part in the completion of the monument.
Dahl (1935, p. 35) sees the sense of forward movement
here as very restricted, but from a rider's point of
view it is stronger than in the case of Cosimo's horse, and
the now frontal and more erect head can be considered
a correction (compare Pl. 220). This is not to say
that Ferdinando's horse seems livelier: it is cold, stiff,
and unhappily idealized, Mannerist yet inelegant.
Compared to Cosimo's monument, Ferdinando's made
little impression on later artists. Its greatest virtue is its
superb situation.

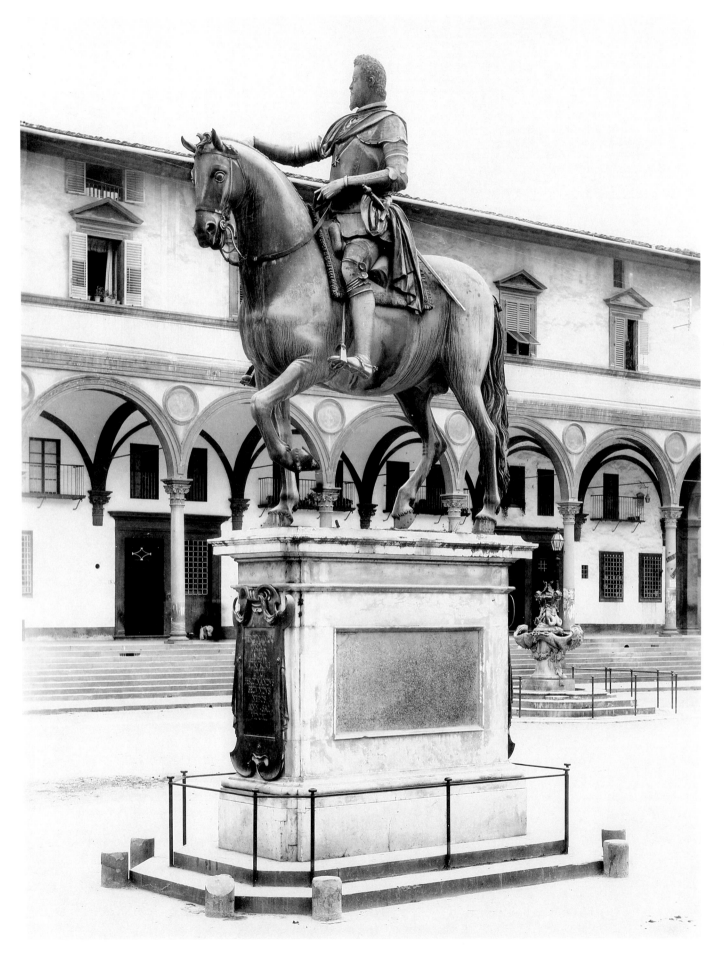

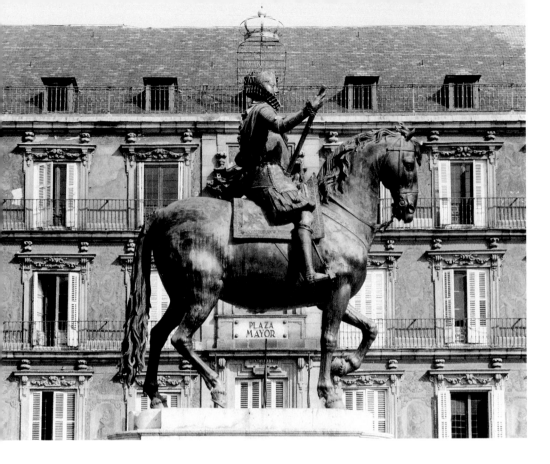

68 Giambologna and Pietro Tacca, *Equestrian Monument of Philip III*, 1606–16.
Bronze, over life-size.
Madrid, Plaza Mayor (formerly Casa del Campo).

The statue was commissioned in 1600 by Ferdinando I as a gift to Philip III. Giambologna worked on the project between 1606, when he received a Spanish portrait of the king, and his death in 1608. Tacca finished the work in 1613; it was finally shipped to Spain in 1615 and was presented to Philip III in October 1616. Dahl (1935, p. 42) considers the swelling forms of the horse and the more energetic movement as early Baroque qualities, but the rubbery inflation and counterpoise of curving contours evident in this amusing mount seem like a typically Mannerist appreciation of anatomy. In any case, the monument made a great impression at the Spanish court. An anonymous 17th-century painting of the statue in the garden of the Casa del Campo is reproduced in Brown and Elliott, 1980, fig. 16.

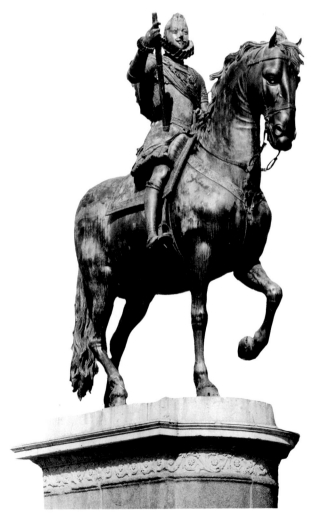

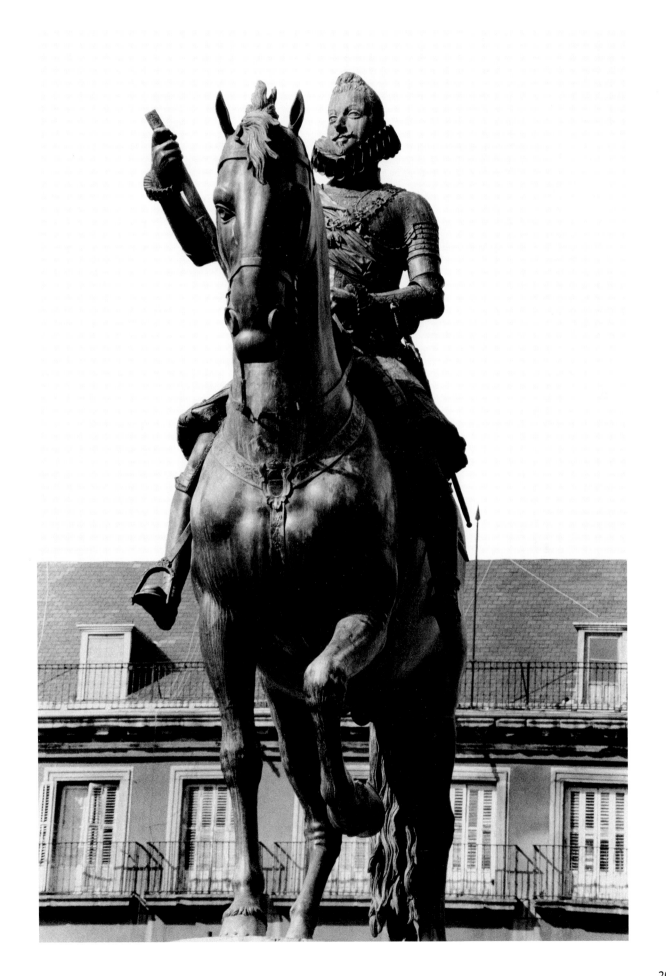

69 Giambologna, *A Rearing Horse*.
Bronze, 10 in. (25.5 cm) high.
Her Majesty the Queen.

Charles Avery (*Giambologna*, 1978, no. 153)
describes this piece as the only cast "of respectable
quality" to represent Giambologna's idea of a
rearing horse, and he suggests that "it fits well
into the development of equestrian sculpture at
the time, for it provides a possible prototype for
Pietro Tacca's rearing horses." The horse's weight
is too far forward, and the action too free, to
approach a *levade* (compare Pl. 108), which was
clearly not the artist's intention. Evidently
referring to this composition, Baldinucci spoke
simply of "*il cavallo che sta in su due piedi.*"

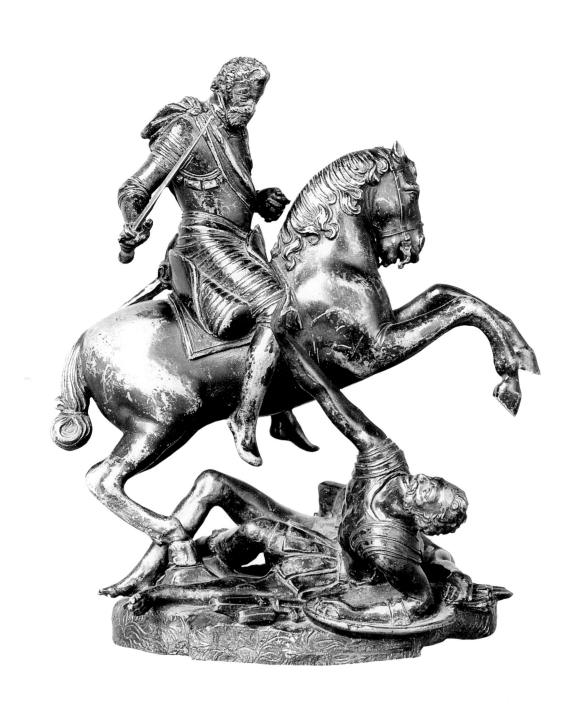

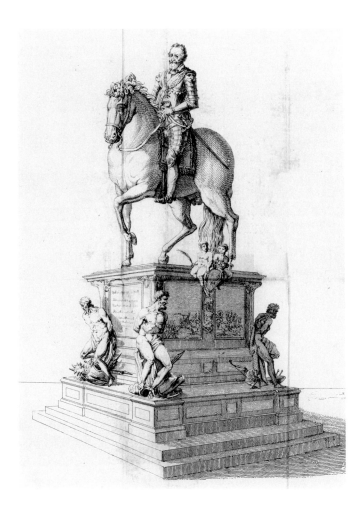

70 Adriaen de Vries, *Duke Heinrich Julius of Braunschweig on Horseback*, about 1607–13. Bronze, 20½ in. (52 cm) high. Formerly Braunschweig, Herzog Anton Ulrich-Museum (missing since 1945).

De Vries, trained in Florence by Giambologna, was the Emperor Rudolf II's court sculptor in Prague between 1601 and 1612. Exceptionally, he was allowed to undertake some private commissions from his patron's most trusted officials, such as Karl von Liechtenstein and Heinrich Julius von Braunschweig-Lüneburg. The latter was in Prague between 1607 and 1613, and this statuette must date from that time, despite the fact that the Duke appears (not unusually) somewhat younger than he does in an engraving of this period (Larsson, 1967, pp. 44–45). The horse rears; its pose depends not so much upon Tempesta (Larsson's suggestion) as, probably, on Stradanus's *Equile* and other prints (see Pls. 54A, 56A) and on Giambologna (see captions to Pls. 53 and 69). See also Larsson, 1982, p. 229, fig. 22, for a bronze trotting horse by de Vries, dated 1607.

71 Follower of Giambologna (Antonio Susini?), *Henry IV on Horseback above Two Fallen Enemies*, about 1605? Bronze, 8⅝ in. (21.8 cm) high. Hamburg, Museum für Kunst und Gewerbe.

In 1964 (*Jahrbuch der Hamburger Kunstsammlungen*, IX, pp. 225–28) the museum published this new acquisition as French, about 1600–1610, making numerous irrelevant references to Leonardo and so forth. Like Adriaen de Vries's rearing horse (Pl. 70), this lesser work should be associated with Giambologna's workshop. His monument of Henry IV on a trotting horse (Pl. 71A) was begun in 1604, finished in 1611 by Tacca, set up on the Pont Neuf in 1614, and destroyed in the Revolution. On Antonio Susini's role around the time of Giambologna's death (1608) see *Giambologna*, 1978, nos. 160–61 (statuettes of Henry IV and Philip III on trotting horses), and no. 162 (a trotting, not "pacing" horse, signed by Susini).

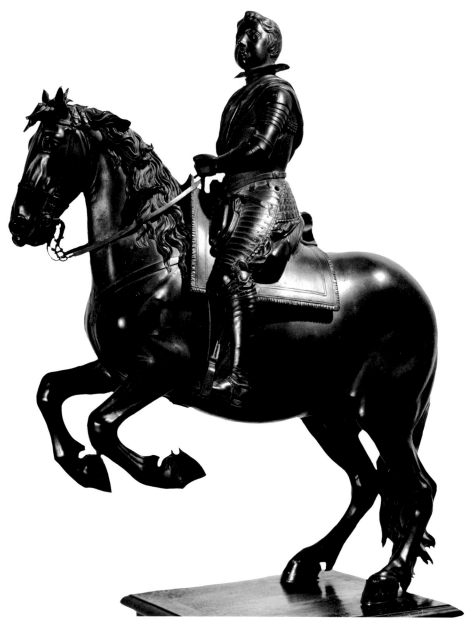

72 Pietro Tacca, *Equestrian Statuette of Louis XIII of France*, 1617.
Bronze, 26⅜ in. (67 cm) high.
Florence, Museo Nazionale del Bargello.

This bronze owes its existence to Cosimo II de' Medici, who intended to give a gold version of it to his young cousin, Louis XIII, the new King of France (r. 1610–1643). The goldsmith Gasparo di Donato Mola received gold for this purpose in 1611 and finally delivered the finished work, now lost, in 1623. At the time the horse was said to be *"in atto di corvettare"* (Fock, 1972, p. 16), the very phrase that Baldinucci (1681) used to describe Tacca's similar statuette of the Duke of Savoy (Pl. 73). The present work was far more likely Mola's model than a replica; the horse's pose, which Tacca called "truly proud and new" (letter of 1622, quoted by Camins, 1981, p. 30),

obviously develops from designs current in Giambologna's studio (Pls. 69–71). From the full passage and other remarks in his book we can assume that Baldinucci knew what he was talking about and really did mean *"courbette"* in the modern sense, that is, a lift to a high *levade* (called a *pesade*) followed by leaps forward on the extended hindlegs. Both of Tacca's equestrian statuettes, especially that of the Duke of Savoy, have a thrust forward which makes it clear that the stationary *levade* is not meant. However, the bronzes fail to represent a convincing *courbette*, which requires a much high lift (in order to balance on the hindlegs) that would look even more unusual in art than it does in the riding ring (Pl. 220). Tacca's intention, then, seems to have been tempered by his background in Giambologna's work (compare Pl. 69). It is doubtful that anyone would have been the wiser so long before the revelations of photography.

73 Pietro Tacca, *Equestrian Statuette of Carlo Emmanuele, Duke of Savoy*, 1619–21.
Bronze, 29½ in. (75 cm) high.
Kassel, Castle Löwenburg (Staatlichen Schlösser und Gärten Hessen).

The equestrian monuments by Giambologna and company in Florence, Paris and Madrid brought Tacca requests for similar statues from such distinguished patrons as the King of England and the Duke of Savoy. The latter, in a letter dated June 3, 1619, penned his approval of the model Tacca had sent to Turin and suggested that the artist come to Turin to execute the monument. Instead, Tacca sent this bronze, for which the Duke thanked him, repeating his proposal, in October 1621. Katharine Watson (in

Giambologna, 1978, no. 163), while acknowledging that the present work is finished very differently, concludes that it was probably cast from the same moulds as the *Louis XIII* (Pl. 72). In any case, Baldinucci's report that Tacca arrived at the pose, a *"courbette"* (wrongly rendered as "rearing" by Watson), in collaboration with the Grand Duke Cosimo II's *cavallerizzo* ("horseman") Lorenzino would appear to apply to both statuettes. They are bold experiments (especially as models for a monument), but not, as Watson subjectively claims, "a splendid conclusion to a problem of design which had interested Giambologna." Tacca reached that point later, again with the advice of an expert rider, in the *Equestrian Monument of Philip IV* (Pl. 74).

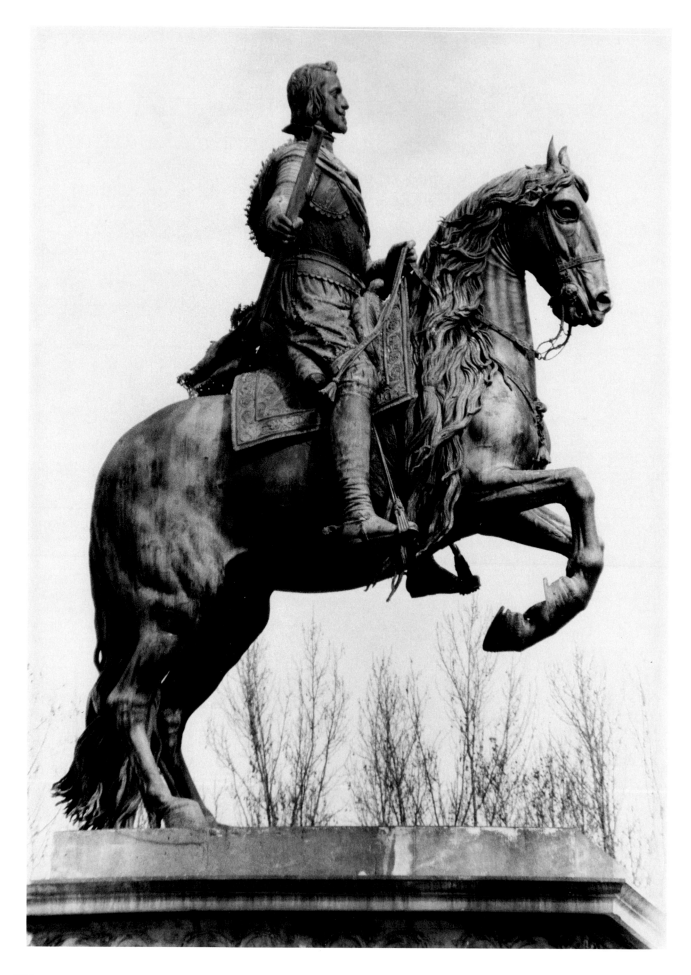

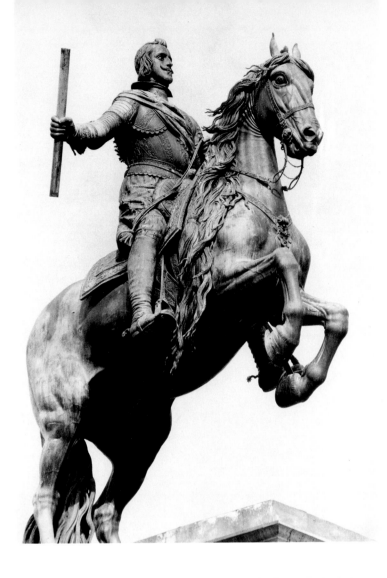

74 Pietro Tacca, *Equestrian Monument of Philip IV*, 1636–40.
Bronze, over life-size.
Madrid, Plaza de Oriente.

Already known in Madrid for his work on the monument of Philip III (Pl. 68), the aging Tacca, in response to a letter of 1634, produced a full-scale model of Philip IV on a trotting horse by the fall of 1636. He was then informed that Olivares insisted upon the pose seen here, which the biographer Baldinucci (1681) astutely describes as "something in between the *courbette*, *pesade* and *levade*, but more like a simple *levade* than anything else" (see captions to Pls. 72, 73). Tacca was sent an unidentified equestrian portrait by Rubens (see Pl. 116), a bust of Philip IV by Juan Martínez Montañés (see Brown and Elliott, 1980, p. 111), and, in the first half of 1640, a portrait of the king painted in Velázquez's studio. The statue was finished in the fall of 1640, but did not arrive in Madrid until June 1642. It was installed by Tacca's son, Ferdinando, in the Queen's Garden of the Buen Retiro Palace on October 29, 1642, and moved to its present location in front of the Palacio Real in 1844. Art historians such as Wittkower have criticized the work for lacking the High Baroque style of Bernini (Pl. 153), but the monument is by an Early Baroque artist who, like Velázquez (Pl. 112), understood that the formality of courtly riding was well suited to the iconic quality of state portraiture.

75 Three views of Tacca's *Equestrian Monument of Philip IV* in the Plaza de Oriente, Madrid (1986).

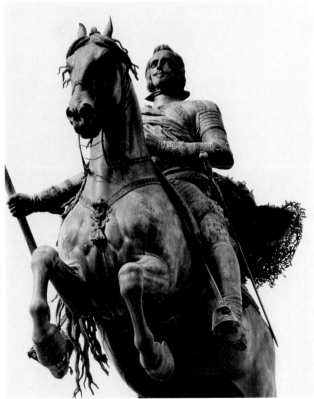

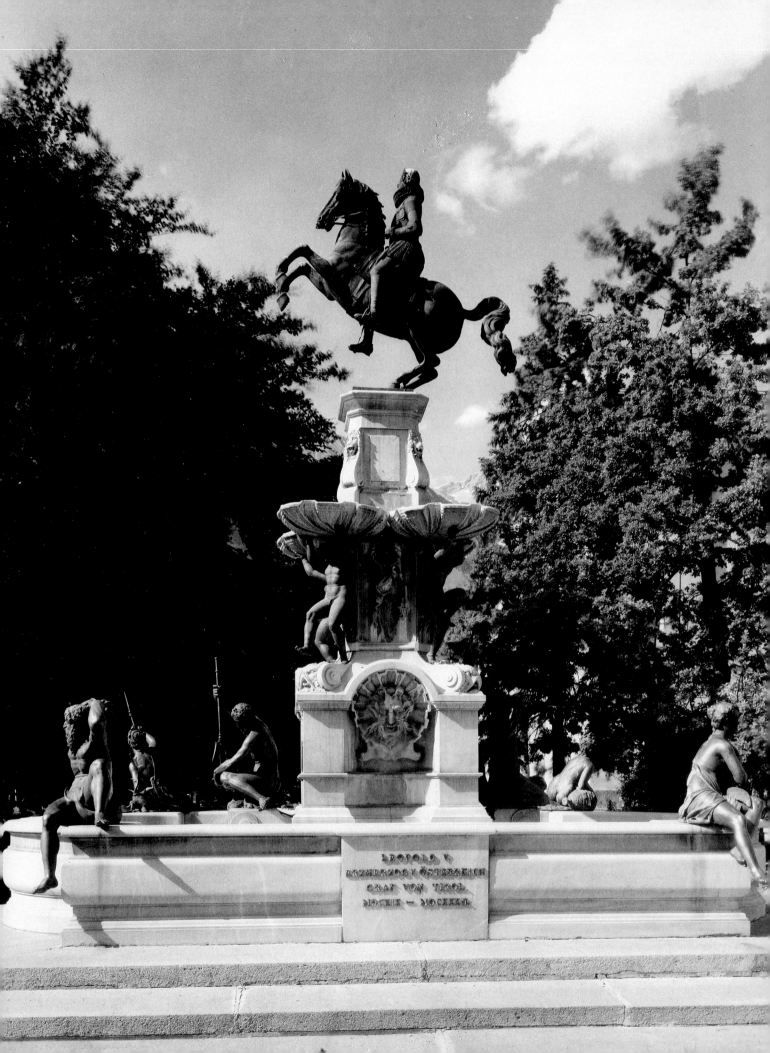

LEOPOLD V.
ERZHERZOG V ÖSTERREICH
GRAF VON TIROL
MDCXIX — MDCXXXII.

76 Caspar Gras, *Equestrian Monument of Archduke Leopold V of Tirol*, 1628–30 (erected in 1894).
Bronze, life-size.
Innsbruck, Rennweg.

Caspar Gras (c. 1590–1674) was an Innsbruck student of Hubert Gerhard, who, like Adriaen de Vries, was an expatriate Dutchman inspired by the Flemish-born Giambologna. Both Gerhard and de Vries produced fountains in Augsburg in the 1590s. Gerhard worked mainly in Munich; Gras succeeded him in 1613 as the principal sculptor in service to Maximilian III of Tirol (d. 1618) and to his successor Leopold V (d. 1632). Little is known about Gras; Weihrauch, (1943, p. 111) could only speculate about a possible study trip to Italy. In any case, this monument, completed a decade before Tacca's *Philip IV* (Pl. 74), indicates how widespread was the influence of Florentine forms and how current in the 1620s was the interest in *haute école* riding (one assumes that the artist and the patron were aware of Pluvinel; compare Pl. 108). The six figures sitting on the fountain are not heavily allegorical, but are relaxed references to Leopold's love of hunting and fishing. That he saw riding in a similar light—one that contrasts refreshingly with the tone adopted in Florence, Paris and Madrid—is suggested by the splashy context here and perhaps by the flip of the horse's tail.

77 Caspar Gras, *Equestrian Statuette of Archduke Ferdinand Karl of Tirol*, probably about 1650.
Bronze, 13¾ in. (34.8 cm) high.
London, Victoria and Albert Museum.

This and several very similar statuettes were once assigned to the workshop of Francesco Susini (Schlosser, 1913–14; Planiscig, 1924), but are now considered to be by Caspar Gras (see Vienna, *Giambologna*, 1978, nos. 163a–d, which cites old documents and new literature and notes that in three instances the sitters are Tirolean). One of the examples in the Kunsthistorisches Museum, Vienna, represents Leopold V (see Pl. 76), this one his son Ferdinand Karl (1628–1662). Presumably the present piece therefore dates from about 1650, but the horses in this series are cast from the same moulds, and the riders' heads are removable (interchangeable). Manfred Leith-Jaspar (*Giambologna*, 1978, no. 163c) stresses the connections between these statuettes, those by Tacca, and the *Equestrian Monument of Leopold V*; and between the ruling families of Tuscany and the Tirol. However, the rider here twists in the saddle (in another type he is frontal), the horse turns its head, and the action seems more spontaneous than in the life-size statue. If pressed, then, one would say that the horse rears, and recalls the one by Adriaen de Vries (Pl. 70) more than those by Tacca (Pls. 72, 73).

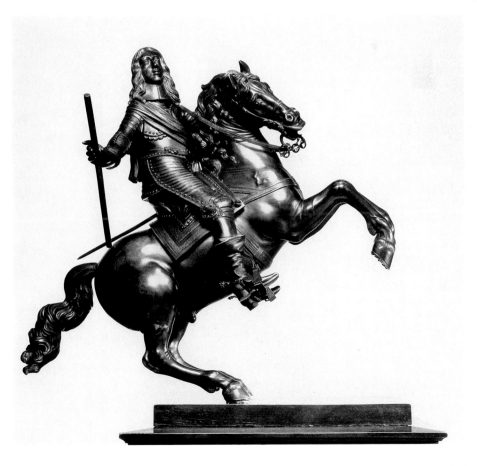

78 Nuremberg (workshop of Jeremias Ritter?), mid-17th Century, *Gustav II Adolf, King of Sweden, on Horseback.*
Bronze, in part chased, the horse and rider 2½ in. (6.4 cm) high.
Berlin, Staatliche Museen.

In this delightful little morsel of bronze, a horse with a heart as big as the king's belly leaps forward at the sound (so it seems) of the order to charge. The suggestion that this tiny statuette might be a model for a larger bronze or even a monument is far less plausible than the assumption that it is self-sufficient or perhaps intended as a finial (on a ceremonial goblet?) or some other ornamental form.

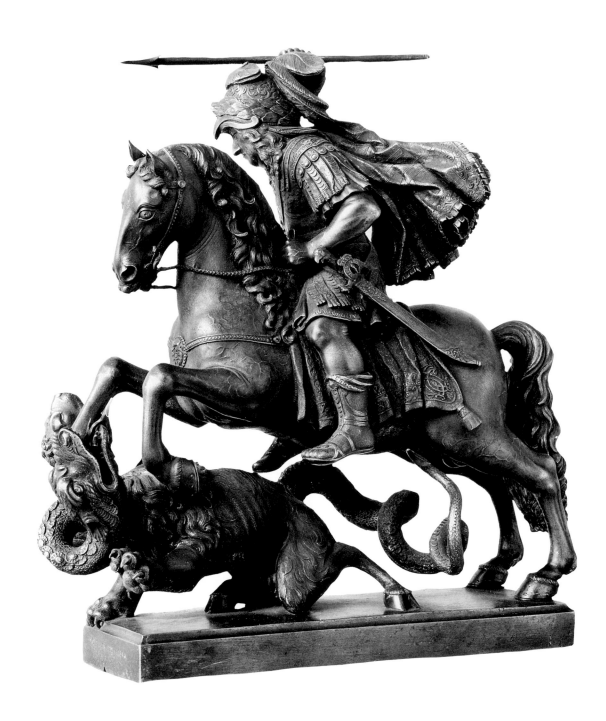

79 Gottfried Christian Leygebe, *The Great Elector as St. George*, 1680.
Iron, 11 in. (27.7 cm) high, including base.
Berlin, Staatliche Museen.

The heroic rider is Friedrich Wilhelm I, Kurfürst von Brandenburg, who calmly dispatches the most imaginative monster, with a goat's body, head, and hoofs, a lion's head and paws, a dragon's head and necks, and a serpent's tail. Leygebe, working in Berlin for the Elector since 1668, had earlier completed similar statuettes of the Emperor Leopold I (Copenhagen, Schloss Rosenberg), and of Charles II, King of England (Dresden), the latter also as St. George. In both St. George compositions the chimera represents political opponents; one of the seven heads in Dresden is Oliver Cromwell's. Here the design, however convincing, may be described as conventional (compare Pl. 42).

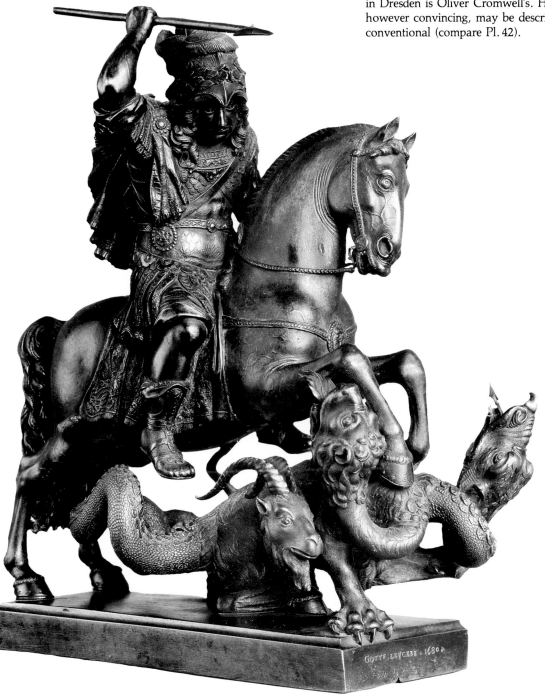

80 South German, mid-17th Century,
A Rearing Horse.
Bronze, 14⅛ in. (36 cm) high.
Berlin, Staatliche Museen.

After all the instances in which one may or may
not say that a Baroque horse rears it is a relief
to find a few in which one *must* say that the horse
rears. The statuette was designed to jet water.

81 South German, 17th Century,
A Rearing Horse.
Bronze, gilded, and richly chased, 4⅜ in. (11.2 cm)
high.
Berlin, Staatliche Museen.

Like Tuby's quadriga in the Apollo Basin at
Versailles (1668–70; Berger, 1985, Pls. 34–36), this
exquisite statuette reveals a stylized treatment
of the subject that is typical of the second half of the
17th century. The flowing forms of the legs are as
anatomically wrong as they are aesthetically right.

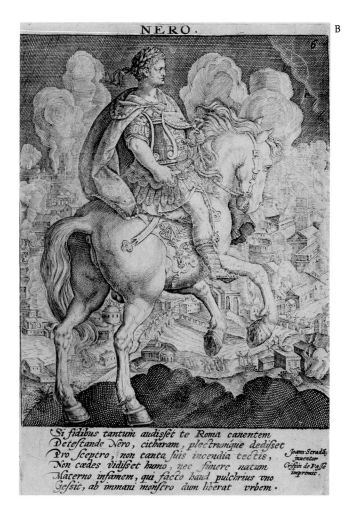

82 Crispijn de Passe (?)
after Stradanus,
A.*Tiberius*, and B. *Nero*,
about 1590.

After we reproduced prints by Stradanus (Pls. 53–56)
we traced Leonardo's legacy and the influence of
ancient sculpture through Giambologna, and then
covered some 17th-century sculptors who were
influenced by him. We now return, by way of
Stradanus and his pupil Tempesta, to the years
around 1600, and to predominantly pictorial
examples of equestrian portraiture and related
subjects.

218

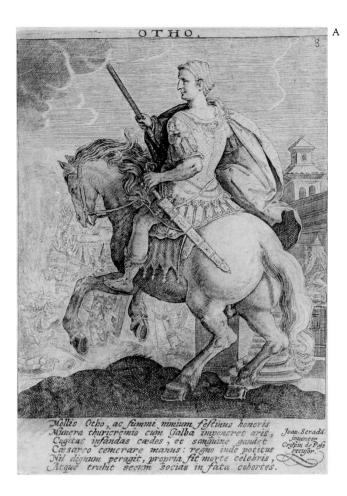

OTHO.

8.

Mollis Otho, ac summi nimium festinus honoris,
Munera thuricremis cum Galba imponeret aris, Joan. Stradā.
Cogitat infandas cædes, et sanguine gaudet Inuentor
Cæsareo temerare manus: regno inde potitus Crispin de Pass
Nil dignum peragit, propria fit morte celebris, excusor.
Atque trahit secum socias in fata cohortes.

82–83 After Johannes Stradanus,
The Twelve Caesars, about 1590.
Engravings.
New York, Metropolitan Museum of Art.

Between the time that Michelangelo moved the
Marcus Aurelius to the Capitol and the years in
which Louis XIV admitted some resemblance to
Alexander the Great, the Duke of Urbino was told
that Giambologna was making a "Horse of Trajan"
for Cosimo I (see Pl. 61); Rubens and his Genoese
patron considered the Roman Consul Decius Mus
(Pl.98) a model of princely responsibility; and almost
any courtier would have cited Suetonius as an
authority on the greatest, or at least the most
entertaining, emperors of ancient Rome. It was to
be expected, then, that Stradanus's *Twelve Caesars*
of about 1590, made to illustrate an editon of
Suetonius's lively biographies, would enjoy enormous
circulation and a long afterlife in the series by
Tempesta (Pl. 85) and in the many paintings and
prints that were directly or indirectly derived from
Stradanus's designs. They were conceived with
ancient examples in mind and with an interest in
modern riding, making the prints doubly appealing
to authors and patrons of 17th-century equestrian
portraiture.

83A Crispijn de Passe (?)
after Stradanus,
Otho, about 1590.

83B Adriaen Collaert
after Stradanus,
Otho, early 1590s.

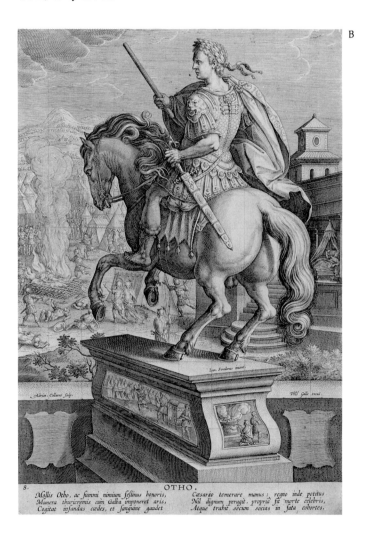

OTHO.

8. *Mollis Otho, ac summi nimium festinus honoris,* *Cæsareo temerare manus: regno inde potitus*
Munera thuricremis cum Galba imponeret aris, *Nil dignum peragit, propria fit morte celebris,*
Cogitat infandas cædes, et sanguine gaudet *Atque trahit secum socias in fata cohortes,*

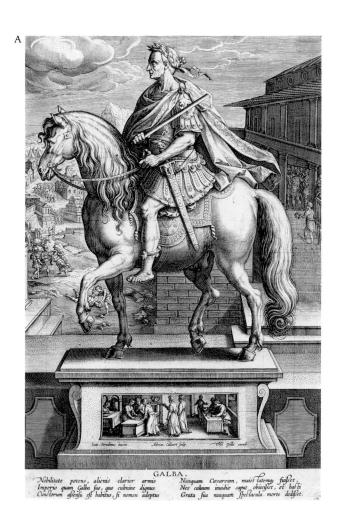

A

GALBA.

Nobilitate potens, alienis clarior armis *Nunquam Cæsareum, maiesˆtatemq; fuiʃet,*
Imperio quam Galba ʃuo, quo culmine dignus *Nec caluum inuidiæ caput obieciʃet, et hoʃti*
Cunctorum aʃʃenʃu eʃt habitus, ʃi nomen adeptus *Grata ʃua nunquam ʃpectacula morte dediʃʃet.*

B

12. DOMITIANVS.

Domitiane, tuæ labes turpiʃʃima gentis, *Mox ruis in peius contemto numine Diuûm,*
Æmula famoʃo cur fingis ʃceptra Neroni? *At quoniam inʃonteis nullâ ratione trucidas,*
Principâ arriʃit probitas ʃimulataq; virtus *Te merità mœrire tui cœuntur amici.*

84 Adriaen Collaert after Stradanus,
A. *Galba*, and B. *Domitian*, early 1590s.
Engravings.
New York, Metropolitan Museum of Art.

85 Tempesta, four of the *The Twelve Caesars*,
published in Rome, 1596.
A. *Vespasian*, B. *Titus*, C. *Galba*, and D. *Tiberius*
Engravings.
New York, Metropolitan Museum of Art.

A

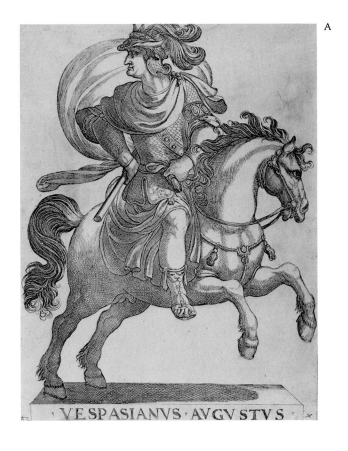

VESPASIANVS AVGVSTVS

B

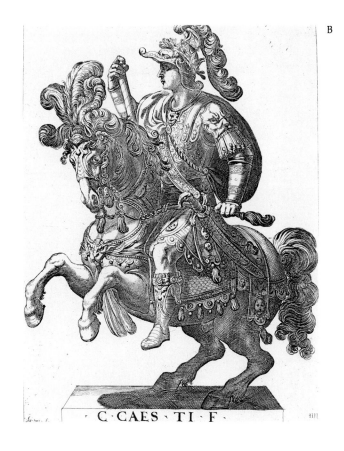

C·CAES·TI·F

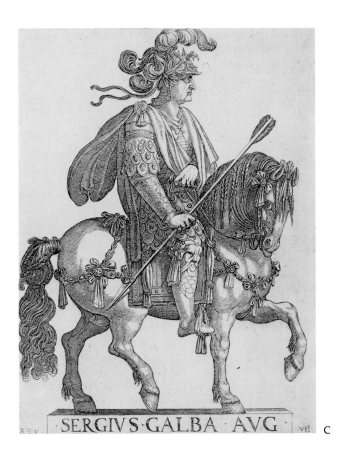

SERGIVS·GALBA·AVG VII

C

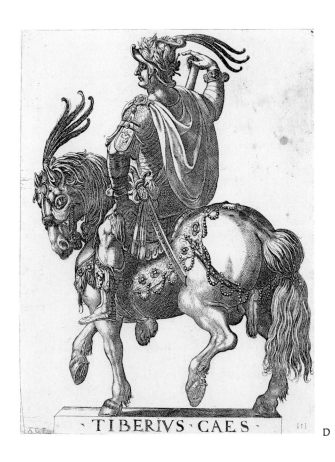

TIBERIVS·CAES III

D

221

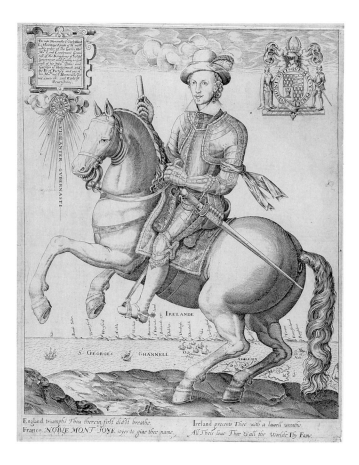

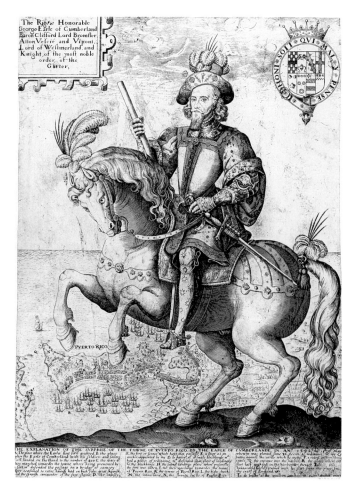

86 Thomas Cockson, *Charles Blount, Earl of Devonshire, on Horseback*, about 1604.
Engraving.
London, British Museum.

The horse is borrowed from Stradanus's "Stable of Don Juan" (*Equus Hispanus*, Pl. 54A). See the caption to the following plate.

87 Thomas Cockson, *George Clifford, 3rd Earl of Cumberland, on Horseback*, about 1598–99.
Engraving.
London, British Museum.

Cumberland, a bit batty about things Medieval, here wears the same splendid outfit as in Hilliard's miniature portrait of about 1590 (Washington, 1985, pp. 62, 64, fig. 4 in color) and the same plumage as that sported by his horse fore and aft. The most likely model for this engraving is Tempesta's *Titus* (Pl. 85A), while the horses in Cockson's printed equestrian portraits of the Earls of Devonshire (Pl. 86) and Essex (Hind, I, pl. 126) clearly were copied from Stradanus's *Equile* (Devonshire rides the *Equus Hispanus* and Essex the trotting *Brito*; Pls. 54A, 55B). Cockson's *Earl of Nottingham* of about 1599 (Hind, I, pl. 127) again recalls Tempesta's *Titus*, although the Earl's fluttering cape and especially his horse's windblown mane suggest that the mount given by Goltzius to Marcus Curtius in 1586 (Pl. 89) got into Cockson's stable (as well as Tempesta's; see caption to Pl. 89).

▶

88 Willem de Passe, *Equestrian Portrait of George Villiers, Duke of Buckingham, as Lord High Admiral*, 1625.
Engraving.
London, British Museum.

Despite the fact that his brother, Crispijn de Passe the Younger, had already engraved more modern models in Pluvinel's *Maneige royal* of 1623 (see Pl. 108), Willem de Passe, working in London, is here happy with Cockson's examples of a quarter-century earlier. The pose (and our view) of Buckingham's horse follows that in Cockson's Cumberland print (Pl. 87), but the horse's conformation (compare the forelegs) and the higher carriage of the head come from the Devonshire portrait (Pl. 86), as do the position of the rider (or rather, of his left arm and leg) and the general scheme of the setting. The engraving's bloodlines are thus about as extensive as those of the Duke's fine "hand-horses" in the background (their "hand-blankets" bearing his coat of arms), reaching back to both Stradanus and Tempesta by way of Cockson and adding the refining effects of Dutch landscape, still life, and portraiture, as well as the De Passe family tradition of superb technique.

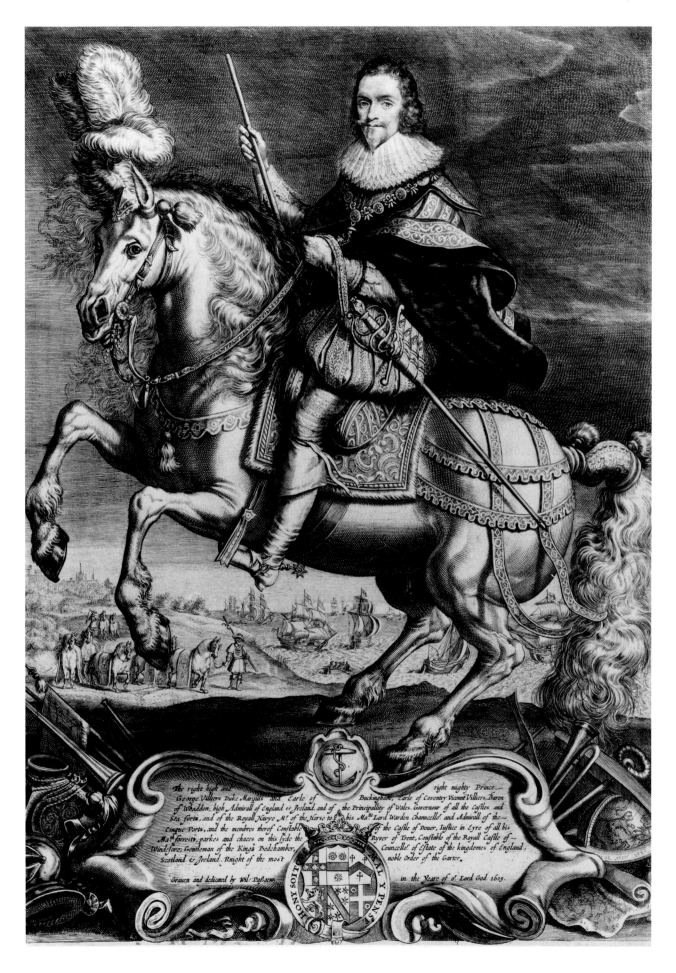

The right high and right mighty Prince
George Villiers Duke Marquis and Earle of Buckingham, Earle of Coventry Vicount Villiers, Baron
of Whaddon, high Admirall of England & Ireland, and of the Principallity of Wales, Governour of all the Castles and
Sea forts, and of the Royall Navye M.rs of the Horse to his Ma.tie Lord Warden Chauncello.r and Admirall of the
Cinque Ports, and the membres therof Constable of the Castle of Douer, Iustice in Eyre of all his
Ma.ties forrests, parkes and chaces on this syde the Ryver of Trent, Constable of the Royall Castle of
Windsore, Gentleman of the Kings Bedchamber, Councello.r of Estate of the kingdomes of England,
Scotland & Ireland Knight of the most noble Order of the Garter.

Grauen and dedicated by Wil: Passaeus in the Yeare of o.r Lord God 1625.

HONY SOIT QVI MAL Y PENSE

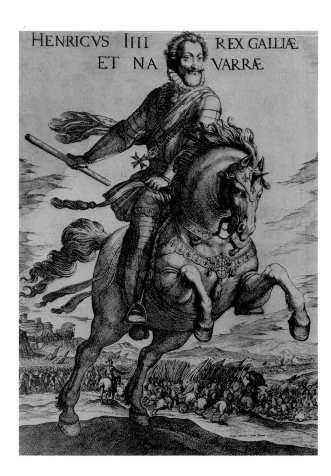

HENRICVS IIII REX GALLIÆ ET NA VARRÆ

90 Antonio Tempesta, *Equestrian Portrait of Henry IV*, 1593.
Engraving.
London, British Museum.

The horse's pose in this influential engraving is the stylized gallop found in prints dating from as much as a century earlier (e.g., Dürer's *Little Courier* of about 1496) and from throughout the 1500s, but the dramatic point of view, soon to become a Baroque device (Pls. 96, 115), was evidently Tempesta's innovation (or transformation; compare Pl. 89), at least in the genre of equestrian portraiture. Tempesta's teacher Stradanus shows horses in the same pose and from nearly the same point of view in the larger context of his battle scenes (for example the *Mediceae Familae* series engraved and published in 1583), which include passages similar to the background here (see also Pl. 53, right background). Equestrian tomb monuments, usually seen from below (Pl. 17), may also have stimulated Tempesta's imagination. The following plates reproduce three of the many prints that were derived from this one (Larsson, 1968, illustrates five others).

▶

89 Hendrick Goltzius, *Marcus Curtius* (from *The Roman Heroes*), 1586.
Engraving.
New York, Metropolitan Museum of Art.

Goltzius engraved probably five of Stradanus's twenty-two illustrations of *The History of Giovanni de' Medici* of about 1578 (Strauss, 1977, nos. 12–16); about a year later Goltzius engraved fifteen of the forty horses in Stradanus's *Stable of Don Juan* (*Equile...*; Strauss, nos. 91–105). The horse and rider here and in one other of the ten *Roman Heroes* of 1586 were evidently inspired by this close study of Stradanus and appear to have influenced in turn Tempesta's *Twelve Caesars* of 1596. They are, like Goltzius's musclemen and horses of 1586, much more emphatically modelled than the horses and riders in Stradanus's *Twelve Caesars*, and they include two prints that in composition correspond much more closely to Goltzius's *Heroes* than to any engravings after Stradanus: Tempesta's *Tiberius* (Pl. 85D), reversing Goltzius's *Titus Manlius on Horseback* (Strauss, no. 237), and his *Titus* (Pl. 85B), following the present print (see also the caption to Pl. 87 on Goltzius and Cockson). In the comparatively cosmopolitan world of published prints the circumstances can be complicated; here, for example, a Haarlem artist (who went to Italy in 1590) has in a sense slipped between Stradanus and his Florentine student Tempesta.

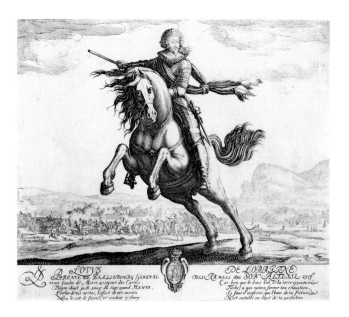

91 Jacques Callot, *Equestrian Portrait of Louis de Lorraine, Prince of Phalsbourg*, about 1623.
Etching and engraving.
New York, Metropolitan Museum of Art.

Callot's preparatory drawing is in the British Museum. As in the case of his sketches after Tempesta's *Twelve Caesars* (see Ch. 1, n. 50). Callot modifies his model (Pl. 90) with a more fluid (and here seemingly windblown) drawing style.

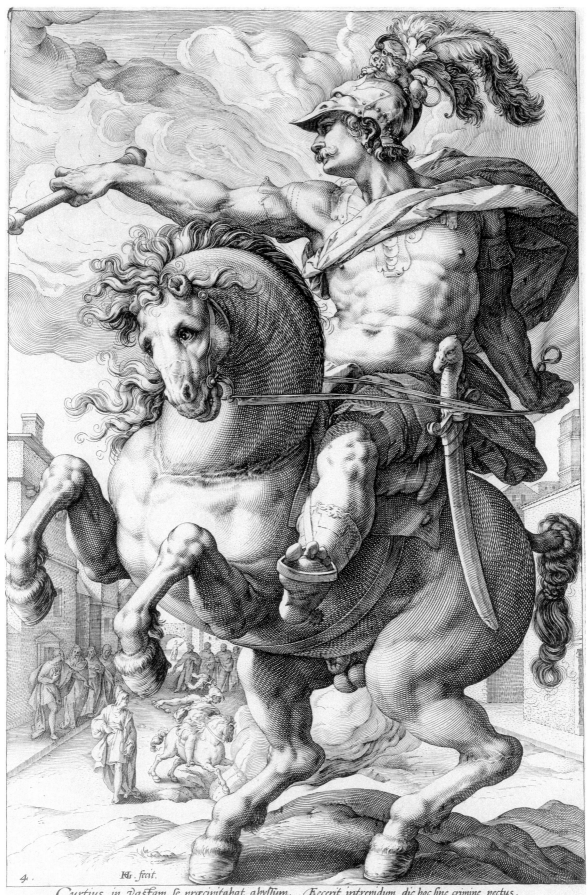

4. Hr. fecit.

Curtius in vastam se præcipitabat abyssum, *Fecerit intrepidum dic hoc sine crimine pectus,*
 Expiet vt tristi Romula tecta lue. *An Patriæ, vt facinus tale subiret, amor.*

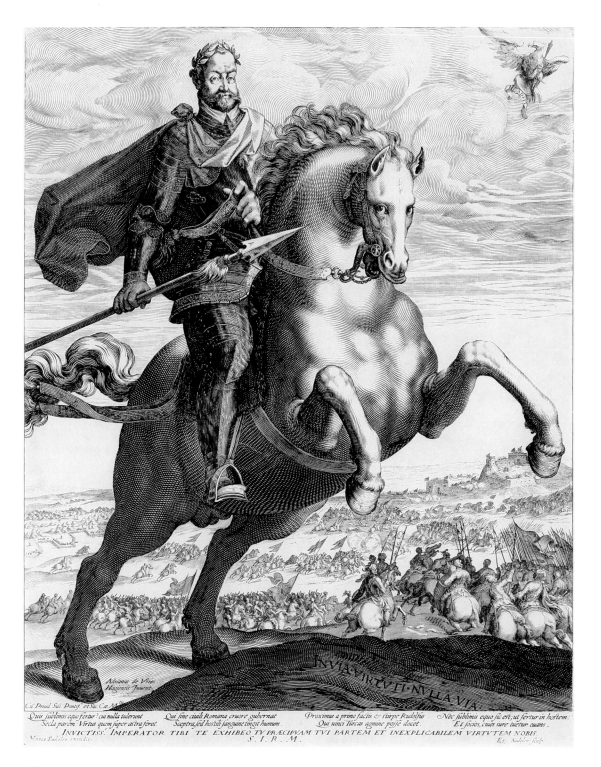

Quis sublimis equo fertur? cui nulla tulerunt Qui sine ciuili Romana cruore gubernat Proximus a primo factis & stirpe Rudolfus Nec sublimis equo sic est; ut fertur in hostem:
Secla parem: Virtus quem super astra feret. Sceptra,sed hostili sanguine tingit humum. Qui uincis Turcas agmine posse docet. Et socios, cuius iure tuetur cuens.
INVICTISS: IMPERATOR TIBI TE EXHIBEO TV PRÆCIPVAM TVI PARTEM ET INEXPLICABILEM VIRTVTEM NOBIS.
S. I. R. M.

92 Aegidius Sadeler after Adriaen de Vries,
Equestrian Portrait of the Emperor Rudolf II
(d. 1612).
Engraving.
New York, Metropolitan Museum of Art.

De Vries, trained by Giambologna, moved
to Prague as court sculptor in 1601 (cf. Pl. 70).
See Larsson, 1967, pp. 42–44.

93 Aegidius Sadeler, *Equestrian Portrait
of the Emperor Ferdinand II as Victor over
the Turks*, 1629.
Engraving.
Minneapolis, The Minneapolis Institute of Arts.

Ferdinand II was King of Bohemia from 1617,
King of Hungary from 1618, and Emperor
from 1619 to his death in 1637.

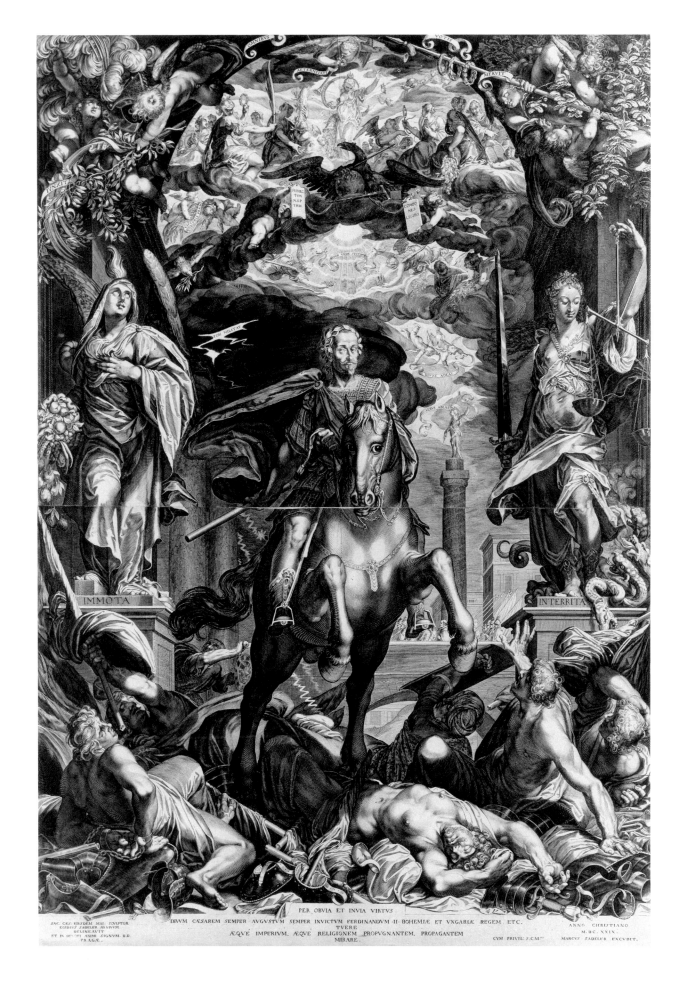

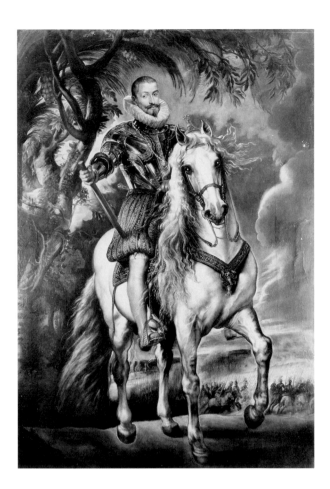

94 Peter Paul Rubens, *Equestrian Portrait of the Duke of Lerma*, 1603.
Canvas, 111½ x 78¾ in. (283 x 200 cm).
Madrid, Museo del Prado.

Apart from members of the royal family, only the most powerful figures at the Spanish court—Lerma, and later Olivares (Pl. 119)—would have commissioned such an authoritative image as this large equestrian portrait. Rubens popularized the frontal approach to the horse and rider that occurs frequently in 17th-century examples, especially in northern Europe. Here and in his later equestrian portraits Rubens modernized ideas found in 16th-century prints (compare Pl. 95).
Colorplate 10

95 Title page of Antonio Francesco Oliviero's *Carlo Quinto in Olma*, Venice, 1567, representing a triumphal arch framing an equestrian portrait of Charles V. Woodcut.
New York Public Library, Spencer Collection.

Like triumphal arches, equestrian monuments were sometimes made of impermanent materials, as they were for Charles V's triumphal entries into Florence and Siena in 1536 (permanent statues were planned earlier and later in Rome). Rubens may have referred to this print when he designed his equestrian portrait of the Duke of Lerma (Pl. 94), and van Dyck, in *Charles I on Horseback with M. de St. Antoine* (Pl. 131), repeated the idea—admittedly familiar from "everyday" life—of the rider coming through an archway.

▶
96 Peter Paul Rubens, *Equestrian Portrait of Giancarlo Doria*, about 1606.
Canvas, 104⅜ x 74 in. (265 x 188 cm).
Florence, Palazzo Vecchio.

According to Baglione (*Le vite de' pittori...*, 1642, p. 263), Rubens "depicted a number of Genoese noblemen from life mounted on horseback, in various canvases, life-size, executed with love and very similar [to each other]; and in this genre he had few equals." The eagle, above left, refers to the Doria arms. With one wild exception, scholars agree on a date of about 1606. The horse and even the dog in this early work by Rubens are in the conventional galloping pose found throughout Renaissance art, but the viewpoint—a worm, dragon, or Dacian's-eye view, depending upon whether one's point of reference is modern, Medieval or Ancient—is new to the comparatively conservative genre of painted equestrian portraiture. Though Rubens referred to earlier printed examples, such as Tempesta's *Henry IV* of 1593 (Pl. 90), the turn of Doria and his horse toward the viewer, the dramatic use of light and shade, and the entirely different background make a much more realistic and exciting impression. For a full discussion and two splendid colorplates see New York, Metropolitan Museum of Art, *The Age of Caravaggio*, 1985, no. 54.
Colorplate 11

97 Peter Paul Rubens, *Saint George and the Dragon*, about 1606.
Canvas, 119¾ x 100¾ in. (304 x 256 cm).
Madrid, Museo del Prado.

Like a number of pictures painted by Rubens in the period 1605–10, this one is aggressively advanced in style. The desperate action derives less from any earlier interpretation of the subject than from Leonardo's furious *Fight for the Standard* (Pl. 31).

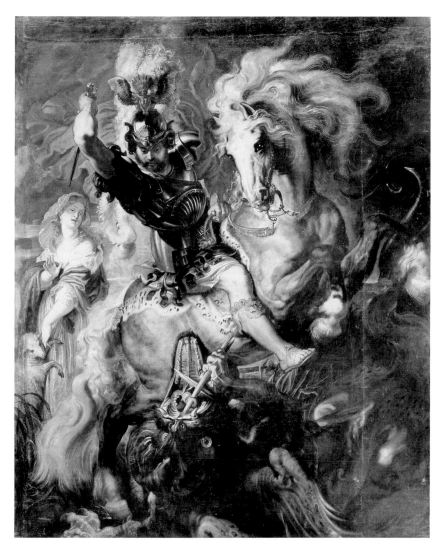

98 Peter Paul Rubens, *Decius Mus Killed in Battle*, 1617–18.
Canvas, 113 x 195½ in. (288 x 497 cm).
Vaduz, Collection of the Princes of Liechtenstein.

This is the largest of eight canvas cartoons for tapestries designed by Rubens for a Genoese nobleman (see New York, 1985, pp. 338–55). One of the most meticulous Rubens scholars has written that the Roman consul's dapple-gray horse "rears up in a royal *levade*," which is both a non sequitur and an absurdity. The painting is illustrated here precisely because it demonstrates the great distance between contemporary equestrian portraiture and Rubens's riders in combat. It is also one of the best examples of Rubens working in the spirit, if not according to the letter, of Leonardo's *Fight for the Standard* (Pl. 31).

99 Workshop of Peter Paul Rubens,
"The Riding School," about 1612.
Canvas, 49¼ x 76⅜ in. (125 x 194 cm).
Formerly Berlin, Kaiser-Friedrich Museum
(destroyed in World War II).

This large canvas was evidently used in Rubens'
studio as a model for equestrian portraits. Van Dyck
and other artists of the period made similar studies
of horses and riders in different poses (Pls. 133–135),
but no painting of the type appears to have been so
widely known and influential as this one.

100 Peter Paul Rubens, *A Wolf and Fox Hunt,*
about 1616.
Canvas, 96⅝ x 148⅛ in. (245.4 x 376.2 cm).
New York, Metropolitan Museum of Art.

This very large canvas, painted with the help of
assistants, is one of Rubens's earliest *Hunts.* It
was probably cut down somewhat before its sale to the
Duke of Aarschot. The horse to the left is derived from
Rubens's *Equestrian Portrait of Giancarlo Doria* (Pl. 96),
while the one to the right is based on the central motif
in the artist's *Riding School* formerly in Berlin (Pl. 99).
Performing a *levade* would be impossible for a horse,
and ridiculous for his rider, in the final moments of a
wild animal hunt; the pose of the horse on the right
recalls the *haute école* air without being intended to be
read as such. It suffices here to suggest riding well,
which, like dressing well, having falcons, servants, land
and enormous paintings, presupposes a certain social
level. See further Liedtke, 1984, pp. 198–209.

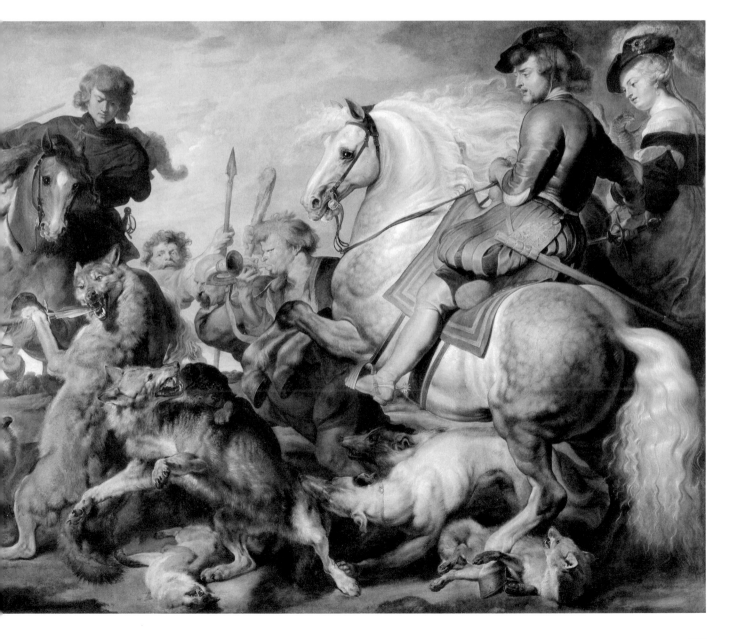

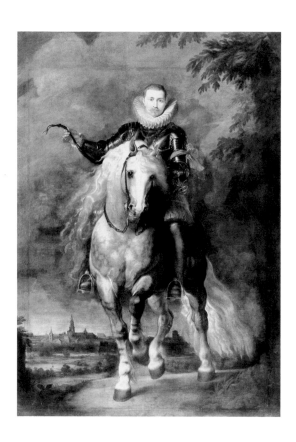

101 Workshop of Peter Paul Rubens, *A Knight of the Golden Fleece*, about 1612(?).
Canvas, with later additions 120 x 85¼ in. (304.5 x 216.5 cm)' originally about 104⅜ x 74¾ in. (265 x 190 cm).
Her Majesty the Queen.

There is a considerable number of equestrian portraits in Rubens's style with this composition, which is based on the horse and rider to the left in Rubens's *Riding School* (Pl. 99). The heads change, rather like those that can be lifted off the little bronzes dating from later in the century (Pl. 77). The rider here may be a rather flattering portrait of Rubens's patron in Brussels, Archduke Albert (1559–1621).

102 Gaspar de Crayer, *Equestrian Portrait of the Count-Duke Olivares*, about 1627–28.
Canvas, about 106 x 79 in. (about 270 x 200 cm).
Present whereabouts unknown (with a New York dealer in the 1960s).

The horse and rider appear almost identically in De Crayer's *Equestrian Portrait of the Marquis of Leganés (?)* in the Kunsthistorisches Museum, Vienna, and—like dozens of mostly Flemish pictures dating from the 17th century (see also Pl. 101 here)—are ultimately adopted from the horse and rider on the left in *The Riding School* from Rubens' studio (Pl. 99). De Crayer's very small *Equestrian Portrait of Philip IV* in the Prado closely follows the central horse and rider in the same canvas. There is a large equestrian portrait of Olivares by De Crayer at Boston College (Vlieghe, 1972, pl. 229); the horse performs a *levade* and the composition on the whole anticipates that of Velázquez's portrait of Philip IV on horseback (Pl. 112). A somewhat similar equestrian portrait of the king by De Crayer hangs in the staircase of the Palacio de Liria, Madrid (Vlieghe, 1972, no. A 258, pl. 235, as in the Palacio de Viana). All of De Crayer's equestrian portraits of single figures appear to date from about 1627–28, and were painted in the Southern Netherlands using engravings for the faces and making liberal use of other artist's ideas, including De Passe's plates in Pluvinel's treatise. (See further Vlieghe, 1967).

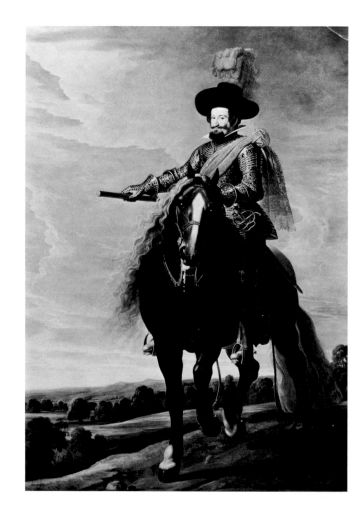

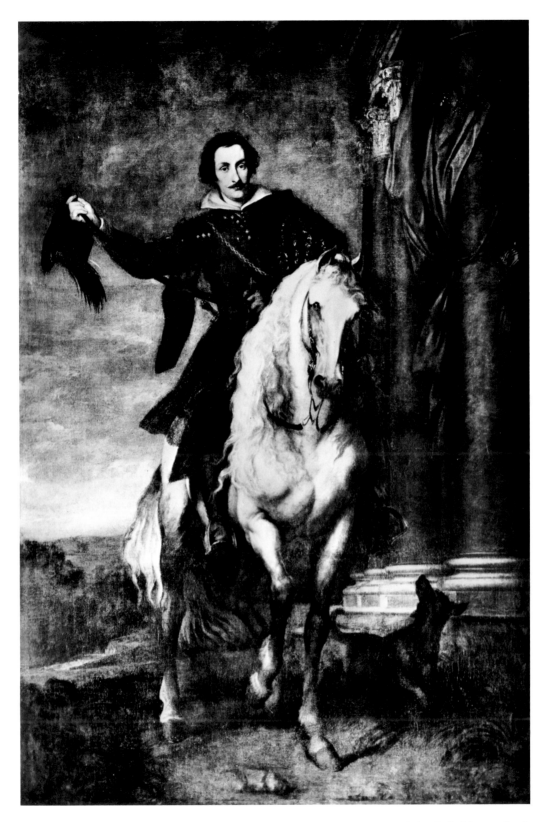

103 Anthony van Dyck, *Equestrian Portrait of Anton Giulio Brignole-Sale,* painted in Genoa in the mid-1620s. Canvas, 113½ x 79 in. (288 x 201 cm).
Genoa, Palazzo Rosso.

Although the pose and view of the horse and rider conform to a type employed repeatedly by Rubens (Pls. 94, 99, 101; the last example even includes the gesture of holding up the reins), the sitter's elegant sway in the saddle and the doffed hat make this an invention typical of van Dyck. His portrait of Charles I riding through an archway (Pl. 131) recalls this one of a newly enobled merchant, where—if one can forgive the comparison—the position and the glance of the dog seem to anticipate those of Charles' equerry, M. de St. Antoine. Rubens included such an enthusiastic dog in an earlier Genoese portrait (Pl. 96).

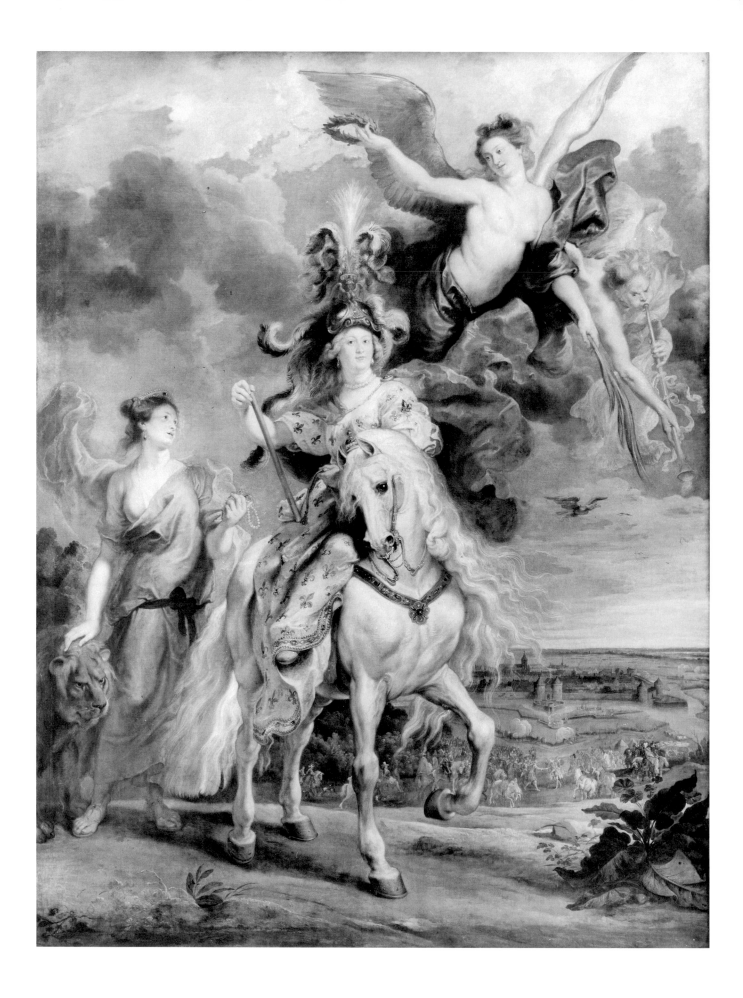

105 Peter Paul Rubens, *The Triumph of Henry IV*, 1627–28.
Panel, 8⅝ x 16 in. (21.8 x 40.7 cm).
Canberra, Australian National Gallery.

This is the first of four known oil sketches painted by Rubens in preparation for his very large canvas in the Uffizi, Florence, which was intended for the end wall of the east gallery in the Luxembourg Palace in Paris. In the final work and the other three sketches (see Liedtke, 1984, pp. 156–63) the king rides in a chariot, "in the manner of the triumphs of the Romans," as specified in Rubens's contract of 1622. This newly discovered sketch reveals that Rubens, around 1627, first considered a more contemporary triumph with Henry IV on horseback, accompanied by allegorical figures, and preceded by a wagon full of trophies. The equestrian portrait recalls that of Marie de Médicis in the preceding cycle of pictures (Pl. 104).

104 Peter Paul Rubens, *The Triumph of Juliers*, 1622–25.
Canvas, 155 x 116 in. (394 x 295 cm).
Paris, Musée du Louvre.

Queens were not frequently featured in equestrian portraits until the 1620s, nor were they expected to master the manly art of riding in *haute école* style. Consequently – given Rubens as author – this is one of the most natural images in the *Life of Marie de Médicis*, the heavily allegorical cycle of paintings made for the Luxembourg Palace in Paris. This type of portrait, when somehow connected with a victory (not with the struggle itself), was immediately associated with the idea of triumphal entry. It is not surprising, then, that Rubens thought of this picture when he turned to the portrait of Marie's husband in the *Triumph of Henry IV* (Pl. 105). *Colorplate 14*

106 Two woodcut illustrations in Federico Grisone, *Gli ordini di cavalcare*, Naples, 1550. New York Public Library.
(Many later editions in Italy and, by 1570, in England, France, Germany, and Spain.)

Grisone's "principles of riding" were most widely known through this book, but his influence at the most important courts of Europe was exercised through a direct line of associates. Grisone's pupils, Paolo d'Aquino and Bernardo de Vargas Machuca, introduced formal equitation in Spain, and Grisone's associate in Naples, G.B. Pignatelli, was the teacher of the Chevalier de St. Antoine (see Pl. 131), of Salomon de la Broue, and of the latter's successor in Paris, Pluvinel (see Pls. 107–108).

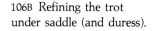

107 Crispijn de Passe the Younger, two plates in Antoine de Pluvinel, *L'Instruction du roy en l'exercise de monter à cheval*, Paris, 1625. Engravings.
New York, Metropolitan Museum of Art.

The plates were first used in Pluvinel's earlier version of this treatise, *Maneige royal*, Paris, 1623. In Pl. 107A, "*du Plu*," to the far left, patiently instructs the confident king, Louis XIII, "*age de 16 anns*," which would date De Passe's drawing for the print (and his earliest known activity in Paris) to about 1617. These large engravings appealed to an international audience in several complementary ways: as one of the finest examples of an illustrated book in the early seventeenth century; as a riding manual; as an artist's pattern book of poses and equine anatomy; as a record of courtly life in Paris, complete with labelled portraits of the members of Louis XIII's suite.

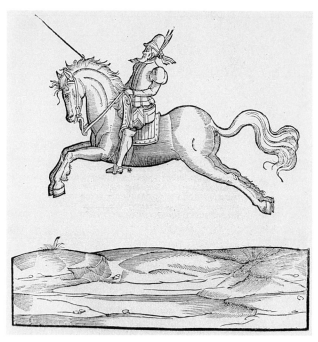

106A *Capriole.*

106B Refining the trot
under saddle (and duress).

107A The *levade* between pillars.

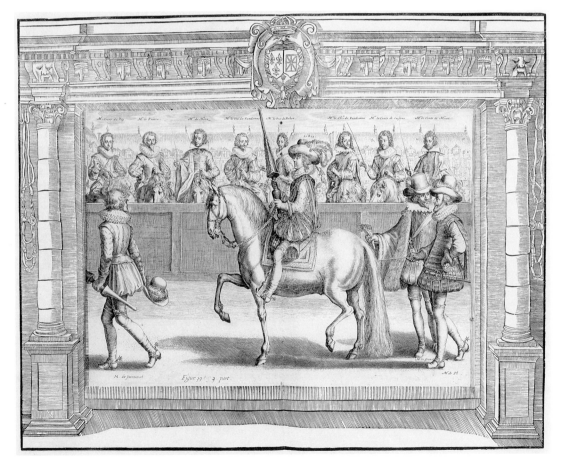

107B The *passage*, with *Le Roy* up.

239

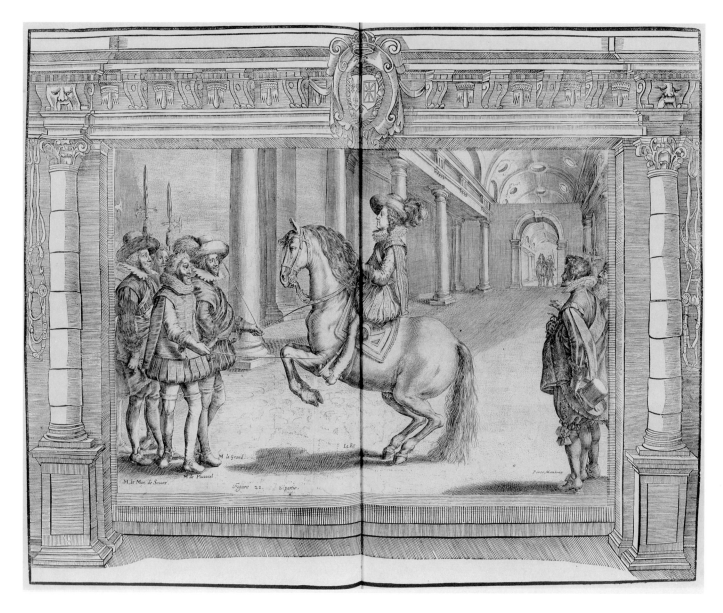

108 Another plate in Pluvinel's treatise
(see Pl. 107): Louis XIII on a horse performing
a *levade*, with the author foremost on the left.

109 Michel Lasne and Jacques Callot,
Equestrian Portrait of Louis XIII, 1634.
Engraving and etching.
New York, Metropolitan Museum of Art.

Callot etched the background only, not including
the sky. Though the king's attention is distracted by
the viewer and the battlefield, his horse ignores both,
as well as the *son et lumière* spectacle above, and
performs a *levade* almost as commendable as that
illustrated in Pluvinel's plates (Pl. 108). Compare pre-
Pluvinel printed equestrian portraits such as those
by Cockson (Pl. 86).

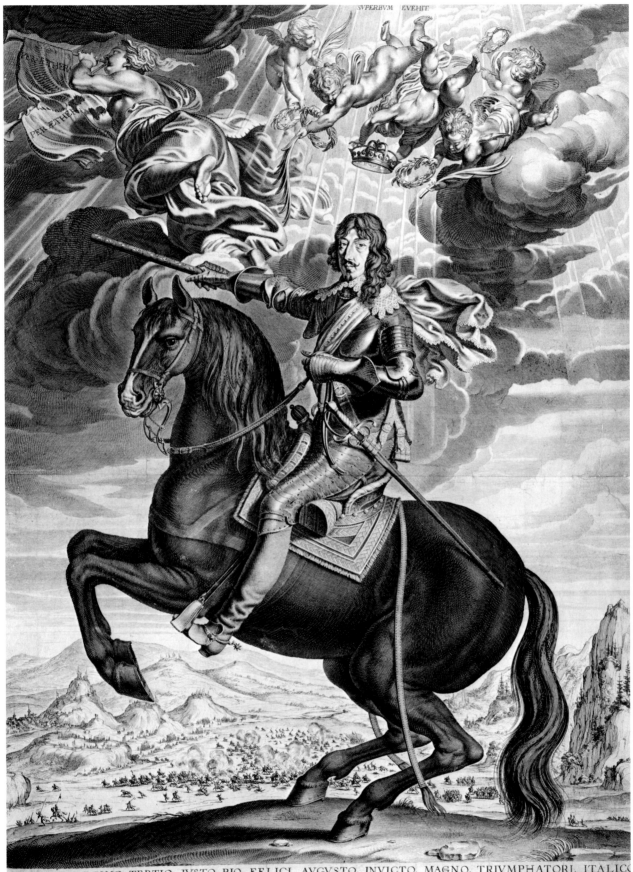

SVPERBVM EVEHIT

PER ÆTHERA

LVDOVICO DECIMO TERTIO IVSTO. PIO. FELICI. AVGVSTO. INVICTO. MAGNO. TRIVMPHATORI. ITALICO
ALEMANNICO. LOTHARINGICO. FRANCIAE ET NAVARRAE REGI CHRISTIANISSIMO.
ÆTATIS SVÆ ANNO 33. ET SVI REGNI 23.

N. 149

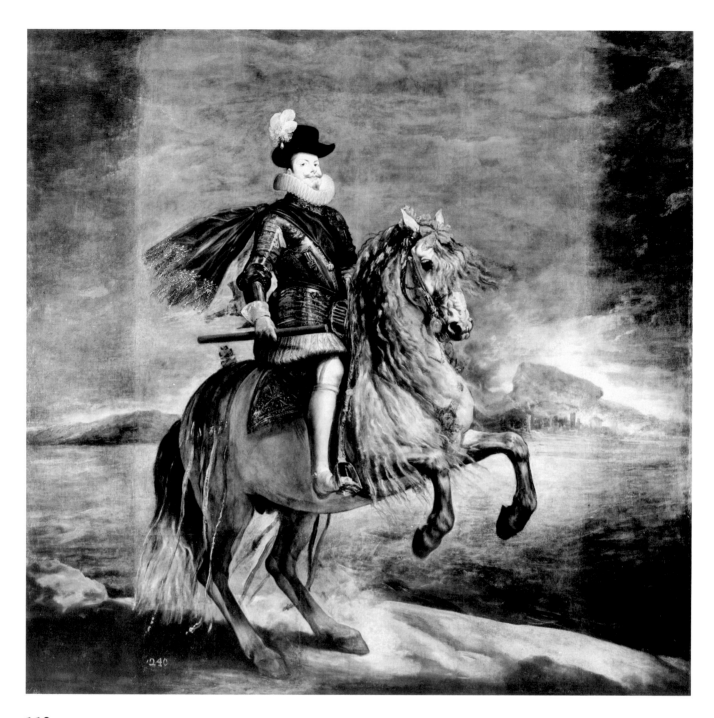

110 Velázquez and assistants, *Equestrian Portrait of Philip III*, completed by about 1634.
Canvas, 118 x 123½ in. (300 x 314 cm).
Madrid, Museo del Prado.

The picture was painted by Velázquez and assistants around 1634–35 for the Salón de Reinos of the Buen Retiro Palace (see reconstruction, Pl. 114). Vertical strips of canvas were added later, perhaps in the 18th century when the paintings were installed in the Royal Palace. Prints by Tempesta (compare Pl. 85B), a canvas by Rubens (see Pl. 116), and probably the lost Velázquez that the Rubens replaced anticipate the pose and view of the horse, which are repeated in Velázquez's *Prince Baltasar Carlos in the Riding School* (Pl. 122).
Colorplate 16

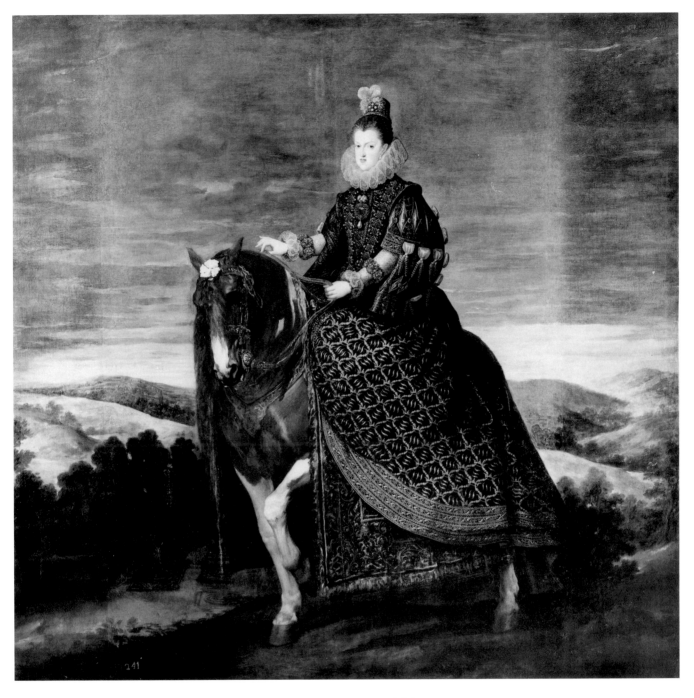

111 Velázquez and assistants, *Equestrian Portrait of Margarita of Austria, wife of Philip III*, completed by about 1634.
Canvas, 117 x 122 in. (297 x 309 cm).
Madrid, Museo del Prado.

Like the portraits of Philip III and Isabella of Bourbon (Pls. 110, 113), this large canvas was painted by Velázquez with the help of assistants and installed in the Salón de Reinos of the Buen Retiro Palace (see Pl. 114). The canvas was later expanded at the sides.
Colorplate 17

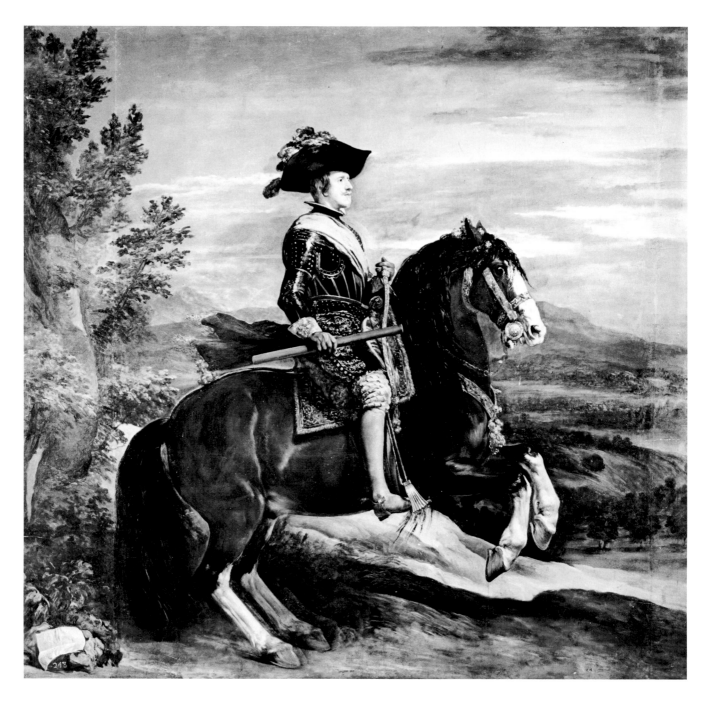

112 Velázquez, *Equestrian Portrait of Philip IV*,
1634–35.
Canvas, 118½ x 123½ in. (301 x 314 cm).
Madrid, Museo del Prado.

This large canvas, perhaps the best example of royal
equestrian portraiture in Spain, was originally part of
the decoration of the Salón de Reinos in the Buen
Retiro Palace (see Pl. 114). The king is seen in complete
control of the horse, implying that he is an able ruler.
The horse performs a *levade*; riding in such a subtle
style required, of course, that no armor or heavy boots
interfere with the signals of the rider's legs. Philip IV
must have been impressed by (and no doubt jealous of)
the rôle of his brother-in-law, Louis XIII, as illustrated
in Pluvinel's famous treatise on horsemanship (Pl. 108).
Colorplate 18

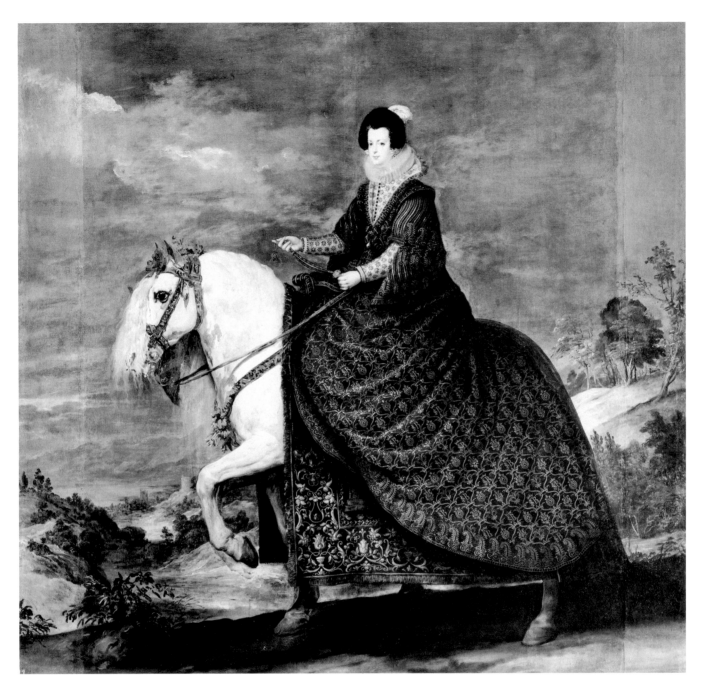

113 Velázquez and assistants, *Equestrian Portrait of Isabella of Bourbon, wife of Philip IV*, completed by about 1634.
Canvas, 118½ x 123½ in. (301 x 314 cm).
Madrid, Museo del Prado.

The queen was the sister of a famous horseman, Louis XIII (see Pl. 108), and the wife of another. The composition recalls older French equestrian portraits (see Pl. 49) but is more directly related to prints by Stradanus (e.g., Pl. 84A). In front of the painting itself, and even in reproduction, it is obvious that Velázquez completely repainted the horse's head (bringing it upward) and forelegs, using the long mane and the landscape to mask earlier work (see Brown, 1986, pl. 134, for a color detail of the horse's head).
Colorplate 19

114 Reconstruction of the west wall (above) and east wall (below) of the Salón de Reinos (Hall of Realms) in the Buen Retiro Palace outside Madrid: from J. Brown and J.H. Elliott, *A Palace for a King*, New Haven and London, 1980 (photos kindly lent by the authors). The decoration of the hall with equestrian portraits and battle scenes was conceived by Olivares, supervised by Velázquez, and completed by the spring of 1635.

115 Velázquez, *Equestrian Portrait of Prince Baltasar Carlos*, 1634–35. Canvas, 82½ x 68 in. (209 x 173 cm). Madrid, Museo del Prado.

This overdoor for the Salón de Reinos (see Pl. 114) in the Buen Retiro Palace has been interpreted as an allegory of the young prince's coming of age and eventual succession (see Ch. 1, n. 78). The pony supposedly would have been seen as springing in the direction of the throne at the other end of the Hall of Realms.

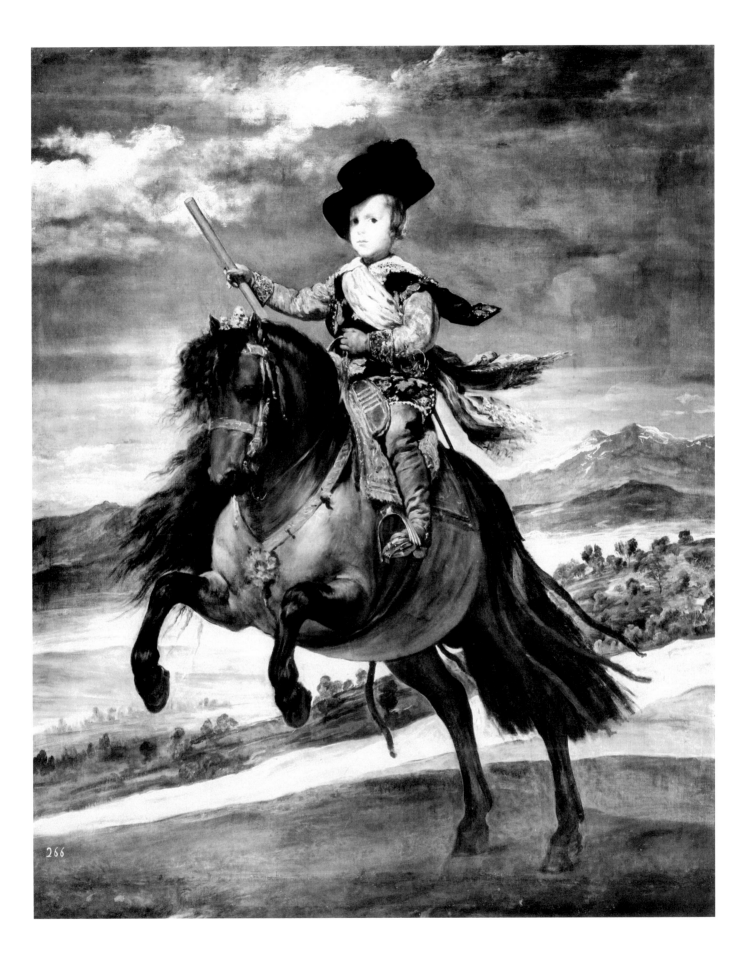

266

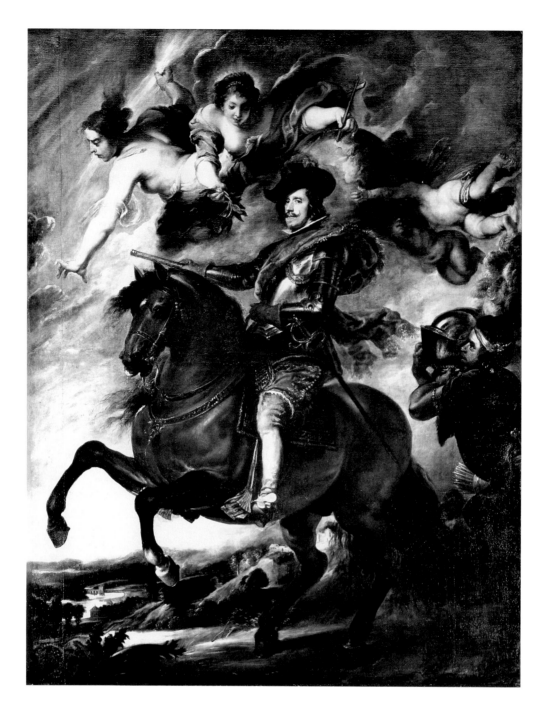

116 Copy after Peter Paul Rubens,
Equestrian Portrait of Philip IV (original 1628).
Canvas, 11 x 8⅔ ft. (337 x 263 cm).
Florence, Uffizi.

This is a copy after Rubens's large canvas, now lost,
that was painted in Madrid in 1628. The head and
hat in this version are thought to have been revised
by Velázquez (see Harris, 1982, p. 68, on this point);
the king appears as he did in the mid-1630s. Rubens's
original painting was ordered to replace Velázquez's
Equestrian Portrait of Philip IV of 1625 (which has
also long since disappeared) and probably derived
from Velázquez's composition. On the iconography
see pp. 40–43 above.

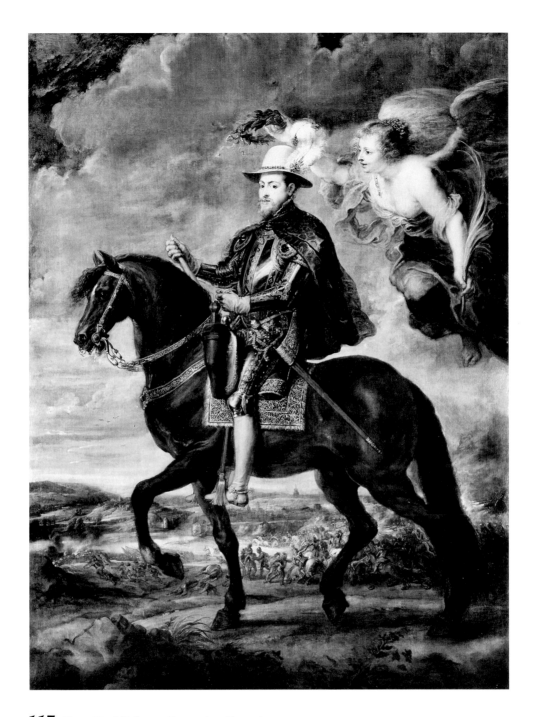

117 Peter Paul Rubens, *Equestrian Portrait of Philip II*, about 1628–29.
Canvas, 123½ x 89¾ in. (314 x 228 cm).
Madrid, Museo del Prado.

This conventional composition is not what one
would expect of Rubens right after he painted
the equestrian portrait of Buckingham (Pl. 130). The
picture conforms to Spanish models, which in turn
derive from prints by Stradanus (e.g., Pl. 84A).
Because of its traditional design and marginal place
in the development of royal equestrian portraits the
picture has not attracted much attention in the
literature, but it is brilliantly painted, an imposing
companion in the Prado to Rubens's neighboring
portraits of Lerma and the Cardinal-Infante
Ferdinand (Pls. 94, 139). *Colorplate 15*

118 The frontispiece of Juan Mateos,
Origen y dignidad de la caza, Madrid, 1634.
Engraving.
New York, The Hispanic Society of America.

This equestrian portrait of the Count-Duke Olivares
was one of the most important because it would
have been more widely known than any painted
composition. The print probably predates the large
canvas in the Prado (Pl. 119), and, in its design,
conforms to a type already well established
throughout Europe.

119 Velázquez, *Equestrian Portrait of the Count-
Duke Olivares*, probably painted about 1636.
Canvas, 123¼ x 94 in. (313 x 239 cm).
Madrid, Museo del Prado.

The picture was probably commissioned by the
sitter, in response to the royal equestrian portraits
that Velázquez painted for the Buen Retiro Palace
(Pl. 114). Olivares was — or rather, had been
earlier — one of Spain's greatest horsemen, but at this
date he was entirely preoccupied by affairs of state
and his own position at court. He was surely aware
that such a picture asserted his authority in a manner
usually reserved for his few superiors. In a letter of
1633 to the Marquis of Aytona, Olivares recalls his
early days as a rider, complaining that "I am so
racked by illness that when I tried to mount a horse
the other day I simply could not manage it." (Kindly
brought to my attention by Prof. Jonathan Brown).
Colorplate 22

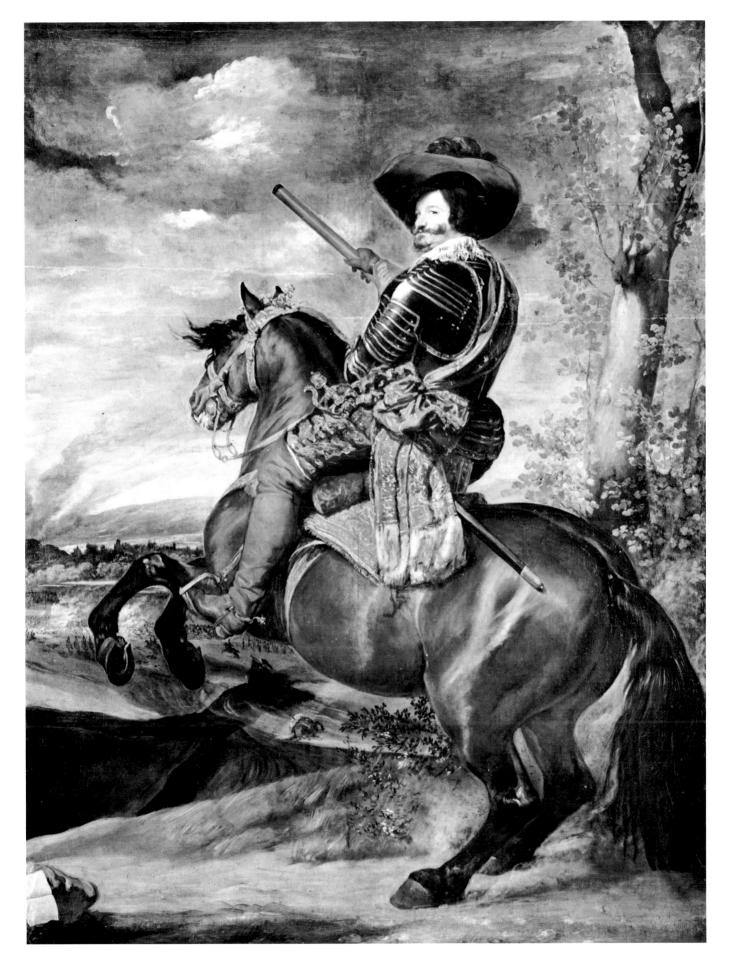

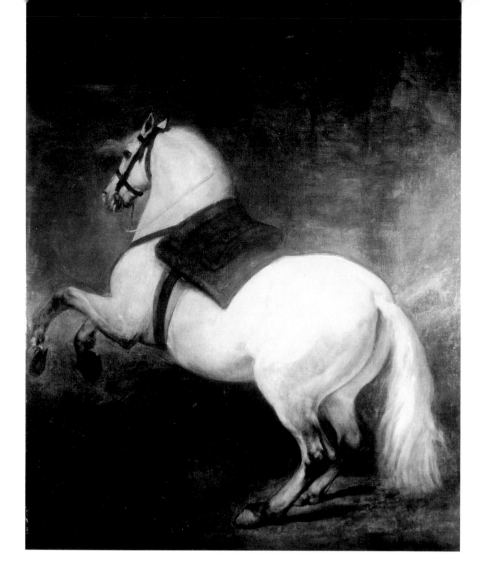

122 Velázquez, *Prince Baltasar Carlos in the Riding School*, about 1636–37. Canvas, 57½ x 36½ in. (144 x 91 cm). By kind permission of His Grace The Duke of Westminister, DL.

The prince precociously makes his pony perform a perfect *levade*. Unlikely as this seems, the composition appears less contrived than almost any other Spanish equestrian portrait. Olivares, to the right, acts as the boy's instructor, while the king and queen watch from a balcony of the Buen Retiro Palace. Next to Olivares is the prince's valet, Alonso Martinez de Espinar who later wrote a book on riding (*Arte de Ballesteria y Monteria,* Madrid, 1664); behind him is the author (see Pl. 118) and Master of the Hunt, Juan Mateos. The painting was probably commissioned by the Count-Duke. (Further on the picture: Washington, 1985, no. 497; Brown, 1986, pp. 125, 129, 145. Concerning equestrian exercises on the Buen Retiro grounds: Brown and Elliott, 1980, pp. 60, 63, 77.) *Colorplate 20*

120 Attributed to Velázquez, *A White Horse*, about 1635 (?) Canvas, 122 x 96½ in. (310 x 245 cm). Madrid, Palacio Real.

This is probably one of the three large paintings of different horses that were listed in the artist's estate. They may have served as models for equestrian portraits, as did the mounted horses in *The Riding School* from Rubens's studio (Pl. 99). However, having recently examined the canvas, which features a striking red saddle and a battle scene in the background, the author feels that the picture may also be regarded as an unfinished equestrian portrait.

121 "In Adulari Nescientum," an emblem in Andrea Alciati's *Emblemata*, Antwerp, 1581. Woodcut. New York, Metropolitan Museum of Art.

The title of this emblem, "To him unable to flatter," refers to the horse and suggests that the rider, no matter how high his station, will not succeed without actual ability.

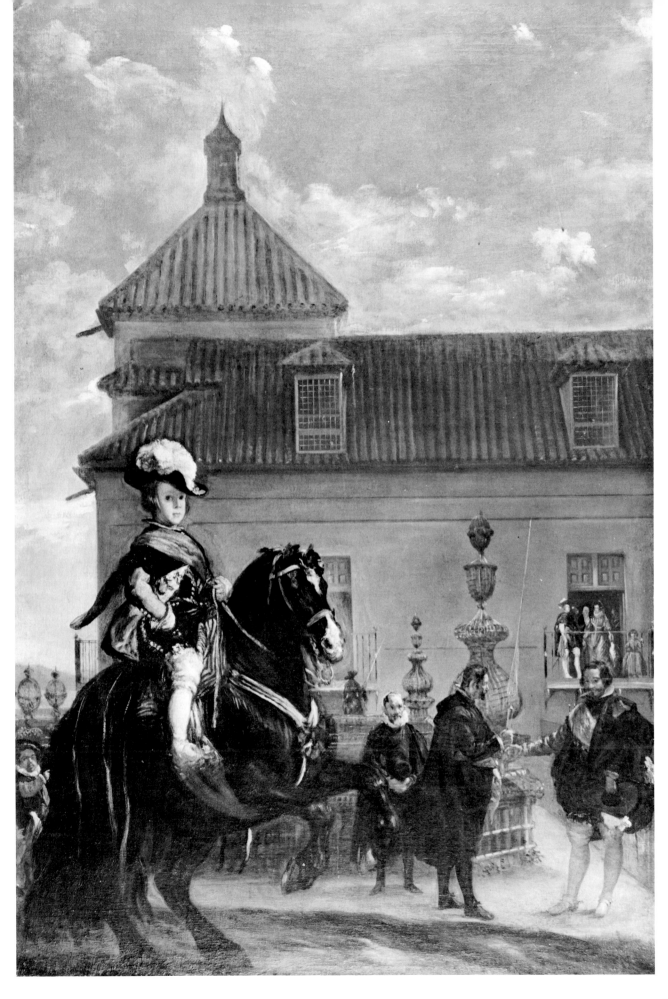

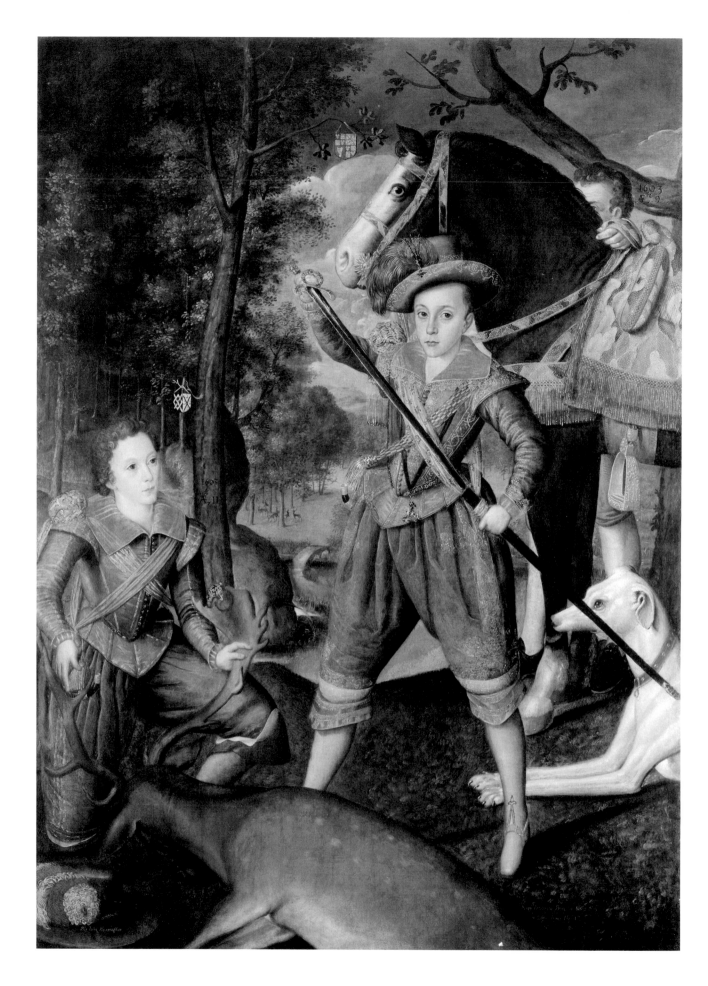

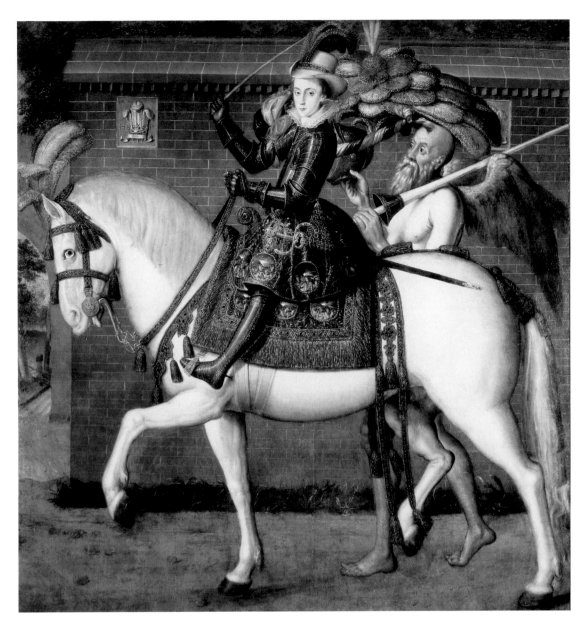

124 Robert Peake the Elder, *Equestrian Portrait of Henry, Prince of Wales (1594–1612)*, about 1610. Canvas, 90 x 86 in. (228.8 x 218.4 cm). Parham Park, Mrs. P.A. Tritton.

123 Attributed to Robert Peake the Elder, *Henry Frederick (1594–1612), Prince of Wales, and Sir John Harington (1592–1614)*, 1603. Canvas, 79½ x 58 in. (201.9 x 147.3 cm). New York, Metropolitan Museum of Art.

The nine-year-old prince is sheathing his sword, as prescribed in *Turbervile's Booke of Hunting*, London, 1576, p. 134: "the chiefe huntsman (kneeling, if it be to a prince) doth holde the Deare by the forefoote, while the Prince or chief, cut a slyt drawn alonst the brysket... This is done to see the goodnesse of the flesh, and how thick it is." (Quoted by Held, 1958, p. 145.)

Until its recent exhibition and cleaning (Washington 1985, no. 56) the entire setting in this remarkable picture was covered over by the 17th-century addition of a Titianesque landscape, and its brilliant colors were obscured. It now appears that both the background and the horse and rider derive from Clouet's equestrian portraits of Henry II (Pl. 49). Not so the figure of Father Time serving as groom: as Roy Strong suggests in the Washington catalogue, this is probably "a rare late Renaissance instance of Time in the classical sense of Opportunity," which the young prince has seized by the forelock. By this date Henry had seized every opportunity to make his court a brilliant cultural center comparable to those in Florence and France; expectably, his initiatives included a riding school, built at St. James's in 1607–09. *Colorplate 9*

125 Paul van Somer, *Queen Anne of Denmark*, 1617.
Canvas, 103 x 82 in. (261.6 x 208.4 cm).
Windsor Castle. Reproduced by Gracious Permission of Her
Majesty the Queen.

Like Peake's picture (Pl. 123), van Somer's "dismounted equestrian
portrait" anticipates van Dyck's painting of Charles I at the hunt
(Pl. 126): the composition (here with a negro groom behind the
horse) is similar in reverse, and the king seems to take after his
mother in his pose and confident stare. Surprisingly, the pictures
have never been considered as pendants; their dimensions are
almost exactly the same.

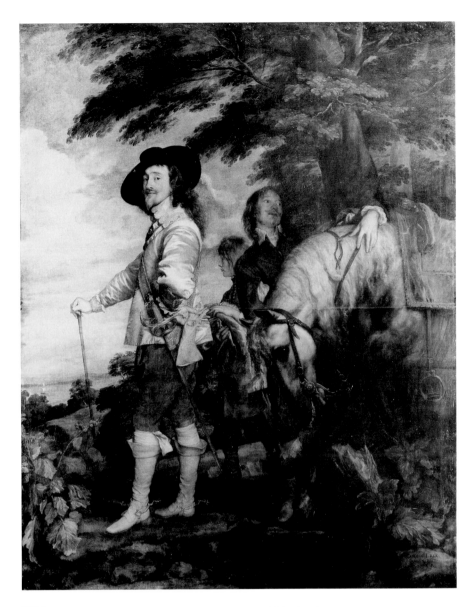

126 Anthony van Dyck, *"Le Roi à la ciasse" (Charles I at the Hunt)*, 1635.
Canvas, 104¾ x 81½ in. (266 x 207 cm).
Paris, Musée du Louvre.

In contrast to van Dyck's imperial equestrian portrait of the king
(Pl. 132), the Louvre canvas, yet another "dismounted equestrian
portrait," depicts Charles I as a courtier – the man not the office,
though still an ideal. The walking cane and silk jacket are, like the
ability to ride, among the attributes distinctive of a gentleman. Even
the king would not be expected to have hunted in such an outfit,
but the occasion is ceremonial, a late example of the type of
painting seen earlier with Peake (see Pl. 123). Held (1958) rightly
brushed aside the innocent ideas of earlier art historians, who
thought that the horse might be pawing the ground, chasing a fly,
or even kneeling down to allow the rider to dismount. However,
Held's reference to "the horse's reverence" here and in van Dyck's
likely source for the pose, Rubens's oil sketch, *The Triumph of
Rome*, of about 1622–23 (Mauritshuis, The Hague; see also *The
Consecration of Decius Mus* in Vaduz), will itself be considered
somewhat sceptically by riders. The king has just dismounted, the
horse simply wipes its foaming mouth, and the groom (identified as
Endymion Porter by Johns, 1988) keeps the reins from slipping
down the horse's neck. *Colorplate 25*

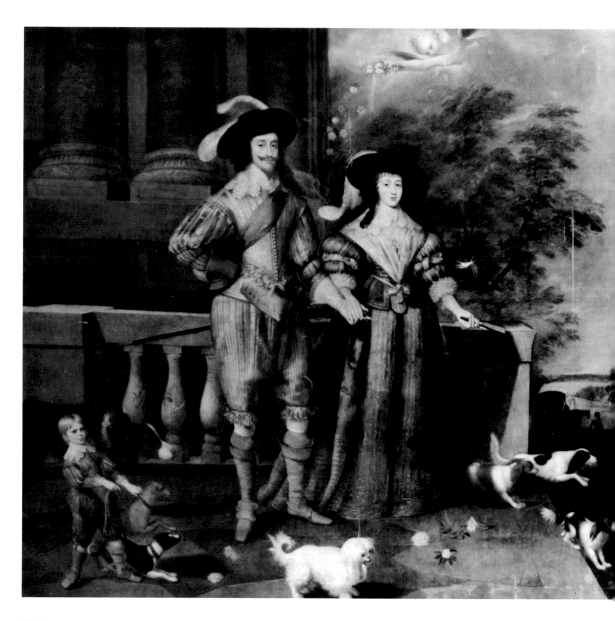

128 Daniel Mijtens and assistants, *Charles I
and Henrietta Maria Departing for the Chase,* about
1630–32.
Canvas, 111 x 160¾ in. (282 x 377.3 cm).
Hampton Court. Reproduced by Gracious Permission
of Her Majesty the Queen.

The Dutch artist Mijtens was the leading portraitist
in England between the death of van Somer (see
Pl. 125) in 1621, and van Dyck's arrival there in
1632. This large canvas, a "double dismounted
equestrian portrait" for those inclined to categorize,
looks back to van Somer's picture and forward to
van Dyck's (Pl. 126). Unlike the latter, however,
Mijtens' royal portrait has a domestic quality that is
distinctly Dutch, but was to become an English
tradition (see Pl. 196).

127 Anthony van Dyck, *Portrait of the Marchese Filippo Spinola*, about 1625.
Canvas, 86 x 55 in. (218.3 x 139.6 cm).
Australia, private collection.

This grand, rarely seen canvas was painted in Genoa, brought to England in 1827, and sold at Agnew's, London, a few years ago. It barely qualifies as a "dismounted equestrian portrait" (compare Pl. 126), but van Dyck was not one to conform closely to conventions, and there is an Italian precedent of sorts in Moretto da Brescia's *Portrait of a Gentleman in Armor* in the North Carolina Museum of Art.

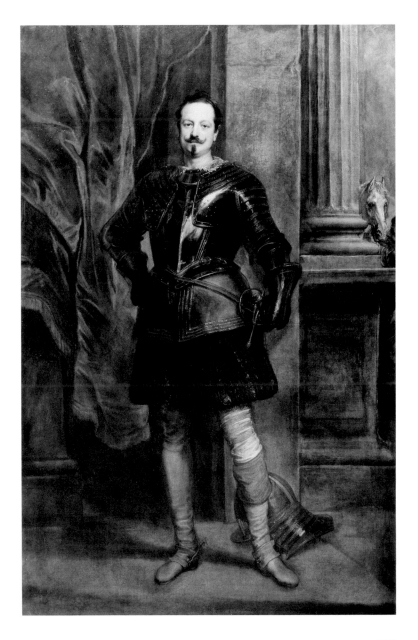

127A Detail of Pl. 127.

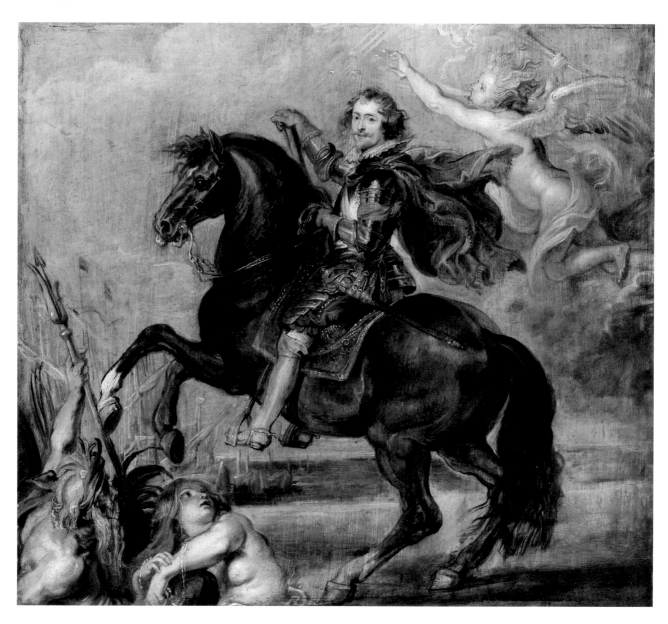

129 Peter Paul Rubens, *Equestrian Portrait of George Villiers, Duke of Buckingham*, late 1625. Oil sketch on panel, 17½ x 19½ in. (44.5 x 49.2 cm). Forth Worth, Texas, Kimbell Art Museum.

In this recently rediscovered sketch (Held, 1976) Rubens, as usual, is less concerned with allegorical details than in the final picture (Pl. 130); the essential concept and composition are determined here. Rubens, like De Passe (Pl. 88), drew upon English prints (certainly Cockson's *Devonshire*, Pl. 86), but those stiff compositions are here made nimble by an energy expressive of Buckingham's political power and irrepressible personality. The formality of Rubens's slightly later equestrian portraits painted in Spain (Pls. 116, 117) is all the more striking when they are compared with this vigorous invention. (Note to the nonreader: the horse rears.) *Colorplate 21.*

130 Peter Paul Rubens, *Equestrian Portrait of George Villiers, Duke of Buckingham*, 1627. Canvas, 10 x 11 ft. (307 x 337 cm). Formerly at Osterley Park, Collection of the Earl of Jersey (destroyed by fire in 1949).

Buckingham is depicted as General of the Fleet, a rank he attained in 1625, the year Rubens painted the oil sketch for this picture (Pl. 129). A victory goddess holding a laurel wreath and a cornucopia seems to urge the duke onward. Another undressed accomplice (Concord?) dispatches a disagreeable demon, probably Discord, to the right. Maritime deities and an armada of warships fill the lower left corner of the composition. Most critics regret the more complex allegorical apparatus of the large canvas, but these additions to Rubens's original idea were probably requested by Buckingham; they add meaning to the work in a way that would have been appreciated by his literal-minded contemporaries; and the flying figures lend a certain rationale to the horse's excitement.

131 Anthony van Dyck, *Charles I on Horseback with M. de St. Antoine*, 1633.
Canvas, 145 x 106¼ in. (368.4 x 269.9 cm).
London, Buckingham Palace. Reproduced by Gracious Permission of Her Majesty the Queen.

The king rides through a triumphal arch and is flanked by a shield bearing the royal arms and by his riding master and equerry, Pierre Antoine, Sieur de St. Antoine. The latter had been sent to England by Henry IV, King of France, in 1603 with a present of horses for Henry, Prince of Wales. This enormous painting originally hung at the end of the Gallery in St. James's Palace; after the Restoration it was given a similar position at Hampton Court. The pose and frontal view of the horse and rider had been used on a number of earlier occasions by Rubens (Pl. 99). Van Dyck may have borrowed the idea of the arch from one of Rubens' supposed sources, the titlepage of Oliviero's book of 1567 (Pl. 95); however, the idea is found elsewhere, for example in Pozzoserrato's fresco decorations in the Villa Soranza sul Brenta. For a fine discussion of van Dyck's picture see Millar, 1982, no. 11.

132 Anthony van Dyck, *Equestrian Portrait of Charles I*, about 1638.
Canvas, 144½ x 115 in. (367 x 292 cm).
London, The National Gallery.

In 1672 the biographer Bellori considered this enormous painting to have been inspired by Titian's *Charles V at Mühlberg* (Pl. 51). The setting is similar, but van Dyck's invention owes more to a number of appropriate sources, such as the *Marcus Aurelius* (Pl. 8); the *Equestrian Portrait of Henry, Prince of Wales* (Pl. 124) and its French models; and Hubert Le Sueur's *Equestrian Monument of Charles I* (Pl. 148). For a fairly full discussion of this picture's meaning, see Strong, 1972. *Colorplate 27*

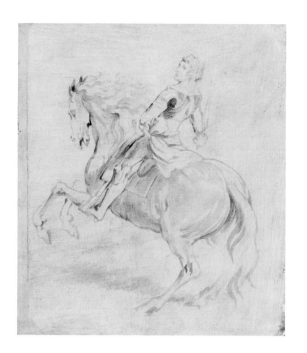

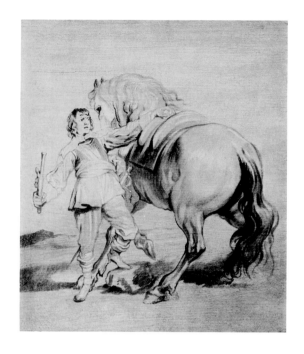

133 Anthony van Dyck, *A Man Riding a Horse*, probably about 1630.
Oil on panel, monochrome, 10⅛ x 8⅞ in. (25.7 x 22.5 cm).
New York, Metropolitan Museum of Art.

This painting and the two other panels depicting men mounting horses (Pls. 134, 135) probably form a set and may be compared with Rubens's studies of horses in different positions in the *Riding School* formerly in Berlin (Pl. 99). Van Dyck would have kept these small panels in his studio to use as models for equestrian portraits and similar subjects. This oil sketch corresponds closely to van Dyck's equestrian portrait of the Prince of Arenberg (Pl. 137).

134 Anthony Van Dyck, *A Man Mounting a Horse*, probably about 1630.
Oil on panel, monochrome, 9⅞ x 8½ in. (25 x 21.5 cm).
Sold at Lepke, Berlin, March 18, 1930.

The poses of the horse and rider are essentially the same as in one of the oil sketches in the Metropolitan Museum (Pl. 135). The idea of studying the same equestrian motif from opposite points of view occurs in Rubens's *Riding School* (Pl. 99) and — with no likely connection — in the background of Pollaiuolo's *Martyrdom of St. Sebastian* in the National Gallery, London. The motif in the Berlin panel corresponds closely with Rubens's painting of the Roman consul Decius Mus mounting his horse, *The Dismissal of the Lictors*, of about 1617–18 (New York, 1985, no. 213). Van Dyck worked in Rubens' studio at about this time.

136 Anthony van Dyck, *Equestrian Portrait of Albert de Ligne, Prince of Barbançon and Arenberg*, about 1630.
Pen drawing, 9 x 9½ in. (22.8 x 24 cm).
New York, Metropolitan Museum of Art.

This is one of two known drawings for van Dyck's canvas at Holkham Hall (Pl. 137). The other, in the British Museum, lacks the page but depicts the horse and rider in the same direction as in the final painting.

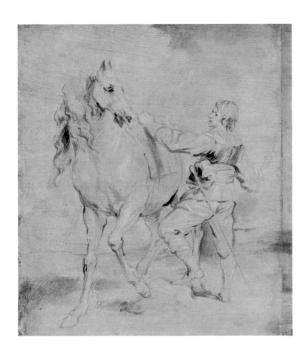

135 Anthony van Dyck, *A Man Mounting
a Horse*, probably about 1630.
Oil on panel, monochrome, 10 x 8¾ in.
(25.4 x 22.2 cm).
New York, Metropolitan Museum of Art.

The pose of the horse does not derive from
formal equitation, and the relationship between
the man and the nervous animal is not what
one would expect in an equestrian portrait of
the Baroque period. However, van Dyck was
hardly a conformist in this area, and the idea
of depicting a specific sitter about to mount a
horse is not unknown in the seventeenth-century
(for example, a drawing by Thomas Willeboirts
Bosschaert, dated 1643, published in *Oud
Holland*, 1950, p. 248).

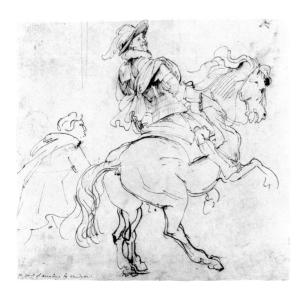

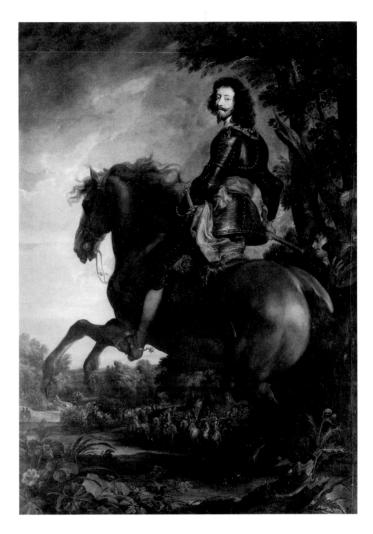

137 Anthony van Dyck, *Equestrian Portrait of
Albert de Ligne, Prince of Barbançon and Arenberg*,
about 1630.
Canvas, 126 x 94 in. (320 x 240 cm).
Holkham Hall, The Earl of Leicester.

Albert de Ligne (Madrid 1600–1674 Madrid) was
Commander-in-Chief of the Spanish forces in the
Netherlands, but in the early 1630s he participated in
a plot against Spanish rule and was imprisoned
in Antwerp from about 1635 to 1642. Some scholars
prefer to date the Holkham painting to 1634, when
van Dyck, on a visit to Brussels, painted the
Equestrian Portrait of Thomas de Savoie-Carignan
(Turin; Brown, 1982, pl. 156). However, the prince's
political position and the fact that van Dyck painted
a full-length portrait of him in about 1630 (now in
the York City Art Gallery; see the Gallery's *Bulletin*
of October 1981), suggest that the equestrian portrait
dates from about 1630 as well. The poses of the
horse and rider may be traced back to Rubens (see
the caption to Pl. 133) and (as in the case of
Velázquez's *Equestrian Portrait of Olivares*, Pl. 119)
to engravings after Stradanus (Pl. 83).

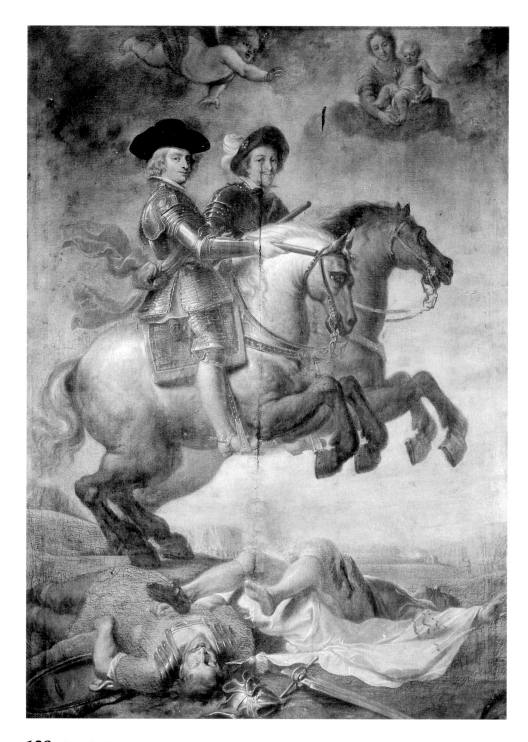

138 Cornelis Schut, *The Victory of Nördlingen*, 1634–35.
Canvas, 89 x 63 in. (226 x 160 cm).
Ghent, Oudheidkundig Museum (in the Town Hall, Ghent,
until 1811).

The Battle of Nördlingen took place on September 5–6, 1634,
and was an important victory for the Catholic troops led by the
Cardinal-Infante Ferdinand and his cousin, Ferdinand of Austria
and Hungary. Schut's double portrait of the Hapsburg generals
was made to decorate the Arch of Ferdinand, which was erected
for Ferdinand's entry into Ghent in 1635 (see also Pl. 140). Schut
probably referred to models provided by Gaspar de Crayer,
since he was the senior artist involved in the venture and had
painted very similar equestrian portraits of Philip IV and of
Olivares some years earlier (see caption to Pl. 102).

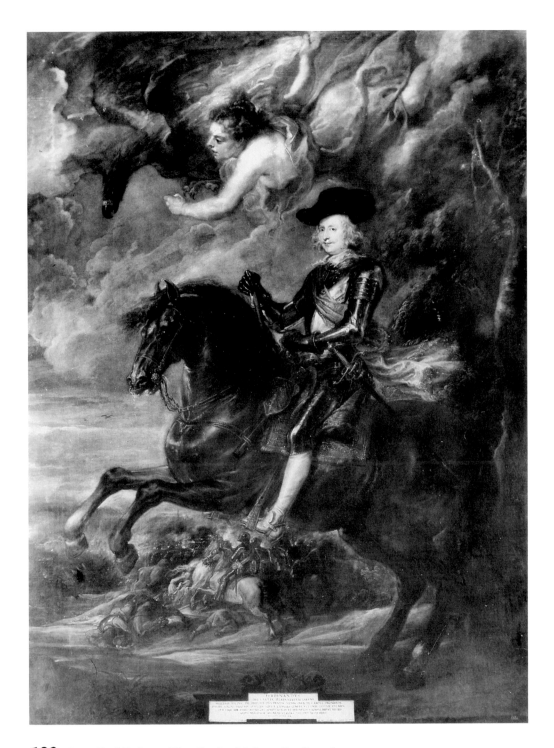

139 Peter Paul Rubens, *The Cardinal-Infante Ferdinand
at the Battle of Nördlingen,* about 1635.
Canvas, 132 x 101½ in. (335 x 258 cm).
Madrid, Museo del Prado.

This composition, which Rubens formulated in a large oil sketch
now in the Detroit Institute of Arts, evolved from his *Equestrian
Portrait of Philip IV* of 1628 (see Pl. 116). The horse's pose is
similar but less restrained here, which is appropriate to a battle
scene and broadly reminiscent of Titian's *Charles V* (Pl. 51). The
painting remained in Rubens' studio until shortly after his death.
Olivares bought it, but upon his fall from power in 1642 the
canvas became Philip IV's property and was hung in the Alcázar
in Madrid.

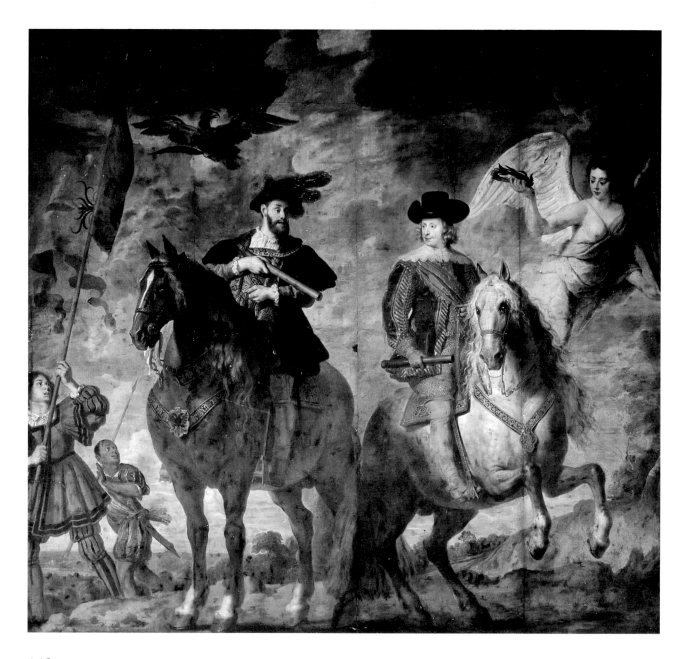

140 Gaspar de Crayer, *Charles V Instructing His Great-Grandson Ferdinand to Follow His Example*, 1634–35.
Canvas, 179 x 214½ in. (455 x 545 cm).
Ghent, Town Hall.

This enormous and rather comical canvas is one of De Crayer's contributions to the Arch of Charles V which, with the smaller Arch of Ferdinand, decorated the main square of Ghent during the State Entry of Cardinal-Infante Ferdinand on January 28, 1635 (Pl. 138 is from the same celebration). Hans

Vlieghe has observed that many elements of this composition come from works by Rubens or van Dyck—the head of the horse to the right and the neighboring victory figure are, for example, inspired by Rubens's *Triumph of Juliers* (Pl. 104)—but the engaging portrait of Charles V on a standing horse (perhaps appropriate for such a "spirit" from the past) and the friendly exchange between the two riders lend De Crayer's conception considerable charm. The picture is to some extent reminiscent of Dutch "cavalcade" portraits (Pls. 174, 175), which are also dynastic.

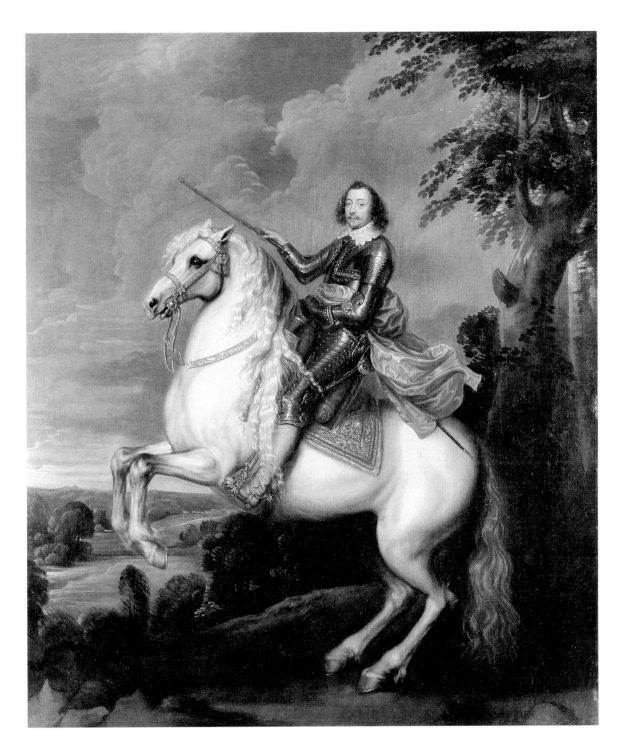

141 Gonzales Coques, *Equestrian Portrait of Thomas, 3rd Baron Fairfax* (1612–71), probably painted during the 1650s.
Canvas, 35½ x 29¾ in. (90.2 x 75.6 cm).
Formerly New York, Schaeffer Galleries.

"Black Tom" served as commander-in-chief for Parliament against Charles I, but he denounced the death sentence and resigned his powerful post, in 1650, in favor of his former second-in-command, Cromwell. The horse, its pose, and the sitter's pose were copied by Coques from van Dyck's *Equestrian Portrait of Thomas de Savoie-Carignan*, dated 1634, in the Galleria Sabauda, Turin. The background is different and was probably inspired by van Dyck's *Equestrian Portrait of Charles I* (Pl. 132).

142 Jacob Jordaens, *A Young Cavalier on a Horse
Executing a Levade in the Presence of Mercury and
Mars*, about 1645.
Canvas, 37¾ x 61½ in. (96 x 153 cm).
Ottawa, The National Gallery of Canada.

In the catalogue of the 1968 Jordaens exhibition
at Ottawa the painting is titled *Young Cavalier
Executing a Passade*. Actually the horse, not the
rider, performs the *haute école* air, which is much
closer to a *levade* than a *pesade* (the latter is higher
than a *levade*, with the hindlegs more extended).
Particularly impressive is the rider's straight back,
which shifts his weight over the horse's hindquarters.
The canvas was used as a *modello* for one of eight
tapestry designs representing a *Riding Academy*
(Jaffé, 1968, no. 282); the horse's pose was probably
adopted from one of Pluvinel's plates. Julius Held
(1949) explains that Mercury and Mars are present
because the planets determined the temperaments
of horses. Mercury usually attends gray and dappled
horses (their colors being "mercurial"?), while Mars
watches over sorrels and bays. Mars and Mercury
might also be appropriate as grooms because of their
respective talents as messenger and warrior. Such
lines of thought are found in Pasquale Caracciolo's
La Gloria del Cavallo, Venice, 1566.

143 Jacob Jordaens, *A Cavalier on a Horse
Executing a Levade*, about 1635–45.
Panel, 28¾ x 23½ in. (73 x 59.7 cm).
Springfield, Mass., Museum of Fine Arts,
The Gilbert H. Montague Collection.

Like the Ottawa canvas (Pl. 142) this panel is
thought to be a *modello* for a tapestry, a supposition
strongly supported by the use of architecture and
swags to frame the central motif. D'Hulst suggests
that the archway was inspired by that in van Dyck's
portrait of Charles I with M. de St. Antoine
(Pl. 131), an entirely implausible and unnecessary
idea. So is the frequent reference to Newcastle,
whose residence in Antwerp and treatise on
horsemanship (see Pl. 145) date from later than
Jordaens's interest in "riding schools." Everything in
Jordaens's equestrian oeuvre was already well
established by Rubens, van Dyck, and above all
Pluvinel (Pl. 108). *Colorplate 26*

272

144 Jacob Jordaens, *Willem II on Horseback,*
a detail of *The Triumph of Frederick Hendrick,* a
monumental canvas decoration in the Oranjezaal
of the Huis ten Bosch at The Hague, 1649.

Jordaens's equestrian portrait of the young Prince
Willem II is one of the few memorable motifs in his
sprawling composition commemorating the recently
deceased Stadholder, Frederick Hendrick. It seems
inevitable that the Stadholder's short-lived successor
should appear as a mounted commander, since
Frederick Hendrick himself is seen on horseback in
three other murals in the hall, once with his
predecessor Prince Maurits. Dynastic group portraits
on horseback ("cavalcades") were already a long-
standing Dutch tradition (see Pls. 173–175). For the
other murals and related images: Peter-Raupp, 1980.

145 Lucas Vorsterman the Younger after
Abraham van Diepenbeck, Plate 25 in William
Cavendish, the Duke of Newcastle's *Méthode
et invention nouvelle de dresser les chevaux,*
Antwerp, 1658.
Engraving.
Private Collection.

The book is dedicated to the exiled Charles II;
Newcastle himself was in exile in Antwerp, where
he rented Rubens's house from the artist's widow.
A pupil of St. Antoine (see Pl. 131), the Duke
attempted to simplify Pluvinel's precepts. Many
of his ideas were adopted in Paris during the reign
of Louis XIV.

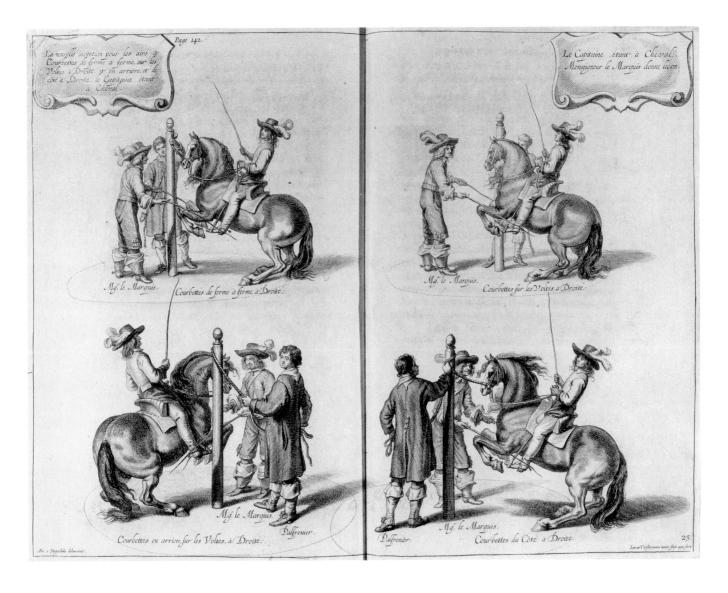

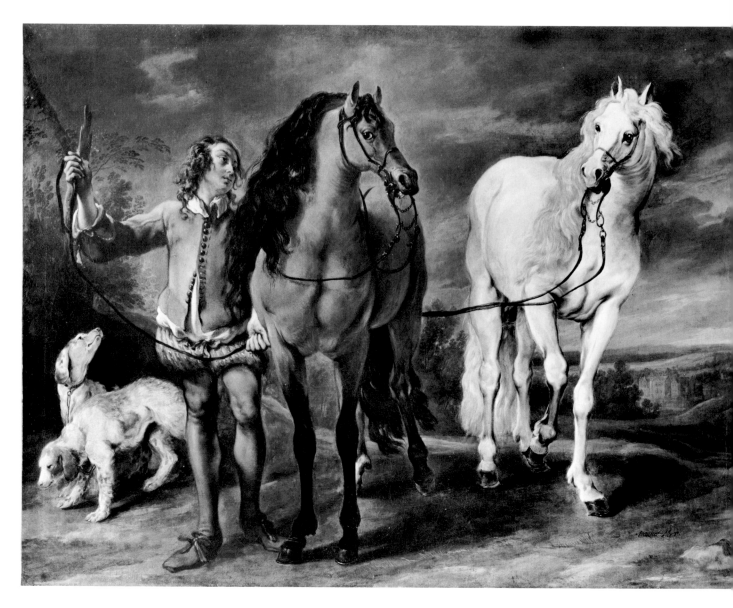

146 Jan Fyt, *A Groom with Two Horses,*
about 1650 (?)
Canvas, 40⅛ x 54⅜ in. (102 x 138 cm).
Vaduz, Collection of the Princes of Liechtenstein.

This large, signed canvas was probably painted to
decorate an appropriate room in a country house.
Similar pictures (Pls. 57, 172) portray specific horses,
but here the animals appear to be types. The
composition recalls that of De Crayer's double
equestrian portrait of Charles V and the Cardinal-
Infante Ferdinand (Pl. 140), and of Fyt's large *Lion
Hunt* (Chaucer Fine Arts, London, 1986 catalogue)
in which a man and a woman on horseback charge
toward the viewer and their quarry in the
foreground (the figures are attributed to Thomas
Willeboirts Bosschaert).

147 David Teniers the Younger,
Horse Trading, 1645.
Oil on copper, 9⅞ x 13⅝ in. (25 x 34.7 cm).
Vaduz, Collection of the Princes of Liechtenstein.

This peculiar, personal picture is an eccentric kind
of equestrian portrait: the central figure is the artist,
and behind him is his son David Teniers III.
The pretty dappled-gray pony has been brushed and
shod, the long mane is fluffed, and the tail is
braided, but all this and the old groom's
recommendation do not distract the painter's eye.
Teniers presents himself as a tasteful consumer and
a knowledgeable horseman, both roles reflecting his
well-known social ambition. However, this little
picture was probably intended not as a public
gesture but as a private memento, and considered as
a portrait of a father and son, it is a rather charming
one. (A color reproduction and further comments
may be found in New York, 1985, no. 192).

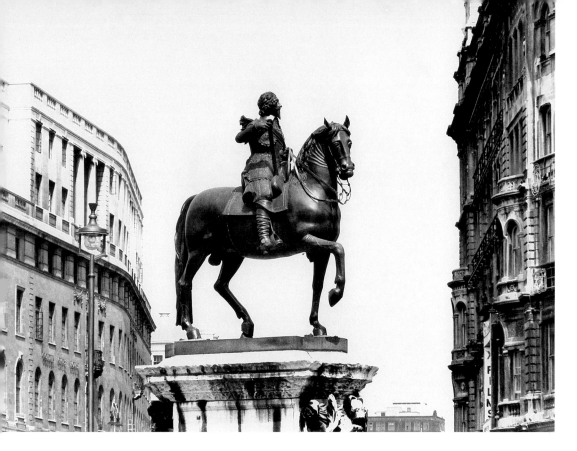

148 Hubert Le Sueur, *Equestrian Monument of Charles I*, dated 1633.
Bronze, 9½ ft. (290 cm) high.
London, Trafalgar Square.

Le Sueur (c. 1595–c. 1650) was not, as Horace Walpole assumed, a pupil of Giambologna, but then, in a broader sense, almost every sculptor was in the early 17th century when faced with the formidable task of creating an equestrian monument. The principal source of inspiration for the present piece was surely the Giambologna and Tacca monument of Henry IV erected on the Pont Neuf in 1614 (Pl. 71A), although Le Sueur was also told to consult Charles I's horsemen. The statue was commissioned in 1630 by the Chancellor Richard Weston (created Earl of Portland in 1633) for his new house at Roehampton. In 1644 Parliament ordered the work sold for scrap, but the buyer, the King's Brazier, hid it until the Restoration. Charles II bought the statue from the second Earl's widow in 1675 (see Avery, 1982, p. 177, and pl. 48b for a photo of the horse's head and the rider). A bronze statuette of this subject (not quite a "reduction," since the horse's head is not turned, the armor is different, and the King inconveniently wears leg-armor) is at Ickworth in Suffolk (Avery, 1982, no. 15, pls. 49a–49c, as dating from about 1632).

149 Stefano della Bella, *The Place Royal with the Equestrian Monument of Louis XIII* (by Pierre Biard; erected 1639, destroyed 1792). Etching.
New York, Metropolitan Museum of Art.

Biard was commissioned by Richelieu to mount a portrait of Louis XIII on Daniele da Volterra's horse (see Pl. 58), which had been intended for Henry II and had finally been brought to France in 1622. The gilt bronze figure was criticized as a poor likeness and as out of proportion to the horse (the helmet did not help). However, a work for which Michelangelo was ultimately responsible stood on this superb site (now the Place des Vosges) for 150 years.

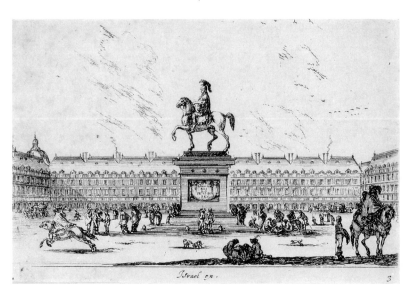

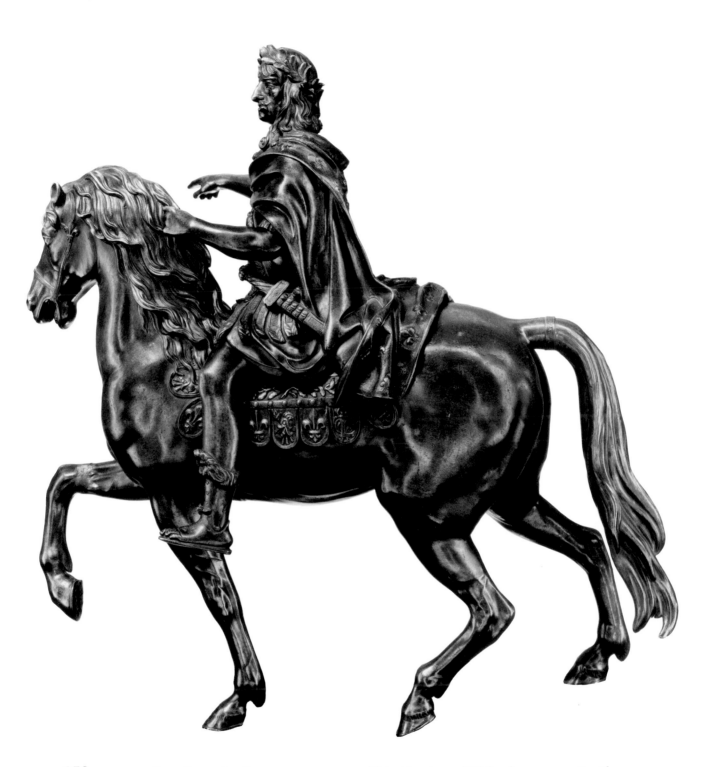

150 Simon Guillain, *Equestrian Statuette of Louis XIII*, c. 1640.
Bronze, 25 in. (63.5 cm) high.
London, Alexander and Berendt, Ltd. (1984).

Simon Guillain (1581–1658), the son of a sculptor, returned from a trip to Italy by 1612, and enjoyed a successful career in and around Paris. This vigorously modelled bronze equestrian portrait of Louis XIII at about the age of forty was first published by Avery (1984), who compares it with the Biard-Volterra monument of Louis XIII erected in 1639 (Pl. 149). Like Biard-Volterra's horse (see Pl. 58) the mount here briskly trots, and his rugged rider, like Biard's, is dressed *all' antica*. Compared with what might be called the Tacca-type monuments of Henry IV and Charles I (Pls. 71A, 148) this work is at once a fresh breeze and a revival, not only of the *Marcus Aurelius* but of 16th-century North Italian forms (Pl. 47).

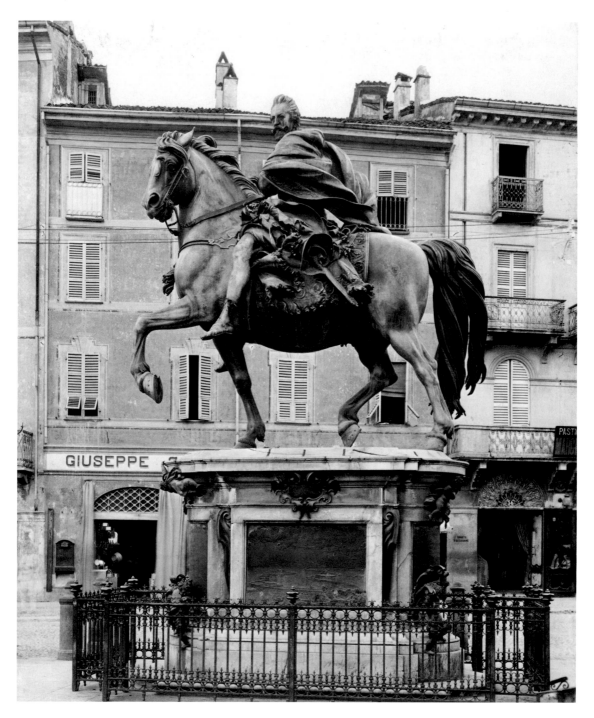

151 Francesco Mochi, *Equestrian Monument of Alessandro Farnese (1545–1592)*, 1620–23, unveiled 1625.
Bronze, life-size.
Piacenza, Piazza Cavalli.

Though trained in Florence and Rome, Francesco Mochi (1580–1654) revealed a remarkable independence from the *Marcus Aurelius* and Giambologna's circle; his dashing dukes of Parma on horseback represent the culmination of a North Italian tradition that may be traced from the *Regisole* in nearby Pavia (Pl. 9) through Leonardo in Milan and Paduan bronzes (Pl. 47), which, given time to outdistance their antique sources, would trot with the freedom of the Farnese steeds. It was only in the spring of 1616, after the first horse (Pl. 152) was nearly completed, that Mochi went to see the monuments by Donatello and Verrocchio (Pls. 24, 25) and the *Horses of San Marco* (Pl. 10). This experience was more important for the figure of Ranuccio (see Pope-Hennessy, 1970, p. 105) than for the posthumous portrait of Alessandro or his horse; indeed, the stronger bend in the advancing legs recalls the *Regisole* and Paduan statuettes more than the mounts Mochi went to see. The artist's wax model for the present work is in the Bargello: see, besides the more expected literature, Charles Avery's article on "Wax Sketch-Models for Sculpture," *Apollo*, CXIX (1984), p. 175, fig. 20.

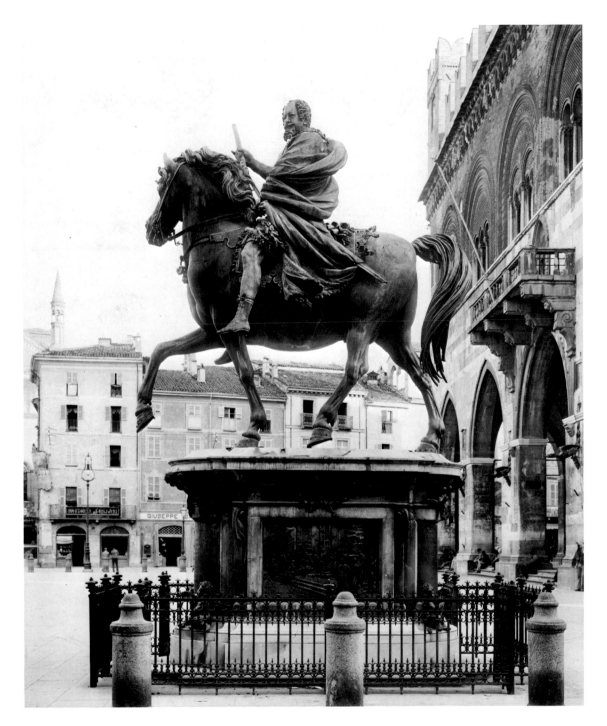

152 Francesco Mochi, *Equestrian Monument
of Ranuccio Farnese (1569–1622),*
1612–1620, unveiled 1620.
Bronze, life-size.
Piacenza, Piazza Cavalli.

The pair of equestrian portraits appropriately owe
their existence to a formal entry into Piacenza,
that of Ranuccio's wife, Margherita Aldobrandini,
whose son was to be baptised there (see Pope-
Hennessy, 1970, p. 444). Giulio Cesare Procaccini
of Milan was intrusted with a model of the
statue of Alessandro Farnese; that of the reigning
Duke of Parma went to Mochi, who won the
commission for both statues in November 1612.
The contract required antique armor and different
but complementary steeds. That the horses, not
the riders, look toward each other is a conceit
perhaps inspired by the *Horses of San Marco* and
more certainly by Mochi's imagination of the
Farnese as commanders in the field. The fluttering
drapery and flowing manes and tails anticipate
Bernini and a number of 19th-century monuments.

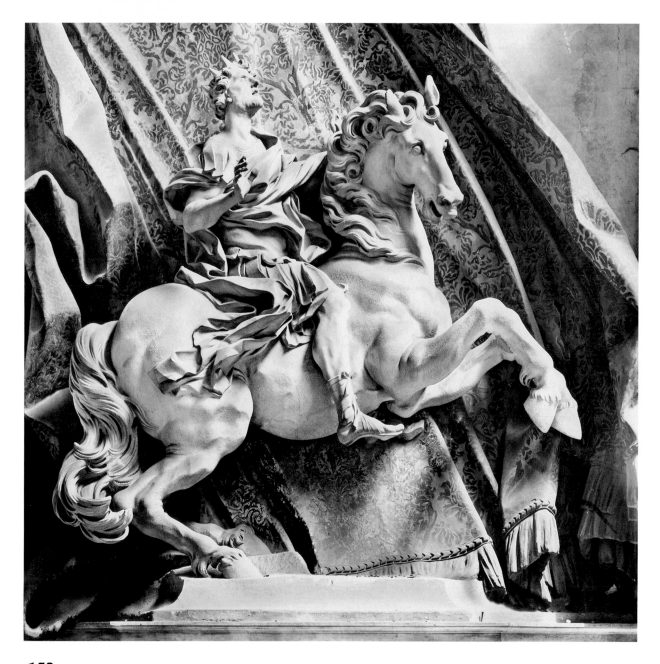

153 Gianlorenzo Bernini, *Equestrian Statue
of Constantine*, 1654–70.
Marble, over life-size.
Rome, Vatican, Scala Regia.

The execution of this monumental marble group
dates mostly from 1662–68; unveiled in the fall
of 1670, it immediately became the object of
enthusiastic scorn. Contemporary critics wondered
how the rider managed without stirrups and reins;
they found the first Christian emperor too small
for his horse and complained that the visionary
cross ("in this sign conquer") was invisible (see
Wittkower, 1966, p. 254). Modern commentators

have been kinder, but concentrate almost as
exclusively on interpretation rather than on
Bernini's awareness of the tradition that is
extended here. His horse ultimately derives from
Leonardo (Pls. 31, 38), who inspired at least one
of Raphael's horses in a nearby room (Pl. 40A,
where the horse is likewise startled by a celestial
apparition), and later some of Stradanus's battles
and hunts. Stradanus's *Equus Hispanus* (Pl. 54A)
in the *Equile* series of engravings would be an
appropriately pictorial source for Bernini's
composition, but even bronzes from
Giambologna's circle (Pl. 69) offer interesting
precedents.

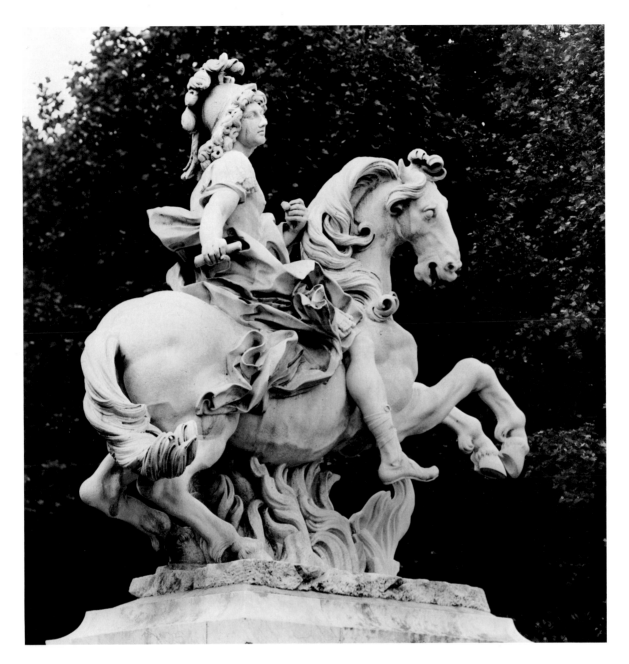

154 Gianlorenzo Bernini, *Equestrian Statue of Louis XIV*, 1671–73 (revised by Girardon in 1687 to represent *Marcus Curtius*).
Marble, over life-size.
Versailles, Pièce d'Eau des Suisses.

The idea for this influential but largely ruined piece goes back at least to 1665, when Bernini was working on the similar *Constantine*. Extraordinary delays followed, due to the sculptor's envious enemies in France, especially Colbert (d. 1683) and Lebrun (see Pl. 158), to salary disputes, and to Bernini's own ambivalence. The marble was mostly carved in the early 1670s, with assistants to the aging artist playing a much larger rôle than in the *Constantine*. The horse is essentially a studio replica, its head under-standably reminded Cecil Gould (1982, pp. 126–34) of Fuseli's *Nightmare*. In 1671 it was still

uncertain where the statue was headed, whether to French turf in Rome (at S. Trinità de' Monti) or to Paris or Versailles. It was finally delivered to France in 1685 and in November of that year was found "so badly done that [the king] resolved to have it destroyed" (according to the courtier Dangeau: see Gould, p. 129, and Berger, 1985, ch. 6 and appendix 2 for a detailed interpretation of the subsequent events). This was only partly accomplished by Girardon, who cleverly changed the subject by recarving the head and the base. The story of the mounted Marcus Curtius leaping into a flaming chasm (compare Pl. 89) is actually better suited to the steed's startled expression and recoiling pose (familiar to anyone who has surprised a horse in its stall), which made more sense in the *Constantine* than it did here notwithstanding Bernini's elaborate explanation (See caption to Pl. 157).

155 Bernini, *Sketch for the Equestrian Monument of Louis XIV*, probably about 1673. Bassano, Museo Civico.

Following his work on the *Constantine*, Bernini imagined another *tableau* in which, in his own words, "King Louis, by virtue of his long series of famous victories, has already conquered the precipice of the mountain" (where "Glory resides"). The concept will be "much more readily apparent when [the statue] is installed in its destined setting. For there will be fashioned, in another piece of marble, a cliff which is appropriately steep and rocky on which the horse is to be placed in the manner which I shall have indicated" (see Gould, 1982, p. 130). The scroll-like forms beneath the horse's belly are to be read as banners in the background, but when the work was freestanding rather than, like the *Constantine* (Pl. 153), given its own stage the pedestal must have looked about as familiar to the French as would a model for the Guggenheim Museum. The flames stoked under the statue at Versailles are surprisingly sympathetic to Bernini's style if not to his idea of a mountaintop, which was borrowed by Lebrun (Pl. 158) and ultimately realized, though very differently, by Falconet (Pls. 202–03).

156 Another view, as in Pl. 154, of the statue after its recent restoration (photo: Robert Berger).

In an act of poetic justice to Bernini a lead cast of the statue is now situated grandly in front of the new entrance (*pyramide*) to the Louvre.

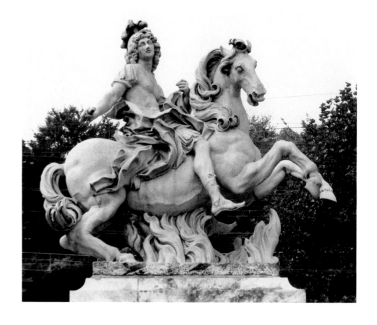

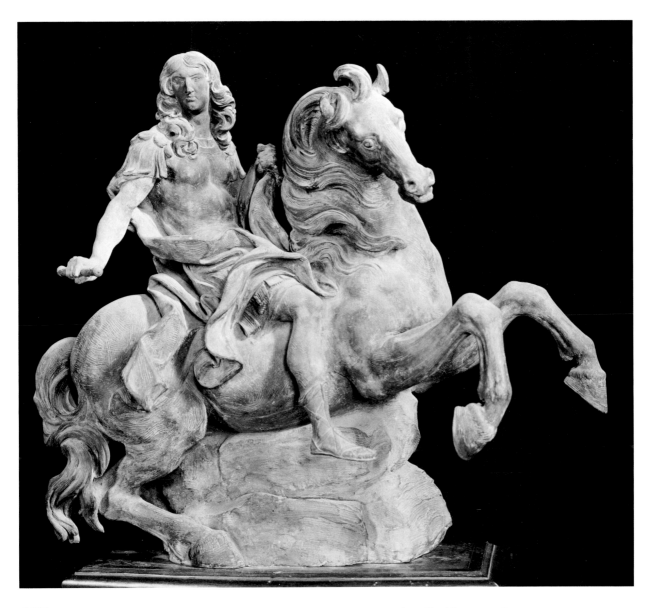

157 Bernini, *Model for the Equestrian
Monument of Louis XIV*, about 1670.
Terracotta, 30 in. (76 cm) high.
Rome, Galleria Borghese.

On December 30, 1669, Bernini wrote to Colbert
that he would first "make with my own hand the
clay model of the work, then I will be constantly
on hand to assist the aforesaid youths in working
from my model and telling them precisely how
to do it. Then I will carve the head of His Majesty
entirely with my own hand... This statue will be
quite different from that of the Constantine, since
Constantine is in the act of gazing at the cross
which has appeared to him, while the King will
be shown in an attitude of majesty and
command" (see Gould, 1982, p. 125). That attitude
is strongly felt in this *bozzetto*, where the smile
that must have so disturbed the French court does

not yet appear (see Gould, p. 131, for some
sensible remarks on this point). Since the horse's
pose and the King's expression here are consistent
with a tradition extending from Leonardo (Pl. 32)
to Mochi (Pl. 151) and to Bernini's own sketch
(Pl. 155), one wonders whether the real reason
for the subsequent smile was an accident rather
than the extraordinary reasoning that Bernini
offered after the fact: "I have not depicted King
Louis in the act of commanding his armies...;
since a jovial expression, and a mouth agreeably
laughing, are proper to him who rejoices" (etc.,
as quoted by Gould, p. 130). This does not sound
like the master of unequivocal emotions who
conceived the *St. Teresa*, the Chigi Chapel saints,
or the *Constantine* (see Wittkower, 1966,
pls. 72–75, 89–92; pls. 113–14 for details of this
bozzetto and of the *Constantine*).

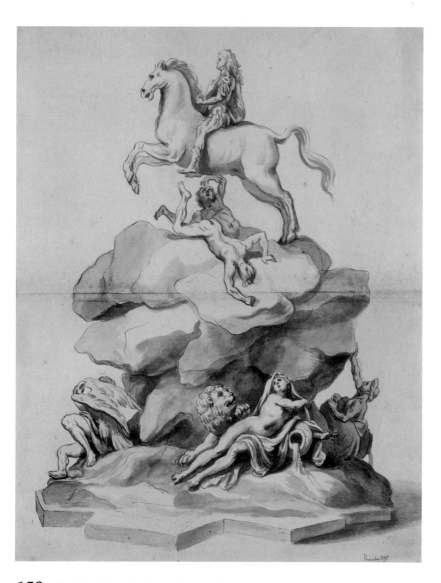

159 Antoine Coysevox, *Equestrian Portrait of Louis XIV*, about 1680. Marble relief, monumental scale. Versailles, Salon de la Guerre (designed by J.H. Mansart and Charles Lebrun).

Coysevox (1640–1720), like Bernini, was a Baroque thorn in the classicist Girardon's side; he rose to prominence in the 1680s while Girardon's stature declined. Here the king, though dressed in classical armor, is presented as if in actual battle. The greatly varied depths of relief suggest diagonal recessions. The broad similarity to approximately contemporary compositions such as Bernini's (Pl. 157) and Mignard's (Pl. 167) should not obscure the fact that the poses of the horse and rider, and indeed the conception of the whole, go back about eighty-five years to engravings such as Tempesta's *Henry IV* (Pl. 90, and Pl. 93 for an example with fallen enemies).

158 *Charles Lebrun's design for an Equestrian Monument of Louis XIV* (probably late 1670s), as recorded by Nicodemus Tessin the Younger. Stockholm, Nationalmuseum.

This is one of a few known drawings by or after Lebrun (see Wittkower, 1961, pp. 509, 513–14, figs. 22, 23, 33, 35) relating to the painter's design for an enormous equestrian monument of Louis XIV, which was inspired by whatever Lebrun could find out about his rival Bernini's idea. The figures immediately below the horse represent Heresy and Rebellion, while those at the base personify the four rivers that the king crossed during his successful military campaigns. The rock itself is equally allegorical, referring to the hard path of Virtue by which Hercules attained the summit of Glory; in another drawing Lebrun has Louis riding a winged horse, Pegasus, which Ripa, following Erizzo's reading of ancient coins (see Wittkower, p. 508), identified as Fame. The actual execution of this ambitious project was assigned to the sculptor Girardon, who made large models for it between 1679 and 1683. In that year Colbert died, and his successor Louvois, eager to erase any trace of his enemy's accomplishments, squashed Lebrun's plans and had Bernini's sculpture shipped to France.

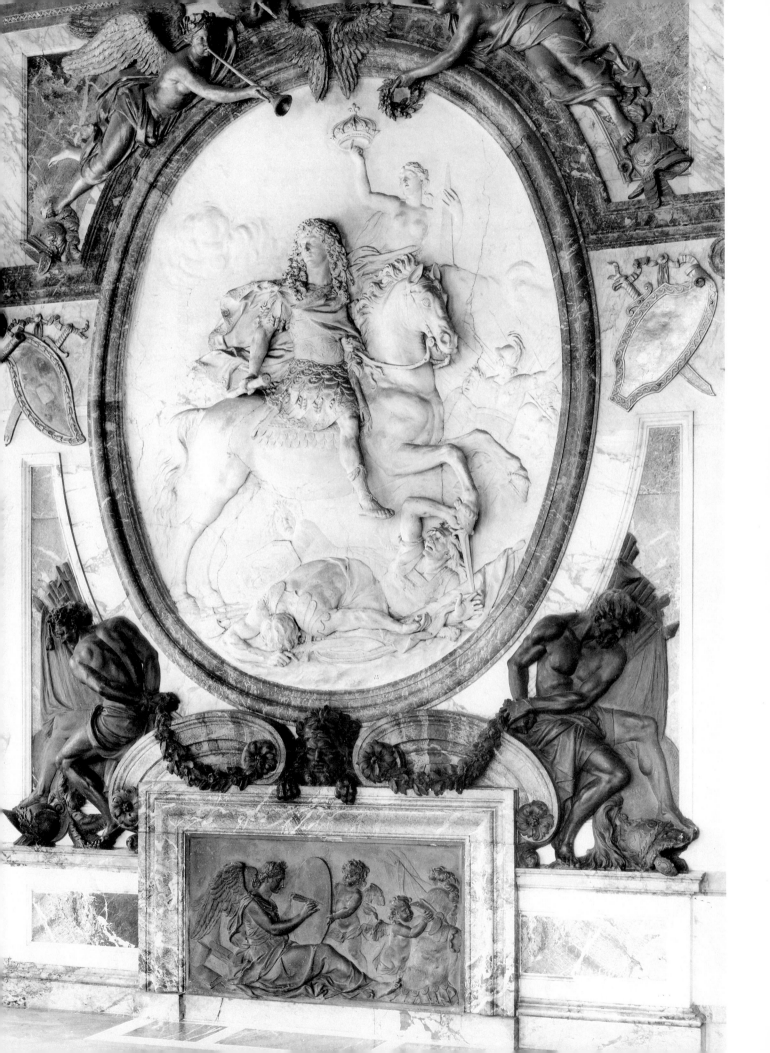

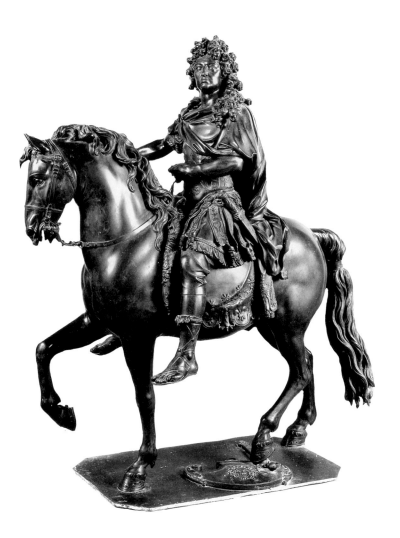

160 François Girardon, *Equestrian Statuette of Louis XIV*, about 1696–1700.
Bronze, 40 in. (102 cm) high.
Paris, Musée du Louvre.

In 1685 Louis XIV bought the site of the Hôtel de Vendôme in Paris. The new Place Vendôme, with Girardon's huge bronze equestrian monument of the king in the center, was designed by Mansart as an arcaded square comprised of public buildings such as the royal library. (For financial reasons the project was turned over to the city in 1698 and became the private preserve of the extremely rich.) Girardon's statue was begun in 1685, the year in which a new plaster cast of the *Marcus Aurelius* was placed in the courtyard of the Louvre; the bronze was cast in 1692 and set on its pedestal, amid much fanfare (see Pl. 161), in 1699. The work was destroyed in the Revolution but is recorded in many prints (e.g., Camins, 1981, nos. 78, 79) and drawings and by several bronze reductions of varying size.

161 Claude François Menestrier, *The Temple of Glory* (with a copy of Girardon's statue of Louis XIV), 1699.
Engraving and etching.
New York, Metropolitan Museum of Art.

This print records the temporary temple that was set up on a rock in the Seine when Girardon's equestrian monument of Louis XIV was unveiled in the Place Vendôme on August 13, 1699. Another engraving, by Guerard (Camins, 1981, no. 79), shows the cavalcade that circled the statue on the same day. Menestrier's idea depends upon Lebrun's (Pl. 158; see Wittkower, 1961, p. 515) but, in the building, blends Palladio with Mansart.

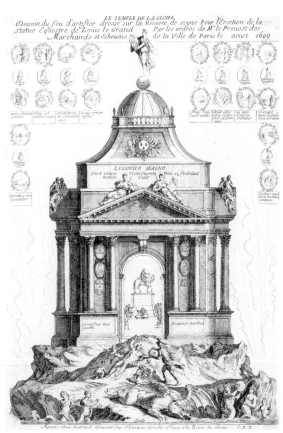

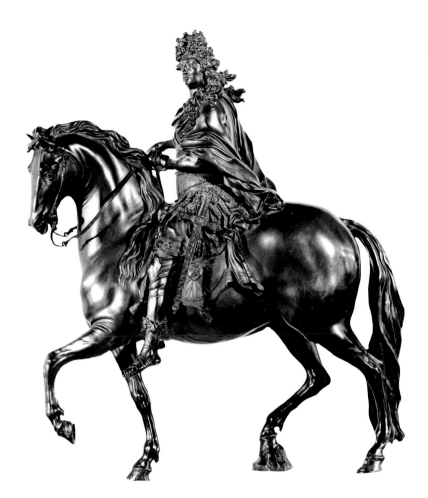

162 Simon Thomassin after Antoine Coysevox, *Coysevox's Equestrian Monument of Louis XIV*, 1699.
Engraving.
Paris, Bibliothèque Nationale.

This life-size bronze equestrian statue by Coysevox was executed under Mansart's supervision and intended for Nantes, but eventually was erected in Rennes in 1726. One of the reliefs on the marble base represented France triumphant at sea, the other, the arrival of foreign ambassadors through the ports of Brittany, the province that paid for the monument. Coysevox's work was one of twenty-two equestrian statues of Louis XIV that were planned between about 1665 and 1695, and one of the six that were actually completed.

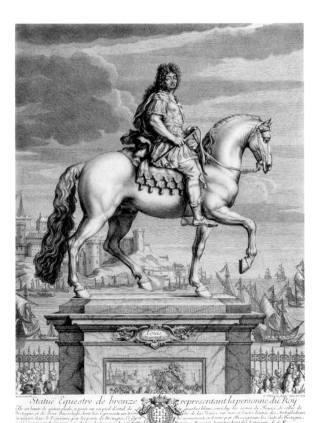

163 After Desjardins (Martin van den Bogaert), *Equestrian Statuette of Louis XIV* (based upon the Lyons monument), probably about 1700.
Bronze, about 17½ in. (44.5 cm) high.
Windsor Castle, Her Majesty the Queen.

This is a version, not a reduction, of the statue by Desjardins that was executed between 1686 and the year of the artist's death, 1694; it was set up in Lyons in 1713 and destroyed in the Revolution. Statuettes of similar quality are in the Wallace Collection and in Washington (see Camins, 1981, pp. 36, 126; and Lewis, 1974).

Stendhal, writing on June 7, 1837 (and working, as often in the *Memoirs*, from secondary sources), called the Lyons monument:

> very dull.... Very much Voltaire's Louis XIV, the farthest thing in the world from the natural and tranquil majesty of the Marcus Aurelius at the Capitol....
> "But," triumphantly remarks a French artist, "the thighs of Marcus Aurelius go back into the sides of his horse."
> I reply, "I have seen a letter of Voltaire's with three spelling mistakes in it."

(Stendhal, 1985, pp. 98–99)

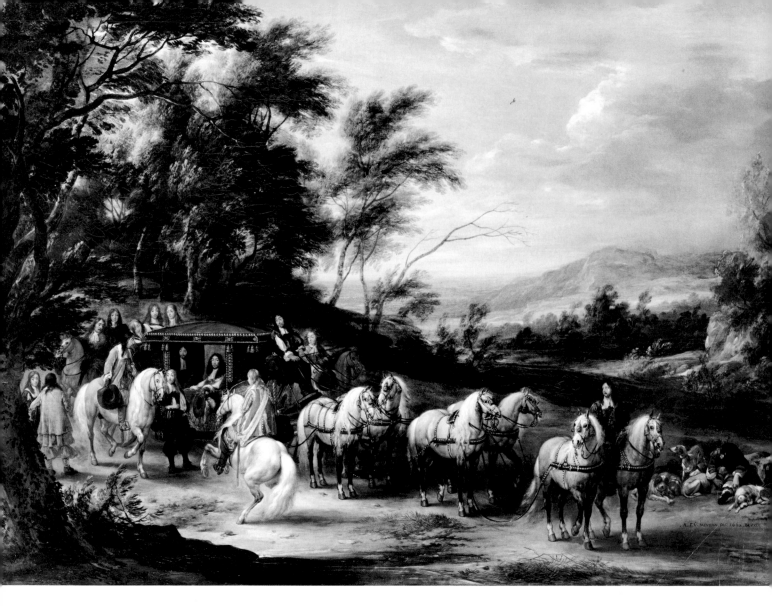

164 Adam Frans van der Meulen, *Phillipe-François d'Arenberg Saluted by the Leader of a Troop of Horsemen*, 1662.
Canvas, 23¹/₁₆ x 31⅞ in. (58.5 x 81 cm).
London, The National Gallery.

Van der Meulen (1632–1690), from Brussels, earned a reputation for depicting courtly figures and their mounted retinues before he went to Paris, where he entered Louis XIV's service in April 1664. As if in response to the formality of the occasion, the horses next to the coach perform a *passage* and a *levade*, the two airs that were later used by the artist in equestrian portraits of the king (e.g., Leningrad, Hermitage, no. 1754).

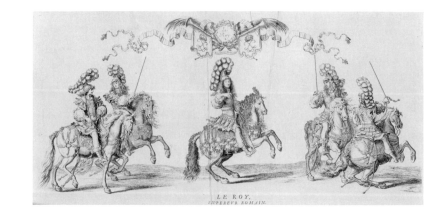

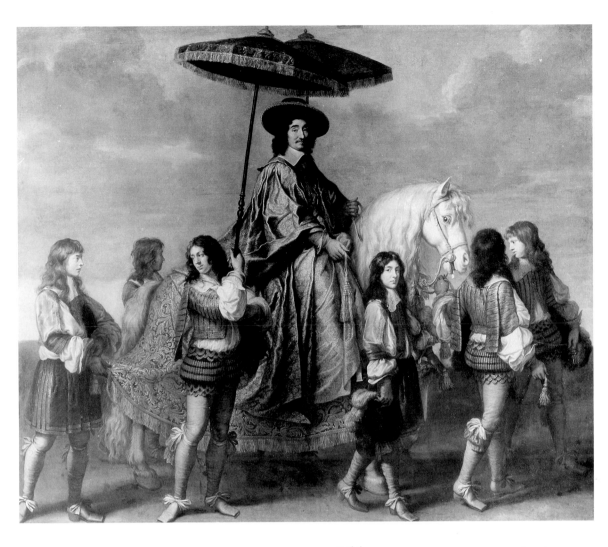

166 Charles Lebrun, *The Chancellor Séguier on Horseback*, 1661.
Canvas, 116⅛ x 138¼ in. (295 x 351.2 cm).
Paris, Musée du Louvre.

In this imposing portrait of his first protector, Séguier, Lebrun follows the old French form as adopted by Velázquez (Pl. 113), adding the pages who presumably accompanied the chancellor at the entry of Louis XIV and Marie-Thérèse into Paris in 1661. However, the circle of eight slowly walking figures (two of them behind the horse) is almost certainly adopted from the turning Hours that ring around Apollo in Guido Reni's *Aurora*, the famous ceiling fresco that the Frenchman would have studied during his stay in Rome (1642–46). Lebrun brilliantly borrowed other artist's compositional ideas, moving easily from engravings after Rubens to accounts about Bernini (see Pl. 158); here, colors, textures, even smiles and gestures reminiscent of van Dyck (compare Pl. 126) lend life to the Poussinist principles that this painter preached.

◄

165 François Chauveau after Charles Perrault, *Course de Testes et de Bague...* (staged in 1662), Paris, 1670.
Etched book plate, 22 x 29½ in. (55.8 x 74.9 cm).
Washington, The Library of Congress, The Lessing J. Rosenwald Collection.

The book in which this illustration of Louis XIV as a Roman emperor appears records the carrousel of 1662 held in front of the Tuileries in Paris (*Place du Carrousel*). Quadrilles of ten horsemen led by the king, his brother, the Prince de Condé and other eminent figures represented the nations of the world in appropriate if fanciful costumes. (See further Camins, 1981, p. 55, on this event; pp. 48–58 for a short history of equestrian "triumphs and festivals.")

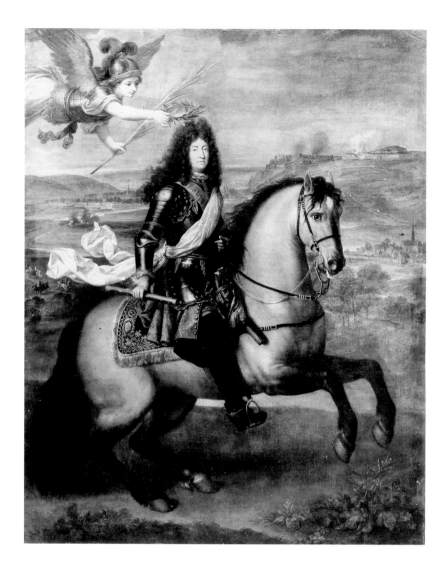

167 Pierre Mignard, *Equestrian Portrait of Louis XIV.*
Canvas, 11¾ x 8½ ft. (359 x 260 cm).
Versailles, Musée de Versailles.

Here and in very similar equestrian portraits, Mignard, Lebrun's pupil Houasse (Pl. 168), and before them, van der Meulen (see Pl. 164), follow in the footsteps (or hoofprints) of Rubens and Velázquez with notably less success than Jordaens, Coques, or, differently, Lebrun (Pls. 112, 130, 141, 144, 166).

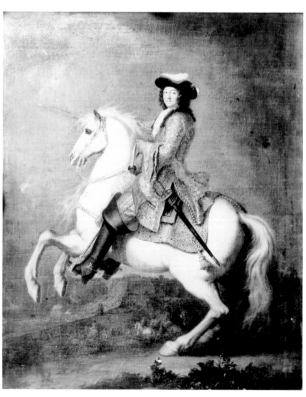

168 René-Antoine Houasse,
Equestrian Portrait of Louis XIV.
Canvas, 36⅝ x 29½ in. (93 x 75 cm).
Dijon, Musée des Beaux-Arts.

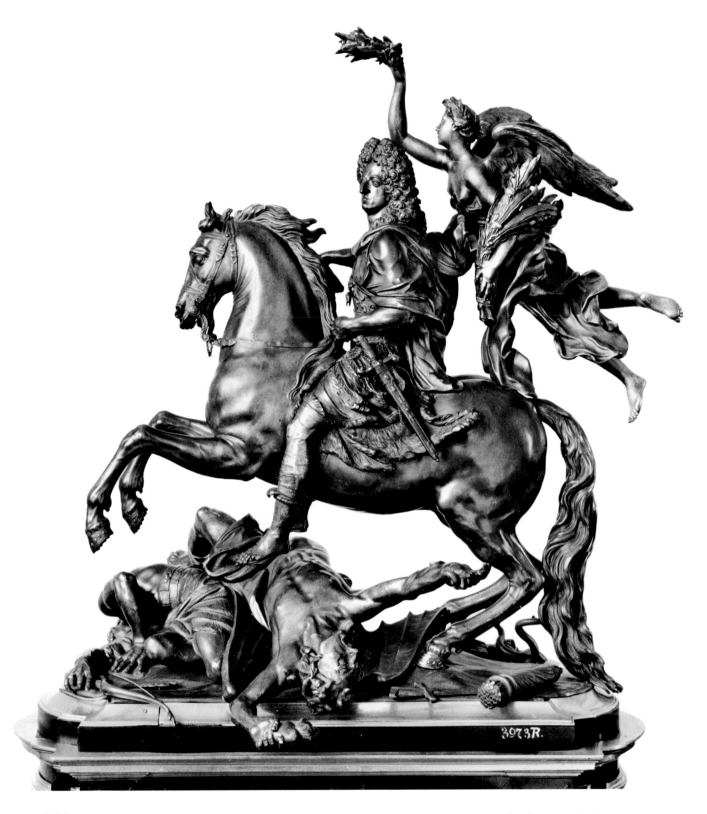

169 Guillielmus de Grof, *The Elector
Maximilian II Emanuel of Bavaria as Victor over the
Turks*, signed and dated 1714.
Bronze, 21 in. (53.3 cm) high.
Munich, Bayerisches Nationalmuseum.

This is one of many bronzes dating from about
1700–1715 that were inspired by Bernini and Lebrun
(Pls. 154, 158), by bronzes in the Giambologna

tradition (Pls. 70, 71, 77), and by the most familiar
type of painted equestrian portraits of Louis XIV
(Pl. 167). The pose here has to be considered a rear
even though it resembles a *levade*; in many statuettes
the action of the horse accomodates and seemingly
responds to a fallen enemy (here two of them, with
a Victory above). Examples by or attributed to
Martin Desjardins (see Pl. 163), Jean (?) Gobert, de
Grof and others are discussed by Peter Volk (1966).

170 Probably Italian, Second Half of the 17th Century, *A Standing Horse*.
Bronze, 6 in. (15.2 cm) high.
Berlin, Staatliche Museen.

When other forms of expertise fail, one can fall back on fashion. The standard Pelican volume on 16th-century German and Netherlandish art (van der Osten and Vey, p. 35) considers this sturdy mount to be a model for Maximilian I's unfinished equestrian monument in Augsburg of about 1500–1509 (see Habich, 1913). The Berlin museum now displays the work as possibly after the Florentine Francesco Fancelli (1624–1681). A review of horses reproduced above indicates that the very long, flowing mane and tail found here were favored in the finer stables of the 17th-century (Pls. 57, 101, 104, 108–113) and that there is no grooming style quite like this earlier on. As for "the small, back-tilted [tucked-in?] head of the Renaissance," it counts for nothing next to the conformation of the whole, which exhibits the same broad proportions, continuous contours, and exaggerated arch of the neck as in the evidently contemporary portrait of *"Le Tigre François"* (Pl. 171).

◄

171 Attributed to Adam Frans van der Meulen,
"Le Tigre François," about 1665–75.
Canvas, 14⅜ x 18 in. (36.5 x 45.5 cm).
Paris, Heim Gallery (in 1975).

The canvas is inscribed "LE TIGRE FRANCOIS/VILLE DE
TOVRNAY" and includes a view of Tournai in the
background. If it is in fact by van der Meulen, then
this painting would not be "the only 'portrait of a
horse' of the 17th-century French school" (Paris,
1975, no. 26); rather, it would take its place among
the many Dutch and Flemish portraits of horses (and
Dutch cows and bulls, like Potter's). A very similar
composition by Cuyp is now in a private collection
in New York (Dordrecht, 1977, no. 26). The present
picture may record a prize of the siege of Tournai
(June 1667) and would thus be an "equestrian trophy"
quite like De Gheyn's (Pl. 57).

172 Johann Georg von Hamilton, *Portrait
of a Piebald Horse from the Eisgrub Stud,* 1700.
Canvas, 101⅝ x 82⅝ in. (258 x 210 cm).
Vaduz, Collection of the Princes of Liechtenstein.

Hamilton, a native of Brussels, worked at the
Viennese court from about 1698 until his death in
1737. This is one of six life-size equine portraits that
were painted in 1700 to decorate the Liechtenstein
Garden Palace at Vienna. The Eigsrub stud, founded
by Prince Karl Eusebius (1611–1684), himself the
author of a stud book, often had over a hundred
stallions of different breeds and was admired
throughout Europe. A stable with four wings,
designed by the architect Fischer von Erlach, was
built for Prince Johann Adam between 1688 and
1698. In such a context it almost goes without
saying that the Liechtenstein horses, as depicted by
Hamilton, perform airs of the *haute école.*
Colorplate 31

173 Bernard van Orley, *Otto van Nassau and his wife Agnes van Leiningen*, a design from one of the tapestries in the series known as the "Nassau Genealogy," about 1530.
Drawing, 14 x 19½ in. (35.7 x 49.3 cm).
Munich, Staatliche Graphische Sammlung.

A set of eight tapestries after van Orley's designs was inherited by William the Silent, while the artist's painted cartoons came into the possession of Prince Maurits of Nassau. Prince Frederick Hendrick had a second set of tapestries made in the 1630s. A full history of the lost tapestries and some comments on their relationship to earlier and later equestrian portraits of Dutch princes has been published by Fock, 1969.

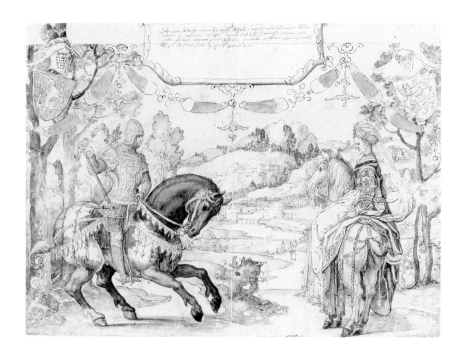

174 Pauwels van Hillegaert, *Cavalcade of Nassau Princes, including Maurits and Frederick Hendrick,* about 1630.
Panel, 31⅛ x 53½ in. (79 x 136 cm).
The Hague, Vereniging Oranje-Nassau Museum (on loan to the Paleis Het Loo, Apeldoorn). See caption to Pl. 175.

175 Adriaen van de Venne, *Frederick V
of the Palatinate and his wife Elizabeth Stuart
on Horseback*, 1628.
Canvas, 60⅞ x 75½ in. (154.5 x 191 cm).
Amsterdam, Rijksmuseum.

Dutch paintings have been placed in this late
section of the plates because they either depended
upon conventions developed elsewhere (as in
Pls. 176, 179), or they represent types of
equestrian portraiture that were largely indigenous
to Holland until they became more widely
employed in the eighteenth century. Large
equestrian portraits (to say nothing of
monuments) representing princely persons were
not to be expected in the United Provinces; the
most important equestrian portraits of members
of the House of Orange and Nassau were the

comparatively small "cavalcade" pictures that were
painted by Pauwels van Hillegaert (Pl. 174),
Hendrick Pacx, and Adriaen van de Venne. These
works continued a Dutch tradition of dynastic
group equestrian portraits that began with prints
such as Jacob Cornelisz. van Oostzanen's nine
woodcuts of 1518, *The Counts and Countesses of
Holland* (see Leeuwarden, 1979–80, fig. 13), and
tapestries such as the "Nassau Genealogy" (Pl.
173). However, almost all the 17th-century Dutch
examples rationalize the princely perogative of
riding in procession not as a triumphal entry but
as the merely aristocratic pastime of setting out to
hunt. In Van de Venne's grisaille painting this
forward-looking convention (compare Pl. 184)
probably corresponds to "everyday" life since the
exiled King and Queen of Bohemia had time on
their hands at The Hague.

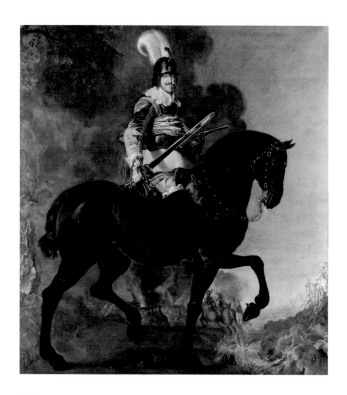

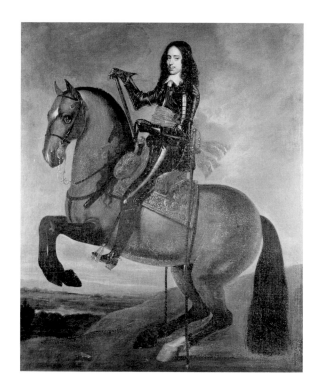

176 Carel van Mander III, *Equestrian Portrait of Christian IV of Denmark*, about 1643.
Canvas, 121¼ x 109½ in. (308 x 278 cm).
Frederiksborg, Frederiksborgmuseet.

Carel van Mander III, grandson of the well known Haarlem artist, was born in Delft around 1610. His father, the tapestry designer and manufacturer Carel van Mander II, provided a great series of tapestries depicting the life of Christian IV and visited Frederiksborg in 1616 and two later trips. Carel III settled in Copenhagen after his father's death in 1623, although he visited the Netherlands and travelled to Italy between 1635 and 1638. His best known paintings are portraits of Christian IV (among them four equestrian portraits) and other figures at the Danish court. The old formula of the high-stepping trotter in profile, found in numerous 16th- and 17th-century prints, is here impressively revitalized by the realistic rendering of the well-armed king. The horse's pose lends an air of formality as appropriate to state portraiture as it is unlikely on a battlefield.

177 Anselmus van Hulle, *Prince Willem II on Horseback*, about 1645.
Canvas, 47⅝ x 40½ in. (121 x 103 cm).
The Hague, Dienst Verspreide Rijkskollekties.

The horse in this signed picture performs a *levade*, as does the horse in the equestrian portrait of Prince Willem II, one of five similar paintings attributed to the Fleming van Hulle (1601–after 1674) in the Royal Palace, Amsterdam (see Leeuwarden, 1979–80, cat. no. 15, and pp. 105–06, nos. 144–48).

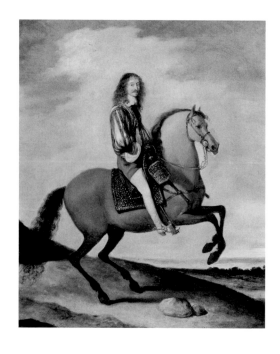

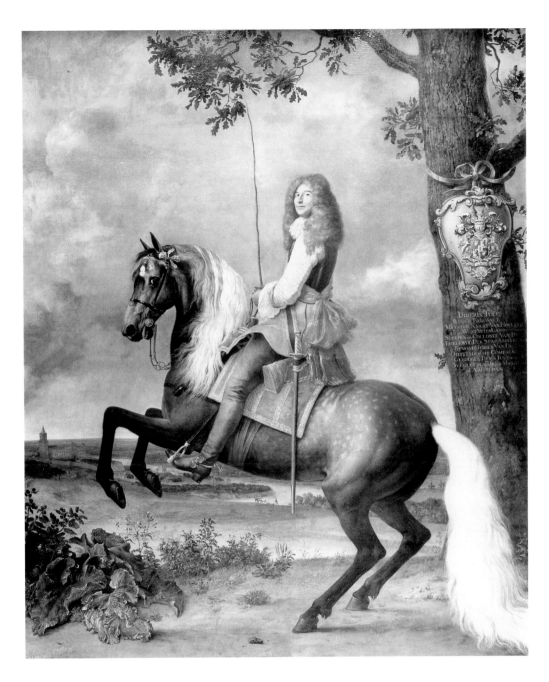

178 Gerard ter Borch, *Equestrian Portrait of Henri de Bourbon-Orléans, Duke of Longueville*, about 1646–47.
Canvas, 19¼ x 16⅛ in. (49 x 41 cm).
Formerly New-York Historical Society.

This is, surprisingly, the more successful of the two equestrian portraits that are known to have been painted by ter Borch (see Leeuwarden, 1979–80, cat. no. 16), who had little experience as an animal painter and none as a student of courtly equestrian forms. Considering ter Borch's great talent as a portraitist, there are few pictures so reminiscent of Dr. Johnson's observation, "Sir, a woman's preaching is like a dog's walking on his hindlegs. It is not done well; but you are surprised to find it done at all" (Boswell's *Life*, the passage dated July 31, 1763).

179 Paulus Potter, *Dirck Tulp (1624–1682) on Horseback*, 1653.
Canvas, 122 x 108 in. (310 x 274 cm).
Amsterdam, Six Collection.

The sitter is Theodorus ("Dirck") Tulp, a director of the East India Company, and son of the Amsterdam *burgemeester* Nicolaes Tulp, whose daughter Margaretha (Dirck's stepsister) married Jan Six. This life-size picture is generally considered to be the first monumental equestrian portrait by a Dutch painter, but what is more significant is that it remained one of the few, and that the sitter was merely a member of the upper middle class. The horse's imperfect *levade* serves as a sign of patrician aspirations rather than rulership (not quite the way the Company was run).

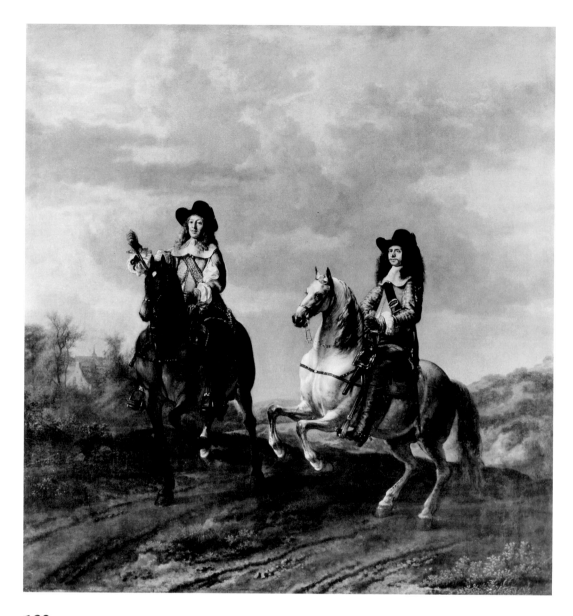

180 Thomas de Keyser, *Two Unknown Riders*, 1661.
Canvas, 38⅝ x 36⅜ in. (98 x 92.5 cm).
Dresden, Gemäldegalerie.

With all due respect to van Hillegaert and van de Venne, Holland's two best equestrian portraitists were Thomas de Keyser and the generation-younger Aelbert Cuyp. In his canvases in Amsterdam *(Pieter Schout on Horseback)*, The Hague, Frankfurt and elsewhere (see Leeuwarden, 1979–80, p. 111, for a list), which mostly date from the 1660s, de Keyser carefully observes proper riding forms without ever seeming pretentious. The behavior of his horses suits the seriousness of his sitters and contributes to the impression of good breeding in both man and mount.

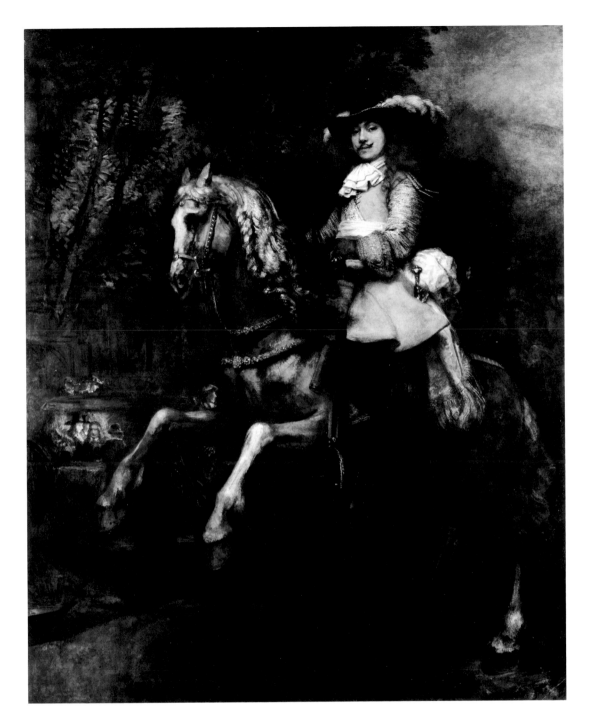

181 Rembrandt, *Equestrian Portrait of Frederick Rihel*, 1663.
Canvas, 116 x 95 in. (294.5 x 241 cm).
London, The National Gallery.

Rembrandt began this very large painting in 1660, a year earlier than Lebrun's broadly comparable work (Pl. 166) and the year in which the rich Lutheran merchant Rihel took part in the state entry of William III into Amsterdam. The wealthy merchant-banker commemorated this moment of close association with the Houses of Orange and Stuart by commissioning the most princely portrait that Rembrandt ever painted. The ambitious scale of the picture was anticipated by Potter (that is, by Dirck Tulp; Pl. 179) and, more expectedly, by van

Hulle in his five portraits of Orange princes (see caption to Pl. 177).

It has recently been suggested by a member of the Rembrandt Research Project that the horse in this painting is not by Rembrandt. The actual execution is obviously consistent throughout, so the idea must rest solely on the often criticized and misunderstood pose of the horse. The extended right arm of the rider, the turn of the horse's head, and the uneven position of both the front and hindlegs indicate a sudden turn, as if the rider had paused to acknowledge the very close viewer and now pirouettes back to the parade. Rihel owned a stable of horses and, like most riders of his class, keeps his heels down and his nose up. *Colorplate 29*

182 Jan Mijtens, *Maria, Princess of Orange (1642–1688), with Her Horse and Two Pages.*
Canvas, 59 x 73 in. (150 x 185.5 cm).
The Hague, Mauritshuis (on loan to the Dienst Verspreide Rijkskollekties).

Jan Mijtens of The Hague was the pupil of his uncle Daniel Mijtens (see Pl. 128) and was much influenced by English portraiture, including, obviously, van Dyck's (compare Pl. 126). Here the daughter of Prince Frederick Hendrick and Amalia van Solms exhibits frightfully fashionable taste in such chic attributes as blackamoor grooms, pleasure riding, and inappropriate riding apparel.

183 Jan Baptist Weenix, *Johan van Twist at the Blockade of Goa,* 1650s.
Canvas, 39¾ x 70½ in. (101 x 179 cm).
Amsterdam, Rijksmuseum.

Johan van Twist (died 1643), on the rearing horse, was the Dutch East India Company's ambassador to the Sultan of Visiapur, whose representative rides beside van Twist. One of the ships in the harbor is the "Uytrecht," named for the city where the van Twists and, after 1649, Weenix resided. The composition closely anticipates that of Bakhuizen's *Arrival of Willem III at Oranjepolder in 1691,* dated 1692, in the Mauritshuis, The Hague.

184 Aelbert Cuyp, *Starting for the Hunt: Michiel (1638–1653) and Cornelis (1639–1680) Pompe van Meerdervoort with their Tutor and Coachman*, about 1653.
Canvas, 43¼ x 61½ in. (109.8 x 156.2 cm).
New York, Metropolitan Museum of Art, The Friedsam Collection.

Cuyp's equestrian portraits may be considered the crowning achievement of the genre in the Netherlands; they combine, more convincingly than de Keyser's pictures, mounted figures and landscape to create the impression of an everyday event. The artist's entry into this field was probably due to a commission, namely that for the so-called "Salmon Fishing," an *Equestrian Portrait of Pieter de Roovere (1602–1652)*, in the Mauritshuis, The Hague. The Pompe van Meerdervoort family was from Cuyp's native Dordrecht. Other equestrian group portraits by Cuyp include *Willem, Jan and Cornelis van Beveren*, in the Barber Institute, Birmingham; the portrait of an unidentified couple in the National Gallery of Art, Washington; and pictures of unknown riders in Dordrecht, in the Louvre, and in a private collection in America. A few single equestrian portraits by Cuyp are also known (see Leeuwarden, 1979–80, pp. 103–05). *Colorplate 28*

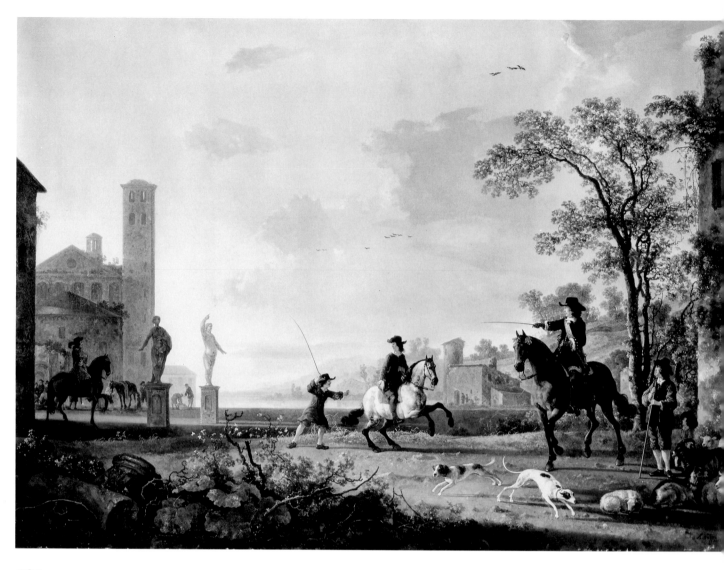

185 Aelbert Cuyp, *The Riding Lesson*, about 1660.
Canvas, 46¾ x 67 in. (118.7 x 170.2 cm).
Toledo, Ohio, The Toledo Museum of Art.

This is one of the largest and best examples of a type
of picture that was a Dutch and Flemish specialty.
Views of informal "riding schools," occasionally
including portraits, were painted by Cuyp and by his
pupil Abraham van Calraet (some of his pictures
are optimistically ascribed to Cuyp); by Karel
Dujardin (National Gallery of Ireland); by Gerrit
Berckheyde, who also painted "cavalcades" set by the
Hofvijver at The Hague; by Hendrick Verschuring
(Braunschweig, no. 277); by Pieter van Bloemen
(Dresden, no. 1118); and many other minor artists.
Like other subjects involving polite and leisurely
pastimes (e.g. foreign travel, suggested here by a
version of the lost Mariakerk at Utrecht and a
seemingly southern landscape), Dutch "riding school"
pictures date mostly from after 1650. The genre
flourished internationally in the following century.

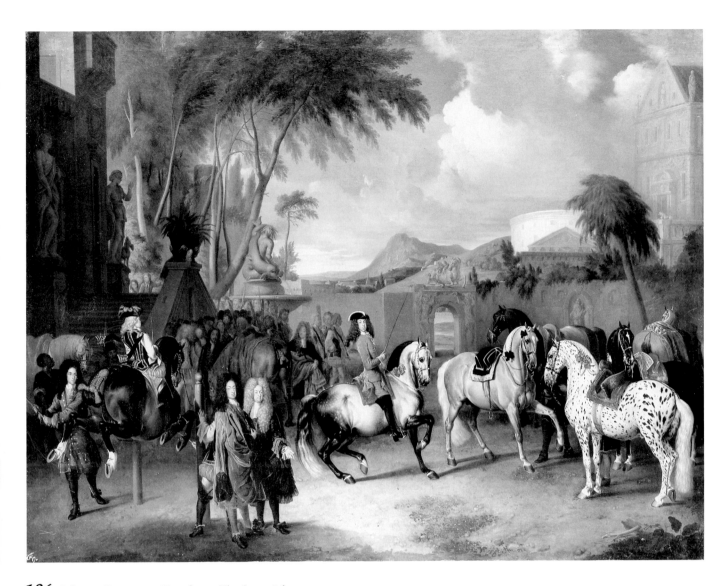

186 Johann Georg von Hamilton, *The Imperial Riding School in Vienna*, about 1700–1703.
Canvas, 27⅛ x 35 in. (69 x 89 cm).
Vaduz, Collection of the Princes of Liechtenstein.

In this brilliantly colorful picture, the young rider in the center is Archduke Charles (later Emperor Charles VI), son of the Holy Roman Emperor Leopold I. In the foreground is his mentor and High Steward, Prince Anton Florian von Liechtenstein (1656–1721), and, to the right, Count Cobenzl. The Archduke's horse performs a *piaffe* (trot in place), while the horse to the left executes a *capriole* between pillars. Courtly riding schools of earlier centuries than ours were as concerned with cultivating gentlemen (a number of whom appear here in the left background) as they were with training horses to perform difficult airs.
Colorplate 30

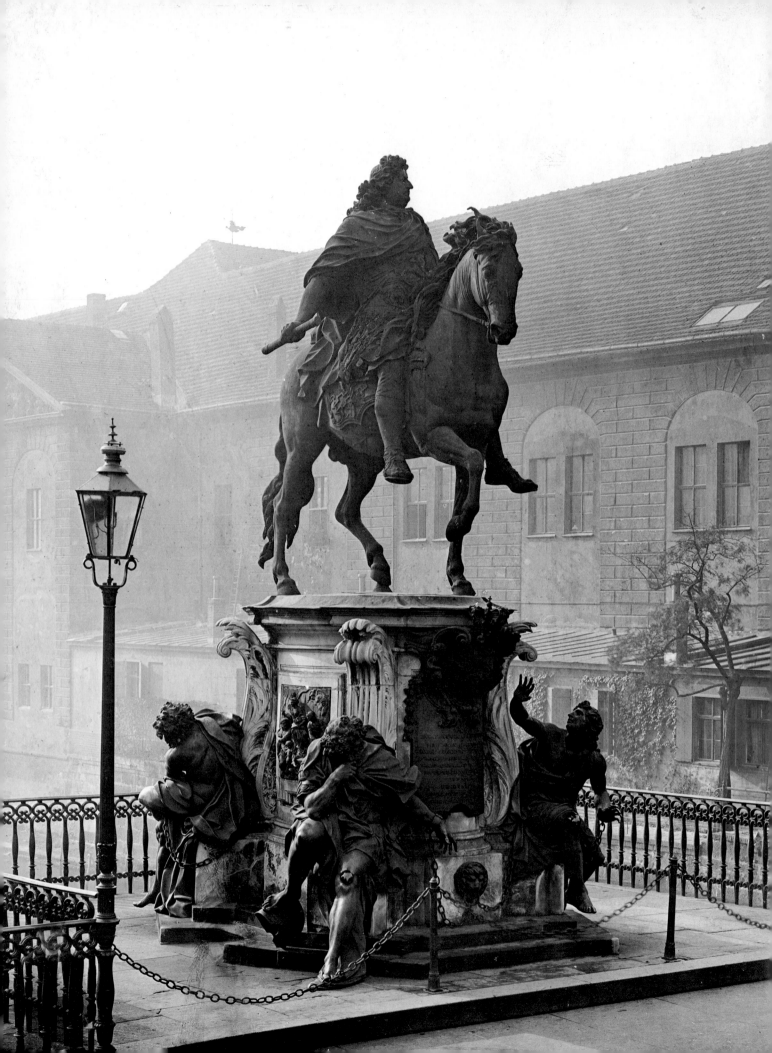

187 Andreas Schlüter, *Equestrian Monument of the Great Elector, Friedrich Wilhelm (r. 1640–1688),* 1696–1709.
Bronze, the statue 9½ ft. (2.9 m) high.
Berlin, in front of Schloss Charlottenburg (here seen in its original location on the Lange Brücke).

The horse and rider, cast in 1700, may be considered one of the last Baroque equestrian statues in that the proportions are broad and powerful, the action almost impulsive (Hempel, sensibly, sees the horse as "ready at any moment to break into a canter"), the bond between master and mount as one of will, authority, and reason, tempering spirit and inspiring obedience. The four captives around the base have been convincingly considered as personifications of the Temperaments (Keller, 1971, ch. IV). Schlüter obviously looked to Rome and to Paris (compare Pls. 8, 149, 160), but Piacenza seems the source of energy: Mochi's *Alessandro Farnese* (Pl. 151) set the pace for Schlüter's horse (the right foreleg now leading), influenced the position of the rider and determined the rhythm that runs from mane to tail.

187A Schloss Charlottenburg, Berlin. Schlüter's *Equestrian Monument of the Great Elector* was moved to this location during the city's reconstruction in the years after World War II.

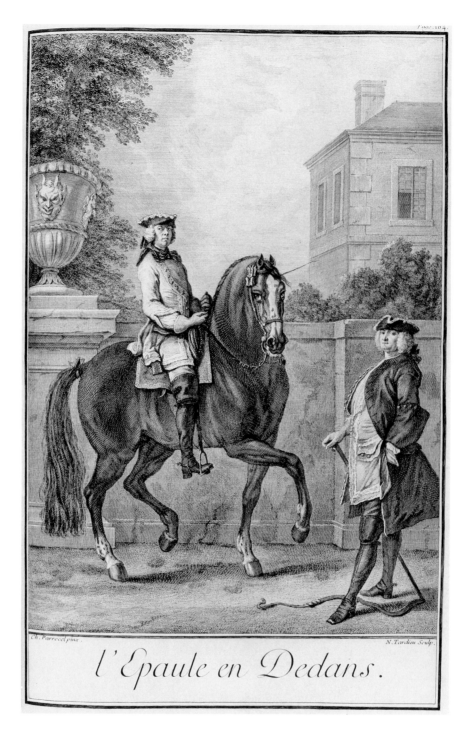

l'Épaule en Dedans.

188 A plate from François de la Guérinière, *École de cavalerie, contenant la connoissance, l'instruction, et la conservation du cheval*, Paris, 1733 (engravings by N.-H. Tardieu after Charles Parrocel), the "shoulder-in" at the trot.
Engraving and etching, 17¼ x 11¹/₁₆ in.(43.8 x 28 cm).
Middleburg, Virginia, The National Sporting Library.

The author was Louis XV's *Ecuyer ordinaire*, and the leading authority and innovator of riding style in the 18th century. La Guérinière's Parisian schools coexisted with the *Grand Ecurie du Roi* at Versailles, but were more influential; his teaching, embodied in this treatise (first published in 1731), superseded the tradition of La Broue and Pluvinel and formed a foundation for the training still practiced today at the Spanish Riding School in Vienna and by the Cadre Noir at Saumur. Grace, elegance, and movements more natural (and sympathetic to the horse's conformation) were favored by La Guérinière over the comparatively rigid and difficult airs illustrated by Pluvinel and Newcastle, which, in the eighteenth-century author's own words, "look better in still pictures than in actuality: the former fail to reveal the strain and violence in the motion" (translation and most of these details from Camins, 1981, pp. 44–45). The *levade* fell out of favor with artists after about 1720 as it did with La Guérinière, who considered the trot ideal, in its lightness and suppleness, for permitting proper balance and freedom in the saddle as well as precise commands.

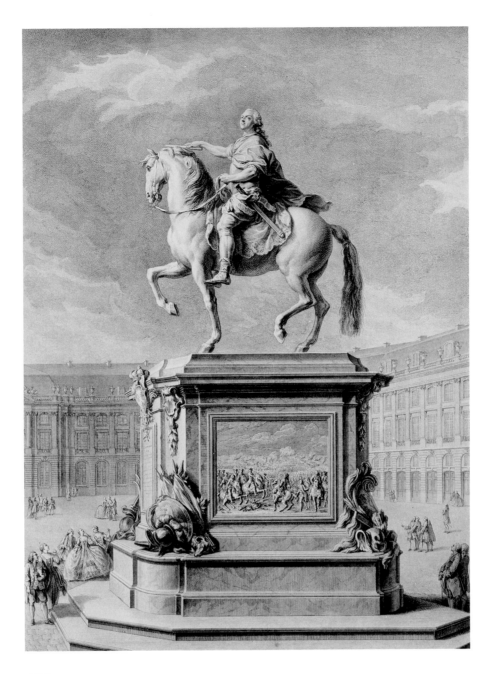

189 *Jean-Baptiste Lemoyne's Equestrian Monument of Louis XV in the Place Royale, Bordeaux* (engraved by J.-G. Dupuis after Charles-Nicolas Cochin), 1731–41, inaugurated and this print published in 1743. Engraving, 29⅞ x 20 ³⁄₁₆ in. (75.9 x 52.9 cm). New York, Metropolitan Museum of Art.

This large, precise, and slightly silly print (a Parisian's view of how people gape at statues in the provinces) records one of the many major works in bronze that were hauled down during the Revolution. The rider's gesture and expression suggest concord more than command, the horse's gait relaxation rather than submission. Lemoyne was told to study the horse from life, his fidelity to which was assessed by the *Ecuyers du Roi.* They and Louis and his favorite sculptor Lemoyne seem much in sympathy with La Guérinière, who represents what in hindsight might be seen as part of an aesthetic shift from Versailles to Paris.

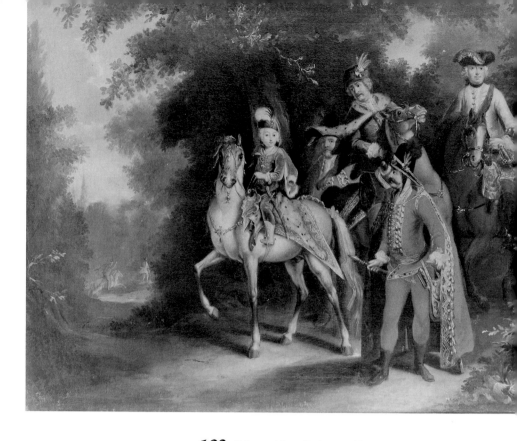

190 Johann Elias Ridinger, *Equestrian Portrait of the Archduke Joseph of Austria and his Suite,* about 1745.
Canvas, 20 x 24½ in. (51 x 62 cm).
Monaco, Sotheby's, 13 June, 1982.

Ridinger (1698–1767), from Ulm, specialized in painting animals and especially horses; he published several series of equestrian prints, such as *Neue Reit-Kunst*, 1722; *Neue Reit Schul*, 1734; *Vorstellung und Beschreibung derer Schul und Campagne Pferden* ("Kleine Reitschule"), 1760 (23, 18, and 47 engravings, respectively). In the painting reproduced here Ridinger portrays the pint-size future emperor (Joseph II, r. 1765–90) in an equestrian conversation piece, a genre more at home in the Netherlands and England. The pony looks and acts like a frightened deer; the figures are less alert. Considering that this is a royal, or rather imperial, equestrian portrait one can complain that the category (and its iconography) have come a long way since Velázquez placed *Baltasar Carlos in the Riding School* (Pl. 122).

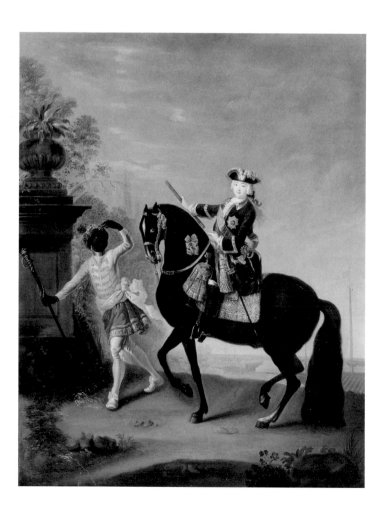

191 Georg Christoph Grooth, *The Empress Elizabeth of Russia (1709–1762) on Horseback, Attended by a Page,* about 1745.
Canvas, 31⅜ x 24½ in. (79.7 x 62.2 cm).
New York, Metropolitan Museum of Art.

Grooth (1716–1749), from Stuttgart, went to Leningrad in 1743, and in that year painted the large version of this equestrian portrait in the Tretiakoff Gallery, Moscow. The New York canvas appears to be an autograph replica. Though presented as a Marshal, the Empress seems content to be simply a rider ready for any air depicted in La Guérinière's plates (here, improbably, a *piaffe*).

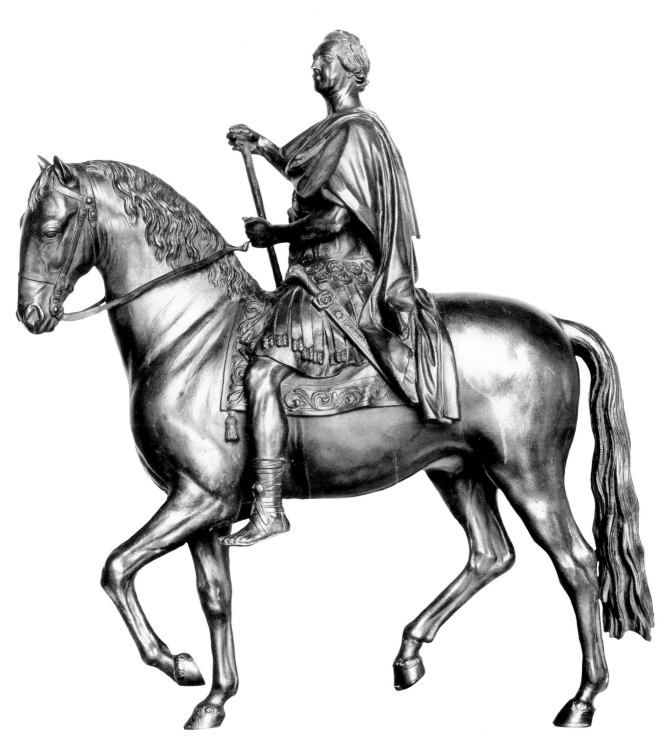

192 Edme Bouchardon, *Equestrian Statuette
of Louis XV*, about 1760.
Bronze, 28 in. (71 cm) high.
Paris, Musée du Louvre.

Bouchardon was successor and antagonist to
Lemoyne (Pl. 189), whose pictorial approach he
opposed in favor of classicism and, for this work,
a Stubbsian study of equine anatomy. His reform
was not a revival: stylistically the huge equestrian
statue for Paris upon which this piece depends owed

as much to Lemoyne's celebrated sculpture in
Bordeaux as it did to Girardon's *Louis XIV* (Pl. 160).
As for the *Marcus Aurelius* (Pl. 8), which
Bouchardon knew from casts and copies as well as
from his years in Rome (1723–32), not every
scholar agrees that it "almost too patently inspired"
the *Louis XV* (Levey and Kalnein, 1972, p. 62). For
Bouchardon, ancient works were touchstones more
than models, as the more than four hundred
drawings for this project reveal.

194 Agostino Carlini, *Modello for an Equestrian Statue of George III*, c. 1775 (?).
Plaster, 34½ in. (87.5 cm) high.
London, Royal Academy of Arts.

This appears to be one of the first examples in sculpture of an idea derived from battle scenes, as well as from works by Stubbs and Sawrey Gilpin: the horse reacts to something unexpected rather than to the rider's command. Thus the sitter is seen as a stalwart soldier in the saddle but also as an ordinary man. Numerous pictures and monuments (e.g., John Bacon Junior's *William III*, 1806, in St. James's Square; Friis, 1933, fig. 202) extend and exaggerate this pose (Pls. 195, 216), which has a parallel in the "romantic rears" of horses represented by artists from David (Pl. 204) and Gros to Barye and beyond. The action of the horse here is almost the same as in Gros's *Napoleon* of 1800 in the Musée de Malmaison (Bühler, 1949, Pl. 44).

193 Alexandre Roslin, *Equestrian Portrait of Louis-Philippe, Duc d'Orléans*, 1757.
Canvas, 117½ x 87½ in. (298 x 222 cm).
Detroit, The Institute of Arts.

Roslin le Suédois, as this large canvas is signed, was trained in Sweden but settled in Paris, where he was a highly successful if uninspired portraitist. He returned to Scandinavia in 1774 and then went from Leningrad to Paris via Warsaw and Vienna, painting kings, queens, and empresses (Catherine the Great) along the way. His tendency to bourgeoisify illustrious sitters is perhaps typically Swedish and happily evident here: horse and rider are arranged as they were by Girardon and Schlüter but the baton becomes a hat, while a smile (like a stallion) becomes a gentleman. The same tone was adopted by most of Roslin's approximate contemporaries, for example, Gainsborough in his *Equestrian Portrait of General Philip Honywood* (Sarasota, John and Mable Ringling Museum of Art).

195 Jacques-Louis David, *Equestrian Portrait of Count Stanislas Potocki*, 1781.
Canvas, 119¾ x 85¾ in. (304 x 218 cm).
Warsaw, National Museum.

Even if it were true (as legend once had it) that David saw Potocki ride an untamable horse, it would still be falsely applied to this picture, which, as seen from the examples of Roslin and Carlini, pumps adrenaline into tested forms. David writes this prescription even for Rubens, whose similar and much cited steed in *The Dismissal of the Lictors* (Decius Mus cycle in Vaduz) is less excitable, in keeping with his master's resolve (New York, 1985, no. 213).

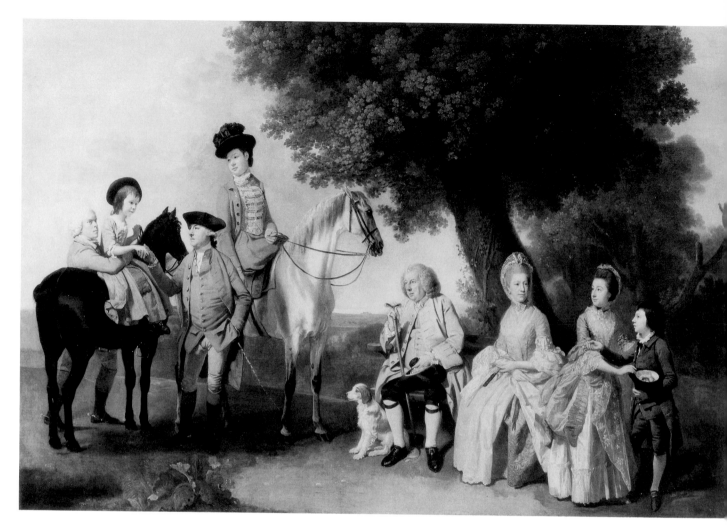

196 Johann Zoffany, *The Drummond Family*,
about 1765–69.
Canvas, 41 x 63 in. (104 x 160 cm).
New Haven, Yale Center for British Art, Paul
Mellon Collection.

Important as horses are in the 18th-century English
"conversation piece" (and however much they depend
on Dutch examples), they are treated merely as
attributes of landed society. Nontheless, equestrian
portraits proper, such as those by Reynolds and by
Stubbs (as in Pl. 198), are as much indebted to these
pictures — are in a sense details of them — as they are
continuations of a tradition dating from the time of
Mijtens and van Dyck. Gentility and domesticity
come naturally to these owners of country homes
and stables; only in the 19th-century, above all with
Victoria (Pls. 215, 217), were these virtues something
to wear in the saddle and on one's sleeve.

197 Sir Joshua Reynolds, *John Manners,
Marquess of Granby*, 1766 (?).
Canvas, 97 x 82¼ in. (246.4 x 209 cm).
Sarasota, Florida, John and Mable Ringling
Museum of Art.

Reynolds and, trailing behind him, Raeburn
(Pls. 200, 201) were among the last masters of the
"dismounted equestrian portrait:" horses became
props for Raeburn (and for his sitters' elbows),
but for Reynolds they were still relevant to the
subject's character and occupations, and essential
parts of the mise-en-scène. See Colorplate 33

198 George Stubbs, *John and Sophia Musters Riding Out at Colwick Hall,* 1777.
Panel, 39½ x 49 in. (100.4 x 124.4 cm).
England, private collection.

Stubbs's conversation pieces and double equestrian portraits such as this one show the subjects in natural scale to the settings and in everyday situations such as hunting, riding for pleasure, and admiring horses on a sunny day (*The Third Duke of Portland with his Brother, Lord Edward Bentinck,* at Welbeck Abbey). Waterhouse was being both perceptive and British when he wrote that Stubbs "had no eye for fashion at all. He saw human beings of all degrees at their best when they were affectionately associated with animals, and he shows us as a result the rural life of the English gentleman as no other painter succeeds in showing it, and the gentle rhythm of his designs, with their slow curves, makes the ideal formal language for this revelation" (*Painting in Britain,* 1969, p. 209).

The painting probably celebrates the Musters' marriage of the year before and records the remodelling of their house. Mrs. Musters soon found city and court life, and the attentions of another man (rumored to be the Prince Regent), more attractive than the Nottinghamshire existence that her husband preferred. He had her painted out of the picture and then himself; the figures were uncovered in 1935. (See further London, 1984, no. 116, with colorplate.)

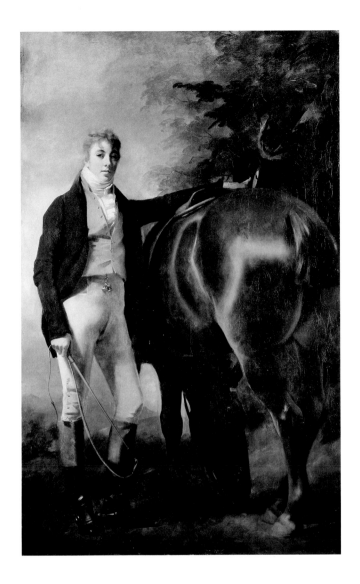

200–201 Sir Henry Raeburn, *George Harley Drummond* and *The Drummond Children*, about 1812.
Canvas, each about 94 x 60 in. (239 x 152.5 cm).
New York, Metropolitan Museum of Art.

Raeburn (1756–1823), the leading portrait painter of Scotland in his time, worked directly on the canvas with little or no preliminary drawing; his pictures, accordingly, are often more impressive in execution than conception. In this splendid pair of decorative canvases the artist's goal is charming portraiture and the embellishment of large wall surfaces. The horse and the pony serve to establish nothing more than ambiance and a clever link between pendant compostions. *Colorplate 32*

◄

199 T.P.C. Haag, *Otto van Randwijck on Horseback*, 1786.
Panel, 16⅜ x 13 in. (41.5 x 33 cm).
Arnhem, Stichting Vrienden der Geldersche Kasteelen.

The painting strikes one as an expected response to English portraiture and to La Guérinière's plates, but it is also a special case, since the baron was Prince Willem V's stablemaster, and the horse in profile is a portrait or at least a type (a Holstein). Nine others are presented in this set of ten pictures, the original frames of which bear cartouches inscribed with each horse's breed.

202 Etienne-Maurice Falconet, *Equestrian Monument
of Peter the Great*, 1766–82.
Bronze statue on granite base, over life-size.
Leningrad, Square of the Decembrists.

A pupil of Lemoyne at the time that the Louis XV monument
was made (Pl. 189), Falconet, Madame de Pompadour's
favorite sculptor, had no comparable commissions until
Diderot arranged this imposing project for Catherine the
Great. Falconet condemned Bernini's *Louis XIV* as well as the
Marcus Aurelius, but the Baroque artist's rearing horse and
mountaintop were, through Lebrun's intended tableau
(Pl. 158), the ultimate source of Falconet's inspiration. The
horse's pose, the anchored tail, and even the symbolic snake
(Envy) are anticipated in the equestrian statuettes by De Grof
and his contemporaries (Pl. 169). Yet precedents do not
explain Falconet's conception, with its seemingly snow-blown
rock *"au milieu des glaces du Nord,"* nor the emperor's
enlightened gesture, *"étendant sur sa capitale une main
protectrice"* (Diderot, quoted by Benot, 1958, pp. 156–57); *in
situ*, the nervous horse (see Levetine, 1972, fig. 105, showing
the wide eyes, pricked ears and flaring nostrils) and the calm
rider appear to face down the forbidding elements, as if
willing St. Petersburg into being on the frozen banks of the
Neva river. Falconet worked in Leningrad from 1766 to 1778;
he returned to France four years before the statue was
unveiled. In keeping with the monument's minimal allegory
and realistic style, the artist composed the succinct inscription:
PETRO PRIMO, CATHARINA SECUNDA.

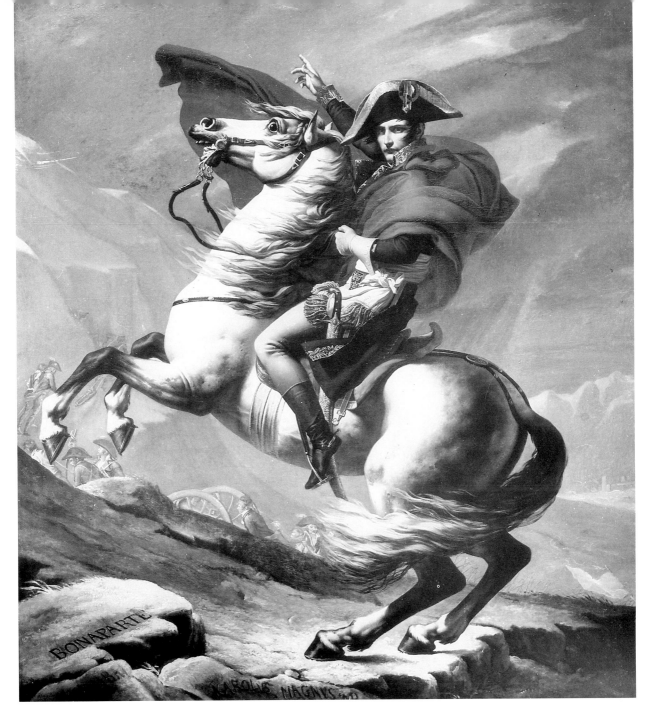

203 Anton Losenko, *Drawing after Falconet's Plaster Model for the Equestrian Monument of Peter the Great*, 1770. Nancy, Musée des Beaux-Arts.

204 Jacques-Louis David, *Napoleon Leading his Army over the Alps*, 1805.
Canvas, 106⅔ x 91⅓ in. (271 x 232 cm).
Versailles, Musée de Versailles.

Falconet's icy setting is taken to extremes by David, and by his sitter, the self-declared successor (again, as graven in the rock) to KAROLVS MAGNVS (Charlemagne) and HANNIBAL. The path is more perilous, the weather worse, the horse naturally more frightened, though more likely by the rider and his fluttering cape than by the situation. Falconet's statue is usually cited as a source (e.g., by Brookner, 1980, p. 147), but line for line the composition is Baroque, perhaps by way of Goya (Pl. 207), except that earlier artists favored diagonal recessions, and earlier riders knew where to place their lower legs. Here the gap between art and life is about as wide as the St. Bernard pass, through which Napoleon — that "world spirit on horseback" (Hegel) — rode a mule on a sunny day.

206 Francisco Goya, *Equestrian Portrait of the Duke of Wellington*, 1812.
Canvas, 116 x 95 in. (294 x 241 cm).
London, The Wellington Museum (Apsley House).

Goya's equestrian portraits were awkwardly derived from those by Velázquez, a few of which he etched (Pl. 207). The horse here follows Philip IV's (Pl. 112) as if it were an unfamiliar form of furniture. The English sitter's condescending but insecure expression was evidently recorded after he entered Madrid in August 1812; his head was painted over another which wore a large hat, which required that the surprisingly civilian suit follow inadequate anatomy (see Kauffmann, 1982, pp. 64–65). Goya's practice of allowing reality to intrude upon convention was somehow successful at the court of Carlos IV, but Wellington kept this canvas rolled up. One would not expect such a mount to amount to much on the playing fields of Eton, let alone at Waterloo. See Colorplate 34.

207 Goya, *Copy afer Velázquez's Equestrian Portrait of Olivares* (Pl. 119), 1778.
Etching.
New York, Metropolitan Museum of Art.

This is one of sixteen etchings after paintings by Velázquez that were in the then-little-known collection of Carlos IV.

205 Antonio Canova, *Equestrian Monument of Carlo III*, 1807–19.
Bronze, over life-size.
Naples, Piazza del Plebiscito.

Originally intended as an equestrian statue of Napoleon, this work was commissioned by his brother, Joseph Bonaparte, King of Naples, from the emperor's favorite sculptor. Canova had little enthusiasm for the assignment, especially after his more dramatic idea—the rider looking backward, urging on his troops—was badly received, and the subject was changed upon Napoleon's fall. As is evident here and in the trotting horse of the companion monument to Ferdinand I, the artist admired the Bourbons less than he did the *Horses of San Marco* (see the caption to Pl. 10). The result is a "simple continuation of an already exhausted tradition" (Licht, 1983, p. 113), which the meaningless motif of the horse's raised foreleg cannot conceal.

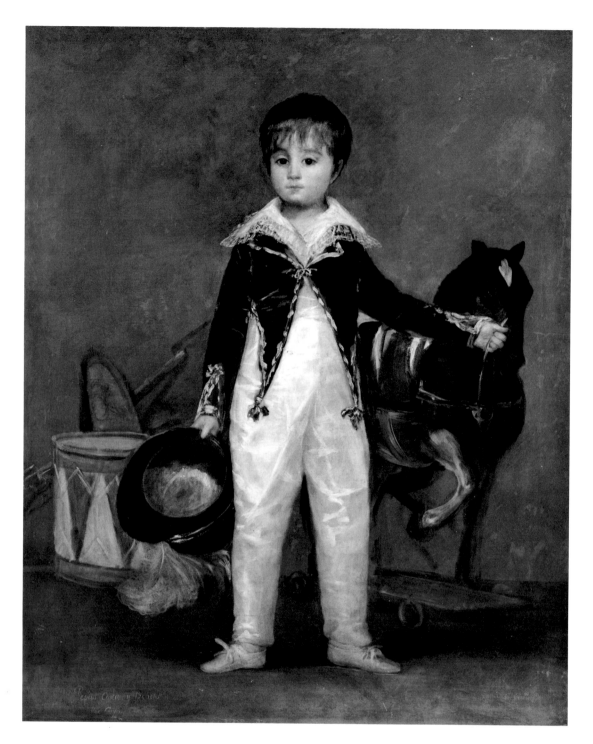

208 Goya, *Pepito Casta y Bonells (the son of Ferdinand VII's physician)*, about 1813. Canvas, 41⅜ x 33¼ in. (105.1 x 84.5 cm). New York, Metropolitan Museum of Art.

DECLINE AND FALL. The three paintings reproduced as Pls. 208–210 demonstrate, with different degrees of sophistication, that after the French Revolution equestrian portraits and especially monuments were not likely to carry the convictions they had in the past. To read this into the portrait of Pepito, a private little person playing soldier with his hobbyhorse, is not to stretch the point, since Goya never used an iconographic convention, in this case the "dismounted equestrian portrait," without simultaneously seeing through its pretense. The natural corollary of the fact that the family of Carlos IV, or even Wellington, could not stand on the stage or sit in the saddle once occupied by men such as Olivares and Philip IV was that only a child, someone still untested and innocent, could pretend to be this sort of adult.

209 Johannes Oertel, *Pulling Down the Statue of George III at the Bowling Green, City of New York, July 1776* (as inscribed on the related engraving published in New York in 1859), about 1859. Canvas, 32¾ x 42⅛ in. (83.2 x 107 cm). New York, The New-York Historical Society.

Sixteen years before statues of royal riders fell all over France, an equestrian monument, the first in America, was hauled down in New York and made into bullets for the American army. The gilded lead statue, by the English artist Joseph Wilton, was voted by the Colony of New York in 1766, and rode in on the coattails of the Colony's more immediate requirement, a pedestrian statue of William Pitt, champion in Parliament of the American cause. Both works arrived from London and were set up in the summer of 1770. Oertel's representation of the monument is entirely imaginary: it was closely modelled on the *Marcus Aurelius*, with the horse trotting, and the king in classical dress (see Wall, 1920). The statue fell on the very night (July 9, 1776) that the Declaration of Independence was read to the Continental Army; a week later (July 17) the *Pennsylvania Journal* reported that the scrap was "to be run into bullets, to assimilate with the brains of our infatuated adversaries, who, to gain a pepper-corn, have lost an empire."

210 Hubert Robert, *A Capriccio of the Statue of Marcus Aurelius with Antiquity Thieves*, 1801. Oval canvas, 29¼ x 23½ in. (74.3 x 59.7 cm). London, Christie's, 11 April, 1986.

Marcus Aurelius understandably gestures with alarm (and with the wrong hand) as he looks down on a gang of Roman relic robbers; the setting recalls the graveyards of Cerveteri rather than the Capitol. This entertaining trivialization of Europe's most admired equestrian monument differs from its appearance in pictures by Pannini, Robert's older colleague, in that here the statue's time is up as well as passed. Robert was a royalist, curator of paintings to Louis XVI. (He survived the Revolution when a fellow prisoner, one Hubert Robert, was mistakenly taken to the guillotine.)

211 Théodore Géricault, *Start of the Riderless Horse Race*, 1817.
Oil on paper, laid on canvas, 8 x 11½ in.
(20.3 x 29.2 cm).
Malibu, Calif., The J. Paul Getty Museum.

As important for equestrian portraits and monuments
as the Revolution was a new concept of nature as wild,
irrational, frightful—"sublime." Byron, Victor Hugo,
Horace Vernet, Delacroix, and Géricault, among others,
all described the tale of the Polish page Mazeppa, who
because of an affair (itself an intemperate act) was tied
naked to the back of a wild horse that ran, terrified, until
it dropped dead (a sort of "terminal equestrian portrait").
This image and that of the riderless horse race—wild
"Barberi" (i.e., Arabians, from "Barbary") deliberately
made hysterical and turned loose on the Corso (1½
miles) in Rome—were the antithesis of equestrian
portraits of the preceding ages, those of Absolutism and
Enlightenment. Géricault witnessed this senseless
amusement in 1817, and made numerous drawings and
oil sketches for a monumental painting that was never
realized. In this study the naked "trainers" and their
charges are transfigured into heroes from an ancient
frieze (note the "Greek" mane) and thus become all the
more intensely sensual. The artist himself was an
impetuous horseman; he died at the age of 32 from the
effects of two riding accidents. (See further Eitner, 1983,
pp. 117–34).

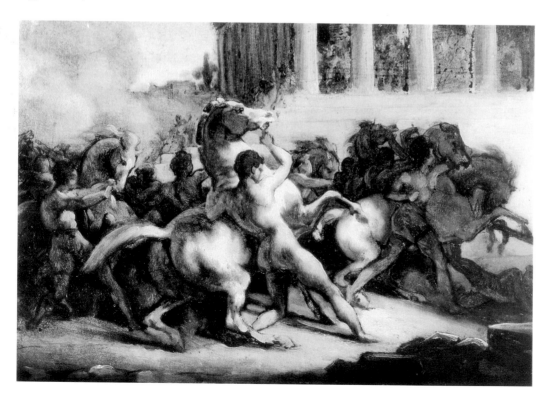

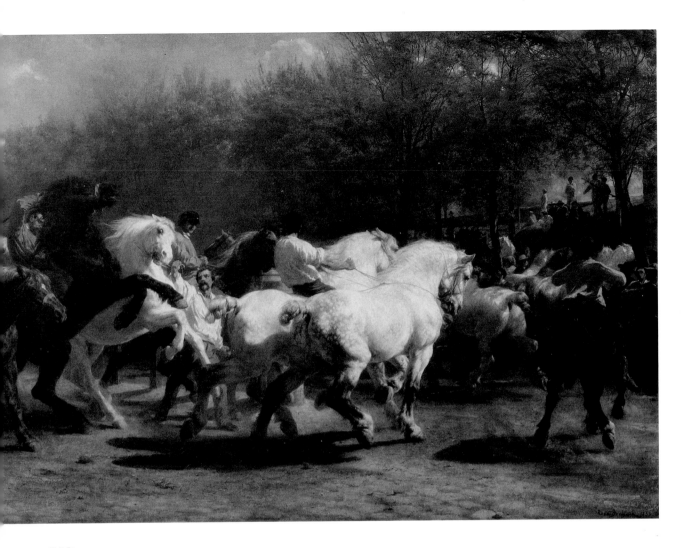

212 Rosa Bonheur, *The Horse Fair*, 1853.
Canvas, 96¼ x 199½ in. (244.5 x 406.8 cm).
New York, Metropolitan Musuem of Art.

In later years the artist called this enormous canvas her
"Parthenon Frieze," which, like the original (bought
by the British government in 1816), was neglected by its
country, and then regretted after it was sold to an
Englishman (the London dealer Gambart, in 1855). The
picture toured the United States from 1858 and became
widely known through engravings and photogravures.
Bonheur began exhibiting paintings of animals in mostly
rural settings at the Salon of 1841, when she was
nineteen. This canvas, shown in the Salon of 1857, is
Parisian in subject, size, and sensibility. It depicts the
horse market on the Boulevard de l'Hôpital in a manner
that is deeply indebted to Géricault (not only his
dramatic horse paintings, but more prosaic
compositions such as *Horses Going to a Fair*, a
lithograph of 1821). At the same time, the work recalls
Courbet's exhibition pictures in its celebration, on a
grand scale, of what might be called the heroic
proletariat, a term that suits the heavy Percheron horses
as well as their rugged handlers. Bonheur was
republican, feminist, and pro-American long before
Buffalo Bill called on her at Fountainbleau in 1889.

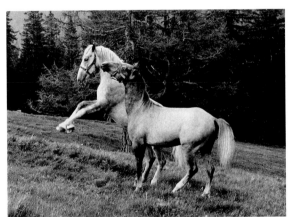

212A *Young Lipizzaners at play.* The poses
of Bonheur's horses are based on careful
observation; here the rearing horse is in a
position similar to that of the white horse in
the center of her composition.

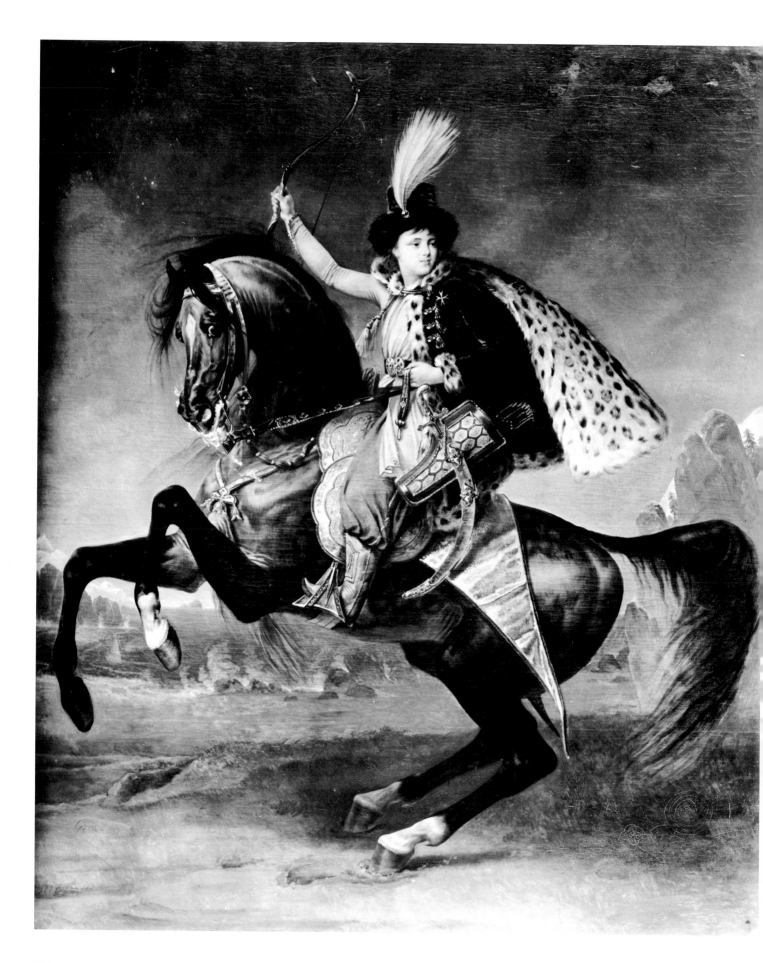

214 Nicolaas Pieneman, *Equestrian Portrait of King Willem III*, 1853.
Panel, 19¼ x 13⅜ in. (49 x 34 cm).
The Hague, Vereniging Oranje-Nassau Museum (on loan to Rijksmuseum Paleis Het Loo, Apeldoorn).

The king's horse makes a sharp turn at the canter in the midst of battle. Such realistic action portraits probably derive from French examples that go back to Gros, but they reveal closer study of the horse in motion, and are romantic only in their sense of adventure. The rider exudes authority and ability; the horse instantly responds. The best of these mid-19th-century equestrian portraits (this one is remarkably superior to J.P. van der Hulst's superficially similar portraits of Willem II; see Leeuwarden, 1979–80, no. 37) are among the last believable images of royal riders as military heroes.

213 Antoine-Jean Gros, *Equestrian Portrait of Prince Youssoupoff (Jussupow)*, 1809.
Canvas, 126⅜ x 104¾ in. (321 x 266 cm).
Moscow, Pushkin State Museum of Fine Arts.

The horse's rearing pose is a rather contrived counterpart to the arrested trot that dates, in portraiture, from the late eighteenth century (see captions to Pls. 194, 195). Gros used the pose repeatedly, in his equestrian portraits of Jerome Bonaparte (1808), of Prince Murat, King of Naples (1812), and in the other version of the present picture (all at Versailles; see Chiego, 1981–82, figs. 4–6, and compare his fig. 2, Géricault's sketch for *The Chasseur*). The action, exotic costume, and emphatically foreign locale look forward to Delacroix's Moroccan imagery (and back to Falconet) but smack of the studio even more than the horse's pose and the setting in David's *Napoleon* (Pl. 204).

215 Sir Francis Grant, *Queen Victoria Riding Out with her Gentlemen at Windsor Castle*, 1840.
Canvas, 38 x 53 in. (96.5 x 134.6 cm).
Windsor Castle, Reproduced by Gracious Permission of Her Majesty the Queen.

The Scottish *amateur* Grant specialized in equestrian portraits of Victoria, becoming through these and social connections the most popular painter of the right sort of people. His strong suit was the sporting conversation piece; this celebrated specimen comes close to 17th-century Dutch examples in composition (e.g., Cuyp's *"La Promenade"* in the Louvre) but is less convincingly aristocratic. To the left is Lord Conyngham, to the right the Prime Minister, Lord Melbourne; the queen's horse is Comus, her dogs Islay and Dash. (Further essential details in Washington, 1985, under no. 540, Grant's replica in the Byng collection.)

217 Sir Edwin Landseer, *Queen Victoria at Osborne*, 1866.
Canvas, 58 x 82 in. (146.7 x 207 cm).
Reproduced by Gracious Permission of Her Majesty the Queen.

Several Dutch conventions—the horse standing with a groom, the estate, the faithful dog, and the evocative act (recalling ter Borch) of reading a letter—combine here to enhance a composition derived from a photograph. Compared with earlier equestrian portraits of Victoria and most of what was carried out on the Continent (e.g., by the Parisian Alfred Dedreux) the picture is unaffected and thereby dignified. (A certain stateliness is achieved through the corresponding stances of John Brown and the horse's hindlegs, which with the profile presentation provides a base for the queen's pyramidal form). Victoria herself treasured the painting for its honesty: "as I am now, sad and lonely, seated on my pony, led by Brown" (Journal, 6 May, 1865).

216 Thomas Thornycroft, *Equestrian Statuette of Queen Victoria*, 1854.
Bronze, 21¼ in. (54 cm) high.
London, Buckingham Palace, Reproduced by Gracious Permission of Her Majesty the Queen.

The work is characteristic of early Victorian equestrian imagery in that it disclaims its stodgy formula (compare Pl. 194) with some conspicuous motif—here the raised foreleg (see Pl. 205)—and superficial flare (which compares to Barye's bronzes as tea does to Turkish coffee). Something startles the horse, not cannonfire now but a leisure-class annoyance such as a snake. The queen keeps her head, conveying through the accumulation of anecdote her ability to rule.

216A Antoine-Louis Barye, *An Ape Riding a Gnu*, about 1840.
Bronze, 9 in. (23 cm) high.
London, Victor Franses Gallery (1986).

219 Giuseppe Primoli, photograph of
Annie Oakley making her horse rear,
in Buffalo Bill's Wild West Show in Rome,
1890. Courtesy of the Fondazione Primoli,
Palazzo Primoli, Rome. (On the
photographer, see John Phillips's article in
Connoisseur, March 1984.)

220 *Haute école* airs performed by Lipizzaners
at the Spanish Riding School, Vienna.

218 Edward Kaiser, *Mme. Tourniaire at
at the Circus Renz, Vienna*, late 19th Century.
Lithograph.
Sarasota, Florida, John and Mable Ringling
Museum.

This illustration "Nach der Natur" shows
a rear on command, which compares to a
levade as the circus does to ballet.

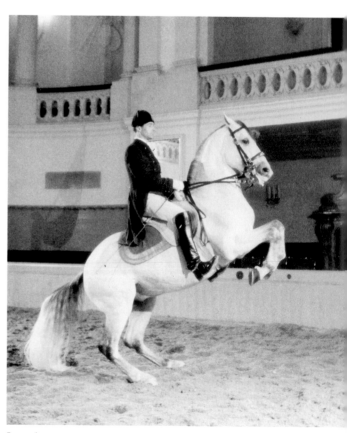

Levade

Capriole

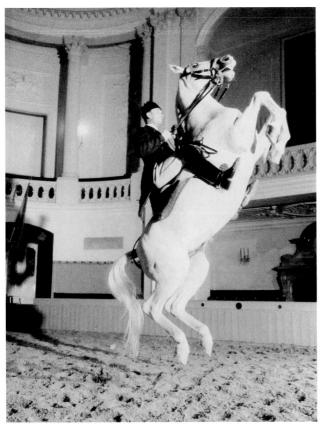

Courbette

Passage (Trot)

INDEX

Uccello, Paolo, 40, 52, 89, 95 (n. 7), 98 (nn. 11, 17), 158, 159, 161, 164; Pl. 20; Colorplate 4
 Battle of San Romano, 52, 159, 161; Pl. 22
Urbino, Duke of, 69, 70, 145, 219

Valerian, 186
Vargas Machuca, Bernardo de, 23, 35, 37, 93 (n. 12), 238
Vasari, Giorgio, 29, 31, 54, 55, 98 (nn. 29, 33), 158, 164, 165, 168
Velázquez, 13, 15, 23–28, 32–35, 40–47, 50, 59, 61, 64, 70, 80, 92 (col. 1, nn. 1–3), 97 (nn. 47, 54), 102 (n. 40), 176, 188, 211, 234, 242–248, 250, 265, 289, 290, 319; Figs. 1, 4, 9, 11, 12, 18, 20, 22, 23, 25, 32; Pls. 110–115; Colorplates 16–20, 22, 23
Velázquez, and Rubens: see Rubens
 and Titian, 40
Venne, Adriaen van de, 80, 295, 298; Fig. 64; Pl. 175
Vernet, Horace, 85, 322
Verrocchio, Andrea del, 49, 52, 54, 58, 61, 65, 70, 89, 100 (nn. 16, 18), 148, 157, 163, 165, 171, 180, 183, 278; Fig. 71; Pls. 25, 27
Versailles, 78, 282, 284, 306, 307
Verschuring, H., 302
Victoria, Queen, 85, 102 (nn. 40, 42), 312, 326, 327; Fig. 70; Pls. 215–217
Vienna, 303 (see also Spanish Riding School)
Villanueva, Jéronimo de, 28
Visconti dukes (Milan), 52
Vitruvius, 165
Vittorio Amedeo I, 58
Voltaire, 287
Volterra: see Daniele
Vorsterman, Lucas, 23, 273; Pl. 145
Vouet, Simon, 70
Vries, Adriaen de, 50, 58, 207, 213; Pls. 70, 92

Wael, Cornelis de, 101 (n. 18)
walking horse, 10, 51, 61, 72, 87, 96 (n. 10), 148, 153, 157, 158, 162, 184
Wallhausen, J.J. de', 20, 92 (col. 2, n. 8)
Walpole, Horace, 276
Weenix, J.B., 300; Pl. 183
Wellington, 83, 102 (n. 30), 319, 320; Pl. 206
whip, 64, 99 (n. 5)
Wierix, Jerome (Hieronymus), 29; Pls. 54, 55
Willeboirts: see Bosschaert
William I (the Silent), 294
William II (Willem II), 101 (n. 27), 273, 296, 325; Pls. 144, 177
William III, 101 (n. 23), 299, 300, 310
William III (King Willem III), 325
William V (Willem V), 315
William the Conqueror, 88
Wilton, Joseph, 321
Witt, Johan de, 80
Wittkower, Rudolf, 16, 20, 50, 75, 93 (n. 16), 211
Wölfflin, Heinrich, 14, 16, 92 (col. 1, n. 7)
Wouwerman, Pieter, 102 (n. 29)

Xenophon, 20, 22, 89, 92 (col. 2, n. 3)

Zarate, Francisco de, 41–43, 96 (nn. 25, 30)
Zoffany, Johann, 312; Pl. 196